PEACE SIGNS

The Anti-War Movement Illustrated

ZEICHEN DES FRIEDENS
Die Illustrationen der Antikriegs-Bewegung

SIGNES DE LA PAIX
Le mouvement contre la guerre illustré

Edited and compiled by/Herausgegeben und zusammengestellt von/Édition et compilation:

James Mann

With a foreword by/Mit einem Vorwort von/Préface de:

Howard Zinn

Historical Introduction by/Historische Einleitung von/Introduction historique de:

Nicolas Lampert

EDITION OLMS ZÜRICH
2004

First published in Switzerland by

EDITION OLMS AG ZÜRICH
Breitlenstr. 11
CH-8634 Hombrechtikon/Zürich
Switzerland
Tel. +41/55 244 50 30
Fax +41/55 244 50 31
edition.olms@bluewin.ch
www.edition-olms.com

ISBN 3-283-00487-0

Bibliographic information published by Die Deutsche Bibliothek,
Die Deutsche Bibliothek lists this publication in the Deutsche
Nationalbibliografie;
Detailed bibliographic data are available in the Internet at http://dnb.ddb.de

Design and Art Direction: James Mann

Translation:
Sonja J. Fath, Florence Baader for French
Katja Heimann-Kiefer for German
Paul Harrison Supervision

Production: Weiss – Grafik & Buchgestaltung

Printed in Italy

TABLE OF CONTENTS

Foreword

Howard Zinn

Foreword

I have always been immensely impressed with how the artist can speak with a special force and passion, saying, with a few strokes of the pen, accompanied by a few words, what we call ourselves writers cannot possibly do with such economy. And when this talent is used on behalf of a profoundly important message, about war and peace, life and death, then it is especially welcome.

We all know that the machinery for dispensing words and images (in newspapers, on radio, on television) has been seized by giant corporations, hugely wealthy, possessed of enormous power, and determined to use that machinery to protect and enhance that wealth, that power.

We are in great need of an opposing power, one that does not depend on money and position, but on talent, determination, moral courage. Art gives us that – as through history it has always placed itself at the service of the poor, the oppressed, the victims of war, the targets of racial and national hatred.

That is why I welcome with gratitude this inspired volume.

The words and pictures in these pages are outrageous in a way that the rest of us often hesitate to be, but that artists dare. They are sobering, sometimes frightening, often hilarious.

What is depicted is so outrageous that we are tempted to think that they are exaggerations, even if we accept them. But no, they are not exaggerations. They seem that way because our ordinary ways of communicating are so pallid, so cautious. But what we see on these pages, however provocative, however startling, cannot possibly match the realities of the world.

No image of war, however shocking, can match the reality. The United States government itself described its bombardment of Iraq with the words "shock and awe."

Thousands of men, women, and children died in that bombardment, who remain faceless and unknown to the American public. Thousands others were injured – blinded, crippled. Occasionally, a photo would appear in the press, showing a little boy without arms. What posters, what work of art, indeed what photograph, can match the reality of that horror? The artist can at least bring us a little closer to it than the cold words of a journalist's or a historian's description, certainly closer than the despicable term used by the government: "collateral damage."

The images collected under the title "No Blood for Oil" likewise cannot possibly match the reality of that unspeakable greed which brings about the deaths of tens of thousands of people. And the signs of "Peace" cannot match the reality of ten million people around the world demonstrating on one day against war.

But those images can wake us up, can cause us to think, to feel, and hopefully, to act.

Vorwort

Ich war schon immer überaus beeindruckt davon, mit welch besonderer Kraft und Leidenschaft Künstler sich ausdrücken können, wenn sie mit nur wenigen Pinselstrichen, begleitet von einigen wenigen Worten, auf den Punkt bringen, was wir, die wir uns Schriftsteller nennen, vermutlich nicht so ökonomisch zur Sprache bringen könnten. Und wenn dieses Talent im Namen einer tiefgreifenden, wichtigen Botschaft zum Einsatz kommt, in der es um Krieg und Frieden, Leben und Tod geht, so ist es besonders willkommen.

Wir alle wissen, dass die Maschinerie, die Wörter und Bilder verteilt (in Zeitungen, im Radio oder im Fernsehen), in der Hand riesiger Medienunternehmen ist, schwerreich, außerordentlich mächtig und entschlossen, diese Maschinerie zum Schutz und Erhalt ihres Reichtums und ihrer Macht einzusetzen.

Wir brauchen dringend eine Gegenmacht, eine Kraft, die unabhängig von Geld und Sozialprestige funktioniert und auf Talent, Entschlossenheit, Moral und Mut aufbaut. Die Kunst ist eine solche Kraft, hat sich doch im Laufe der Geschichte gezeigt, dass sie auf der Seite der Armen, Unterdrückten, der Kriegsopfer und der Opfer von rassistischem oder nationalistischem Hass steht.

Voller Dankbarkeit begrüße ich daher dieses anregende Buch. Die Bilder und Worte auf den folgenden Seiten sind schockierend – da die Künstler zu zeigen wagen, was wir nicht einmal denken mögen. Die Bilder und Worte sind ernüchternd, manchmal beängstigend, oft auch komisch.

Das, was im Folgenden zu sehen ist, ist so schockierend, dass man geneigt ist, die Inhalte für übertrieben zu halten, um die Bilder dann doch als Übertreibungen zu akzeptieren. Aber es handelt sich hier nicht um Übertreibungen. Die Bilder ähneln der Übertreibung, da unsere normalen Kommunikationsmittel blass und vorsichtig sind. Denn das, was wir auf diesen Seiten sehen, reicht, so provozierend oder verstörend es auch scheinen mag, nicht annähernd an die Realitäten dieser Welt heran. Kein noch so schockierendes Bild vom Krieg kann die schreckliche Realität des Krieges vermitteln. Die Regierung der Vereinigten Staaten selbst beschrieb die Bombardierung des Irak als „shock and awe" (Schrecken und Einschüchterung).

Tausende von Männern, Frauen und Kindern starben durch diese Bombardierung und bleiben für die amerikanische Öffentlichkeit ohne Gesicht und ohne Namen. Tausende andere wurden verletzt. Sie überlebten, erblindet, verkrüppelt. Gelegentlich erschien ein Foto in der Presse, das z.B. einen kleinen Jungen ohne Arme zeigte. Welches Kunstwerk, ja, welches Foto kann an die fürchterliche Realität heranreichen? Künstler können uns diese Realität wenigstens ein bisschen besser nahe bringen als die kühlen Worte eines Journalisten oder die Beschreibung eines Historikers, ganz zu schweigen von dem von der Regierung verwendeten abscheulichen Ausdruck für solche Kriegsrealitäten: „Kollateralschäden".

Die Bilder unter der Überschrift „Kein Blut für Öl" können unmöglich die Realität der unsäglichen Gier wiedergeben, die den Tod von Zehntausenden Menschen verursacht. Und die „Friedenszeichen" können nicht die Realität von zehn Millionen Menschen in aller Welt wiedergeben, die an einem Tag gegen den Krieg demonstrieren.

Aber diese Bilder können uns aufwecken, uns zum Denken anregen, zum Fühlen und hoffentlich auch zum Handeln.

Préface

J'ai toujours été très impressionné par la force et la passion avec lesquelles les artistes peuvent prendre position et par ce qu'ils peuvent dire en quelques traits de stylos accompagnés de peu de mots. Nous, qui nous donnons nous-mêmes le titre d'écrivains, nous ne pouvons peut-être pas le faire avec une telle frugalité. Et lorsque ce talent est utilisé au nom d'un message d'une importance capitale, sur la guerre et la paix, sur la vie et la mort, alors il est tout particulièrement le bienvenu.

Nous savons tous que la machinerie qui diffuse les mots et les images dans les journaux, à la radio et à la télévision a été accaparée par des conglomérats gigantesques, immensément riches, possédant un pouvoir illimité et étant bien déterminés à employer cette machinerie pour protéger et accroître encore plus cette richesse et ce pouvoir.

Nous avons un besoin urgent d'un contre-pouvoir, d'un pouvoir qui ne dépende pas de l'argent et du statut social, mais qui s'appuie sur le talent, la détermination et le courage moral. L'art nous donne cette possibilité et au fil de l'histoire, il s'est toujours placé du côté des pauvres, des opprimés, des victimes de la guerre, des cibles de la haine raciale et nationale.

C'est pour cette raison que j'accueille avec gratitude ce livre rempli d'inspiration. Les posters et les mots de ce livre sont choquants dans un sens que nous autres hésitons souvent à suivre. Les artistes, eux, osent. Ils nous poussent à la réflexion, sont parfois effrayants, voire souvent comiques.

Mais ce qui est présenté est tellement scandaleux que nous sommes tentés de soupçonner l'exagération, quitte à l'accepter. Mais non, ce n'est pas une exagération. Les images nous paraissent invraisemblables car nos moyens habituels de communication sont trop insipides et trop réservés. Mais ce que nous voyons sur ces pages, si provocant et si saisissant soit-il, ne peut égaler les réalités de ce monde.

Aucune image de guerre, si choquante soit-elle, ne peut représenter la réalité. Le gouvernement des Etats-Unis lui-même a dépeint ses bombardements en Irak par les termes « choc et intimidation ».

Des milliers d'hommes, de femmes et d'enfants sont morts lors de ces bombardements ; ils sont restés sans visage et sans nom pour l'opinion publique américaine. Des milliers d'autres ont été blessés, aveuglés, estropiés. De temps en temps, une photo paraissait dans la presse montrant un petit garçon sans bras. Quel poster, quel travail artistique, quel photographe peut vraiment traduire la réalité de cette horreur ? L'artiste, lui, peut au moins nous en rapprocher un peu plus que les mots froids d'une description journalistique ou historienne, et assurément plus près que le terme méprisable utilisé par le gouvernement américain : « dommages collatéraux ».

Les images recueillies sous le titre « Pas de sang pour le pétrole » (No Blood for Oil) ne peuvent retranscrire la réalité de cette avidité indicible à l'origine de la mort de dizaines de milliers de personnes. Les signes de « Paix » ne peuvent égaler la réalité de dix millions de personnes dans le monde entier qui manifestent en une seule journée contre la guerre.

Mais ces images peuvent nous réveiller, nous faire réfléchir, nous faire ressentir quelque chose et souhaitons-le, nous faire agir.

Anti-War Art History

Nicolas Lampert

The book you have in your hands, **Peace Signs**, is much more than a collection of 200 anti-war graphics relating to the Iraq War in 2003 and the global protests leading up to the conflict. **Peace Signs** is about the collective effort of a worldwide resistance to war. The graphic styles displayed in this collection are as diverse as the people and countries themselves, ranging from the humorous to the sobering, each containing their own brand of thought-provoking slogans and images. Many of these graphics and posters are the ones seen carried in the marches, posted on city walls and shown via television and photos in newspapers and magazines throughout the world. **Peace Signs** documents the creative side of activism and reminds future generations that massive resistance to war and public policy existed in 2003. It connects the past to the present and has the ability to inspire future artwork and actions against war. A book such as this should not have to exist, because war does not need to exist. The fact that it

is long entrenched. The subsequent "shock and awe" military campaign was met with a backlash of world-wide street protests condemning a war suspected to be waged for empire and control of oil. At the same time, a massive outpour of anti-war graphics emerged in a visual art campaign that was primarily Internet-based and unprecedented in its global reach and scope. The visual documentation – the photographs, the banners, video footage and the posters, live on as a reminder of the global opposition that began before the war and continues through the present time.

The anti-war graphics and posters in Peace Signs are part of a long history of artists responding to war. Every society has examples of well known and unknown artists from both the past and the present. From Goya's "Disasters of War" etchings to Picasso's "Guernica" (see illustration 1) to Alfredo Jaar's photographic installations of the Rwanda genocide, artists have done more than

based propaganda campaigns. Military recruitment posters aided in the process in both Europe and the United States. In England, Alfred Leete's "Your Country Needs You" presented the Secretary for War, Lord Kitchener, into an icon that was easily recognizable by the British public. The poster, released in 1914, reflected a change in the state regulating everyday life and making demands on private individuals. The composition of the poster with its bold pronouncement and finger-pointing directed at the viewer highlighted this sudden bond between the individual and the state.[1]

The poster's format was duplicated in many countries, often using an allegorical figure rather than a soldier or politician.[2] The U.S. Army's version, "I Want You" (see illustration 3) by James Montgomery Flagg, employed Uncle Sam in the same manner. His authoritarian expression was meant to convey to the viewer that refusing military service was not an option to be considered.

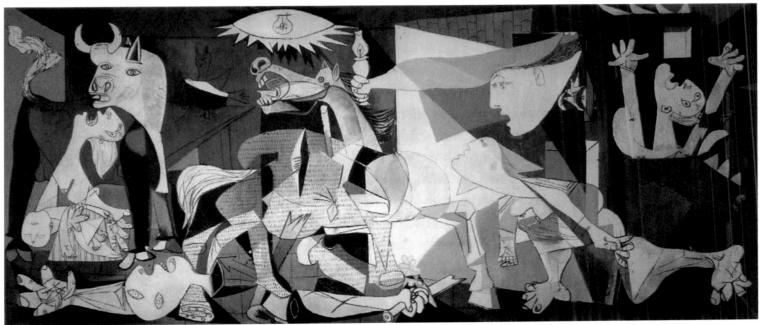

Illustration 1: "Guernica" Pablo Picasso, 1937

does is evidence of an unstable world full of sharp dichotomies.

The information age has provided an equal dose of information and misinformation. Mainstream media, owned by a handful of multinational corporations, reaches billions of people, yet the information is manufactured by only a select number of individuals. Politicians, regardless of the nation-state, are public servants who have largely become disconnected from the interests of the public they claim to represent.

In this climate, a growing distrust of political leaders and multinational corporations has led people to organize. **The Global Day of Protest Against War On Iraq** on February 15, 2003 was considered to be the largest global anti-war demonstration in the history of the world. Mainstream media attempted to downplay the significance of the global outcry and quickly moved on to the next story, but the day will not be soon forgotten. **The Global Day of Protest Against War On Iraq** saw between 10–13 million people in over 600 cities voice opposition to the Bush/Blair-led preemptive strike. (refer to chart) These numbers are staggering considering the demonstrations took place before the war had started, an important distinction considering that anti-war protests in the past have often taken place at the start of a war or when the conflict

simply provide visual documentation to historical events. The artist in opposition to war has taken a moral stand and has acted as a global citizen – one who is concerned with the human rights of all people and the lives of all soldiers. The Chicago printmaker, poet and IWW member, Carlos Cortez, said it best in his print, "Draftees of the World Unite! You Have Nothing to Lose but Your Generals!" (see illustration 2)

Looking back at social and political works in art history, technical inventions have long played a role in how the artist communicates to the public. Before the camera was invented in 1837, war was documented by paintings (commissioned by those in power), which in their scale and grandeur would often depict war as heroic and honorable. The new medium of photography presented the harsher realities of armed conflict as artists such as Matthew Brady and Timothy O' Sullivan documented the US Civil War. The camera could capture all aspects of battle and was assumed to convey the truth by evidence of the negative. Images of dead soldiers lined up in rows on the battlefields reminded the public that war was not as glamorous as it was often portrayed in traditional paintings.

In the early 1900's, a war-reluctant public combined with low enlistment numbers for military service in World War I led to an increase in government-

Posters were printed in editions of ten thousand to one million copies that flooded American towns and cities. More importantly, the posters employed all the techniques of modern advertising, a language familiar to a consumer-based society. Instead of selling a product, a war was sold.

During World War II, the same tactics were utilized. The underlying messages of the government-sponsored posters from the United States, England, Germany, Italy, and Russia are remarkably similar. The effect of the posters, regardless of the language, was to make war seem familiar and to glamorize it through emotional appeals and references to popular culture. In many recruitment posters, the idea of defending the nation was combined with the idea of defending the family. Posters, which featured women with children imploring men to fight, reiterated the dominant conception of masculinity as protective and femininity as defenseless.

Posters were not limited to recruitment themes. Many WWII posters served to dehumanize and demonize the enemy. Graphics created on both sides of the conflict portrayed enemy soldiers as monsters, thieves or rapists. Racial and gender stereotypes were exploited to incite prejudices both against the enemy and the civilian population. Other posters were designed to encourage the public to buy war bonds. Yet, through this haze,

many artists still created strong graphics against war. The Dada movement in Europe formed in response to the horrors of WWI. Strongly opposed to militarism, nationalism and colonialism, the movement produced some of the most celebrated artists of the 20th Century. In Germany, George Grosz created savage drawings of German soldiers returning from battle as cripples. Another German dissenting artist, John Heartfield, credited by many as the inventor of photomontage, waged an all out graphic attack against Hitler. His images reached over a half a million German people through the publication AIZ (Workers International) and served as a testament to the resistance within Germany to the rise of fascism. (see illustration 4)

In the United States, the government took extra steps to quell dissent. President Woodrow Wilson enacted the Espionage Act in 1917, which made speaking out against the war a crime punishable by prison. Over 900 people were sent to jail and anti-war newspapers lost mailing privileges, including "The Masses" which housed some of the leading critical artists of the time. In this climate, fueled by patriotism and the notion of the "great war", anti-war graphics were of limited effect in changing public opinion.

Other nations at this time employed drastic forms of state censorship using art as a means to convey an illusion, a version of society that was far from reality. Socialist Realism was ushered in by Joseph Stalin in Russia and later duplicated by Mao Tse-tung in China during the Cultural Revolution. Stalin outlawed abstract art and individual expression by artists. Instead, artists were to portray the official party doctrine through paintings and monumental sculptures. Art served as a propaganda tool where glowing images of content factory workers, obedient school children and soldiers were at great odds to the daily hardships and sentiments of the population. The "cult of personality" took shape in the official portraits of Communist leaders that were produced by artists in factory line settings. The giant scale of the images were a constant reminder of who held the power and that the state was always watching. Saddam Hussein would later adopt the "cult of personality" aesthetic to propagate his brutal dictatorship in Iraq. Images and statues of his likeness blanketed the cities and countryside as modern day advertisements to his rule. It is ironic that when a few hundred Iraqi people pulled down the towering statue of Hussein in the main square of Baghdad in 2003, the event was orchestrated and staged by the US military. The use of propaganda is a timely reminder that by their nature, governments often manipulate the truth.

During the Vietnam War, a growing distrust of government policy led to mass civil disobedience in the United States and artistically, a resurgence of the anti-war poster. The war in Vietnam was stopped by the resistance by the Vietnamese to the American invasion and the anti-war movement in the United States that turned public opinion and effected the decisions of the policy makers. Posters were a key ingredient in the anti-war movement.

Notable posters of the anti-war movement included "I Want Out" (see illustration 5) by the Committee to Help Unsell the War. The poster features Uncle Sam appropriated as a tired and wounded icon asking the viewer, the public, to relinquish him from serving the military industrial complex. Another overt poster, "Q. And Babies' A. And Babies" (see illustration 6) by the Art Workers Coalition featured a photograph by Ron Haeberle that documented the aftermath of the shooting of 347 unarmed women, children and elderly men by US troops in the South Vietnamese village of My Lai. The red text on the poster refers to the Mike Wallace interview of a soldier involved in the massacre.

The subsequent news coverage and public outcry helped turn American public opinion against the war. Fifty thousand copies of the poster were printed and distributed worldwide through the mail. The Vietnam War era also saw a multitude of international solidarity posters, not to mention a North Vietnamese government sponsored poster campaign that served as a recruitment tool, similar to the WWI and WWII era posters.

What was lacking was a poster campaign from the US Government. Historian Carol A. Wells notes, "The government had no need to disseminate information via graphic art: The Johnson and Nixon administration presented their positions to the U.S. public and the world daily, via the six o'clock news and the mainstream press. Taking full advantage of television, those in power had the ability to reach millions of homes nightly, and thus directly influence public opinion. Johnson and Nixon dominated the news at will. The anti-war movement could only commandeer headlines by holding demonstrations, sit-ins, teach-ins, moratoriums, or other creative mass actions that disturbed 'business as usual' and so were deemed newsworthy. Activists used posters as their means of mass communication; to inform the general public about the issues, and to notify their constituents of the time, date, and location of various events".[3]

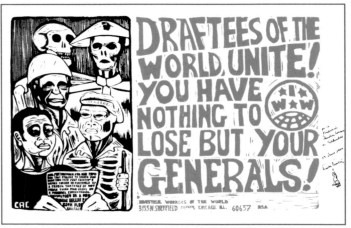

Illustration 2: "Draftees of the World Unite! You Have Nothing To Lose But Your Generals!" Carlos Cortez, 1964/1969

The use of the mass media segues to the first Gulf War. Television coverage was broadcast 24 hours a day on CNN and other major networks under the tight control of government censorship. 160 million Americans watched the outbreak of the war on January 16, 1991, the highest rated televised event in history at the time. Unlike the Vietnam War, reporters were given limited access to the battlefield and were under strict regulations not to show Iraqi civilian or military casualties. Spontaneous interviews with American troops were not allowed nor were pictures of wounded soldiers. In this regard, mainstream media had become a mouthpiece for the government. Even the language of war was rewritten: "smart bombs", "collateral damage", "surgical bombing."

A month after the start of the first Gulf War, the US government proclaimed not only a victory over Iraq but a victory over the "Vietnam syndrome."[4] American confidence and power had been restored. Large demonstrations against the war in the US had been lacking except for a few major cities, most notably, San Francisco. Anti-war graphics and posters were few and far between. This was before the Internet.

The Iraq War of 2003 is a different story. As evidenced by this book and a multitude of web sites, anti-war graphics are more prevalent than ever. The reasons are complex and have a lot to due with access to technology, an unpopular war and world opinion against the only remaining super power. The "peace signs" from around the world and the massive anti-war demonstrations on February 15th, 2003 are encouraging. The Internet, a relatively new form of technology, has

transformed the way we communicate. It has allowed grass roots organizers the ability to reach large groups of people both locally and globally at the click of a button. This shared access to information has connected people from all corners of the world. In this regard, the world has suddenly become much smaller and the nation-state borders that divide people have become less obtrusive.

Artists responding to the war in Iraq had little time to waste in the studio to counter the official doctrine presented by the mainstream media. The idea of the skilled, trained artist was erased. With the influx of computer design programs, scanners and photocopy machines, nearly any person with an idea could create a thought-provoking visual statement. Instead of relying on a handful of well-known political artists, an inclusive mass movement was born. Graphic art was produced quickly on the computer with cut and paste images and text-based slogans. To reach a large audience, many artists utilized the Internet by providing copyright free graphics to a global audience over anti-war web sites. These sites invited artists from around the world to take part, become the media, and participate by posting their images for others to download and then distribute in their communities as wheat-pasted posters, flyers, graphics, stencils and art exhibits. Bypassing the gallery and museum, artists distributed their images for free, where the message and the idea communicated was more important than the profit-based art object.

Posters, for the most part, were created by artists and designers using computer software programs. Many designs utilized standard fonts, san-serif and bold, easily readable when seen from a distance at demonstrations or posted on a wall, leaving no confusion to the artist's intended message. Simple slogans such as "No War" and "No Blood for Oil" were appropriated from the past and present. Images of bombs, oil derricks, gas pumps, politicians and war leaders abounded. The color palette reflected the major themes of the anti-war movement, black and red, signifying anti-capitalism, blood and oil, death and danger. The American flag's red, white and blue, and the stars and stripes representing power and its byproduct – the misuse of power. Other artists chose less politicized colors such as pinks and other pastels, in an effort to add irony or simply to portray a less aggressive, more peaceful vision of the world. But overall, the prevailing colors selected where black and white, thus enabling the artwork to be easily reproduced using photo copying machines. The boldness and simplicity speaks to an urgency on the part of the artist to create visual statements that respond immediately to a crisis situation.

The posters and graphics in Peace Signs add a new chapter in the history of anti-war art. The images in the book are not conclusive; it is not an archive of the entire output of graphic images produced during this time period. Rather, it is a sample from the thousands of images created throughout the world in an artistic outcry that many considered to be unparalleled in history. As the world becomes more uncertain and economic class divisions widen, more artists are merging their politics with their art. A single image can have a powerful impact. It can sum up a thousand words and be universally understood. Artists played an important role in the anti-war movement in 2003. Their work inspired others, envisioned a better world and gave others the courage to speak out. Artists were one of many facets of the peace movement that engaged a new generation of activists, including many who had never before participated in a demonstration. People from around the world collaborated, formed partnerships and supported each other through solidarity movements. It is important to remember that the conflict is not over and there is still much work to be done. Equally important is the recognition that the future and self-determination of

Iraq will come first and foremost from the people of Iraq. Global solidarity with the people of Iraq is as valuable during wartime as it is during the present occupation. To form a broader understanding, one would be wise to learn of the work created by the artists, writers, poets and musicians living in Iraq today. For it is the Iraqi people, and those who have traveled and fought in Iraq that have faced the bitter realities that many of us have only commented upon from afar. With this critique, one should recognize that it is the sum of all our voices that is vital. Oscar Wilde once stated, "the one duty we owe to history, is to rewrite it." By becoming active in your community, nation and world, positive change can and will occur.

Geschichte der Kunst gegen den Krieg
Von Nicolas Lampert

Das Buch, das Sie in Händen halten, *Peace Signs*, beinhaltet weit mehr als nur eine Sammlung von 200 Antikriegsgrafiken anlässlich des Irakkriegs 2003 und der globalen Proteste im Vorfeld der Kampfhandlungen. *Peace Signs* illustriert die kollektiven Anstrengungen des weltweiten Widerstands gegen den Krieg. Die Grafiken, die hier zusammengestellt wurden, gehören den verschiedensten Stilrichtungen an, sie sind ebenso vielfältig wie die beteiligten Menschen und Länder. Das Spektrum reicht vom Humorvollen zum Ernüchternden, jede einzelne Grafik wird getragen von eigenen und unverwechselbaren zum Nachdenken anregenden Slogans und Bildern. Viele dieser Grafiken und Plakate waren auf Demonstrationen zu sehen, wurden an Häuserwänden angeschlagen und im Fernsehen oder auf Fotos in Zeitungen und Zeitschriften in der ganzen Welt gezeigt. *Peace Signs* dokumentiert die kreative Seite der Aktionen und erinnert zukünftige Generationen daran, dass es 2003 massiven Widerstand gegen den Krieg und die offizielle Politik gab. Peace Signs verbindet die Vergangenheit mit der Gegenwart und hat das Potenzial, auch in der Zukunft Kunstwerken und Aktionen gegen den Krieg als Inspiration zu dienen. Ein Buch wie dieses sollte es nicht geben müssen, denn Krieg muss nicht sein. Die Tatsache, dass es dieses Buch gibt, ist Beleg für die Tatsache, dass die Welt instabil und voll harscher Gegensätze ist.

Das Informationszeitalter bringt zu gleichen Teilen Informationen und Fehlinformationen hervor. Die Mainstream-Medien, in der Hand einiger weniger multinationaler Unternehmen, erreichen Milliarden von Menschen. Die Informationen werden aber nur von einer kleinen, exklusiven Gruppe Einzelner produziert. Politiker, gleich welchem Nationalstaat, sind Volksvertreter, die zum großen Teil jeden Bezug zu den Interessen des Volkes, das zu vertreten sie vorgeben, verloren haben.

In diesem Klima hat ein wachsendes Misstrauen gegen die politischen Führer und multinationalen Unternehmen dazu geführt, dass die Menschen sich organisieren. *Der weltweite Aktionstag gegen den Irakkrieg* am 15. Februar 2003 gilt als die größte weltweite Antikriegsdemonstration in der Geschichte. Zwar versuchten die Mainstream-Medien, die Bedeutung dieses globalen Protestschreis herunterzuspielen und wandten sich rasch der nächsten Story zu, aber dieser Tag wird nicht so schnell in Vergessenheit geraten. Am weltweiten Aktionstag gegen den Irakkrieg protestierten zwischen 10 und 13 Millionen Menschen in über 600 Städten gegen diesen von Bush und Blair angeführten „Präemptivkrieges" (siehe Diagramm). Die Zahlen sind überwältigend, angesichts der Tatsache, dass diese Demonstrationen stattfanden, bevor der Krieg überhaupt begonnen hatte: In der Vergangenheit fanden Antikriegskundgebungen häufig erst zu Beginn eines Krieges statt oder wenn der Konflikt bereits seit langem festgefahren war. Die spätere militärische Strategie des „Shock and awe" (Schrecken und Einschüchterung) rief in der ganzen Welt Menschen zu Protesten auf die Straße, die einen Krieg verurteilten, von dem sie annahmen, er

werde aus Machtgründen und zur Kontrolle der Ölvorräte geführt. Zur gleichen Zeit entstand eine enorm große Zahl von Antikriegsgrafiken, im Rahmen einer Kunstkampagne, die vorwiegend über das Internet ablief und die in ihrer weltumspannenden Dimension bisher einmalig war. Die Dokumentation dieser Kampagne, d. h. die Fotografien, die Banner, das Videomaterial und die Plakate, sind Erinnerungszeichen einer globalen Opposition, die vor dem Krieg begann und bis heute andauert. Die in Peace Signs gezeigten Plakate und Grafiken gegen den Krieg setzen eine lange historische Tradition fort, in der Künstler sich mit dem Krieg befassen. Jede Gesellschaft kennt Beispiele bekannter und unbekannter Künstler aus Vergangenheit und Gegenwart. Von Goyas Radierungen „Die Schrecken des Krieges" über Picassos „Guernica" (Abbildung 1) bis hin zu Alfredo Jaars Foto-Installationen über den Völkermord in Ruanda haben Künstler mehr geleistet als einfach nur historische Ereignisse visuell zu dokumentieren. Künstler gegen den Krieg haben eine moralische Position bezogen und als Weltbürger gehandelt, denen die Menschenrechte aller Menschen und das Leben aller Soldaten wichtig sind. Dies hat der aus Chicago stammende Künstler, Dichter und Gewerkschaftsaktivist Carlos Cortez in einem seiner Drucke unübertrefflich ausgedrückt: „Wehrpflichtige aller Länder, vereinigt

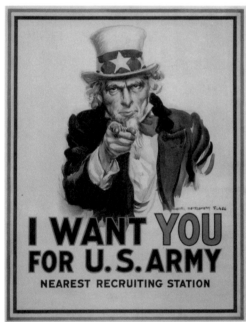

Illustration 3: "I Want You" James Montgomery Flagg, 1916

euch, ihr habt nichts zu verlieren als eure Generäle!" (Abbildung 2) Ein Blick zurück auf gesellschaftskritische und politische Kunstwerke der Vergangenheit zeigt, dass technische Neuerungen schon immer bedeutsam waren für die Art und Weise, wie der Künstler mit der Öffentlichkeit kommuniziert. Vor der Erfindung der Kamera im Jahre 1837 wurde Krieg durch (von den Machthabenden in Auftrag gegebene) Gemälde dokumentiert, die in ihrer Größe und Großartigkeit den Krieg häufig als heldenhaft und ehrenvoll darstellten. Dass das neue Medium der Fotografie die härtere Realität bewaffneter Konflikte wiedergeben konnte, zeigten Künstler wie Matthew Brady und Timothy O'Sullivan im amerikanischen Bürgerkrieg. Die Kamera konnte alle Aspekte des Kampfes festhalten, und es wurde angenommen, dass sie die Wahrheit sprach, indem sie die hässlichen Seiten zeigte. Bilder toter Soldaten, die aufgereiht auf den Schlachtfeldern lagen, riefen den Menschen in Erinnerung, dass der Krieg keineswegs so glanzvoll war, wie er oft auf traditionellen Gemälden dargestellt wurde. Anfang des 20. Jahrhunderts gab es aufgrund der kriegsunwilligen Bevölkerung und niedriger Rekrutenzahlen für den Militärdienst verstärkt Propagandakampagnen der Regierungen. Propagandaplakate sollten die Rekrutierung in Europa und in den USA ankurbeln. In England stilisierte Alfred Leetes Plakat „Your Country Needs

You" („Dein Land braucht dich") den britischen Kriegsminister Lord Kitchener zu einem Symbol, das von den britischen Bürgern problemlos zu erkennen war. Das 1914 erschienene Plakat markierte einen Wendepunkt, an dem der Staat begann, in das alltägliche Leben einzugreifen und Forderungen an den Einzelnen zu stellen. Die Gestaltung dieses Plakats mit seiner direkten und unmissverständlichen Aussage und dem auf den Betrachter zeigenden Finger war ein Ausdruck dieser plötzlichen Verbindung zwischen dem Einzelnen und dem Staat.[1] Das Motiv des Plakats wurde in vielen Ländern kopiert, wobei häufig eine allegorische Gestalt statt eines Soldaten oder eines Politikers verwendet wurde.[2] Die von James Montgomery Flagg für die U.S. Army gestaltete Version „I Want You" (Abbildung 3) setzte Uncle Sam in der gleichen Weise ein. Sein autoritärer Ausdruck sollte dem Betrachter signalisieren, dass eine Verweigerung des Militärdienstes überhaupt nicht in Frage kam. Die Plakate wurden in Auflagen von zehntausenden bis zu einer Million Exemplaren gedruckt und überschwemmten amerikanische Klein- und Großstädte. Was aber noch wichtiger war: Diese Plakate wandten alle Methoden der modernen Werbung an und sprachen somit eine Sprache, die einer Konsumgesellschaft vertraut war. Statt eines Produktes wurde ein Krieg verkauft. Während des Zweiten Weltkriegs verfolgte man dieselbe Taktik. Die unterschwelligen Botschaften der von den Regierungen in Auftrag gegebenen Plakate aus den USA, England, Deutschland, Italien und Russland sind bemerkenswert ähnlich. Ungeachtet der jeweiligen Sprache dienten die Plakate dazu, den Krieg vertraut erscheinen zu lassen und ihn durch emotionale Aufforderungen und Anspielungen auf die Volkskultur zu verklären. Auf vielen Rekrutierungsplakaten wurde das Motiv der Verteidigung der Nation mit dem Motiv der Verteidigung der Familie kombiniert. Plakate, auf denen Frauen mit Kindern die Männer anflehten, zu kämpfen, bedienten sich der vorherrschenden Vorstellung vom männlichen Beschützer und der wehrlosen Frau. Die Themen der Plakate beschränkten sich nicht auf die Rekrutierung. Viele Plakate aus dem Zweiten Weltkrieg zielten darauf ab, dem Feind menschliche Eigenschaften abzusprechen und ihn zu dämonisieren. Jede Seite stellte jeweils die feindlichen Soldaten als Monster, Diebe oder Vergewaltiger dar. Stereotypen auf der Grundlage von Rasse und Geschlecht wurden verwendet, um Vorurteile gegen den Feind und seine Zivilbevölkerung wachzurufen. Andere Plakate sollten die Bürger dazu aufrufen, Kriegsanleihen zu zeichnen. Trotz dieser erstickenden Übermacht schufen viele Künstler kraftvolle Antikriegsgrafiken. Als Reaktion auf die Schrecken des Ersten Weltkriegs entstand in Europa der Dadaismus. Diese Bewegung lehnte Militarismus, Nationalismus und Kolonialismus entschieden ab und brachte einige der meistgeschätzten Künstler des 20. Jahrhunderts hervor. In Deutschland schuf George Grosz drastische Zeichnungen deutscher Soldaten, die als Krüppel aus dem Kampf zurückkehren. Ein weiterer anders denkender deutscher Künstler, John Heartfield, der vielfach als der Begründer der Fotomontage betrachtet wird, führte einen totalen Bilderkrieg gegen Hitler. Seine Bilder erschienen in der „Arbeiter-Illustrierten-Zeitung" (AIZ) und erreichten so über eine halbe Million Deutsche; sie legten Zeugnis ab vom Widerstand innerhalb Deutschlands gegen den aufkommenden Faschismus. (Abbildung 4) In den USA ergriff die Regierung zusätzliche Maßnahmen, um abweichende Meinungen zu unterdrücken. Unter Präsident Woodrow Wilson wurde 1917 das Spionagegesetz verabschiedet, durch das Meinungsäußerungen gegen den Krieg mit Gefängnis bestraft werden konnten. Über 900 Menschen wurden zu Gefängnisstrafen verurteilt und Zeitungen, die sich gegen den Krieg wandten, verloren ihre Postvertriebsrechte. Dazu gehörte auch die Zeitung „The Masses" („Die Massen"), für die einige der damals führenden Künstler arbeiteten. Vor dem Hintergrund eines solcherart von Patriotismus angeheizten Klimas und angesichts der Vorstellung eines „großen Krieges", hatten Antikriegsgrafiken kaum eine Chance, die

öffentliche Meinung zu ändern. Andere Länder setzten zu dieser Zeit drastische Formen staatlicher Zensur ein, wobei die Kunst instrumentalisiert wurde, um ein Idealbild herzustellen, einen ideales Gesellschaftsbild, weit von der Wirklichkeit entfernt. Unter Stalin entstand in Russland der sozialistische Realismus, der später in China von Mao Tse-Tung während der Kulturrevolution kopiert wurde. Stalin ächtete abstrakte Kunst und individuelle Ausdrucksformen. Stattdessen mussten die Künstler in Gemälden und Monumentalskulpturen die offizielle Doktrin der Partei wiedergeben. Kunst diente als Propagandawerkzeug, dessen strahlende Bilder von zufriedenen Fabrikarbeitern, gehorsamen Schulkindern und Soldaten einen scharfen Gegensatz bildeten zum täglichen Elend und den Gefühlen der Bevölkerung. Der Personenkult nahm Gestalt an in den offiziellen Porträts der kommunistischen Führer, die von den Künstlern quasi am Fließband hergestellt wurden. Das gigantische Format dieser Bilder hielt die Machtverhältnisse permanent präsent und gemahnte an die Überwachungsfunktion des Staates. Saddam Hussein übernahm später diese Ästhetik des Personenkults, um seine brutale Diktatur im Irak zu festigen. Bilder und Statuen mit seinem Konterfei überzogen Land und Städte als moderne Reklametafeln für seine Herrschaft. Welche Ironie, dass, als 2003 einige hundert Iraker die riesige Saddam Hussein-Statue auf dem größten Platz Bagdads stürzten, dieses Ereignis von den US-Militärs inszeniert und dirigiert wurde. Der Einsatz von Propaganda erinnert uns zur rechten Zeit daran, dass es in der Natur von Regierungen liegt, die Wahrheit häufig zu manipulieren.

Während des Vietnamkriegs führte ein wachsendes Misstrauen gegen die Politik der Regierung zu massivem zivilen Ungehorsam in den USA und, auf künstlerischer Ebene, zu einer Wiederentdeckung des Antikriegsplakats. Der Krieg in Vietnam wurde beendet durch den Widerstand der Vietnamesen gegen die amerikanische Invasion und die Antikriegsbewegung in den Vereinigten Staaten, die einen Umschwung der öffentlichen Meinung herbeiführte und die Entscheidungen der Strategen beeinflusste. Plakate waren eines der wichtigsten Mittel der Antikriegsbewegung. Eines der bemerkenswertesten Plakate der Antikriegsbewegung war „I Want Out" („Ich will raus") vom Committee to Help Unsell the War. (Abbildung 5) Dieses Plakat zeigt den symbolischen Uncle Sam, müde und verwundet, der den Betrachter die Öffentlichkeit bittet, ihn von seinem Dienst für den militärisch-industriellen Komplex zu entbinden. Ein anderes schonungsloses Plakat ist „Q. And Babies? A. And Babies" („Frage: Auch Babys? Antwort: Auch Babys.") (Abbildung 6) von der Art Workers Coalition, auf dem ein Foto von Ron Haeberle zu sehen ist, das im südvietnamesischen Dorf My Lai aufgenommen wurde, nachdem 347 unbewaffnete Frauen, Kinder und alte Männer von amerikanischen Soldaten erschossen worden waren. Der rote Text auf dem Plakat stammt aus einem Interview mit einem an dem Massaker beteiligten Soldaten. Die anschließende Berichterstattung und die öffentliche Empörung trugen dazu bei, die Meinung der amerikanischen Öffentlichkeit gegen den Krieg zu wenden. Fünfzigtausend Exemplare dieses Plakats wurden gedruckt und weltweit per Post verschickt. Während des Vietnamkriegs entstanden eine Vielzahl internationaler Solidaritätsplakate und nicht zuletzt von der nordvietnamesischen Regierung finanzierte Plakatkampagne, die in der Tradition ähnlicher Plakate aus den beiden Weltkriegen zur Anwerbung von Soldaten diente. Was fehlte, war eine Plakataktion der amerikanischen Regierung. Die Historikerin Carol A. Wells schreibt: „Für die Regierung bestand keine Notwendigkeit, durch Kunst Informationen zu verbreiten. Die Regierungen unter Johnson und Nixon konnten ihre Position der amerikanischen Öffentlichkeit und der Weltöffentlichkeit jeden Tag in den Abendnachrichten und in der Mainstream-Presse präsentieren. Die Führungsspitze nutzte

die Vorteile des Fernsehens restlos aus, um so Abend für Abend Millionen Haushalte zu erreichen, und nahm auf diese Weise direkten Einfluss auf die öffentliche Meinung. Johnson und Nixon dominierten die Nachrichten nach Belieben. Die Antikriegsbewegung konnte nur Schlagzeilen machen, indem sie Demonstrationen, Sit-ins, Teach-ins, Moratorien oder andere kreative Massenaktionen veranstaltete, die den „normalen Betrieb" störten und damit berichtenswert wurden. Die Aktivisten verwendeten Plakate als Massenkommunikationsmittel, um die Öffentlichkeit über die wichtigen Fragen zu informieren und die Menschen von Uhrzeit, Datum und Ort verschiedener Veranstaltungen in Kenntnis zu setzen."[3]

Die Nutzung der Massenmedien setzte sich nahtlos im ersten Golfkrieg fort. Im Fernsehen berichteten CNN und andere große Sender, die der strengen Zensur der Regierung unterlagen, rund um die Uhr. 160 Millionen Amerikaner verfolgten den Beginn des Krieges am 16. Januar 1991 und machten ihn damit zu dem im Fernsehen übertragenen Ereignis mit den bis dahin höchsten Einschaltquoten der Geschichte. Im Gegensatz zum Vietnamkrieg erhielten Reporter nur begrenzten Zugang zu den Schlachtfeldern und hatten strenge Anweisungen, keine zivilen oder militärischen irakischen Opfer zu zeigen. Spontane Interviews mit amerikanischen

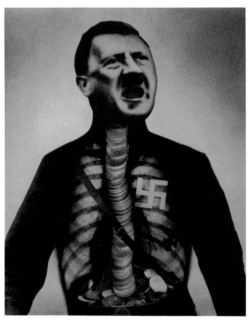

Illustration 4: "Adolf the Superman: Swallows Gold and Spouts Junk" John Heartfield, 1932

Soldaten oder Bilder verwundeter Soldaten waren nicht erlaubt. Auf diese Weise waren die Mainstream-Medien zum Sprachrohr der Regierung geworden. Selbst die Sprache des Krieges wurde neu erfunden: „intelligente Bomben", „Kollateralschäden", „chirurgische Schläge".

Einen Monat nach dem Beginn des ersten Golfkriegs verkündete die US-Regierung nicht nur den Sieg über den Irak, sondern auch den Sieg über das „Vietnam-Syndrom"[4]. Amerikas Selbstvertrauen und Macht waren wiederhergestellt. In den USA fanden, mit Ausnahme einiger größerer Städte, insbesondere San Francisco, keine Großdemonstrationen gegen den Krieg statt. Es gab nur wenige und vereinzelte Grafiken und Plakate gegen den Krieg. Dies war vor dem Internetzeitalter. Beim Irakkrieg 2003 sieht die Sache ganz anders aus. Wie dieses Buch und eine Vielzahl von Websites belegen, sind Grafiken gegen den Krieg so zahlreich wie nie zuvor. Die Gründe dafür sind komplex, sie sind zurückzuführen auf den Zugang zu technischen Möglichkeiten, die Tatsache, dass es sich um einen unpopulären Krieg handelte und es ein weltweites Ressentiment gegen die einzige verbliebene Supermacht gab. Die „peace signs", die Friedenszeichen aus aller Welt, und die gewaltigen Antikriegsdemonstrationen vom 15. Februar 2003 geben Hoffnung. Das Internet ist eine relativ neue Errungenschaft und hat

unsere Kommunikationsformen völlig verändert. Durch das Internet ist es den Organisatoren von Basisgruppen möglich, viele Menschen vor Ort und in der ganzen Welt mit nur einem Mausklick zu erreichen. Dieser gemeinsame Zugriff auf Informationen hat Menschen aus allen Winkeln der Erde miteinander verbunden. Auf diese Weise ist die Welt plötzlich viel enger zusammengerückt und die nationalstaatlichen Grenzen, die Menschen voneinander trennen, sind durchlässiger geworden. Künstler, die den Irakkrieg thematisierten, konnten nicht viel Zeit im Studio verlieren, um der in den Mainstream-Medien präsentierten offiziellen Doktrin entgegenzutreten. Das Konzept des talentierten, geschulten Künstlers löste sich auf. Mit Grafiksoftware, Scannern und Fotokopierern war es praktisch jedem Menschen, der eine gute Idee hatte, möglich, ein aufrüttelndes visuelles Statement zu schaffen. Man war nicht mehr von den paar bekannten politischen Künstlern abhängig, sondern es entstand eine Massenbewegung, an der alle teilhaben konnten. Grafiken wurden durch Kopieren und Einfügen von Bildern sowie textbasierten Slogans ohne großen Zeitaufwand am Computer produziert. Viele Künstler nutzten das Internet, um ein großes Publikum zu erreichen, indem sie auf Websites, die sich gegen den Krieg wandten, Grafiken ohne Copyright einem globalen Publikum überließen. Diese Websites luden Künstler aus aller Welt ein, teilzunehmen, aktiver Bestandteil dieses Mediums zu werden und mitzumachen, indem sie ihre Bilder zum Herunterladen und zur anschließenden Verwendung als wild geklebte Plakate, Flugblätter, Grafiken, Schablonen und Kunstwerke zur Verfügung stellten. Die Künstler nahmen eine Abkürzung an Galerien und Museen vorbei und verteilten ihre Bilder kostenlos: Die Botschaft und die Idee waren wichtiger als das profitorientierte Kunstobjekt. Plakate wurden größtenteils von Künstlern und Grafikern mit Computerprogrammen erstellt. Viele verwendeten gebräuchliche Schriftarten, serifenlos und mit Fettdruck, die auch von weitem – bei Demonstrationen oder an eine Wand angeschlagen – gut lesbar sind und keinen Zweifel an der Intention des Urhebers aufkommen lassen. Auf den Plakaten wurden einfache, alte und neue Slogans wie „No War" („Kein Krieg") oder „No Blood for Oil" („Kein Blut für Öl") verwendet, und Bilder von Bomben, Bohrtürmen, Benzinpumpen und Politikern der Krieg führenden Länder waren in großer Zahl zu sehen. Die verwendeten Farben symbolisierten die zentralen Themen der Antikriegsbewegung: Rot und Schwarz stehen für Antikapitalismus, Blut und Öl, Gefahr und Tod. Ebenfalls stark vertreten sind Rot, Weiß und Blau, die Farben der „Stars and Stripes"-Flagge der USA: Die Sterne und Streifen stehen für Macht und ihr Nebenprodukt, Machtmissbrauch. Andere Künstler haben sich für weniger politisch besetzte Farben entschieden und mit Rosa oder anderen Pastelltönen gearbeitet, um Ironie auszudrücken oder einfach eine weniger aggressive, friedlichere Vision der Welt zu entwerfen. Insgesamt sind die vorherrschenden Farben jedoch Schwarz und Weiß, wodurch sich das Motiv problemlos auf Fotokopierern vervielfältigen lässt. Die Kontrastwirkung und die Schlichtheit verdeutlichen die vom Künstler empfundene Dringlichkeit, eine visuelle Aussage zu schaffen, die unmittelbar auf eine Krisensituation reagierte. Die Plakate und Grafiken in Peace Signs schlagen ein neues Kapitel in der Geschichte der gegen den Krieg gerichteten Kunst auf. Die Bilder in diesem Buch erheben keinen Anspruch auf Vollständigkeit und sind auch kein Archiv aller in diesem Zeitraum erstellten Bilder. Diese Auswahl zeigt einen Ausschnitt aus den tausenden von Bildern, die in der ganzen Welt in einem künstlerischen Aufschrei der Empörung angefertigt wurden, der vielfach für beispiellos in der gesamten Geschichte gehalten wird. Da die Welt zunehmend ungewisser wird und wirtschaftliche Klassenunterschiede sich verstärken, verbinden immer mehr Künstler ihre politische Meinung mit ihrer Kunst. Ein einzelnes Bild kann eine kraftvolle Wirkung erzielen. Es kann ausdrücken, wozu sonst viele Worte notwendig wären und wird universell verstanden. Künstler haben in der Antikriegsbewegung von 2003

eine wichtige Rolle gespielt. Ihre Arbeiten haben andere inspiriert, die Vision einer besseren Welt gezeichnet und anderen den Mut gegeben, ihre Meinung zu äußern.

Künstler waren eine der vielen Facetten der Friedensbewegung, in der sich eine neue Generation von Aktivisten engagiert hat, von denen viele niemals zuvor an einer Demonstration teilgenommen hatten. Rund um den Globus arbeiteten Menschen zusammen, gingen Partnerschaften ein und unterstützten einander in Solidaritätsbewegungen. Es darf keinesfalls vergessen werden, dass dieser Konflikt noch nicht vorüber ist und noch viel zu tun bleibt. Ebenso wichtig ist die Erkenntnis, dass die Zukunft und die Selbstbestimmung des Irak in erster Linie von den Menschen im Irak ausgehen müssen. Die weltweite Solidarität mit den Menschen im Irak ist in Kriegszeiten genauso wertvoll wie während der derzeitigen Besetzung. Für ein tieferes Verstehen wäre es der richtige Weg, aus den Werken der heute im Irak lebenden Künstler, Schriftsteller, Dichter und Musiker zu lernen. Denn es sind die Iraker und diejenigen, die in den Irak gereist sind und dort gekämpft haben, die sich den bitteren Realitäten stellen mussten, die viele von uns nur aus der Ferne kommentiert haben. Ungeachtet dieser Kritik müssen wir aber anerkennen, dass es auf die Summe aller unserer Stimmen ankommt. Um Oscar Wilde zu zitieren: „Die einzige Pflicht, die wir der Geschichte gegenüber haben, ist, sie umzuschreiben." Indem wir an unserem Wohnort, in unserem Land und der Welt aktiv werden, können und werden wir positive Veränderungen bewirken.

Histoire de l'art antiguerre
par Nicolas Lampert

Le livre que vous tenez en main, *Peace Signs*, représente bien plus qu'une collection de 200 graphiques antiguerre sur la guerre en Irak en 2003 et sur les protestations mondiales qui ont précédé le conflit. *Peace Signs* traite de l'effort collectif d'une résistance mondiale contre la guerre. Les styles graphiques représentés dans cette collection sont aussi variés que les peuples et les pays eux-mêmes, allant du plus humoristique au plus désabusé, chacun apposant son propre cachet en créant des slogans et des images qui font réfléchir. Bon nombre de ces graphiques et posters ont été vus portés lors des marches, peints sur les murs des villes, montrés à la télévision et sur des photos dans des journaux et magazines du monde entier. *Peace Signs* retrace le côté créatif de l'activisme et rappelle aux générations futures qu'une résistance massive à la guerre et à la politique officielle a existé en 2003. Peace Signs relie le passé au présent et est une source potentielle d'inspiration pour l'art et les actions futures contre la guerre. Un livre tel que celui-ci ne devrait pas exister, parce que la guerre n'a pas besoin d'exister. Le fait qu'il existe tout de même est la preuve que notre monde est instable et plein de contradictions radicales.

L'ère de l'information nous a apporté information et désinformation. Les mass médias, aux mains de quelques entreprises multinationales, atteignent des milliards de personnes. Pourtant, l'information n'est faite que par quelques rares individus privilégiés. Les hommes politiques, peu importe l'Etat auquel ils appartiennent, sont des serviteurs publics qui ont largement perdu tout contact avec les intérêts de leur peuple qu'ils revendiquent représenter.

Dans un tel climat, la méfiance croissante face aux leaders politiques et aux multinationales a poussé les personnes à s'organiser, ce qui a abouti, le 15 février 2003, au *Global Day of Protest Against the War On Iraq (Journée mondiale de protestation contre la guerre en Irak)* considéré comme la plus grande manifestation mondiale antiguerre de l'histoire de l'art de la planète. Les mass médias ont tenté de minimiser l'importance de ce cri d'indignation générale et sont rapidement passés au sujet suivant. Néanmoins cette journée restera encore

longtemps dans les mémoires. Dans plus de 600 villes, *The Global Day of Protest Against the War On Iraq* a rassemblé une foule de 10 à 13 millions de personnes qui ont manifesté leur opposition à la frappe préventive menée par Bush et Blair (cf. graphique). Ces chiffres sont prodigieux, surtout si l'on considère que les manifestations ont eu lieu avant que la guerre n'ait commencé. Une remarque importante puisque par le passé les protestations antiguerre avaient souvent lieu au début d'une guerre ou lorsque le conflit était entamé déjà depuis longtemps. La campagne militaire « choc et intimidation » qui s'en suit a provoqué des manifestations dans le monde entier condamnant une guerre suspectée d'avoir été lancée pour des raisons impérialistes en vue de contrôler les réserves de pétrole. Au même moment et dans le cadre d'une campagne d'art visuel, une immense production de graphiques antiguerre est apparue tout d'abord sur le Net, sans précédent quant à sa portée mondiale. La documentation visuelle – les photographies, les bannières, les enregistrements vidéo et les posters – est le témoignage de l'opposition mondiale qui a commencé avant la guerre et existe encore aujourd'hui.

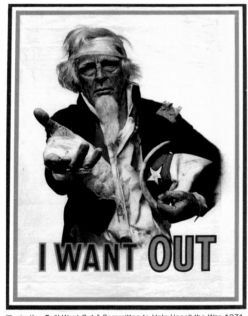

Illustration 5: "I Want Out " Committee to Help Unsell the War, 1971

Les graphiques et posters antiguerre dans Peace Signs font partie d'une longue histoire de réponses d'artistes à la guerre. Chaque société a ses exemples d'artistes connus et inconnus du passé et du présent. Des gravures sur les « Désastres de la Guerre » de Goya, en passant par « Guernica » (illustration 1) de Picasso aux installations photographiques de Alfredo Jaar sur le génocide rwandais, les artistes ont fait bien plus que fournir simplement une documentation visuelle d'événements historiques. L'artiste opposé à la guerre s'est engagé moralement et a agi tel un citoyen du monde – un de ceux qui sont concernés par les droits de l'homme, de tous les êtres humains et par la vie de tous les soldats. Le graphiste, poète et membre du IWW (International Workers of the World Syndicat international de travailleurs), Carlos Cortez de Chicago, l'a fort bien décrit dans son graphique « Draftees of the World Unite! You Have Nothing to Lose but Your Generals! » – Recrues du Monde, unissez-vous ! Vous n'avez rien à perdre à part vos généraux ! (illustration 2)

En jetant un regard en arrière sur les travaux socio-politiques de l'histoire de l'art, les inventions techniques ont depuis longtemps joué un rôle important dans la communication de l'artiste avec son public. Avant que l'appareil photo ne soit inventé en 1837, la guerre était documentée par des peintures (sur ordre de ceux qui détenaient le pouvoir). De par leur nature magnifiante, ces peintures ont souvent présenté la guerre comme héroïque et honorable. Le nouveau média de la

photographie présentait la réalité plus cruelle des conflits armés tels les témoignages documentés de Matthew Brady, Alexander Gardner et Timothy O'Sullivan lors de la Guerre Civile aux USA. L'appareil photo pouvait capter tous les aspects de la bataille et était supposé révéler la vérité en donnant des exemples rebutants par le choc des images négatives. Des photos de soldats morts alignés sur les champs de bataille rappelaient au spectateur que la guerre n'était pas aussi fascinante qu'elle avait été proposée par les peintures traditionnelles.

Au début des années 1900, un public réfractaire à la guerre ainsi que le faible nombre d'appelés au service militaire pour la Première Guerre Mondiale ont conduit à une augmentation des campagnes de propagande menées par les gouvernements. Des affiches pour le recrutement militaire y ont contribué, autant en Europe qu'aux USA. En Grande-Bretagne, les appels de « Your Country Needs You » (Ton pays a besoin de toi) d'Alfred Leete représentaient le Secrétaire d'Etat à la Guerre, Lord Kitchener, sous la forme d'une icône facilement reconnaissable par le public britannique. L'affiche lancée en 1914 reflétait un changement des méthodes de l'Etat qui, désormais, impliquait directement les individus en s'incérant dans la vie quotidienne de tout à chacun. La composition de l'affiche avec ses lettres frappantes et son doigt pointé directement sur le spectateur soulignait ce lien nouveau entre l'individu et l'Etat.[1]

Ce motif fut copié dans de nombreux pays. Cependant une figure allégorique remplaçait généralement l'image d'un soldat ou d'un homme politique[2]. La version de l'armée américaine « I want you » (illustration 3) par James Montgomery Flagg a utilisé l'Oncle Sam de même manière. Son expression autoritaire devait inculquer au spectateur que refuser le service militaire n'était pas une option à considérer. Les affiches ont été imprimées à des tirages de 10 000 à un million d'exemplaires et ont envahi les villes et villages américains. Il est important de préciser que ces affiches employaient toutes les techniques de la publicité moderne, un langage familier pour une société basée sur la consommation. Au lieu de vendre un produit, c'était la guerre que l'on vendait.

Pendant la Seconde Guerre Mondiale, la tactique appliquée a été la même. Les messages sous-jacents des affiches sponsorisées par les gouvernements des USA, Grande Bretagne, Allemagne, Italie et URSS sont sensiblement les mêmes. L'objectif des affiches, peu importe la langue utilisée, était de faire paraître la guerre familière et de la rendre fascinante au travers d'appels émotionnels faisant référence à la culture populaire. Sur de nombreuses affiches de recrutement, l'idée de défendre la nation était liée à l'idée de défendre la famille. Des affiches montrant des femmes et des enfants implorant les hommes d'aller se battre réitéraient la conception dominante de la masculinité protectrice et de la féminité sans défense.

Les affiches n'étaient pas uniquement limités au thème du recrutement. Pendant la Seconde Guerre Mondiale, nombre d'entre elles servaient à déshumaniser et à diaboliser l'ennemi. Des graphiques créés des deux côtés des belligérants faisaient le portrait du soldat ennemi sous la forme d'un monstre, d'un voleur ou d'un violeur. Des stéréotypes raciaux et de genre étaient exploités pour provoquer des préjugés aussi bien contre l'ennemi que contre la population civile. D'autres affiches étaient destinées à encourager le public à acheter des souscriptions de guerre. Malgré ce nombre écrasant d'affiches de propagande, de nombreux artistes ont tout de même créé des graphiques forts contre la guerre. En Europe, le mouvement Dadaïste est né des horreurs de la Première Guerre Mondiale. Fortement opposé au militarisme, au nationalisme et au colonialisme, le mouvement produisit quelques-uns des artistes les plus célèbres du 20e siècle. En Allemagne, George Grosz a créé des dessins féroces de

soldats allemands revenant estropiés des champs de bataille. Un autre artiste allemand dissident, John Heartfield, reconnu par beaucoup comme l'inventeur des photomontages, mena une attaque graphique extrême contre Hitler. Ses photos ont atteint plus d'un demi-million d'Allemands au travers de la publication AIZ (Arbeiter-Illustrierten-Zeitung – Journal illustré des travailleurs) et témoignent de la résistance en Allemagne face à la montée du fascisme. (illustration 4)

Aux Etats-Unis, le gouvernement a pris des mesures particulières pour étouffer les idées dissidentes. Le Président Woodrow Wilson a promulgué une loi sur l'espionnage en 1917 qui fit de toute parole prononcée contre la guerre un crime passible de prison. Plus de 900 personnes ont été ainsi envoyées en prison et les journaux opposés à la guerre ont perdu leurs privilèges d'envoi postal, y compris le journal « The Masses » où travaillaient quelques-uns des artistes critiques les plus renommés de l'époque. Dans ce climat patriotique vibrant sous la notion de « Grande Guerre », les graphiques antiguerre ne pouvaient influencer l'opinion publique que très marginalement.

À cette époque, d'autres pays employèrent des formes drastiques de censure étatique, se servant de l'art comme un moyen de véhiculer une illusion, une version de la société qui était loin de la réalité. Le réalisme socialiste a été inauguré par Joseph Staline en Russie et plus tard copié par Mao Tsé-Toung en Chine pendant la Révolution Culturelle. Staline prohiba l'art abstrait et l'expression individuelle des artistes. Au lieu de cela, les artistes étaient obligés de faire le portrait de la doctrine officielle du parti à travers leurs peintures et des sculptures monumentales. L'art servait d'instrument de propagande où des photos radieuses montrant des ouvriers d'usines satisfaits, des écoliers et des soldats obéissants étaient en contradiction avec les épreuves quotidiennes et les sentiments de la population. Le « culte de la personnalité » prit forme dans les portraits officiels des leaders communistes produits par des artistes qui travaillaient à la chaîne. La taille gigantesque des affiches était un rappel constant à la population pour lui montrer qui avait vraiment le pouvoir et que l'Etat avait les yeux partout. Saddam Hussein adoptera cette esthétique du « culte de la personnalité » afin de consolider sa dictature brutale en Irak. Les affiches et les statues à son effigie tapissaient les villes et les campagnes comme des publicités modernes de son autorité. L'ironie du sort fait que lorsque 200 Irakiens firent tomber l'immense statue de Hussein sur la place principale de Bagdad en 2003, l'événement a été orchestré et mis en scène par les militaires américains. L'utilisation de la propagande nous rappelle de façon flagrante qu'il est dans la nature des gouvernements de manipuler la vérité.

Pendant la Guerre du Vietnam, une méfiance croissante face à la politique gouvernementale a conduit à une désobéissance civile massive aux USA et, au niveau artistique, à une résurgence des affiches antiguerre. La résistance des Vietnamiens à l'invasion américaine a mis fin à la guerre. En renversant l'opinion publique, le mouvement antiguerre aux USA a influencé les décisions des hommes politiques américains. Les affiches ont été un atout majeur de ce mouvement antiguerre.

Ces affiches exceptionnelles du mouvement antiguerre incluaient « I Want Out » (illustration 5) (Libérez-moi) par le « Committee to Help Unsell the War » (Comité pour rendre la guerre inacceptable). L'affiche montre l'Oncle Sam transformé en icône fatiguée implorant le spectateur, le public, de le libérer de l'asservissement au complexe industriel militaire. Un autre poster très direct, « Q. And Babies ? A. And Babies »

(illustration 6) (Question : des bébés aussi ? Réponse : des bébés aussi) par Art Workers Coalition, montrait une photo de Ron Haeberle qui documentait la tuerie de 347 femmes, enfants et personnes âgées non armées par les troupes américaines dans le village sud-vietnamien de My Lai. Le texte en rouge sur l'affiche fait référence à une interview réalisée par Mike Wallace avec un soldat ayant participé au massacre. La couverture d'informations qui s'en suivit et le tollé du public ont aidé à retourner l'opinion publique américaine contre la guerre. 50 000 copies de l'affiche ont été imprimées et distribuées dans le monde entier par courrier. L'ère de la Guerre du Vietnam a été le témoin d'une multitude d'affiches sur la solidarité internationale, sans oublier une campagne de recrutement sponsorisée par le gouvernement du Nord-Vietnam qui s'appuyait sur le principe des affiches de la Première et de la Seconde Guerre Mondiale.

On observe l'absence d'une campagne d'affiches commanditée par le gouvernement américain. L'historienne Carol A. Wells remarque « Le gouvernement n'avait aucun besoin de disséminer l'information au travers de l'art graphique : Tous les jours aux infos de 18 heures et dans les mass médias, les gouvernements sous Johnson et Nixon ont pu exposé leurs positions au public américain et au monde entier. Utilisant à fond l'avantage de la télévision, le pouvoir avait la capacité d'atteindre des millions de ménages chaque soir et d'influencer ainsi directement l'opinion publique. Johnson et Nixon dominaient les infos comme bon leur semblait. Le mouvement

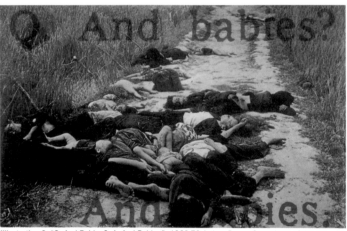

Illustration 6: "Q. And Babies? A. And Babies" 1969-70 Artists Poster Committee of the Art Workers Coalition: Frazier Dougherty, Jon Hendricks, Irving Petlin photo ©Ron L. Haeberle

antiguerre ne put obtenir des gros titres qu'en organisant des manifestations, des grèves sur le tas, des occupations de locaux, des séminaires, des moratoires ou par toute autre action de masse créative qui dérangeait la routine et qui était ainsi considérée comme digne d'apparaître aux infos. Les activistes se servaient d'affiches comme moyens de communication de masse pour informer le public sur les questions importantes et pour lui fournir les renseignements sur la date, l'heure et le lieu des divers événements ».[3]

L'utilisation des mass médias s'est poursuivie lors de la première Guerre du Golfe. La couverture télévisée était assurée 24 heures sur 24 par CNN et d'autres réseaux importants sous le strict contrôle de la censure gouvernementale. 160 millions d'Américains ont suivi en direct le début de la guerre le 16 janvier 1991. L'événement battit un record historique à l'audimat en atteignant le taux le plus élevé de toute l'histoire de la télévision. Au contraire de ce qui s'était passé pendant la guerre du Vietnam, les reporters n'avaient qu'un accès limité aux champs de bataille et étaient soumis à des règles strictes leur interdisant de montrer des civils irakiens ou des victimes militaires. Ni les interviews spontanées avec les troupes américaines, ni les photos de soldats blessés étaient autorisées. Dans ce contexte, les mass médias étaient les porte-parole du gouvernement. Même le langage de la guerre

a été réécrit : « bombes intelligentes », « dégâts collatéraux », « bombardement chirurgical ».

Un mois après le début de la première Guerre du Golfe, le gouvernement américain a proclamé, non seulement une victoire sur l'Irak, mais une victoire sur le « syndrome vietnamien »[4]. La confiance et le pouvoir des Américains avaient été restaurés. Des manifestations importantes contre la guerre au sein des USA n'existaient pas, à l'exception de celles organisées dans quelques grandes villes comme San Francisco. Les graphiques et affiches antiguerre étaient peu nombreux, presque rares. C'était avant l'internet.

La guerre en Irak en 2003 est une autre histoire. Comme le démontrent ce livre et une multitude de sites web, les graphiques antiguerre sont plus présents que jamais. Les raisons en sont complexes et ne sont pas sans rapport avec l'accès aux nouvelles technologies, une guerre impopulaire et une opinion mondiale défavorable à la dernière des superpuissances. Les « signes de paix » en provenance du monde entier et les manifestations antiguerre massives du 15 février 2003 sont encourageants. L'internet, une forme de technologie relativement récente, a transformé notre manière de communiquer. Il a permis aux organisateurs de la base d'atteindre de grands groupes de personnes aussi bien au niveau local qu'international, et ce par un simple clic. Cet accès collectif à l'information a relié les êtres humains aux quatre coins du monde. Ainsi, le monde est soudainement devenu plus petit et les frontières qui séparent les populations se sont avérées moins imperméables.

Les artistes qui ont thématisé la guerre en Irak avaient peu de temps à perdre dans les ateliers pour s'opposer à la doctrine officielle présentée par les mass médias. L'idée de l'artiste talentueux et formé à la tâche a disparu. Avec l'arrivée des logiciels de dessin par ordinateur et avec l'aide des scanners et photocopieuses, n'importe qui avec une idée en tête pouvait créer une pensée qui se traduisait ensuite par une affirmation visuelle. Au lieu de s'appuyer sur une poignée d'artistes politiques bien connus, un mouvement de masse exhaustif était né. L'art graphique était produit rapidement sur ordinateur, utilisant des images, le copier-coller et quelques slogans pour tout texte. Pour arriver à atteindre une grande audience, de nombreux artistes ont utilisé l'internet en fournissant des graphiques libres de copyright à une audience mondiale sur les sites web antiguerre. Ces sites invitaient les artistes du monde entier à se joindre à eux, à devenir eux-mêmes les médias et à y participer en envoyant leurs images afin que d'autres puissent les télécharger et les distribuer dans leurs communautés sous forme d'affiches, tracts, graphiques, modèles et objets d'art. Contournant les galeries et musées, les artistes distribuaient leurs travaux gratuitement. Il était clair que le message et l'idée véhiculés étaient plus importants que l'objet d'art avec valeur de profit.

La plupart des posters ont été créés par des artistes et des designers utilisant des logiciels d'ordinateur. De nombreux dessins employaient des polices d'écriture courantes, sans sérif et gras, facilement lisibles de loin lors d'une manifestation ou collées sur un mur et ne laissant aucun doute sur le message de l'artiste. Des slogans simples sur trois lignes tels « No to War » (Non à la guerre) et « No Blood for Oil » (Pas de sang pour le pétrole) avaient été puisés dans le passé et le présent. Des images de bombes, de derricks de pétrole, de tuyaux de gaz, d'hommes politiques et de chefs guerriers abondaient. La palette des couleurs reflétait les thèmes majeurs du mouvement antiguerre, rouge et noir pour traduire l'anticapitalisme, le sang et le pétrole, le

danger et la mort. Le drapeau américain, rouge, blanc et bleu, des étoiles et des bandes pour représenter le pouvoir et son sous-produit inhérent, l'abus de pouvoir. Les couleurs vert, blanc, noir et rouge du drapeau irakien étaient utilisées à divers degrés de symbolisme positif et négatif. D'autres artistes choisissaient des couleurs moins politisées telles que les roses et les pastels dans un effort d'ajouter de l'ironie, voire simplement de réaliser des visions moins agressives, plus pacifistes du monde. Mais de façon générale, les couleurs dominantes étaient le noir et le blanc, ce qui permettait également de reproduire facilement les divers produits artistiques par photocopies. L'audace et la simplicité des images traduisent le sentiment d'urgence éprouvé par les artistes à créer des affirmations visuelles qui répondent immédiatement à une situation de crise.

Les posters et graphiques dans Peace Signs ajoutent un nouveau chapitre à l'histoire de l'art antiguerre. Ce livre n'a pas d'ambition d'exhaustivité et ne joue pas le rôle d'archive de la production d'images graphiques réalisée pendant cette période de l'histoire. Il s'agit plutôt d'un échantillon de milliers d'images créées dans le monde entier dans un tollé artistique que beaucoup considèrent comme sans précédent. Alors que le monde devient de plus en plus imprévisible et que les divisions économiques entre les classes sociales s'agrandissent, de plus en plus d'artistes mélangent leurs vues politiques à leur art. Une seule image peut avoir un impact puissant. Elle peut résumer mille mots et être comprise dans le monde entier. En 2003, les artistes ont joué un rôle important dans le mouvement antiguerre. Grâce à leurs travaux, d'autres ont été inspirés, la vision d'un monde meilleur a été ébauchée et d'autres encore ont trouvé le courage de s'exprimer à haute voix. Les artistes représentent une des nombreuses facettes du mouvement de paix qui a engagé une nouvelle génération d'activistes, dont un bon nombre d'entre eux n'avaient auparavant jamais participé à une manifestation. Des personnes du monde entier ont collaboré, formé des partenariats et se sont soutenues mutuellement au travers des mouvements de solidarité. Il est important de se rappeler que le conflit n'est pas terminé et qu'il reste encore beaucoup de travail à faire. De la même façon, il est important de reconnaître que l'avenir et l'auto-détermination de l'Irak viendront d'abord et avant tout du peuple irakien lui-même. La solidarité mondiale avec le peuple d'Irak est aussi importante en temps de guerre qu'en temps d'occupation comme actuellement. Afin de comprendre cela, il serait sage de faire la connaissance du travail effectué par les artistes, écrivains, poètes et musiciens vivant en Irak aujourd'hui. Car c'est le peuple irakien et ceux qui ont voyagé et combattu en Irak qui ont fait face aux cruelles réalités que beaucoup d'entre nous ont uniquement commentées de loin. Par cette critique, nous devons reconnaître que c'est la somme de toutes nos voix qui est réellement capitale. Oscar Wilde disait un jour : « Notre seul devoir face à l'histoire est de la réécrire ». En devenant actif dans notre communauté, dans notre pays et dans le monde un changement positif peut se produire et produira.

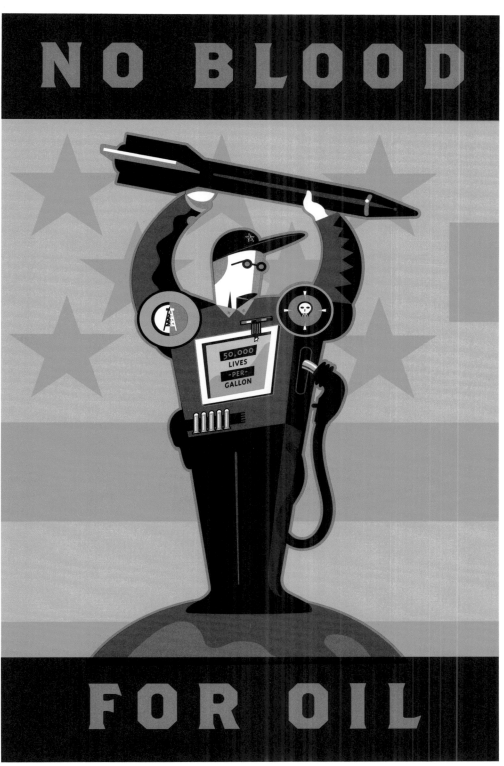

Steven Lyons. "No Blood for Oil ", Keith R. Potter and Steven Lyons, 1990

Notes:
1. Toby Clark, Art and Propaganda in the Twentieth Century (New York, Harry N. Abrams, 1997), 106.
2. Ibid.
3. Decade of Protest: Political Posters from the United States, Vietnam, Cuba 1965-1975, Center for the Study of Political Graphics, Smart Art Press, Santa Monica, 1996.
4. "U.S. President George Bush, on the Success of Shaping Public Opinion for the U.S.-Iraq War," Newsweek, 11 March 1991.

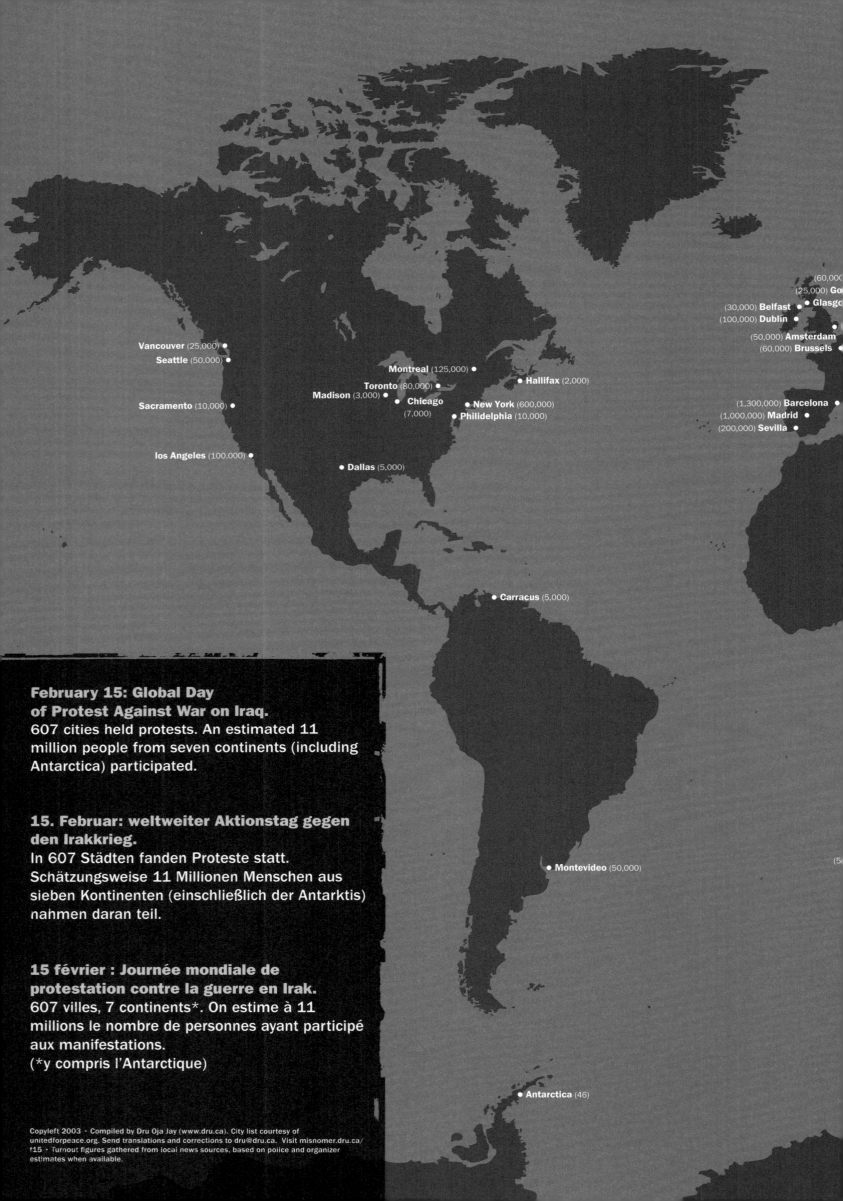

(60,000)
(25,000) Go
(30,000) **Belfast** ● **Glasgo**
(100,000) **Dublin** ●
(50,000) **Amsterdam**
(60,000) **Brussels** ●

Vancouver (25,000) ●
Seattle (50,000) ●

Montreal (125,000) ●
Toronto (80,000) ●　● **Hallifax** (2,000)
Madison (3,000) ●　● **Chicago**
Sacramento (10,000) ●　(7,000)　● **New York** (600,000)
● **Philidelphia** (10,000)

(1,300,000) **Barcelona** ●
(1,000,000) **Madrid** ●
(200,000) **Sevilla** ●

los Angeles (100,000) ●

● **Dallas** (5,000)

● **Carracus** (5,000)

February 15: Global Day of Protest Against War on Iraq.
607 cities held protests. An estimated 11 million people from seven continents (including Antarctica) participated.

15. Februar: weltweiter Aktionstag gegen den Irakkrieg.
In 607 Städten fanden Proteste statt. Schätzungsweise 11 Millionen Menschen aus sieben Kontinenten (einschließlich der Antarktis) nahmen daran teil.

15 février : Journée mondiale de protestation contre la guerre en Irak.
607 villes, 7 continents*. On estime à 11 millions le nombre de personnes ayant participé aux manifestations.
(*y compris l'Antarctique)

● **Montevideo** (50,000)

(5

● **Antarctica** (46)

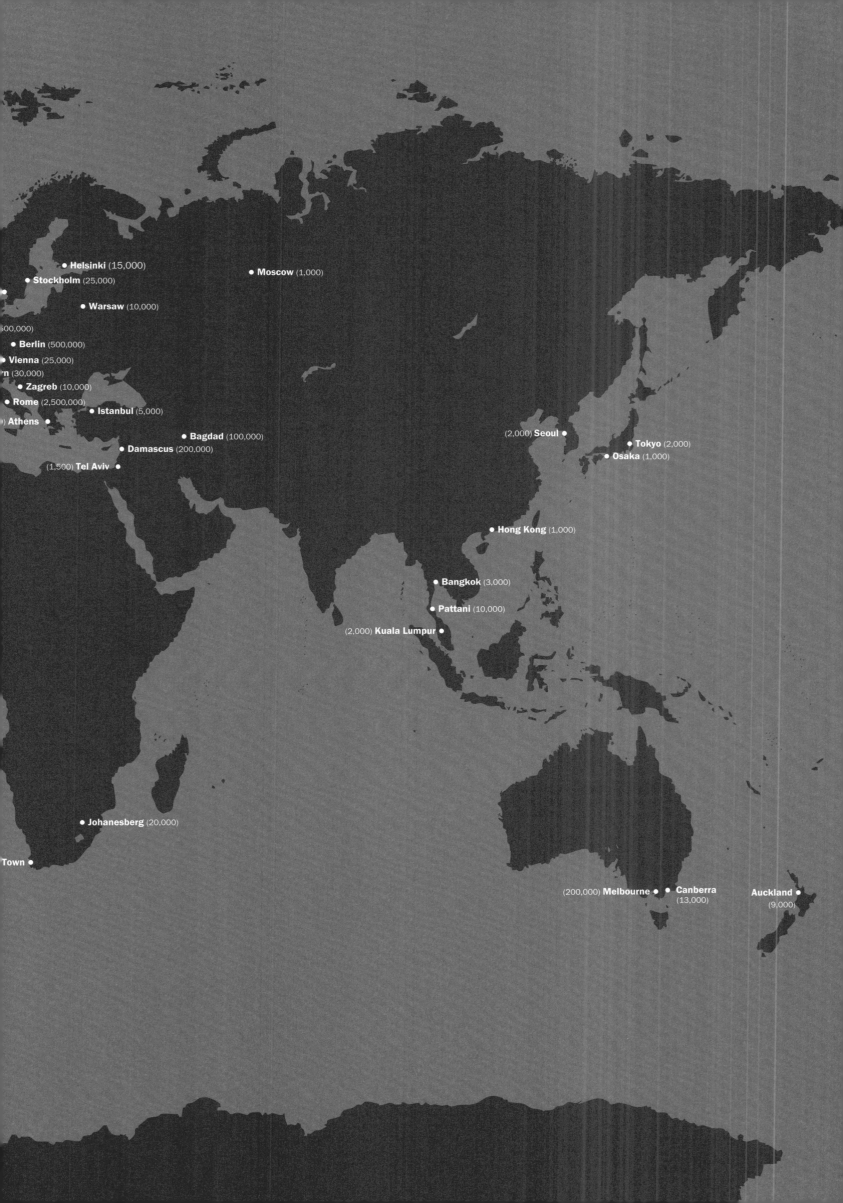

● Helsinki (15,000)

● Stockholm (25,000)

● Moscow (1,000)

● Warsaw (10,000)

00,000)

● Berlin (500,000)

Vienna (25,000)

n (30,000)

● Zagreb (10,000)

● Rome (2,500,000)

● Istanbul (5,000)

Athens ●

● Bagdad (100,000)

● Damascus (200,000)

(2,000) Seoul ●

● Tokyo (2,000)

● Osaka (1,000)

(1,500) Tel Aviv ●

● Hong Kong (1,000)

● Bangkok (3,000)

● Pattani (10,000)

(2,000) Kuala Lumpur ●

● Johanesberg (20,000)

Town ●

(200,000) Melbourne ● ● Canberra
(13,000)

Auckland ●
(9,000)

Copy-left Artwork and Dotcom Dissent

The Internet has provided a space for the multitude of alternative voices that have been virtually shut out of the mainstream media. Far more than simply providing information, it has allowed ordinary people to "become the media" by actively participating in the dissemination of ideas and information to the public. It is ironic that the technology was first developed by the US Military under the research and development program DARPA (Defense Advanced Research Project Agency). In spite of that fact, people worldwide have claimed the medium as their own, democratizing it and using the Internet to voice resistance against the same military industrial complex that first invented the technology.

In the global peace movement against the war in Iraq, the Internet was utilized extensively through emails, online petitions and websites. Communicating by email allowed organizers the ability to reach thousands of people at a click of a button. The large turnout seen on the Global Day of Protest Against War On Iraq on February 15, 2003 was in part due to the success of Internet organizing. Websites such as NoALaGuerra.org in Spain, KeinKrieg.de in Germany, PaxHumana.info in France, and Resistance.org.au in Australia among many others, helped to organize and mobilize the international community.

A couple of weeks later, on February 27, 2003, the organization MoveOn, along with the Win Without War Coalition, organized a virtual protest where over 1 million emails, faxes and telephone calls were sent to the White House and members of U.S. Senate during an 8 hour period in an attempt to thwart the war plans. These non-violent forms of protest reminded the power structure that the public was indeed paying attention.

Artists and designers actively employed Internet technology as well to convey their message to the public. The sudden rise of new web sites in 2003 featuring anti-war posters and graphics was groundbreaking in many regards. The sheer amount of images created and posted by artists throughout the world was beyond comprehension, not only in terms of artistic output, but in the size of the audience able to view and download the images. Wake the World received over 80,000 visitors a week during the height of the conflict and Miniature Gigantic had a record day of nearly 18,000 visitors when the US forces invaded Baghdad. Another Poster for Peace received 4,000–7,000 visitors per day, with the highest day reaching over 12,000 visitors. In the course of a three-month period, the site had over 75,000 downloads. Web sites inviting artists to submit work often could not keep up with the amount of entries submitted. Wake the World was backlogged with over 500 images waiting to be posted.

The sites revolved around the principle of copyright free or "copyleft", a term generally understood to mean that anyone can use the image for free as long as it is not used for profit. The spirit of the graphic resistance was in many cases selfless. Artists and web site designers were not striving to gain personal recognition or monetary compensation. They were trying to stop a war through their creative talents. The majority of artwork displayed on these sites was made on the computer using software such as Adobe Illustrator, Adobe Photoshop or Macromedia Freehand as well as more accessible programs such as Microsoft Word. Saved as .jpeg's, and also the rapidly emerging and highly reliable Adobe Acrobat .pdf (portable document format), artwork was created in a format suitable for high resolution printing but small enough in size to be easily distributed on the Internet.

The merging of art, activism and technology helped to build strong coalitions to counter the mass media's pro-war stance. The protest movement was based on decentralization and global solidarity. Worldwide access to computer technology aided in the process, connecting people from different continents, forming partnerships and collaborations on a scale never before imaginable. As of today, the use of the Internet can be considered truly democratic, it was employed by both the anti-war and the pro-war side and the technology is sure to be utilized in future actions. Media activists and concerned citizens should be vigilant that censorship of web pages and high fees to access information online does not occur.

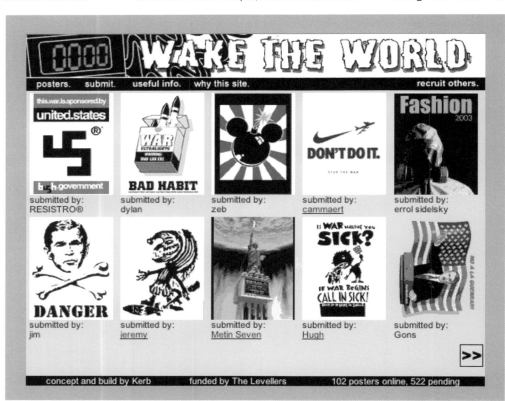

www.waketheworld.com

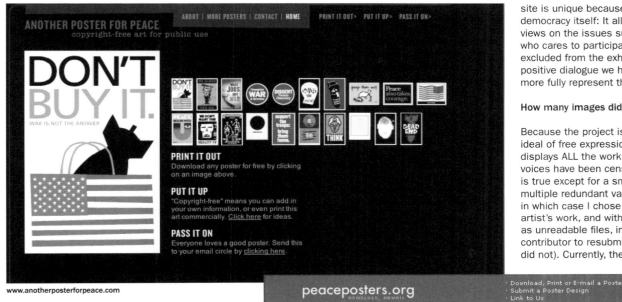

www.anotherposterforpeace.com

site is unique because it was built on the idea of democracy itself: It allows for the expression of ALL views on the issues surrounding the war by anyone who cares to participate, and no voices have been excluded from the exhibition. By engaging in a positive dialogue we hope to approach the truth and more fully represent the complexities of the conflict.

How many images did the site receive?

Because the project is dedicated to the democratic ideal of free expression, the site objectively displays ALL the work that was received, and no voices have been censored or excluded. This is true except for a small number of cases with multiple redundant variations by the same artist, in which case I chose the best examples of that artist's work, and with technical problems such as unreadable files, in which case I invited the contributor to resubmit their work (several of whom did not). Currently, the site features a total of

**Interview with Adam Faja
Miniature Gigantic**

What was your initial impulse in creating a web site to respond to the pending war in Iraq?

This project (www.miniaturegigantic.com) grew out of spirited debates on an online graphic design forum (www.thedesignersrepublic.com) about the then impending war in Iraq. Corey Holms (www.coreyholms.com), an active contributor, suggested that we offset our war anxieties by focusing our energies in a more positive way. He encouraged everyone to create posters expressing their views about the war, and his enthusiasm generated the first 50 or 60 posters. It became clear that people needed a creative outlet to express their views, and when work started filtering in from beyond the confines of the chat room, it was obvious that the exhibition needed a home.

What impact did you hope the web site could achieve?

At a time when the major media outlets are telling the same story, one that doesn't reflect what we hear from our friends, family, neighbors and strangers, the project has provided a supportive forum for real people to broadcast their views. Almost all of the contributions express anti-war attitudes, but the project is not strictly anti-war. The

www.peaceposters.org

460 images from dozens of countries and every continent on earth but Antarctica.

How many visitors did the site receive during the height of the conflict?

At the height of the conflict during the month of April, the site received an impressive 106,052 visitors. By far, the highest traffic for a single day was 17,941 visitors on April 7th, the day that U.S. forces invaded Baghdad. Traffic has steadily tapered off since then (10,144 visitors in May; 6,526 in June) but I still receive an average of over 200 visitors per day.

Were you surprised by the interest and success of anti-war web sites?

No, but I am surprised and disappointed by the lack of meaningful dialogue and dissenting viewpoints in the mainstream media.

Would the impact have been as great had the images been protected by copyright?

While presenting this exhibition on the Internet does help the work to quickly reach a global audience, it also limits the number of people who will be exposed to the messages. Providing copyright-free, printable versions of some posters allows visitors to participate in the initiative by reproducing their favorite posters. They can share their views with the larger public by distributing flyers in their own city, carrying them in marches, stapling them to telephone poles, or even hanging them in their own home. Restricting grassroots activism with a copyright would be counterproductive and would limit the reach of messages that are meant as a public service.

What is the future of the web site now that the war has been proclaimed "over"?

President Bush and the mass media have declared the end of the campaign, but the war is not over. People continue dying every day, and now the justifications for going to war are being called into question. As long as there is still something to say about the war, its causes, and its effects, the site

will continue providing a voice. Once the fighting ends and Iraq is at peace, the site will remain as a monument to the men, women and children that lost their lives in the conflict.

What can be learned from this experience?

I have learned to appreciate the power of a community. A group of people who felt frustrated and helpless at the hands of giant international powers all contributed to the common cause of sharing ideas. The project grew from a small collection of posters by friends, to a widely viewed exhibition by an international coalition of artists and designers. The free exchange of individual voices built respect for the diverse viewpoints within the community. This sort of supportive community dialogue is far more productive and diverse than the singular, unidirectional voice of mainstream media.

What role can artists and designers take in creating positive social change?

Everything big starts small, but change takes time. Artists and designers specialize in appealing to the public with specific messages. One person's message, effectively communicated, can spread to another person, to a community, and beyond. If their idea is compelling, other people take up the cause and help spread the word. The more voices that stand behind an idea, the more closely those in power will listen.

"Never doubt that a small group of thoughtful, committed citizens can change the world. Indeed, it's the only thing that ever has." – Margaret Mead

Kunstwerke mit „Copyleft" und Opposition im Internet

Das Internet bietet eine Plattform für die vielen alternativen Stimmen, die in den Mainstream-Medien praktisch nicht zu Wort kommen. Das Internet ist weit mehr als nur ein Informationsangebot, da es nämlich ganz normalen Menschen ermöglicht, selbst Teil dieses Mediums zu werden, indem sie aktiv an der Veröffentlichung von Gedanken und Informationen mitwirken. Paradoxerweise wurde die dem Internet zugrunde liegende Technik zunächst vom US-Militär im Rahmen des Rüstungsforschungsprogramms DARPA entwickelt. Dennoch haben sich die Menschen in aller Welt das Internet als ihr Medium zu Eigen gemacht, es demokratisiert und eingesetzt, um ihren Widerstand gegen genau jenen militärisch-industriellen Komplex zu formulieren, auf den diese Technik zurückgeht.

Die weltweit agierende Friedensbewegung gegen den Krieg im Irak nutzte das Internet intensiv durch E-Mails, Online-Petitionen und Websites. Mithilfe von E-Mails konnten die Organisatoren tausende von Empfängern mit einem einzigen Mausklick erreichen. Die große Beteiligung am weltweiten Aktionstag gegen den Irakkrieg am 15. Februar 2003 ist zu einem großen Teil der erfolgreichen Aktivität im Internet zu verdanken.

So waren es beispielsweise Websites wie NoALaGuerra.org in Spanien, KeinKrieg.de in Deutschland, PaxHumana.info in Frankreich und Resistance.org.au in Australien, die zum Aufbau und zur Mobilisierung der internationalen Gemeinschaft beitrugen.

Keine zwei Wochen später, am 27. Februar 2003, organisierte das Bündnis MoveOn gemeinsam mit der Win Without War Coalition einen virtuellen Protest, bei dem in einem Versuch, die Kriegspläne zu stoppen, in einem Zeitraum von 8 Stunden über eine Million E-Mails, Faxe und Anrufe im Weißen Haus und bei Mitgliedern des Senats eingingen. Diese gewaltlosen Protestaktionen erinnerten die herrschenden Institutionen

www.designaction.com

www.anti-war .us

daran, dass die Öffentlichkeit ihre Handlungen aufmerksam verfolgte.

Künstler und Designer nutzten die Möglichkeiten des Internets ebenfalls aktiv, um ihre Botschaft an die Öffentlichkeit zu bringen. Dass 2003 so rasch neue Websites entstanden, die Antikriegsplakate und -grafiken zeigten, war in mancherlei Hinsicht bahnbrechend. Allein die Anzahl der von Künstlern in aller Welt angefertigten Arbeiten überstieg das Vorstellungsvermögen, nicht nur was die Menge der Werke betraf, sondern auch in Hinblick auf den Umfang des Publikums, das diese Bilder ansehen und herunterladen konnte. Die Website von Wake the World zählte auf dem Höhepunkt des Konflikts pro Woche über 80.000 Besucher und der Besucherrekord von Miniature Gigantic lag bei fast 18.000 Besuchern, als die US-Truppen in Bagdad einmarschierten. Another Poster for Peace wurde täglich von 4.000–7.000 Menschen besucht, am

verbinden und ermöglichte Partnerschaften und Arbeitsgemeinschaften, wie sie in diesem Umfang zuvor undenkbar waren. Von nun an kann das Internet als wahrhaft demokratisches Medium betrachtet werden – es wurde von Kriegsgegnern und Kriegsbefürwortern verwendet, und dieselbe Technik wird mit Sicherheit auch in der Zukunft genutzt werden. Medienaktivisten und interessierte Bürger sollten wachsam sein, damit es nicht zur Zensur von Webseiten oder zu hohen Gebühren für den Zugriff auf Online-Informationen kommt.

Interview mit Adam Faja
„Miniature Gigantic"

Was hat den Anstoß für Sie gegeben, als Reaktion auf den bevorstehenden Krieg im Irak eine Website einzurichten?

Was hofften Sie mit dieser Website zu erreichen?

Zu einem Zeitpunkt, als alle großen Medien dieselbe Geschichte erzählten, in der das, was wir von unseren Freunden, Verwandten, Nachbarn und von Fremden hörten allerdings nicht vorkam, stellte dieses Projekt ein Forum zur Verfügung, wo ganz normale Menschen ihre Ansichten äußern und verbreiten konnten. Fast alle Beiträge sind gegen den Krieg, aber das Projekt ist kein reines Antikriegsprojekt. Was diese Website einmalig macht, ist ihr demokratischer Anspruch: Alle, die Interesse haben, mitzumachen, können hier UNEINGESCHRÄNKT ihre Meinung zu allen Aspekten des Kriegs äußern und es wurden keine Stimmen von der Ausstellung ausgeschlossen. Indem wir uns auf einen positiven Dialog einlassen, hoffen wir, uns der Wahrheit zu nähern und der Komplexität des Konflikts gerecht zu werden.

Wie viele Bilder gingen auf der Website ein?

Da das Projekt dem demokratischen Ideal der freien Meinungsäußerung verpflichtet ist, sind

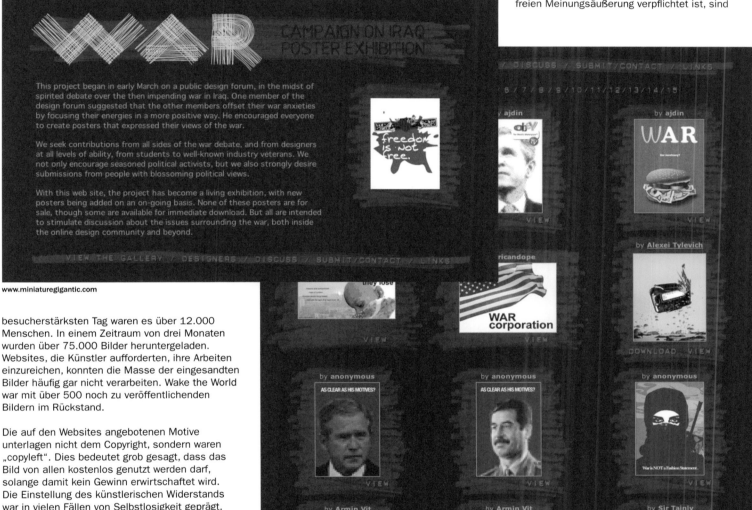

www.miniaturegigantic.com

www.miniaturegigantic.com

besucherstärksten Tag waren es über 12.000 Menschen. In einem Zeitraum von drei Monaten wurden über 75.000 Bilder heruntergeladen. Websites, die Künstler aufforderten, ihre Arbeiten einzureichen, konnten die Masse der eingesandten Bilder häufig gar nicht verarbeiten. Wake the World war mit über 500 noch zu veröffentlichenden Bildern im Rückstand.

Die auf den Websites angebotenen Motive unterlagen nicht dem Copyright, sondern waren „copyleft". Dies bedeutet grob gesagt, dass das Bild von allen kostenlos genutzt werden darf, solange damit kein Gewinn erwirtschaftet wird. Die Einstellung des künstlerischen Widerstands war in vielen Fällen von Selbstlosigkeit geprägt. Die Künstler und Website-Designer strebten nicht nach Anerkennung oder finanzieller Entschädigung: Sie versuchten, mit ihrer Kreativität einen Krieg zu stoppen. Ein Großteil der auf diesen Websites gezeigten Motive wurde auf dem Computer mit Programmen wie Adobe Illustrator, Adobe Photoshop oder Macromedia Freehand und auch mit weiter verbreiteten Programmen wie Microsoft Word erstellt. Die Bilder wurden im JPEG-Format und im immer beliebteren PDF-Format von Adobe Acrobat gespeichert und waren daher zum Ausdrucken in hoher Auflösung geeignet. Gleichzeitig waren die Dateien klein genug, um problemlos über das Internet verbreitet werden zu können.

Die Verschmelzung von Kunst, Aktivismus und Technik förderte die Entstehung starker Koalitionen als Opposition gegen die Massenmedien mit ihrer Befürwortung des Krieges. Die Basis der Protestbewegung waren Dezentralisation und globale Solidarität. Die weltweite Verfügbarkeit von Computern unterstützte den Prozess, Menschen aus verschiedenen Kontinenten miteinander zu

Dieses Projekt (www.miniaturegigantic.com) ist das Produkt angeregter Diskussionen über den zum damaligen Zeitpunkt kurz bevorstehenden Irakkrieg in einem Online-Forum für Grafiker (www.thedesignersrepublic.com). Corey Holms (www.coreyholms.com), der sehr aktiv in diesem Forum ist, schlug vor, einen Ausgleich zu unseren Kriegsängsten zu schaffen, indem wir unsere Energien stärker in einer positiven Richtung bündeln. Er forderte alle auf, Plakate zu entwerfen, die ihre Meinung über den Krieg ausdrückten, und aus dieser Begeisterung entstanden die ersten 50 oder 60 Plakate. Es wurde deutlich, dass die Leute ein kreatives Ventil brauchten, um ihre Meinung auszudrücken, und als die ersten Arbeiten von außerhalb unseres Chatrooms bei uns eingingen, war klar, dass diese Ausstellung eine Heimat brauchte.

auf dieser Website ALLE erhaltenen Motive zu sehen, und es wurden keine Beiträge zensiert oder abgelehnt. Die einzige Ausnahme bilden einige wenige redundante Variationen desselben Themas vom gleichen Künstler. In solchen Fällen habe ich die besten Beiträge dieses Künstlers ausgewählt. Es gab auch manchmal technische Probleme, wenn Dateien nicht gelesen werden konnten. Hier habe ich dann den Künstler gebeten, die Arbeit noch einmal zu schicken (was einige nicht getan haben). Momentan zeigt die Website insgesamt 460 Bilder aus einigen Dutzend Ländern und aus allen Erdteilen, mit Ausnahme der Antarktis.

Wie viele Besucher zählte die Website auf dem Höhepunkt des Konflikts?

Auf dem Höhepunkt des Konflikts im April konnten wir die eindrucksvolle Zahl von 106.052 Besuchern zählen. Die mit Abstand meisten Besucher an einem einzigen Tag gab es am 7. April, als die US-Truppen in Bagdad einrückten. Seitdem hat die Besucherzahl stetig abgenommen (10.144 Besucher im Mai, 6.526 im Juni), aber im Durchschnitt kommen noch immer über 200 Besucher pro Tag.

Hat das Interesse an Websites gegen den Krieg und deren Erfolg Sie überrascht?

Nein, aber ich bin überrascht und enttäuscht davon, dass in den Mainstream-Medien keine ernsthafte Diskussion und keine abweichenden Standpunkte zu finden sind.

Wäre der Erfolg ebenso groß gewesen, wenn die Bilder dem Copyright unterlegen hätten?

Diese Ausstellung im Internet zu präsentieren, ist zwar hilfreich, um schnell ein globales Publikum zu erreichen, aber gleichzeitig ist die Anzahl der Menschen, die die Botschaft erhalten, begrenzt. Dadurch, dass einige Plakate ohne Copyright als druckbare Versionen zur Verfügung gestellt werden, können die Besucher an der Initiative teilnehmen, indem sie ihre Lieblingsmotive ausdrucken. Sie können ihre Ansichten in der Öffentlichkeit bekannt machen, indem sie an ihrem Wohnort Flugblätter verteilen, die Plakate auf Demonstrationen tragen, sie an Laternenpfählen befestigen oder sogar zu Hause aufhängen. Die Aktivität an der Basis durch Copyright einzuschränken, wäre kontraproduktiv und würde die Reichweite von Botschaften, die für die Allgemeinheit bestimmt sind, verkürzen.

Wie sieht die Zukunft dieser Website jetzt aus, da dieser Krieg für „beendet" erklärt wurde?

Präsident Bush und die Massenmedien haben das Ende der Kampfhandlungen verkündet, aber der Krieg ist noch nicht vorbei. Auch jetzt noch sterben jeden Tag Menschen, und die Begründungen, die für diesen Krieg gegeben wurden, werden jetzt in Frage gestellt. Solange es etwas über diesen Krieg, seine Ursachen und seine Auswirkungen zu sagen gibt, wird diese Website ein Forum dafür bieten. Und wenn die Kämpfe beendet sind und Frieden im Irak herrscht, bleibt diese Website erhalten als Erinnerung an die Männer, Frauen und Kinder, die in diesem Konflikt ihr Leben gelassen haben.

Was lässt sich aus dieser Erfahrung lernen?

Ich habe die Macht einer Gemeinschaft schätzen gelernt. Eine Gruppe von Menschen, die sich angesichts riesiger internationaler Mächte frustriert und hilflos fühlten, hat sich an der gemeinsamen Sache beteiligt und ihre Gedanken ausgetauscht. Das Projekt hat sich von einer kleinen Plakatsammlung unter Freunden zu einer häufig besuchten Ausstellung einer internationalen Gemeinschaft von Künstlern und Designern entwickelt. Der freie Austausch individueller Meinungen hat Respekt für die unterschiedlichen Standpunkte innerhalb der Gemeinschaft geschaffen. Ein solcher konstruktiver Dialog innerhalb einer Gemeinschaft ist weit produktiver und vielfältiger als die weitgehend gleichgeschaltete Einbahnstraße der Mainstream-Medien.

Welche Rolle können Künstler und Designer für positive gesellschaftliche Veränderungen spielen?

Alle großen Dinge fangen klein an und Veränderungen brauchen ihre Zeit. Künstler und Designer sind darauf spezialisiert, der Öffentlichkeit bestimmte Botschaften zu vermitteln. Die wirksam vermittelte Botschaft einer einzigen Person kann eine andere Person erreichen und sich von dort in einer Gemeinschaft und darüber hinaus ausbreiten. Wenn diese Botschaft überzeugend ist, werden andere Menschen für die Sache gewonnen, die ihrerseits helfen, die Botschaft zu verbreiten. Je mehr Stimmen hinter einer Botschaft stehen, desto genauer werden diejenigen an der Macht darauf hören.

„Es kann kein Zweifel daran bestehen, dass eine kleine Gruppe engagierter Bürger die Welt verändern kann. Tatsächlich hat nie etwas anderes sie je verändert." – Margaret Mead

Travail artistique « copy-left » et opposition sur le Net

Internet a procuré une nouvelle plate-forme à une multitude de voix alternatives qui avaient pratiquement été exclues des mass médias. Bien au-delà de la simple mise à disposition d'information, il a permis à ces voix de « devenir elles-mêmes les médias » en participant activement à la diffusion d'idées et d'information au public. L'ironie du sort fait que la technologie utilisée a tout d'abord été développée par les militaires américains dans le cadre du programme de recherche et de développement DARPA (Defense Advanced Research Project Agency Agence du projet de recherche avancée pour la

www.protestgraphics.org

défense). Malgré cela, des particuliers du monde entier ont revendiqué ce média comme le leur, le démocratisant de fait et l'utilisant pour exprimer leur opposition précisément à ce même complexe industriel et militaire qui avait tout d'abord développé la technologie.
Lors du mouvement mondial de paix contre la guerre en Irak, l'internet a été utilisé de façon intense au travers de courriels, pétitions en ligne et pages web. En communiquant par courriel, les organisateurs ont pu joindre des milliers de personnes par un simple clic. Le taux élevé de participation constaté lors du Global Day of Protest Against War On Iraq (Journée mondiale de protestation contre la guerre en Irak), le 15 février 2003, est en partie dû au succès de l'organisation sur le Net. Des sites web tels que NoALaGuerra.org en Espagne, KeinKrieg.de en Allemagne, PaxHumana.info en France et Resistance.org.au en Australie, pour ne citer qu'eux parmi tant d'autres, ont permis d'organiser et de mobiliser la communauté internationale.

Deux semaines plus tard, le 27 février 2003, l'organisation MoveOn associée à la Win Without War Coalition a organisé une vague de protestations virtuelles par laquelle plus d'1 million de courriels, faxes et appels téléphoniques ont été

envoyés à la Maison Blanche et à des membres du sénat américain pendant une période de 8 heures, dans le but de contrecarrer les plans de guerre. Ces formes de protestation non-violente rappelaient à ceux au pouvoir que le public restait vigilant.

Les artistes et designers ont également utilisé activement la technologie Internet pour transmettre leur message au public. L'apparition soudaine de nouvelles pages web en 2003 montrant des posters et des graphiques antiguerre était révolutionnaire à plus d'un titre. Rien que le nombre d'images créées et envoyées par des artistes à travers le monde dépassait l'entendement, non seulement en terme de production artistique, mais aussi au niveau de la taille de l'audience en mesure de voir et de télécharger les images. Au faîte du conflit, Wake the World (Réveillez le monde) a reçu plus de 80 000 visites par semaine et Miniature Gigantic a battu le record de presque 18 000 visites le jour où les forces américaines ont envahi Bagdad. Another Poster for Peace (Un autre poster pour la paix) a atteint 4 000 – 7 000 visites par jour, avec un maximum de 12 000 visites en une journée. Pendant une période de trois mois, le site a fait l'objet de plus de 75 000 téléchargements. Les sites web invitant les artistes à soumettre leurs travaux ne pouvaient souvent plus gérer la quantité d'oeuvres soumises. Wake the World avait plus de 500 images en attente de publication.

Les sites fonctionnaient sur le principe du libre copyright ou « copy-left », un terme généralement employé pour désigner le fait que tout le monde peut utiliser librement l'image à condition que ce ne soit pas à but lucratif. Dans de nombreux cas, l'esprit de cette résistance graphique était désintéressé. Les artistes et designers de ces sites web n'avaient pas pour objectif la reconnaissance personnelle ou la compensation monétaire. Ils essayaient d'arrêter une guerre avec leurs talents de créateurs. La majorité du travail artistique présenté sur ces sites a été fait sur ordinateur avec des logiciels tels que Adobe Illustrator, Adobe Photoshop ou Macromedia Freehand, mais aussi avec des logiciels plus accessibles tels que Microsoft Word. Sauvegardé sous la forme de fichiers .jpeg ou sous la forme de fichiers

.pdf (portable document format), en raison de l'émergence du logiciel rapide et hautement fiable de Adobe Acrobat, le travail artistique a été créé dans un format adapté à une impression de haute résolution mais suffisamment petit en taille pour être facilement diffuser sur Internet.

La fusion de l'art, de l'activisme et des technologies a permis de créer des coalitions puissantes pour contrer l'attitude proguerre des médias. Le mouvement de protestation était basé sur la décentralisation et la solidarité mondiale. L'accès généralisé du monde entier à la technologie des ordinateurs a été bénéfique au processus en créant des liens entre des personnes de divers continents, en favorisant des partenariats et en permettant une collaboration à une échelle jamais envisageable auparavant. Aujourd'hui, Internet peut être considéré comme réellement démocratique, car il a été utilisé par les deux partis, antiguerre et proguerre, et la technologie sera inévitablement réutilisée lors d'actions futures. Les activistes des médias et les

www.protestposters.org

citoyens intéressés devraient rester vigilants pour empêcher que la censure de pages web et des tarifs prohibitifs d'accès à l'information en ligne ne soient instaurés.

Interview avec Adam Faja
Miniature Gigantic

Qu'est-ce qui vous a poussé à l'origine à créer un site web pour contrecarrer la guerre imminente en Irak ?

Ce projet est né de débats mouvementés sur un forum en ligne de design graphique qui traitait de l'imminence de la guerre en Irak. Corey Holms, un participant actif, suggéra que nous compensions notre anxiété face à la guerre en centrant notre énergie vers une voie plus positive. Il encouragea tout le monde à créer des affiches exprimant leurs vues sur la guerre, et dans son enthousiasme, il a produit les premiers 50 ou 60 posters. Il devint alors clair que les gens avaient besoin d'un exutoire créatif afin d'exprimer leurs vues, et lorsque les travaux affluèrent de toutes parts au-delà des confins du « chat room », il devint clair que l'exposition avait besoin d'un toit.

Quel est l'objectif que vous souhaitiez atteindre grâce au site web ?

A un moment où les productions des médias majeurs vous racontent toutes la même histoire et que celle-ci ne correspond pas à ce que l'on entend chez les amis, dans la famille, chez les voisins et par les étrangers, le projet a proposé un forum de soutien pour que de vraies personnes puissent exposer leurs points de vue. Presque toutes les contributions ont une attitude antiguerre, mais le projet n'est pas strictement antiguerre. Le site est unique dans le sens où il a été construit sur l'idée de la démocratie elle-même : Il permet l'expression de TOUTES les opinions sur les thèmes autour de la guerre par n'importe qui souhaitant participer. Aucune voix n'a été exclue de l'exposition. En nous engageant dans un dialogue positif, nous espérons nous rapprocher de la vérité et représenter plus pertinemment la complexité du conflit.

Combien d'images le site a-t-il reçu ?

Etant donné que le projet est dédié à l'idéal démocratique de la libre expression, le site présente objectivement TOUT le travail reçu et aucune voix n'a été censurée ni exclue. Ceci est vrai à l'exception d'un petit nombre de cas de variations redondantes multiples d'un sujet par le même artiste. Dans ce cas, j'ai choisi les meilleurs exemples du travail de cet artiste. Un autre cas sont les problèmes techniques de fichiers illisibles, dans ce cas j'ai demandé au participant de soumettre une nouvelle fois son travail (plusieurs d'entre eux ne l'ont pas fait). Actuellement, le site comporte un total de 460 images en provenance de douzaines de pays et de tous les continents à l'exception de l'Antarctique.

Combien de visiteurs le site a-t-il reçu au faîte du conflit ?

Au faîte du conflit, pendant le mois d'avril, le site a eu une fréquentation impressionnante de 106 052 visiteurs. Le plus gros trafic d'une simple journée était de loin le 7 avril, le jour de l'invasion de Bagdad par les forces américaines, avec 17 941 visiteurs. Le trafic s'est continuellement affaibli depuis lors (10 144 visiteurs en mai, 6 526 en juin), mais je reçois toujours et encore une moyenne de 200 visites par jour.

Etiez-vous surpris par l'intérêt et le succès des sites web antiguerre ?

Non, mais je suis surpris et je regrette le manque de dialogue significatif et de points de vue divergents dans les mass médias.

Croyez-vous que l'impact aurait été aussi grand si les images avaient été protégées par copyright ?

Présenter cette exposition sur Internet favorise la diffusion rapide du travail à une audience mondiale, mais cela limite aussi le nombre de personnes qui peuvent lire les messages. En fournissant les versions de certains posters imprimables et libres de copyright, cela permettait à des visiteurs de participer à l'initiative en reproduisant leurs posters favoris. Ils pouvaient alors échanger leurs points de vue avec un public plus large en distribuant des tracts dans leur propre ville, en les portant haut lors des manifestations, en les agrafant sur des pylônes téléphoniques, ou même en les accrochant dans leur propre foyer. Restreindre l'activisme à la base par copyright aurait été contre-productif et aurait entravé la diffusion des messages qui sont vus comme un service public.

Quel est l'avenir du site web maintenant que la guerre a été proclamée « finie » ?

Le Président Bush et les mass médias ont déclaré que la campagne est terminée, mais la guerre n'est pas finie. Des gens continuent de mourir tous les jours et à présent on remet en question les justifications de cette guerre. Aussi longtemps qu'il y aura quelque chose à dire au sujet de la guerre, de ses causes et de ses effets, le site fournira une plate-forme d'échanges. Une fois que les combats auront stoppé et que l'Irak sera en paix, le site restera en tant que monument aux morts pour les hommes, les femmes et les enfants qui ont laissé leur vie dans le conflit.

Que peut-on apprendre de cette expérience ?

Personnellement, j'ai appris à apprécier le pouvoir d'une communauté. Un groupe de personnes qui se sentaient frustrées et sans défense face à des pouvoirs internationaux géants ont toutes contribué à la cause commune de l'échange des idées. Le projet est passé d'une petite collection de posters d'amis à une exposition vue par un grand nombre de personnes autour d'une coalition internationale d'artistes et de designers. Le libre échange d'opinions a permis d'instaurer un climat de tolérance entre les divers points de vue au sein de la communauté. Cette sorte de dialogue communautaire de soutien est bien plus productive et diversifiée que la voix singulière et unidirectionnelle des mass médias.

Quel est le rôle que peuvent jouer les artistes et designers dans la transformation sociale positive ?

Tout ce qui est grand a commencé petit, mais le changement requiert du temps. Les artistes et designers se spécialisent dans les appels au public au travers de messages spécifiques. Le message d'une personne, une fois effectivement communiqué, peut se propager vers une autre personne, une communauté et bien au-delà. Si son idée est convaincante, d'autres personnes vont reprendre la cause à leur compte et aider à propager cette parole. Plus il y a de voix derrière une idée, plus grande sera la chance que ceux au pouvoir entendent.

« Ne doutez jamais qu'un petit groupe de citoyens réfléchis et engagés puisse changer le monde. En vérité, ce sont les seuls qui l'aient jamais vraiment fait.» Margaret Mead

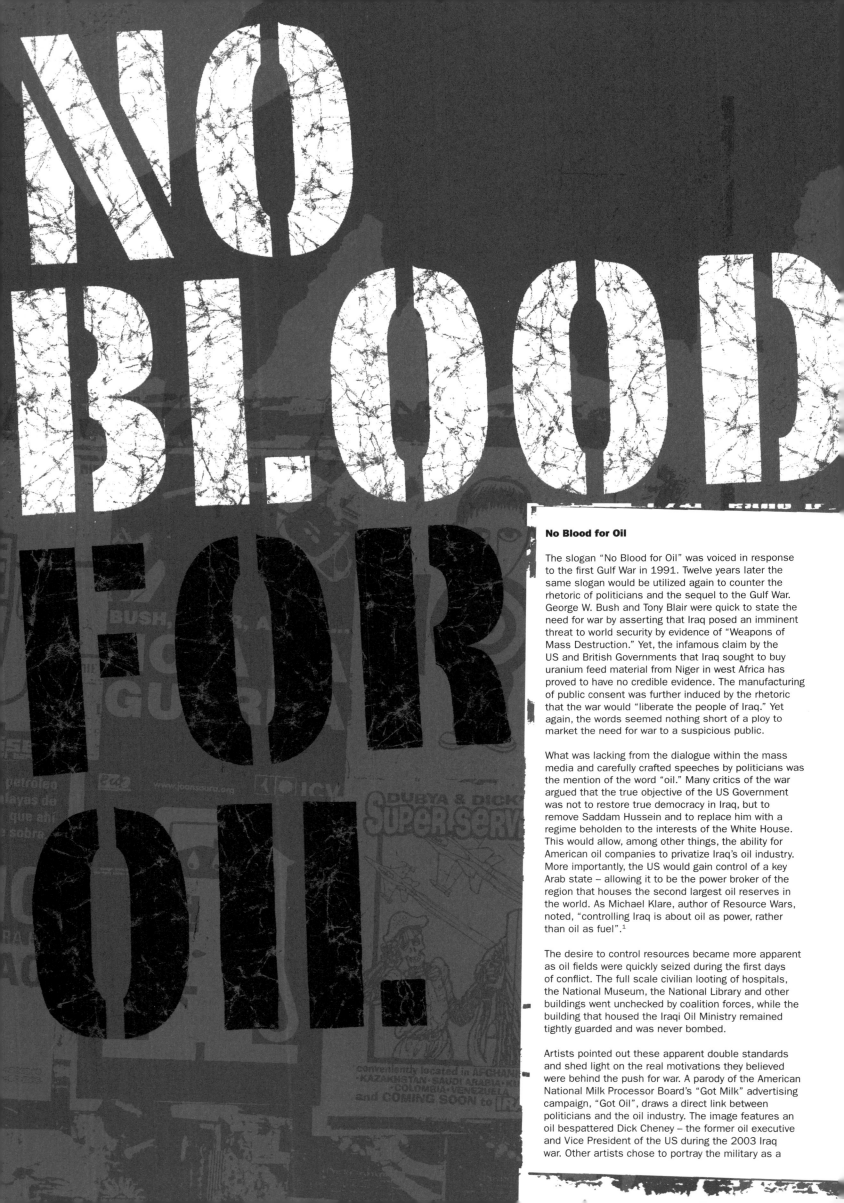

NO BLOOD FOR OIL.

No Blood for Oil

The slogan "No Blood for Oil" was voiced in response to the first Gulf War in 1991. Twelve years later the same slogan would be utilized again to counter the rhetoric of politicians and the sequel to the Gulf War. George W. Bush and Tony Blair were quick to state the need for war by asserting that Iraq posed an imminent threat to world security by evidence of "Weapons of Mass Destruction." Yet, the infamous claim by the US and British Governments that Iraq sought to buy uranium feed material from Niger in west Africa has proved to have no credible evidence. The manufacturing of public consent was further induced by the rhetoric that the war would "liberate the people of Iraq." Yet again, the words seemed nothing short of a ploy to market the need for war to a suspicious public.

What was lacking from the dialogue within the mass media and carefully crafted speeches by politicians was the mention of the word "oil." Many critics of the war argued that the true objective of the US Government was not to restore true democracy in Iraq, but to remove Saddam Hussein and to replace him with a regime beholden to the interests of the White House. This would allow, among other things, the ability for American oil companies to privatize Iraq's oil industry. More importantly, the US would gain control of a key Arab state – allowing it to be the power broker of the region that houses the second largest oil reserves in the world. As Michael Klare, author of Resource Wars, noted, "controlling Iraq is about oil as power, rather than oil as fuel".[1]

The desire to control resources became more apparent as oil fields were quickly seized during the first days of conflict. The full scale civilian looting of hospitals, the National Museum, the National Library and other buildings went unchecked by coalition forces, while the building that housed the Iraqi Oil Ministry remained tightly guarded and was never bombed.

Artists pointed out these apparent double standards and shed light on the real motivations they believed were behind the push for war. A parody of the American National Milk Processor Board's "Got Milk" advertising campaign, "Got Oil", draws a direct link between politicians and the oil industry. The image features an oil bespattered Dick Cheney – the former oil executive and Vice President of the US during the 2003 Iraq war. Other artists chose to portray the military as a

mercenary army: hired guns for the oil companies. Winston Smith responded with a uniform decorated in corporate logos, while others appropriated the famous photograph from WWII of soldiers raising the American flag at Iwa Jima. This time the flag is raised in the middle of an oil field symbolizing American conquest and occupation.

The connection between first world consumers and the war in Iraq was implied in the poster "Stop the Bloody War for Oil" which depicts the violence of war by portraying a gasoline pump as a pointed gun with blood dripping from the muzzle. The image not only lashes out at the warmongers but it reminds those who depend on automobiles that they are also complicit. "We totally Need Their Oil" and "American Hummer" continue this theme by utilizing the commercial language familiar to modern advertising to comment upon war and consumption on a global level. The decision to use the image of a Hummer has dual significance, both as a military vehicle and a luxury vehicle owned by the wealthy. A vehicle such as this, with very low gas mileage, flaunts the wealth of the first world nations by its cost and complete disregard for the world's shrinking resources.

Whether taking aim at politicians and oil executives, the military or first world consumers, the message in these posters is clear. The war in Iraq was waged for control of territory and resources, not liberty or democracy. Politicians may avoid mentioning the economic and imperial reasons behind war, but artists made the connection clear as day in a visual language that all can understand.

Kein Blut für Öl

Der Slogan „Kein Blut für Öl" entstand anlässlich des ersten Golfkriegs 1991. Zwölf Jahre später wurde derselbe Slogan erneut als Entgegnung auf die Argumente der Politiker und die zweite Auflage des Golfkriegs verwendet. George W. Bush und Tony Blair konstatierten schnell die Notwendigkeit eines Krieges, indem sie behaupteten, der Irak stelle aufgrund der „Massenvernichtungswaffen" eine unmittelbare Bedrohung für die Weltsicherheit dar. Allerdings hat sich die unverschämte Behauptung der Regierungen der USA und Großbritanniens, der Irak habe versucht, im Niger Uran zu kaufen, als völlig haltlos erwiesen. Öffentliche Zustimmung sollte zudem durch die Behauptung gewonnen werden, der Krieg werde „das irakische Volk befreien". Wieder einmal schienen diese Worte nichts anderes als ein Trick zu sein, einer argwöhnischen Bevölkerung die Notwendigkeit eines Krieges schmackhaft zu machen.

In den Massenmedien und in den sorgfältig ausformulierten Politikerreden wurde nie das Wort „Öl" erwähnt. Viele Kritiker des Krieges vertraten die Ansicht, dass das wahre Ziel der amerikanischen Regierung nicht die Wiederherstellung einer echten Demokratie im Irak sei, sondern der Sturz von Saddam Hussein, der durch eine dem Weißen Haus und seinen Interessen hörige Führung ersetzt werden solle. Dies würde amerikanischen Ölfirmen unter anderem die Möglichkeit bieten, die irakische Ölindustrie zu privatisieren. Und noch wichtiger: die USA würden die Kontrolle über einen wichtigen arabischen Staat gewinnen und sich so eine zentrale Machtposition in einer Region verschaffen, in der sich die zweitgrößten Ölreserven der Welt befinden. Michael Klare, Autor des Buches „Resource Wars", schrieb: „Bei der Kontrolle über den Irak geht es um Öl als Machtmittel, nicht um Öl als Brennstoff".[1]

Dass es darum ging, die Ressourcen zu kontrollieren, wurde deutlicher, als während der ersten Tage des Kampfes rasch Ölfelder eingenommen wurden. Den rücksichtslosen Plünderungen von Krankenhäusern, der Plünderung des Nationalmuseums, der Nationalbibliothek und anderer Gebäude sahen die Koalitionstruppen tatenlos zu, während das Gebäude, in dem das irakische Ölministerium untergebracht war, streng bewacht und nie bombardiert wurde.

Die Künstler wiesen auf diese offensichtliche Doppelmoral hin und zeigten die ihrer Meinung nach wahren Beweggründe für die Kriegsbestrebungen auf. Die in den USA sehr bekannte Werbekampagne für Milch „Got Milk?" („Hast du Milch?") wurde als „Got Oil?" („Hast du Öl?") parodiert, wodurch eine direkte Verbindung zwischen Politikern und der Ölindustrie hergestellt wird. Das Bild zeigt einen ölbespritzten Dick Cheney – früher in führender Position bei einem Ölunternehmen, während des Irakkriegs 2003 Vizepräsident der Vereinigten Staaten. Andere Künstler stellten das Militär als von den Ölunternehmen angeheuertes Söldnerheer dar. Winston Smith entwarf eine mit Firmenlogos behängte Uniform, andere wandelten das berühmte Foto ab, auf dem amerikanische Soldaten im Zweiten Weltkrieg die Flagge auf der japanischen Insel Iwo Jima hissen. Diesmal wird die Flagge in der Mitte eines Ölfelds gehisst und symbolisiert die amerikanische Eroberung und Besetzung.

Die Verbindung zwischen den Verbrauchern in der ersten Welt und dem Krieg im Irak stellt das Plakat „Stop the Bloody War for Oil" („Stoppt den blutigen Krieg um Öl") her, das die Gewalttätigkeit des Krieges beschreibt, indem es eine Benzinpumpe als Waffe im Anschlag zeigt, Blut tropft aus der Mündung. Dieses Bild attackiert nicht nur die Kriegstreiber, sondern erinnert alle Autofahrer daran, dass auch sie Mittäter sind. Dieses Thema wird fortgeführt von „We Totally Need Their Oil" („Wir sind total auf ihr Öl angewiesen") und „American Hummer?" („Hummer" ist ein amerikanischer Hersteller sehr großer Geländewagen), wo die Sprache der Werbung, die wir aus modernen Anzeigen kennen, für Kommentare zum Krieg und allgemein zum Thema Konsum verwendet wird. Dass gerade das Bild eines Fahrzeugs der Marke Hummer verwendet wird, hat eine doppelte Bedeutung, denn Hummer-Geländewagen werden nicht nur als Militärfahrzeuge eingesetzt, sondern sind auch Luxusfahrzeuge der Reichen. Ein solches Fahrzeug verbraucht enorm viel Benzin und stellt die Macht der Nationen der ersten Welt zur Schau, die es sich leisten können, sowohl Kosten als auch die schrumpfenden Ressourcen der Erde völlig zu ignorieren.

Ob sie nun auf Politiker und Ölmanager, das Militär oder die Verbraucher in den reichen Ländern abzielen, die Botschaft dieser Plakate ist deutlich. Auslöser für den Krieg im Irak war das Bestreben, Macht über das Territorium und die Ressourcen zu erlangen, nicht Freiheit oder Demokratie zu schaffen. Die Politiker mögen die wirtschaftlichen und machtpolitischen Hintergründe des Krieges verschweigen, aber mit einer visuellen Ausdruckskraft, die alle verstehen können, bringen Künstler die wahren Zusammenhänge ans Tageslicht.

No Blood for Oil

Le slogan « No Blood for Oil » a été lancé en réponse à la première Guerre du Golfe en 1991. Douze ans plus tard, on a réutilisé ce slogan pour contrecarrer la rhétorique des politiciens et la suite de la Guerre du Golfe. George W. Bush et Tony Blair ont été prompts à annoncer la nécessité d'une guerre en affirmant que l'Irak représentait un danger imminent pour la sécurité mondiale de par la présence d'« armes de destruction massive ». Cependant, la prétention infâme avancée par les gouvernements américain et britannique que l'Irak cherchait à acheter au Niger (Afrique de l'Ouest) de l'uranium comme matériau d'approvisionnement s'est avérée être une affirmation non crédible. La justification de la guerre par « la libération du peuple irakien » devait permettre alors d'obtenir l'assentiment du public. Une fois de plus, les mots n'étaient qu'une ruse pour vendre la nécessité d'une guerre à un public suspicieux.

Ce qui manquait au sein du dialogue des mass media et dans les discours soigneusement travaillés des politiciens, c'était la mention du mot « pétrole ». De nombreux critiques de la guerre argumentaient que le véritable objectif

du gouvernement américain était, non pas de restaurer la démocratie en Irak, mais de se débarrasser de Saddam Hussein et de le remplacer par un régime acquis aux intérêts de la Maison Blanche. Ceci permettrait, entre autres, aux compagnies pétrolières américaines de privatiser l'industrie pétrolière de l'Irak. Et ce qui est plus important encore, les USA contrôleraient un état arabe clé leur permettant ainsi de de jouer un rôle prépondérant dans une région où l'on trouve les deuxièmes plus grandes réserves de pétrole au monde. A ce sujet, Michael Klare, auteur de Resource Wars (Guerre de ressources) a fait remarquer que « contrôler l'Irak, c'est se servir du pétrole en tant que pouvoir plutôt qu'en tant que combustible »[1].

Le désir de contrôler les ressources devint plus évident lorsque les champs de pétrole furent rapidement conquis pendant les premiers jours de la guerre. Le pillage à grande échelle des civils dans les hôpitaux, au Musée National, à la Bibliothèque Nationale et dans d'autres bâtiments n'a pas été entravé par les forces de la coalition, alors que le bâtiment qui hébergeait le ministère irakien du pétrole est resté sévèrement gardé et n'a jamais fait l'objet de bombardements.

Des artistes ont mis l'accent sur cette hypocrisie apparente et ont révélé les motivations réelles qu'ils soupçonnaient derrière cette velléité flagrante. « Got Oil? » (Avez-vous du pétrole ?), une parodie sur la campagne publicitaire « Got Milk? » (Avez-vous du lait ?) de l'Agence nationale des producteurs de lait américains, American National Milk Processor Board, dénonce le lien direct entre les politiques et l'industrie pétrolière. L'image montre Dick Cheney, l'ancien chef du pétrole et vice-président des Etats-Unis durant la guerre en Irak en 2003, éclaboussé de pétrole. D'autres artistes ont choisi de montrer les militaires en tant qu'armée de mercenaires : des armes engagées pour le compte des compagnies pétrolières. Winston Smith a répondu par un uniforme décoré de logos d'entreprises, alors que d'autres s'appropriaient la fameuse photographie de la Seconde Guerre Mondiale de soldats érigeant le drapeau américain à Iwa Jima. Cette fois-ci, le drapeau est planté au milieu d'un champ de pétrole symbolisant la conquête et l'occupation américaines.

Le lien entre les consommateurs du premier monde et la guerre en Irak était implicite dans le poster « Stop the Bloody War for Oil » (Arrêtez la guerre sanguinaire pour le pétrole) qui montre la violence de la guerre en dessinant une pompe de pétrole sous la forme d'une arme pointée avec des gouttes de sang tombant de l'embout. L'image ne fustige pas seulement les bellicistes, mais elle rappelle à ceux qui dépendent de leur véhicule qu'ils sont complices. Les slogans « We Totally Need Their Oil » (Nous avons TOTALement besoin de leur pétrole) et « American Hummer » (fabricant américain de véhicules tout terrain) continuent sur cette voie en se servant du langage commercial familier à la publicité moderne pour commenter la guerre et la consommation à un niveau mondial. La décision de prendre l'image d'un Hummer a une double signification : d'une part en tant que véhicule militaire et d'autre part en tant que véhicule de luxe conduit par les riches. Un tel véhicule consomme beaucoup d'essence exhibe la richesse des nations du premier monde par ses coûts et son total mépris face au déclin des ressources mondiales.

Qu'ils aient pour cible les politiques ou les magnats du pétrole, les militaires ou les consommateurs du premier monde, le message de ces posters est clair. La guerre en Irak a été menée pour le contrôle de territoires et de ressources, non pas pour la liberté et la démocratie. Les politiques peuvent bien éviter de mentionner les raisons économiques et impérialistes derrière la guerre, mais les artistes ont mis à jour les interrelations grâce à un langage visuel que tout le monde peut comprendre.

Notes:
1. Robert Dreyfus, "The Thirty Year Itch," Mother Jones, March/April 2001, 41.

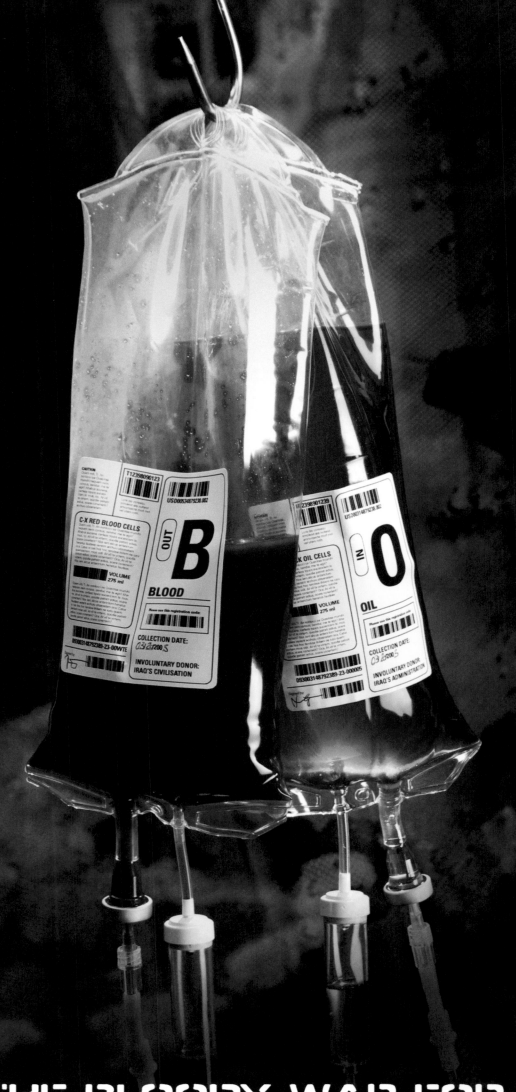

STOP THE BLOODY WAR FOR OIL.

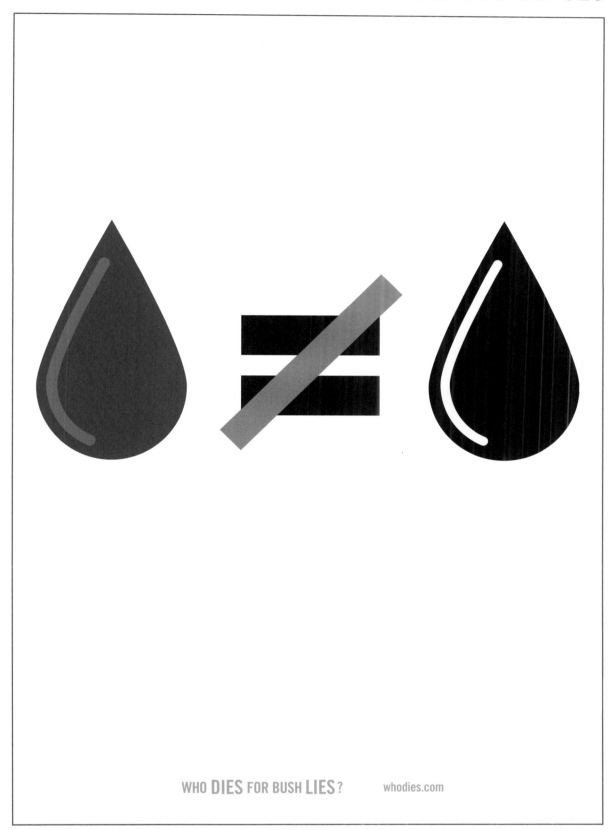

WHO **DIES** FOR BUSH **LIES**? whodies.com

Artist: The Committee to Help Unsell the War
Title: No Blood for Oil
Organization: The Committee to Help Unsell the War
Web Site: www.whodies.com
Country: United States of America

Artist: Lars Bloechlinger, Dominic Ott (Photography)
Title: Stop the bloody war for oil.
Web Site: www.brandmarke.com, www.dott.ch
Country: Switzerland

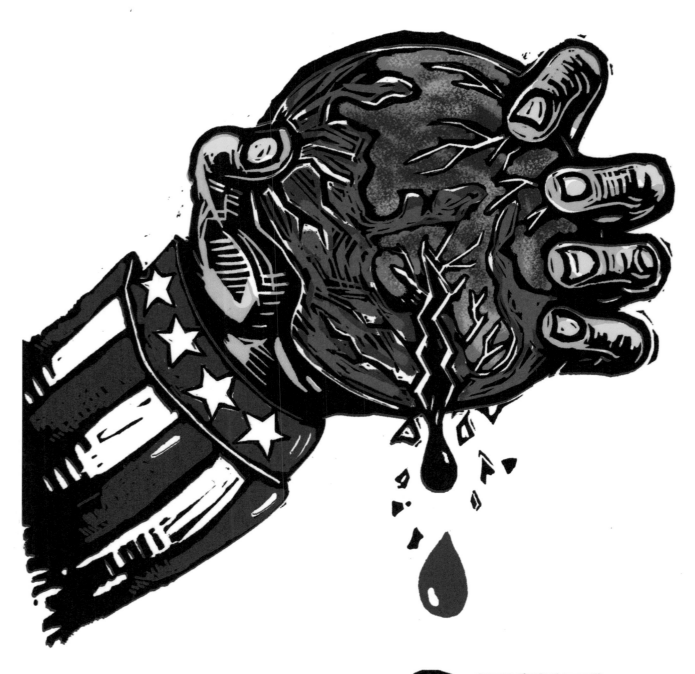

Artist: Nicole Schulman
Title: No Blood for Oil
Organization: World War 3 Arts In Action
Web Site: www.nicoleschulman.com, www.ww3artsinaction.org
Country: United States of America

www.adamnieman.co.uk/posters

NO BLOOD FOR OIL

Say NO to war with Iraq...
Say it loud.

Artist: Adam Nieman
Title: No Blood For Oil
Web Site: www.adamnieman.co.uk/posters
Country: United Kingdom

Si queréis petróleo id a las playas de Galicia, que ahí hay de sobra...

NO
A LA GUERRA EN
IRAQ

mcgraphics +2003+v
+CULTURA Y -BOMBAS

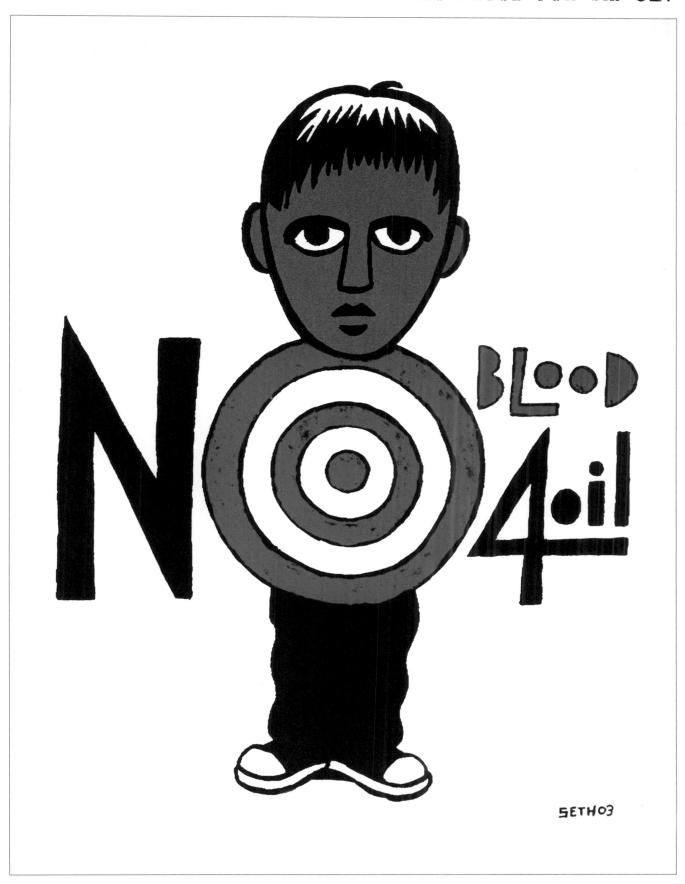

Artist: Seth Tobocman
Title: No Blood for Oil
Country: United States of America

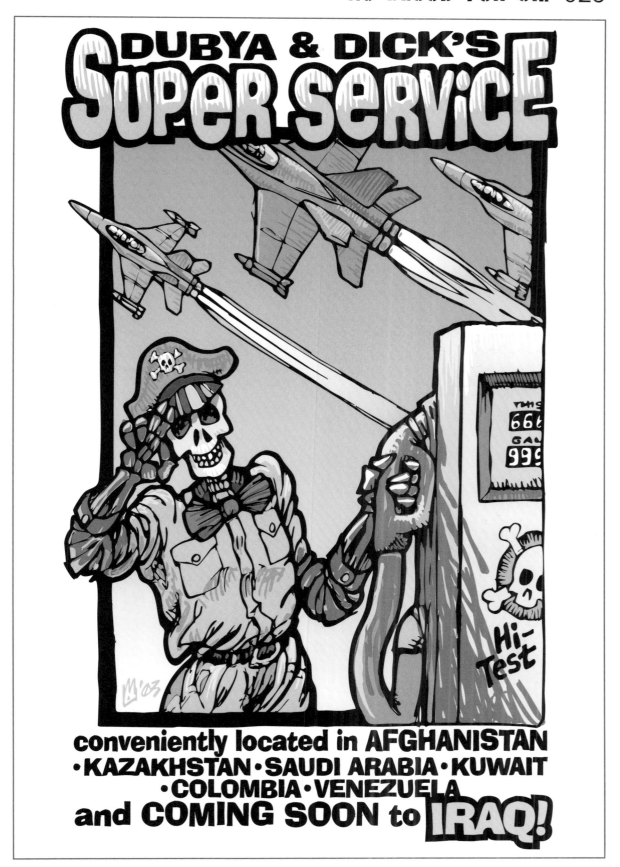

Artist: Mike Flugennock
Title: Super Service
Organization: DC Independent Media Center
Web Site: www.sinkers.org/posters
Country: United States of America

Artist: Toko
Title: Tank
Organization: Toko
Web Site: www.toko.nu
Country: The Netherlands

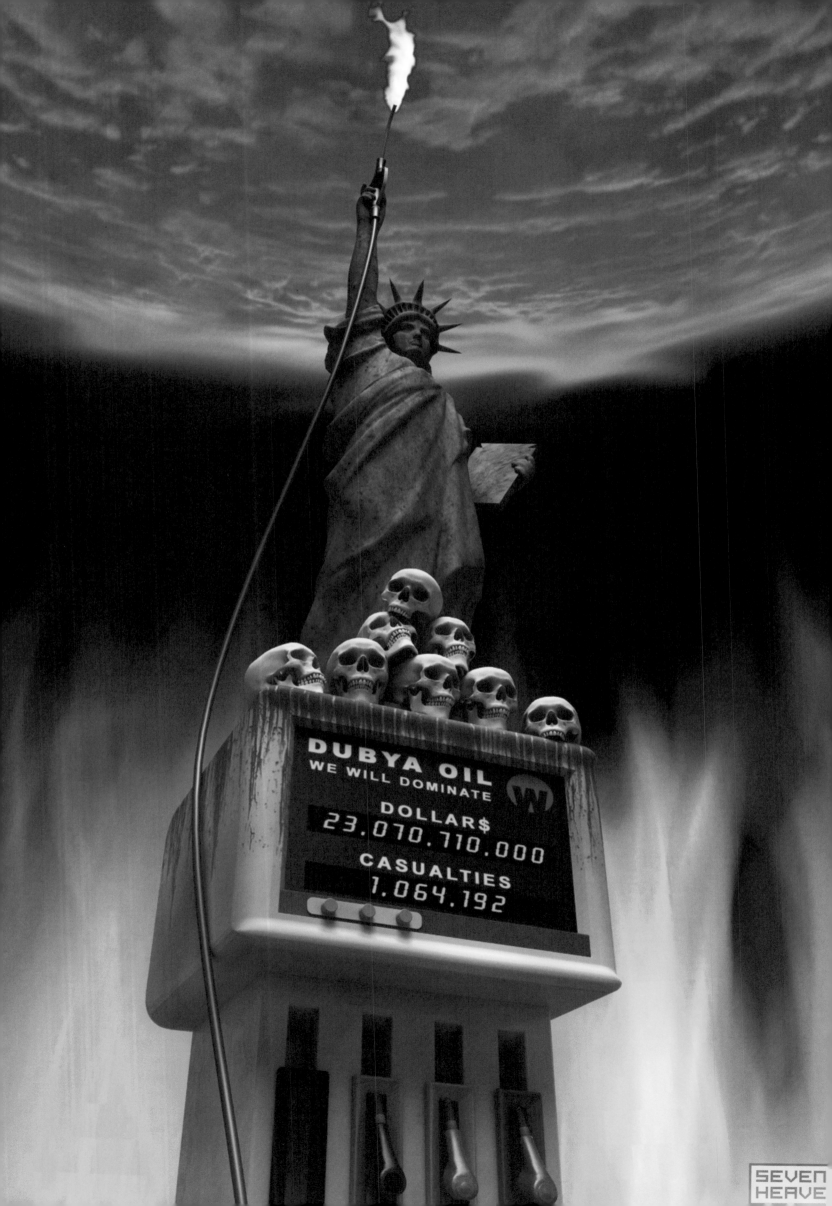

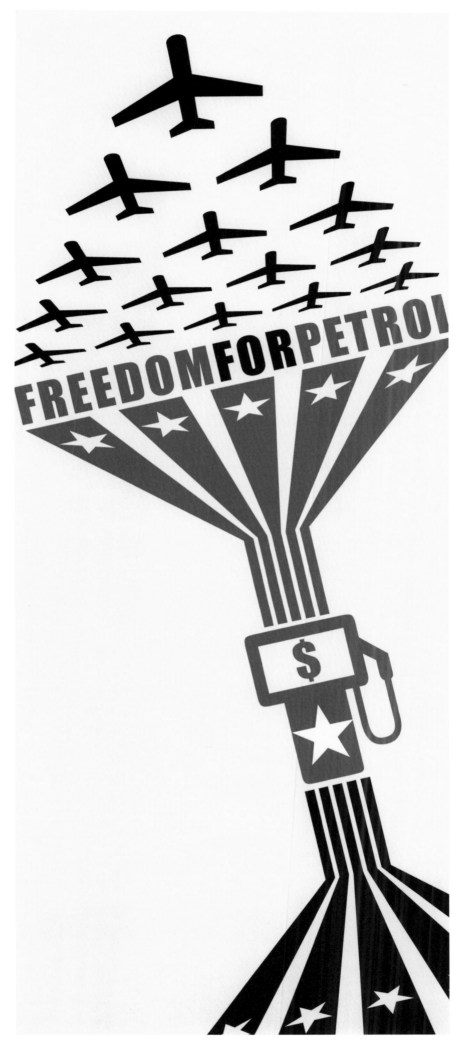

FREEDOMFORPETROI

Artist: Metin Seven
Title: Pumping Irony
Organization: Seven's Heaven
Web Site: www.sevensheaven.nl
Country: The Netherlands

Artist: Vincent de Chavanes
Title: Freedom for petrol
Organization: la langue du cameleon
Web Site: www.cameleons.com
Country: France

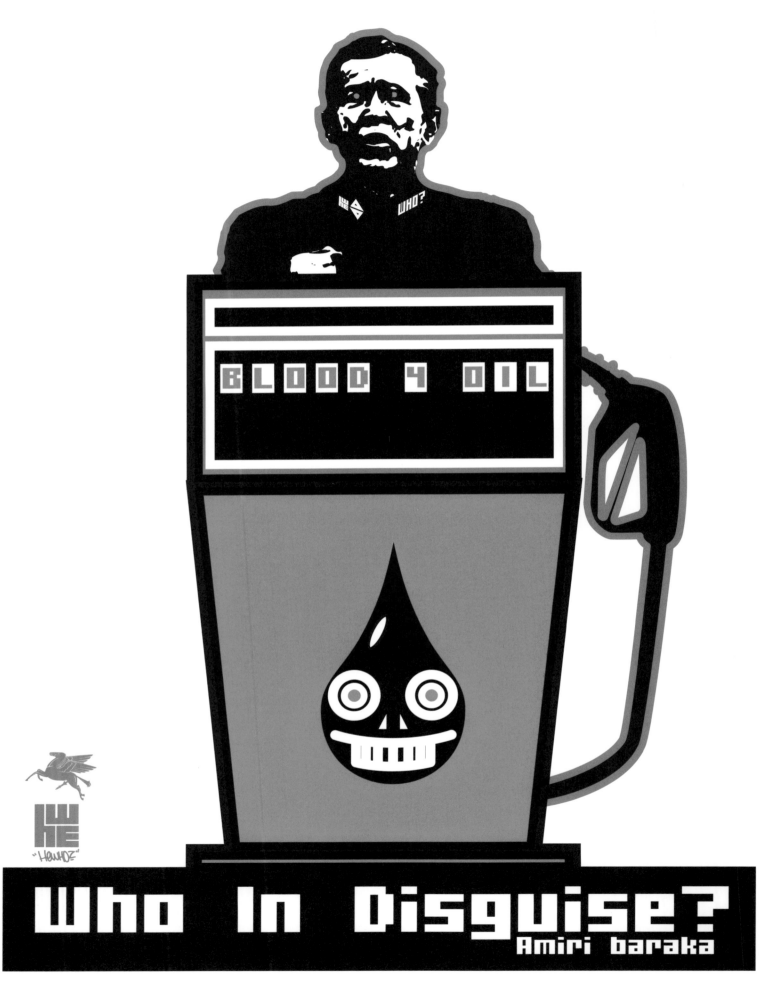

Who In Disguise?
Amiri baraka

Artist: Hugh A. Gran
Title: Who in Disguise/Why We War
Organization: HeWho, Konscious
Web Site: www.hughgran.com, www.konscious.com
Country: United States of America

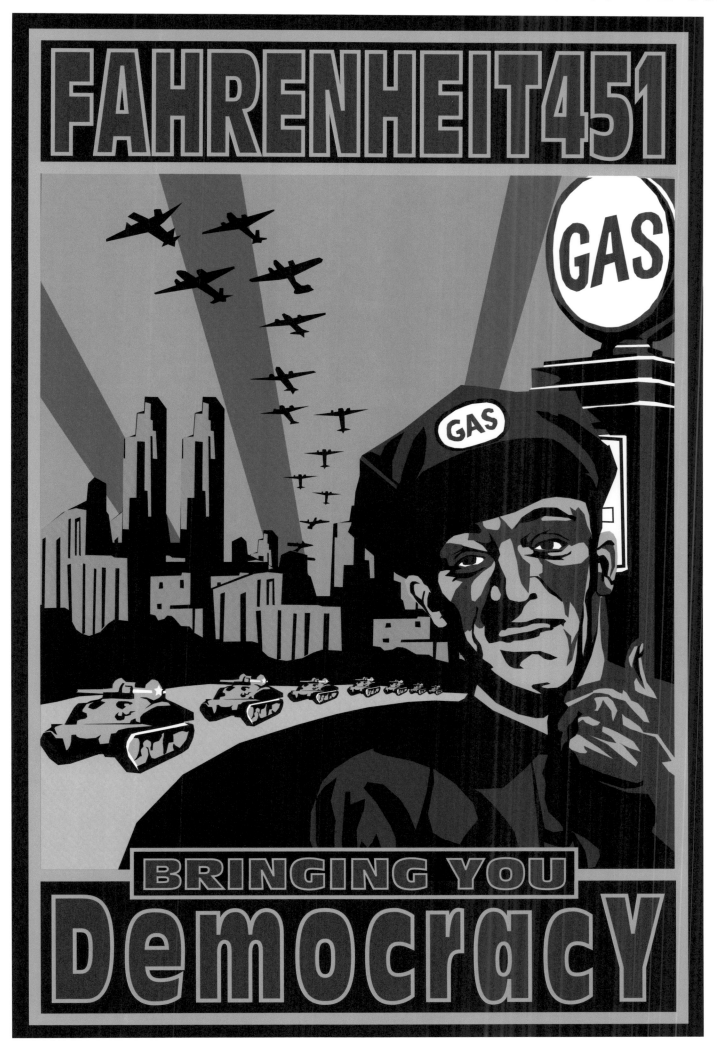

Artist: Benny + Toby Aegerter
Title: Bombing for corporate interests
Organization: FAHRENHEIT 451
Country: Switzerland

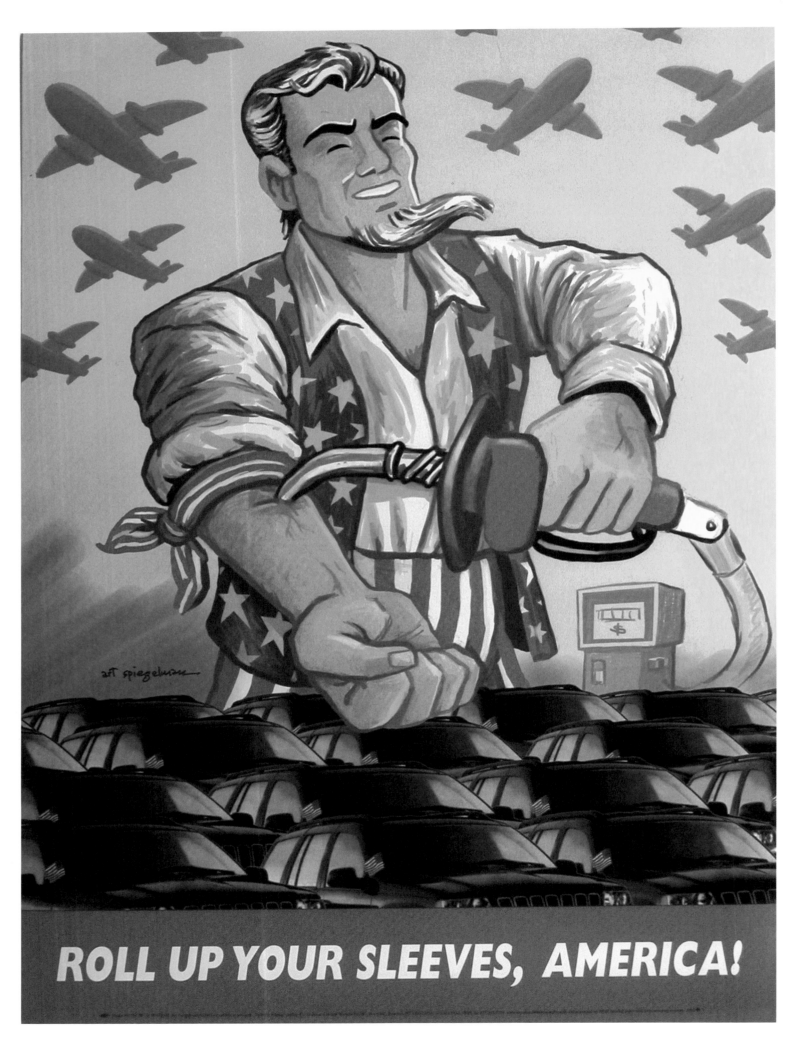

Artist: Art Spiegelman
Title: Roll Up Your Sleeves, America
Organization: Syracuse Cultural Workers
Web Site: www.syrculturalworkers.com
Country: United States of America

Artist: Eric Dubois, Creative Director: Daniel Fortin
+ George Fok, Computer Graphics: André Renaud,
Production Manager: Hélène Joanette
Title: Sans Plomb
Organization: EPOXY
Web Site: www.epoxy.com
Country: Canada

STOP THE BLOODY WAR FOR OIL.

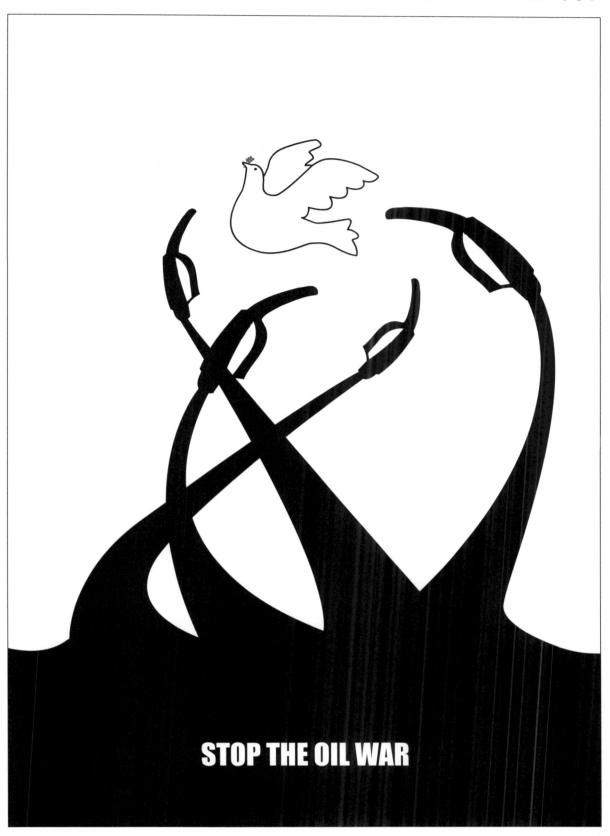

STOP THE OIL WAR

Artist: Daniel Pownall-Benítez
Title: Stop the Oil War
Organization: DRepública
Country: Spain

Artist: Lars Bloechlinger, Dominic Ott (Photography)
Title: Stop the bloody war for oil
Web Site: www.brandmarke.com, www.dott.ch
Country: Switzerland

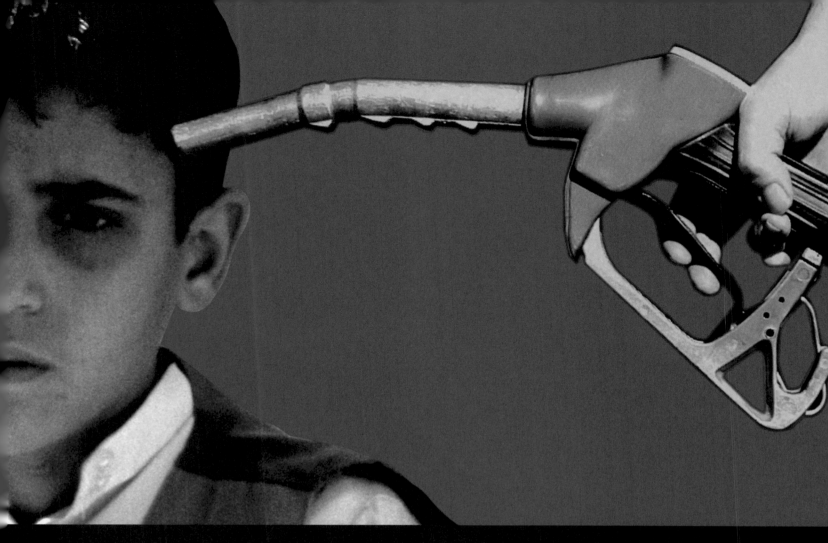

BUSH, BLAIR, AZNAR...
NO A LA GUERRA

www.joansaura.org

ICV
Iniciativa per Catalunya Verds

FILL'ER UP

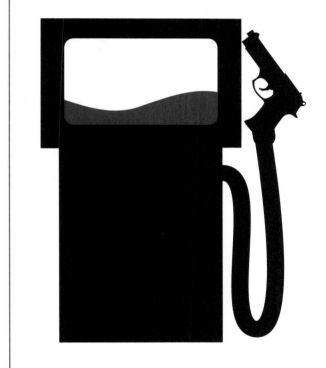

Artist: Michael Redding
Title: Fill'er up
Organization: Divinepixels
Web Site: www.divinepixels.com
Country: United States of America

Artist: Imagina
Title: No a la guerra
Organization: Iniciativa per Catalunya Verds (ICV)
Web Site: www.ic-v.org
Country: Spain

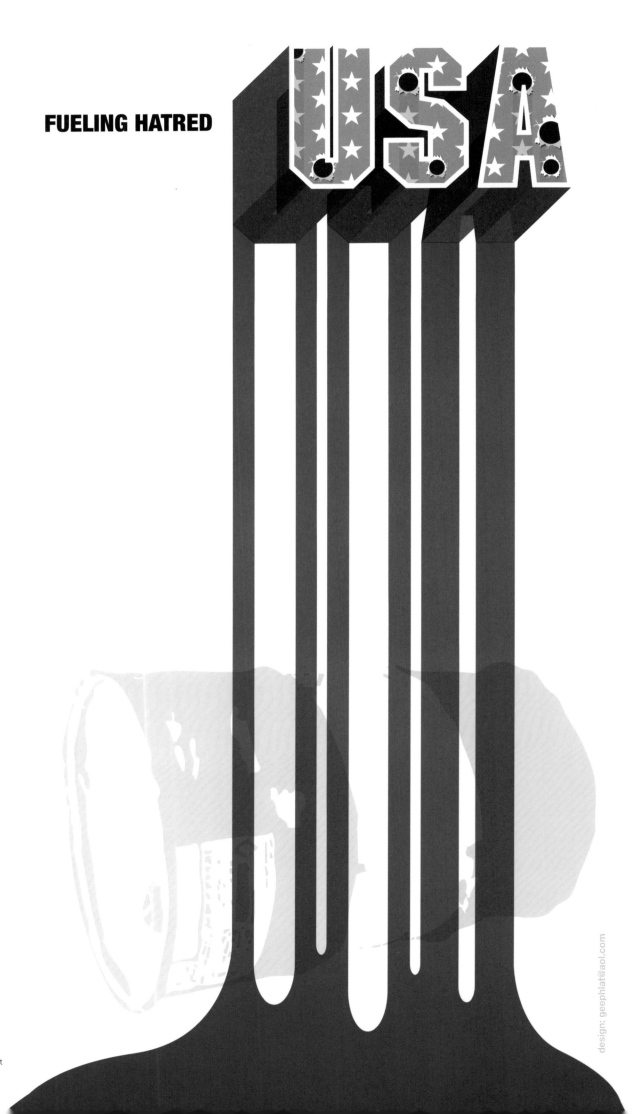

FUELING HATRED

Artist: Stew Graham
Title: Fueling Hatred
Organization: Logoloco.net
Web Site: www.logoloco.net
Country: United Kingdom

design: geephlat@aol.com

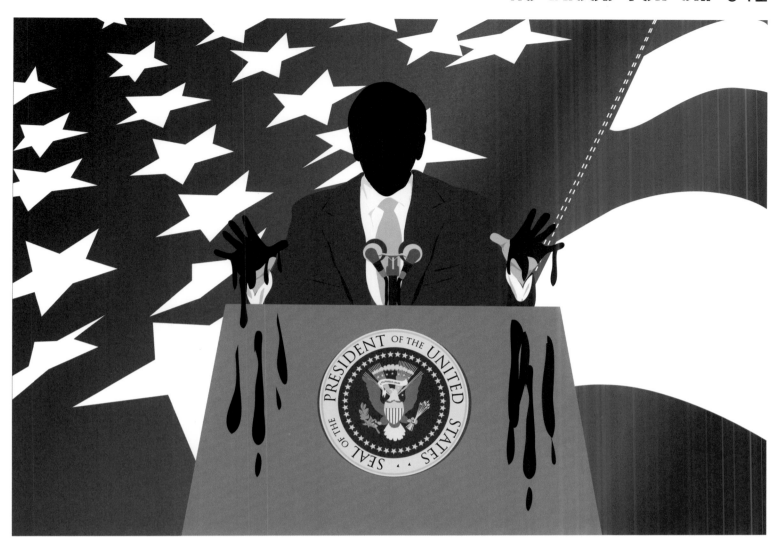

Artist: Daniel Marshall
Title: Oil be Back
Web Site: www.danielmarshall.net
Country: Australia

Artist: Anthony Garner
Title: S.O.S!
Organization: Ant Art
Web Site: www.atomweb.net/ant.html
Country: Spain

Artist: Cereal Jones
Title: Oil War
Country: United States of America

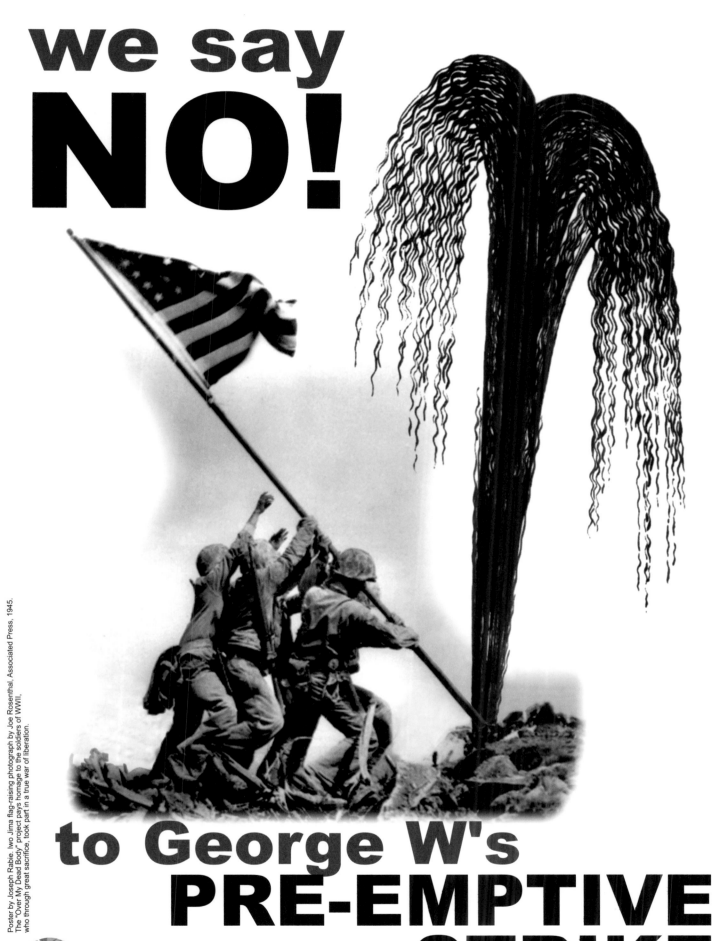

we say
NO!

Poster by Joseph Rabie. Iwo Jima flag-raising photograph by Joe Rosenthal, Associated Press, 1945.
The "Over My Dead Body" project pays homage to the soldiers of WWII,
who through great sacrifice, took part in a true war of liberation.

to George W's
PRE-EMPTIVE
STRIKE

join the world wide online demo!
http://www.overmydeadbody.org

Artist: Joseph Rabie
Title: George W's Pre-emptive Strike
Organization: The "Over My Dead Body" Project
Web Site: www.overmydeadbody.org
Country: France

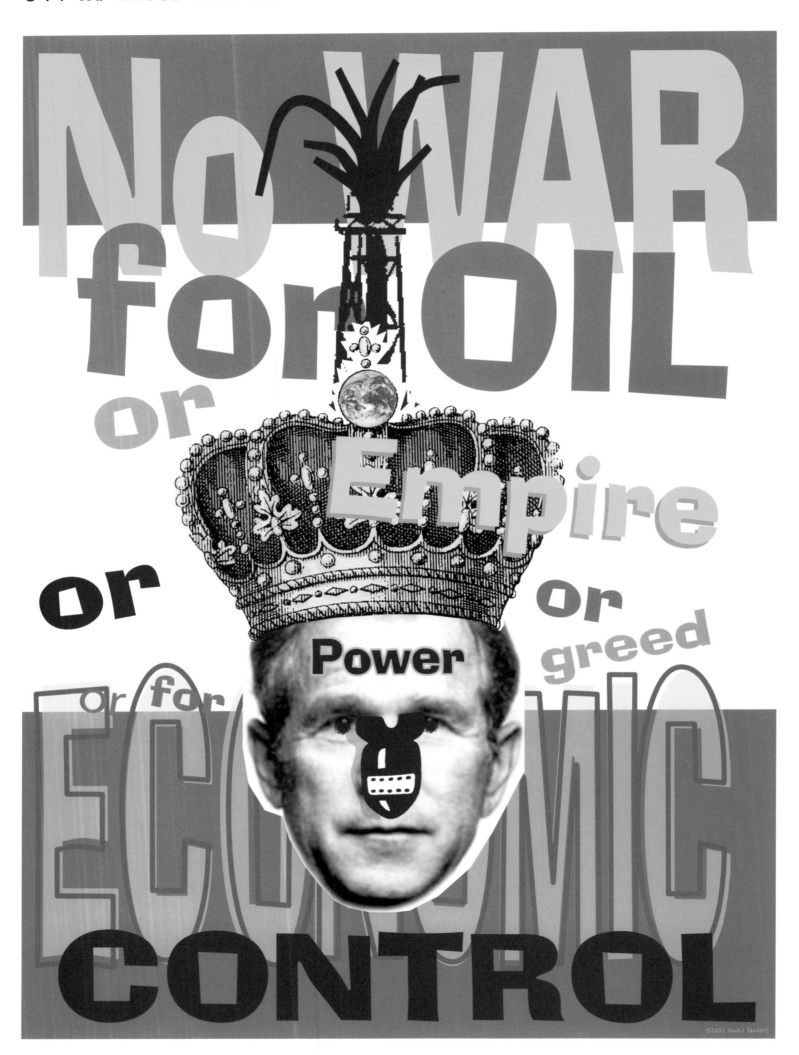

Artist: Sandy Sanders
Title: King of Wrong
Organization: Stand Gallery
Web Site: www.otherthings.com/peace
Country: United States of America

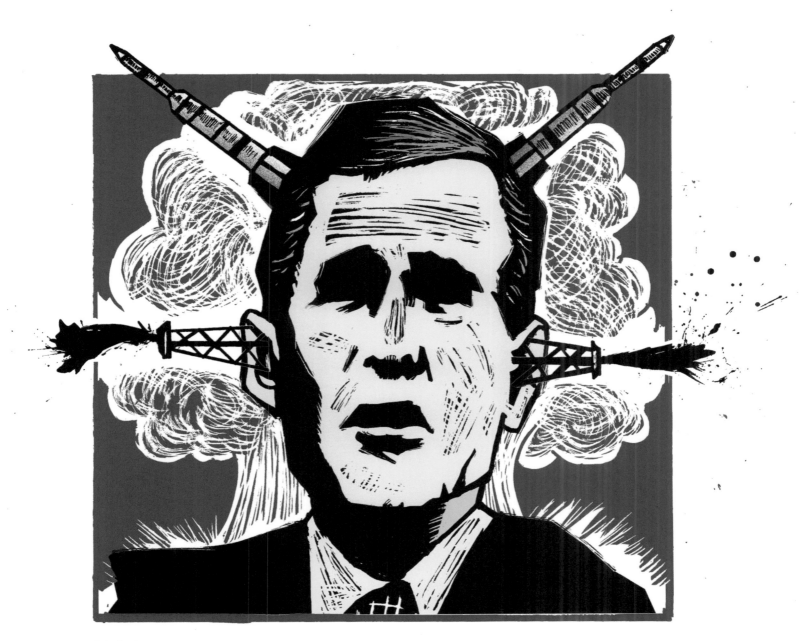

Artist: Ryan Inzana
Title: War Mongoloid
Web Site: http://web1.copleyinternet.com/c29/main.htm
Country: United States of America

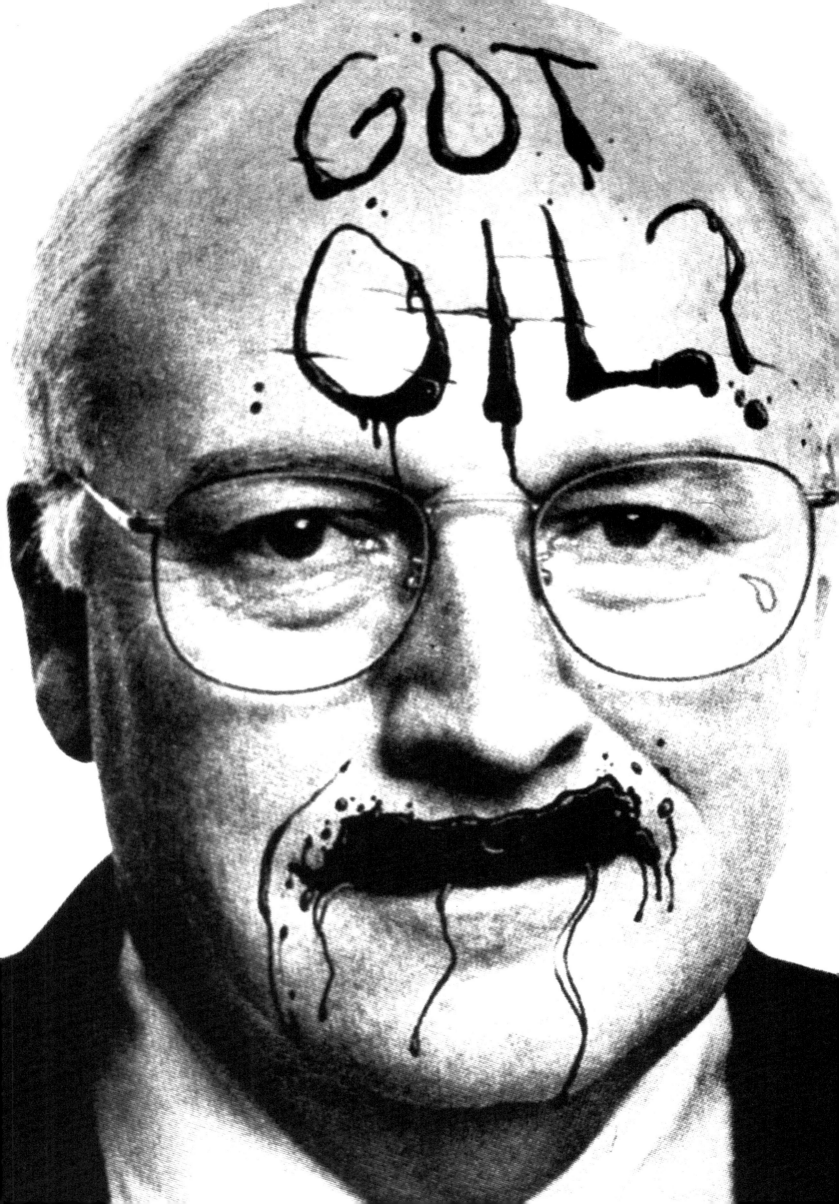

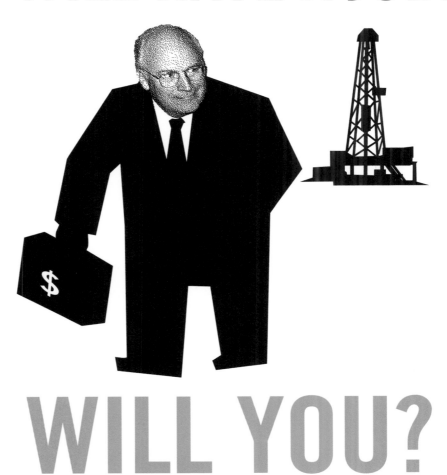

AFTER THE WAR, DICK CHENEY WILL HAVE A JOB.

WILL YOU?

WHO DIES FOR BUSH LIES? whodies.com

Artist: The Committee to Help Unsell the War
Title: Dick Cheney will Have a Job
Organization: The Committee to Help Unsell the War
Web Site: www.whodies.com
Country: United States of America

Artist: StreetRec Collective
Title: Got Oil?
Web Site: www.counterproductiveindustries.com
Country: United States of America

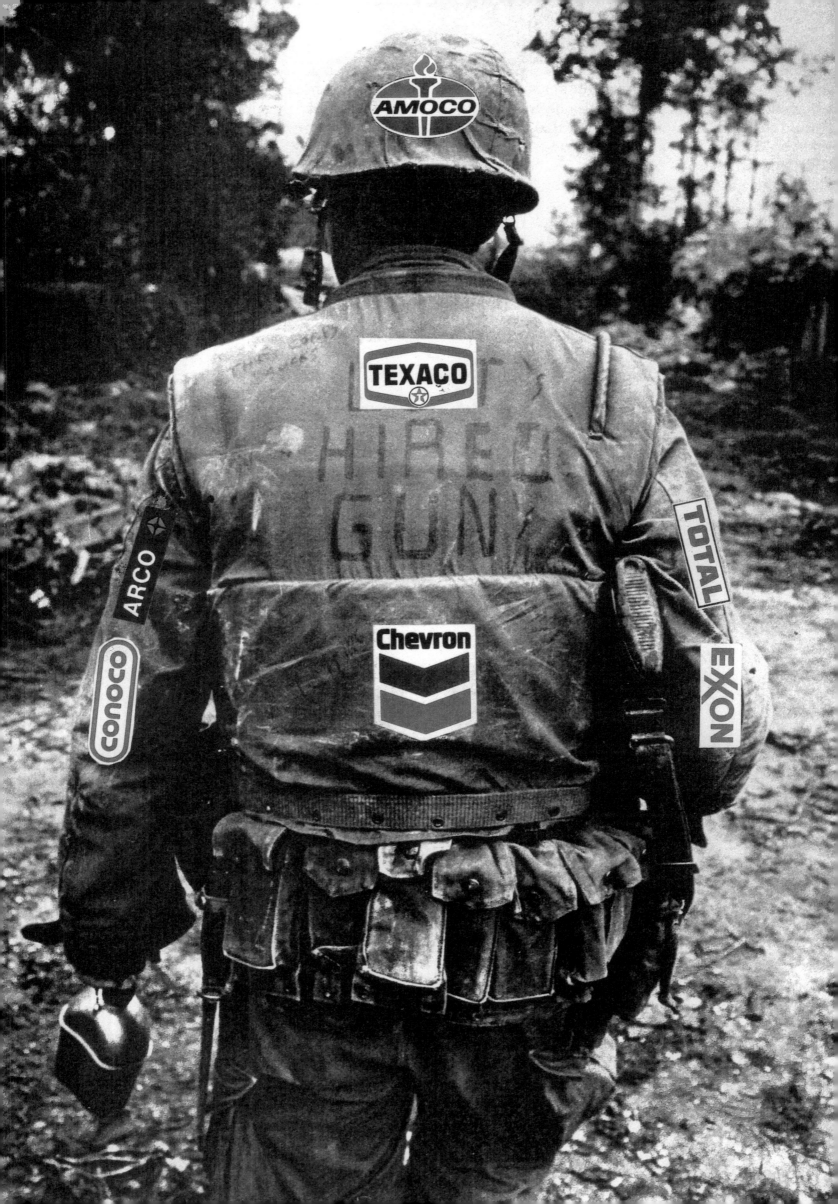

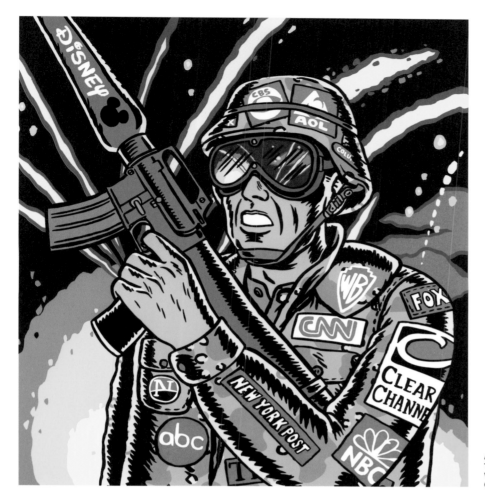

Artist: Ward Sutton
Title: That's Entertainment!
Web Site: www.suttonimpactstudio.com
Country: United States of America

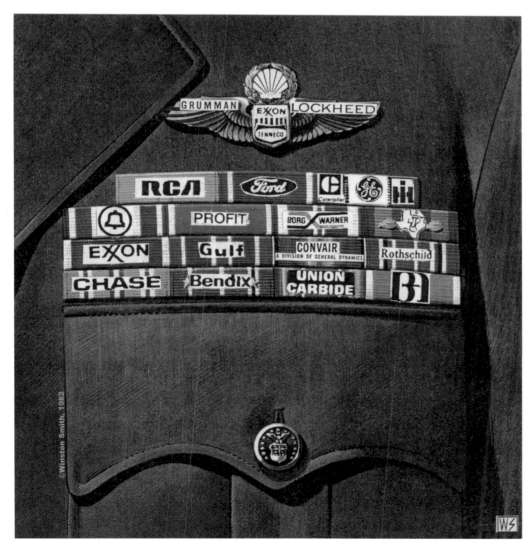

Artist: Winston Smith
Title: Spoils of War
Web Site: www.winstonsmith.com
Country: United States of America

Artist: Nicolas Lampert
Title: Oil Soldier
Web Site: www.machineanimalcollages.com
Country: United States of America

WE Totally NEED THEIR OIL.

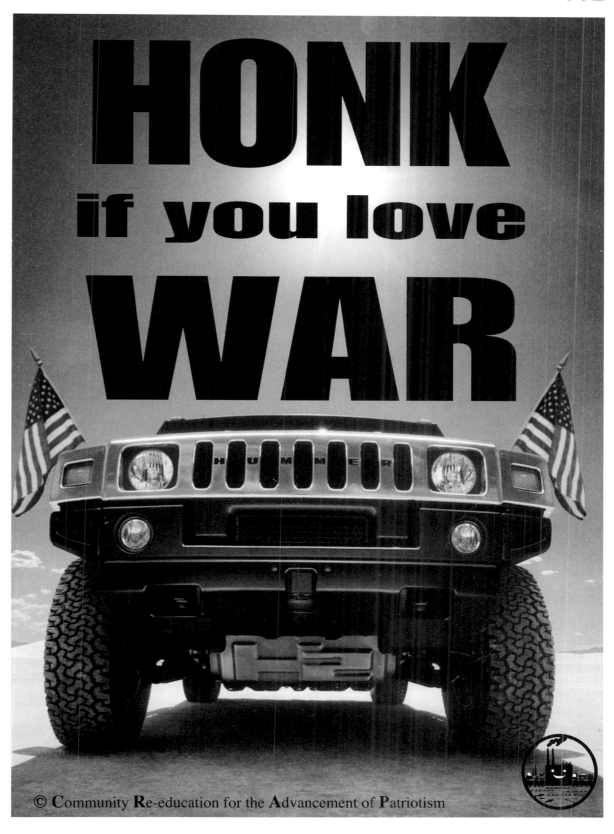

© Community Re-education for the Advancement of Patriotism

Artist: Francesca Berrini
Title: American Hummer
Organization: Community Re-education for the Advancement of Patriotism (CRAP)
Web Site: www.unusualcards.com
Country: United States of America

Artist: Zac
Title: We Totally Need Their Oil
Organization: Community Re-education for the Advancement of Patriotism (CRAP)
Web Site: www.c-r-a-p.org
Country: United States of America

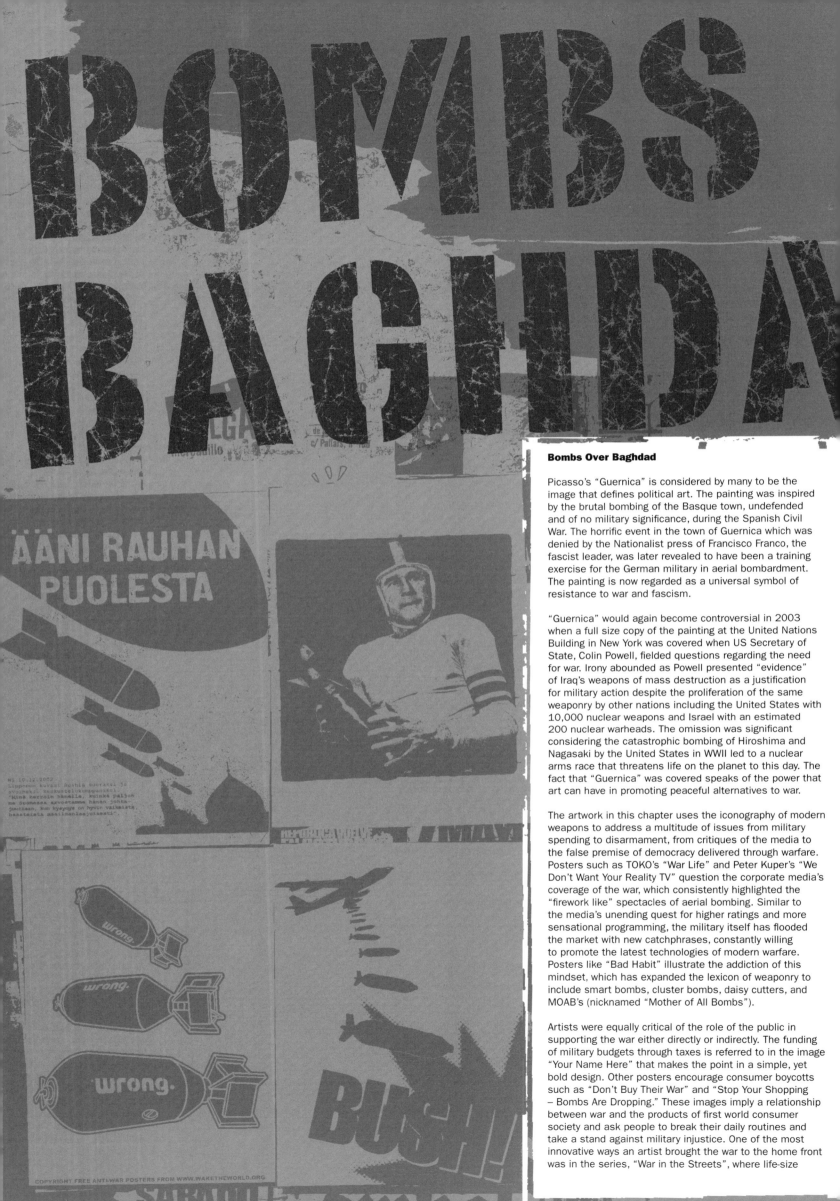

BOMBS BAGHDA

Bombs Over Baghdad

Picasso's "Guernica" is considered by many to be the image that defines political art. The painting was inspired by the brutal bombing of the Basque town, undefended and of no military significance, during the Spanish Civil War. The horrific event in the town of Guernica which was denied by the Nationalist press of Francisco Franco, the fascist leader, was later revealed to have been a training exercise for the German military in aerial bombardment. The painting is now regarded as a universal symbol of resistance to war and fascism.

"Guernica" would again become controversial in 2003 when a full size copy of the painting at the United Nations Building in New York was covered when US Secretary of State, Colin Powell, fielded questions regarding the need for war. Irony abounded as Powell presented "evidence" of Iraq's weapons of mass destruction as a justification for military action despite the proliferation of the same weaponry by other nations including the United States with 10,000 nuclear weapons and Israel with an estimated 200 nuclear warheads. The omission was significant considering the catastrophic bombing of Hiroshima and Nagasaki by the United States in WWII led to a nuclear arms race that threatens life on the planet to this day. The fact that "Guernica" was covered speaks of the power that art can have in promoting peaceful alternatives to war.

The artwork in this chapter uses the iconography of modern weapons to address a multitude of issues from military spending to disarmament, from critiques of the media to the false premise of democracy delivered through warfare. Posters such as TOKO's "War Life" and Peter Kuper's "We Don't Want Your Reality TV" question the corporate media's coverage of the war, which consistently highlighted the "firework like" spectacles of aerial bombing. Similar to the media's unending quest for higher ratings and more sensational programming, the military itself has flooded the market with new catchphrases, constantly willing to promote the latest technologies of modern warfare. Posters like "Bad Habit" illustrate the addiction of this mindset, which has expanded the lexicon of weaponry to include smart bombs, cluster bombs, daisy cutters, and MOAB's (nicknamed "Mother of All Bombs").

Artists were equally critical of the role of the public in supporting the war either directly or indirectly. The funding of military budgets through taxes is referred to in the image "Your Name Here" that makes the point in a simple, yet bold design. Other posters encourage consumer boycotts such as "Don't Buy Their War" and "Stop Your Shopping – Bombs Are Dropping." These images imply a relationship between war and the products of first world consumer society and ask people to break their daily routines and take a stand against military injustice. One of the most innovative ways an artist brought the war to the home front was in the series, "War in the Streets", where life-size

cutout posters of soldiers were placed in public spaces in an effort to shake people out of their complacency and bring some insight into what life would be like in a war zone or under occupation.

Whether showing bombs emblazoned with the word "democracy" or showing the number of places the US has bombed since World War II, artists responded with a sense of urgency and sadness to the terrible consequences of aerial bombardment and military adventurism. In a climate in which "democracy" is delivered in the form of a bomb and a preemptive war is fought to solve international disputes, one has to wonder what type of world future generations will inherit. Albert Einstein's quote "I know not with what weapons WWIII will be fought, but WWIV will be fought with sticks and stones" seems more relevant than ever.

Bomben über Bagdad

Picassos „Guernica" gilt weithin als das Bild, das politische Kunst definiert. Das Werk wurde inspiriert durch die brutale Bombardierung der gleichnamigen baskischen Stadt während des spanischen Bürgerkriegs, die ohne Verteidigung und ohne jede militärische Bedeutung war. Später wurde bekannt, dass das entsetzliche Ereignis, das von der nationalistischen Presse des Faschistenführers Franco geleugnet wurde, ein Übungsmanöver des deutschen Militärs zur Luftbombardierung war. Das Gemälde gilt heute als universelles Symbol des Widerstands gegen Krieg und Faschismus.

„Guernica" wurde neuerlich Gegenstand von Kontroversen, als 2003 eine Kopie des Gemäldes in Originalgröße, das im Gebäude der Vereinten Nationen in New York hängt, verhüllt wurde, als US-Außenminister Colin Powell sich dort Fragen zur Notwendigkeit des Krieges stellte. Es war der Gipfel der Ironie, dass Powell „Beweise" für die Massenvernichtungswaffen des Irak als Rechtfertigung für ein militärisches Vorgehen vorlegte – ungeachtet der Tatsache, dass auch andere Nationen genau diese Art Waffen anhäufen: so besitzen die Vereinigten Staaten 10.000 Atomwaffen und Israel schätzungsweise 200 Atomsprengköpfe. Dass dies keine Erwähnung fand, war insofern bedeutsam, als die verheerende Bombardierung von Hiroshima und Nagasaki durch die USA im Zweiten Weltkrieg zu einem atomaren Rüstungswettlauf führte, der heute die Existenz dieses Planeten bedroht. Die Tatsache, dass „Guernica" verhüllt wurde, ist ein Indiz für die Macht, die Kunst bei der Suche nach friedlichen Alternativen zum Krieg haben kann.

Die Kunstwerke in diesem Kapitel verwenden die Symbolik moderner Waffen, um eine Vielzahl unterschiedlicher Themen anzusprechen, vom Militärbudget bis zur Entwaffnung, von Medienkritik bis zur fälschlichen Annahme, dass Demokratie durch Krieg herbeigeführt werden könnte. Plakate wie „War Life" („Leben im Krieg") von TOKO und „We Don't Want Your Reality TV" („Wir wollen euer Reality-TV nicht?) von Peter Kuper stellen die Kriegsberichterstattung der großen Medienunternehmen in Frage, die durchweg das „wie Feuerwerk" wirkende Spektakel bei der

Bombardierung aus der Luft zeigten. Analog zu der nie endenden Jagd der Medien nach höheren Einschaltquoten und immer reißerischeren Programmen, hat auch das Militär einen kaum abreißenden Strom von Schlagworten kreiert, in dem permanenten Bestreben, die neuesten Technologien moderner Kriegsführung populär zu machen. Plakate wie „Bad Habit" („Schlechte Angewohnheit") illustrieren das Suchtpotenzial dieser Denkweise, der das Lexikon der Waffengattungen Einträge verdankt wie „intelligente Bomben", „Cluster-Bomben" (Streubomben), „Daisy Cutter" („Gänseblümchenschneider", die weltgrößte konventionelle Bombe mit 5,7 Tonnen Sprengstoff) und „MOAB" („Mother of All Bombs", „Mutter aller Bomben").

Die Künstler betrachteten die Rolle der Öffentlichkeit bei der direkten oder indirekten Unterstützung des Krieges genauso kritisch. Um die Finanzierung des Militärbudgets durch Steuern geht es bei „Your Name Here" („Ihren Namen hier eintragen"), dessen Botschaft durch die einfache, aber deutliche Gestaltung vermittelt wird. Andere Plakate rufen zu Verbraucherboykotts auf, etwa „Don't Buy Their War" („Kauft ihnen diesen Krieg nicht ab") oder „Stop Your Shopping – Bombs Are Dropping" („Aufhören mit dem Shopping – es fallen Bomben"). Diese Bilder weisen auf die Beziehung zwischen Krieg und den in der ersten Welt konsumierten Produkten hin und fordern die Menschen auf, ihre alltäglichen Abläufe zu durchbrechen und Position gegen die militärische Ungerechtigkeit zu beziehen. Eine der innovativsten Ideen, den Krieg an die Heimatfront zu bringen, war die Serie „War in the Streets" („Krieg auf der Straße"), bei der lebensgroße ausgeschnittene Plakate von Soldaten an öffentlichen Plätzen aufgehängt wurden, um die Menschen aus ihrer Selbstgefälligkeit aufzurütteln und eine Vorstellung davon zu vermitteln, wie das Leben im Kriegsgebiet oder unter einer Besatzung sein könnte.

Ob nun Bomben dargestellt wurden, auf denen das Wort „democracy" („Demokratie") prangt, oder gezeigt wurde, wie viele Orte die USA seit dem Ende des Zweiten Weltkriegs bombardiert haben, die Künstler haben mit großem Nachdruck und voller Traurigkeit die Konsequenzen von Luftbombardierung und militärischem Abenteurertum deutlich gemacht. In einem Klima, in dem „Demokratie" in Form einer Bombe gebracht werden kann und zur Lösung internationaler Streitigkeiten ein Präemptivkrieg angezettelt werden soll, muss man sich fragen, was wir zukünftigen Generationen hinterlassen werden. Albert Einsteins Worte, „Ich weiß nicht, mit welchen Waffen der 3. Weltkrieg geführt werden wird, aber der 4. Weltkrieg wird mit Keulen und Steinen geführt werden", scheinen heute zutreffender als je.

Bombes sur Bagdad

« Guernica » de Picasso est considéré par beaucoup de personnes comme l'image qui définit réellement l'art politique. Le tableau s'est inspiré du bombardement brutal de la ville basque sans défense et sans importance militaire pendant la Guerre Civile espagnole. L'événement horrifiant dans la ville de Guernica qui fut démenti par la presse nationaliste de Francisco Franco, le leader fasciste, s'est révélé par la suite avoir été un exercice d'entraînement des militaires allemands pour les bombardements aériens. La peinture est aujourd'hui considérée comme un symbole universel de la résistance à la guerre et au fascisme.

« Guernica » a de nouveau été controversée en 2003 lorsqu'une copie grand format de la peinture exposée dans le bâtiment des Nations Unies à New York a été recouverte lorsque le secrétaire d'Etat américain, Colin Powell, dut répondre aux questions sur la nécessité de la guerre. Le comble de l'ironie fut atteint lorsque Powell présenta la « preuve » des armes de destruction massive en Irak afin de justifier l'action militaire, et ce malgré la prolifération du même type d'armes dans d'autres pays, y compris aux Etats-Unis avec 10 000 armes nucléaires et en Israël avec env. 200 ogives nucléaires. L'omission était significative si l'on considère le bombardement catastrophique d'Hiroshima et de Nagasaki par les Etats-Unis lors de la Seconde Guerre Mondiale, qui a conduit à une course aux armements nucléaires qui menace la vie sur la planète jusqu'à aujourd'hui. Le fait que le tableau « Guernica » ait été recouvert illustre le pouvoir de l'art dans son rôle promoteur des alternatives pacifiques à la guerre.

Le travail artistique dans ce chapitre se sert de l'iconographie des armes modernes pour traiter une multitude de sujets, des dépenses militaires au désarmement, des critiques des médias à la fausse hypothèse d'une démocratie mise en place par une guerre. Des posters tels que « War Life » de TOKO et « We Don't Want Your Reality TV » (Nous ne voulons pas de votre télé réalité) de Peter Kuper remettent en question la couverture de la guerre par les grandes entreprises médiatiques qui ont présenté les bombardements aériens comme des spectacles de feux d'artifice. Tels les médias dans leur recherche infinie d'une audience toujours plus forte et d'une programmation toujours plus sensationnelle, les militaires eux-mêmes ont inondé le marché de nouveaux slogans, voulant sans cesse faire la promotion des technologies les plus récentes de la guerre moderne. Des posters tels que « Bad Habit » (Mauvaise habitude) illustrent la dépendance qu'engendre cette façon de voir les choses qui a élargi le dictionnaire de l'armement avec des expressions telles « bombes intelligentes », « bombes à fragmentation », « coupeur de pâquerettes » et MOABs (sobriquet pour « Mother of All Bombs »).

Les artistes étaient tout aussi critiques en ce qui concerne le rôle du public dans son soutien direct ou indirect à la guerre. L'image « Your Name Here » (Votre nom ici) illustre par un design simple mais expressif le financement des budgets militaires par les impôts. D'autres posters poussent les consommateurs au boycott, par exemple « Don't Buy Their War » (N'achetez pas leur guerre) et « Stop Your Shopping – Bombs Are Dropping » (Arrêtez vos emplettes – il pleut des bombes). Ces images expliquent la relation entre la guerre et les produits de la société de consommation du premier monde et somment les consommateurs de briser leur routine quotidienne et de se soulever contre l'injustice militaire. L'une des manières les plus innovatrices d'amener la guerre aux premières loges du foyer était dans la série « War in the Streets » (Guerre dans les rues) où des posters de soldats de taille humaine avaient été placés dans des espaces publics afin de bousculer les habitants hors de leur complaisance et d'apporter quelques aperçus de ce que serait la vie dans une zone en guerre ou occupée.

Qu'ils montrent des bombes portant l'inscription « démocratie » ou qu'ils révèlent le nombre de sites bombardés par les Etats-Unis depuis la Seconde Guerre Mondiale, les artistes ont répondu avec un profond sens de l'urgence et beaucoup de tristesse face aux terribles conséquences des bombardements aériens et de l'aventurisme militaire. Dans un climat où la « démocratie » est livrée avec une bombe et où une guerre de prévention est conduite pour résoudre des disputes internationales, il faut se demander de quel type de monde les générations futures vont-elles hériter ? Albert Einstein avait dit : « Je ne sais pas quelles armes nous utiliserons pour la Troisième Guerre Mondiale, mais nous ferons la Quatrième avec des bâtonnets et des cailloux ». Cela semble plus pertinent que jamais.

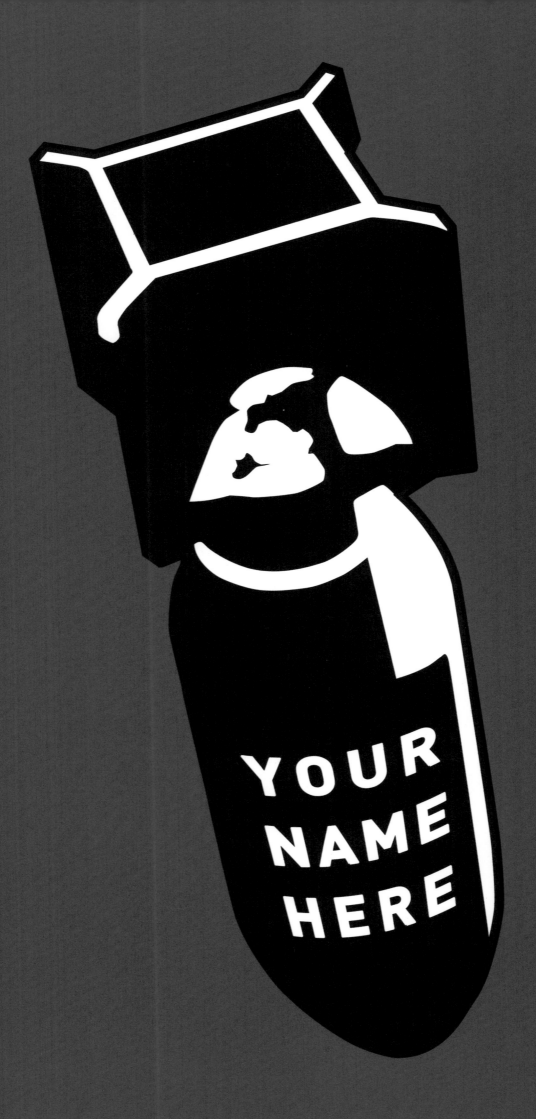

YOUR
NAME
HERE

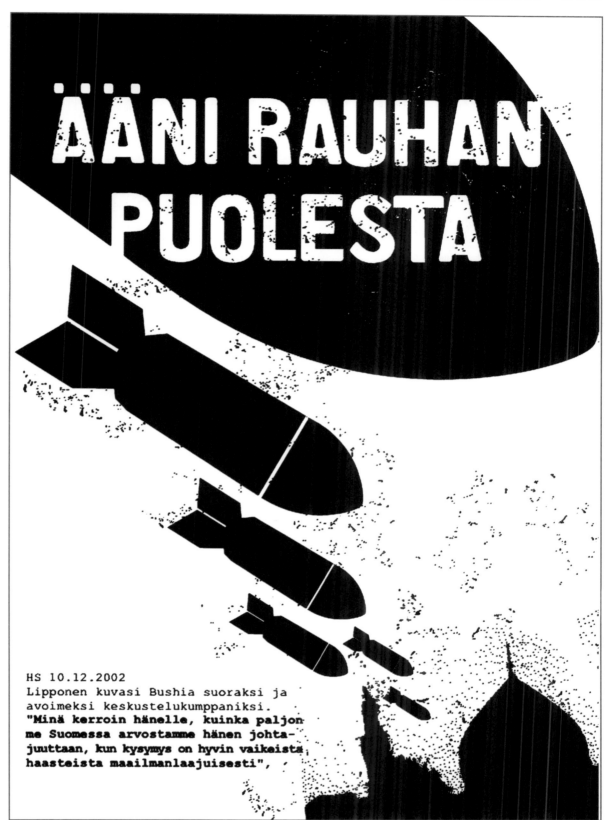

Artist: Hannes Aleksi Hyvönen, Concept/text: Hannu Hyvönen
Title: Ääni rauhan puolesta (A Voice for Peace)
Web Site: http://elonmerkki.net/hannes
Country: Finland

Artist: Ellen Gould
Title: Your Name Here
Organization: Another Poster for Peace
Web Site: www.anotherposterforpeace.com
Country: United States of America

REBEL/RESIST/REVOLT ©2003 MNWRKS:CHAOS

THIS IS WHAT
DEMOCRACY
LOOKS LIKE

Artist: slave/mnwrks
Title: This is what Democracy looks like 1, 2 (page 57)
Organization: viagrafik
Web Site: www.viagrafik.com
Country: Germany

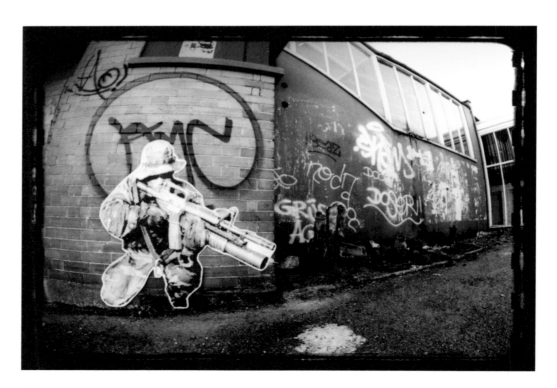

Artist: slave/mnwrks
Title: War in the Streets
Organization: viagrafik
Web Site: www.viagrafik.com
Country: Germany

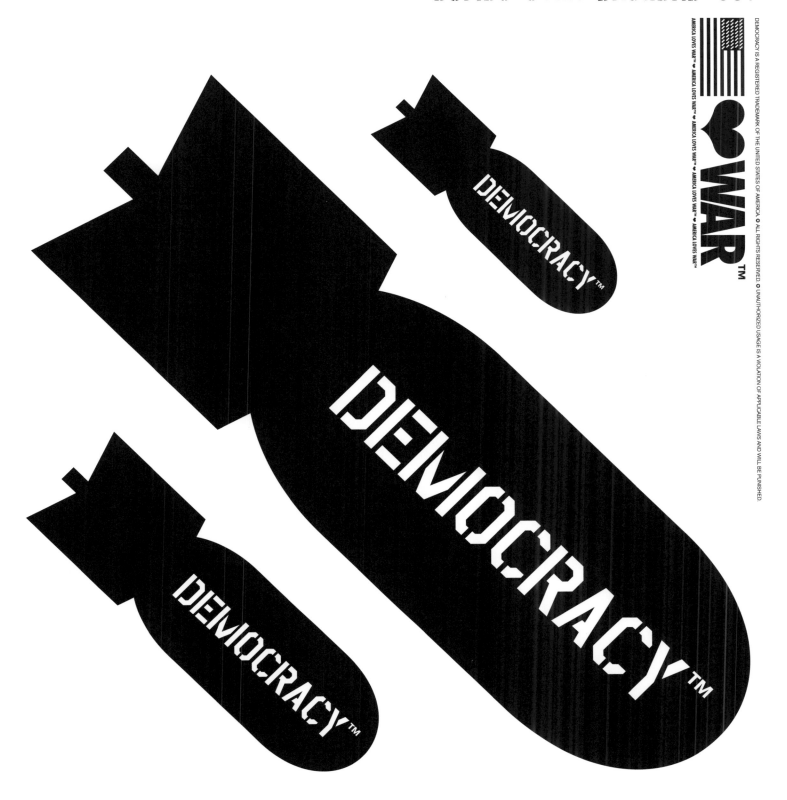

♥WAR™

enslave®

THIS IS WHAT DEMOCRACY LOOKS LIKE.

Artist: Tang ChenHooi (Tankle)
Title: Stop War. Burn out
Organization: loop08
Web Site: www.loop08.com
Country: Malaysia

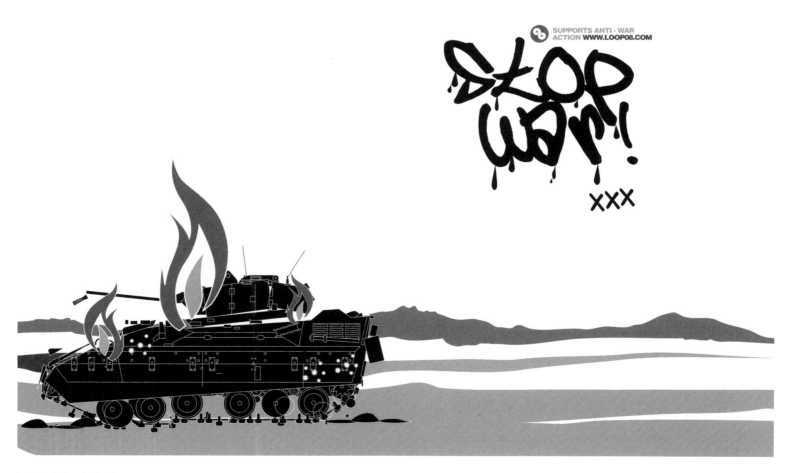

Artist: Daniel Joseph (Demo)
Title: Stop War. Destroyed
Organization: loop08
Web Site: www.loop08.com
Country: Malaysia

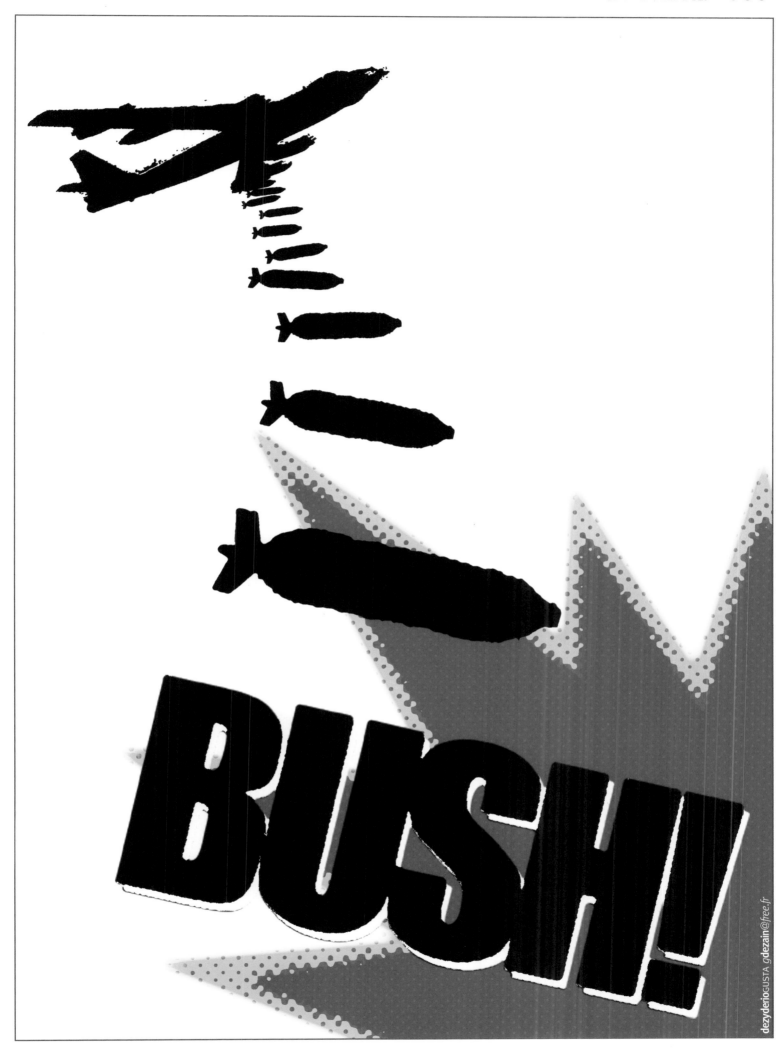

Artist: Dezyderio Gusta
Title: Lui laissez pas ouvrir la bouche
Web Site: http://dezyderio.free.fr
Country: Germany/France

UNITED WAR CORPORATION

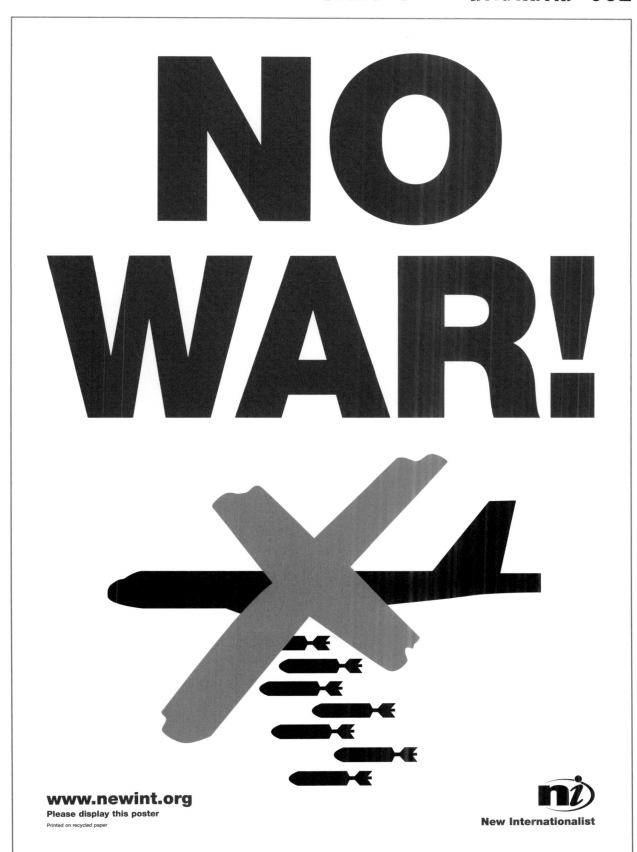

Artist: Alan Hughes
Title: NO WAR!
Organization: New Internationalist Publications Ltd.
Web Site: www.newint.org
Country: United Kingdom

Artist: Sonia and Gabriel Freeman
Title: UNITED 2
Organization: Un mundo feliz / a happy world production
Web Site: www.unmundofeliz.org
Country: Spain

Artist: Claude Moller
Title: NO
Web Site: www.warui.com/stefan/claude
Country: United States of America

Artist: Luis Miguel Munilla
Title: Untitled
Organization: Proyecto Limón
Web Site: www.proyectolimon.org
Country: Spain

CONGRATULATIONS!

Your region has been selected as a target for a humanitarian food drop. Please alert everyone in your area to the impending arrival of a Food Delivery System (FDS) device.

1. The following instructions will guide you through the identification, recovery, and operation of the Food Delivery System. Careful attention to these instructions will ensure countless hours of enjoyable food preparation and consumption.

First, locate and identify the FDS as it falls.

2. Upon recovering the FDS, remove the parachute first. To do this, locate the retaining clip at the base of the device.

3. Detach the clip. Gather the parachute and remove it from the cooking area. (Warning: parachute may be flammable.)

4. Grab the FDS and carefully lift it to an upright position. Although the tripod structure of the tail fins makes it stable virtually anywhere, we recommend a flat surface for maximum cooking enjoyment.

5. Remove the restraining pin from each of the three clips surrounding the nose cone.

6. Remove the nose cone and set it aside.

7. Locate and remove the bay door. Remove all contents and check them carefully against the inventory below.

8. Remove the upper grill and pan from the top of the FDS.

9. Spread the charcoal along the the lower grill. Light the coals, then replace the upper grill. Add meat and corn.

10.

Before operating the FDS, please remove and check the inventory. If any of the following items are missing or damaged, please contact ***** immediately for replacement.

Inventory: Charcoal (1 bag) · Ground beef · Hamburger buns (10) · Matches · Cigarettes · Corn (8 pieces) · Potato chips · Coleslaw · Dill pickles · Barbecue tongs · Marshmallows

Nutri-Gen — Planning tomorrow's dinner...today
Strategic Dynamics
Fine Deli — KIRCHIS — For 80 Years
Global Nutrition Fund — G N F
America's barbecue since 1955 — WEAVER
M·E·A·T — A FOOD FOR FITNESS

Artist: Matt McElligott
Title: Food Delivery System Information Pamphlet
Organization: ®™ark
Web Site: www.rtmark.com
Country: United States of America

design: www.toko.nu (formerly known as 21")

Artist: Toko
Title: War Life
Organization: Toko
Web Site: www.toko.nu
Country: The Netherlands

WE DON'T WANT THIS

REALITY TV

Artist: Peter Kuper
Title: Reality TV
Web Site: www.peterkuper.com
Country: United States of America

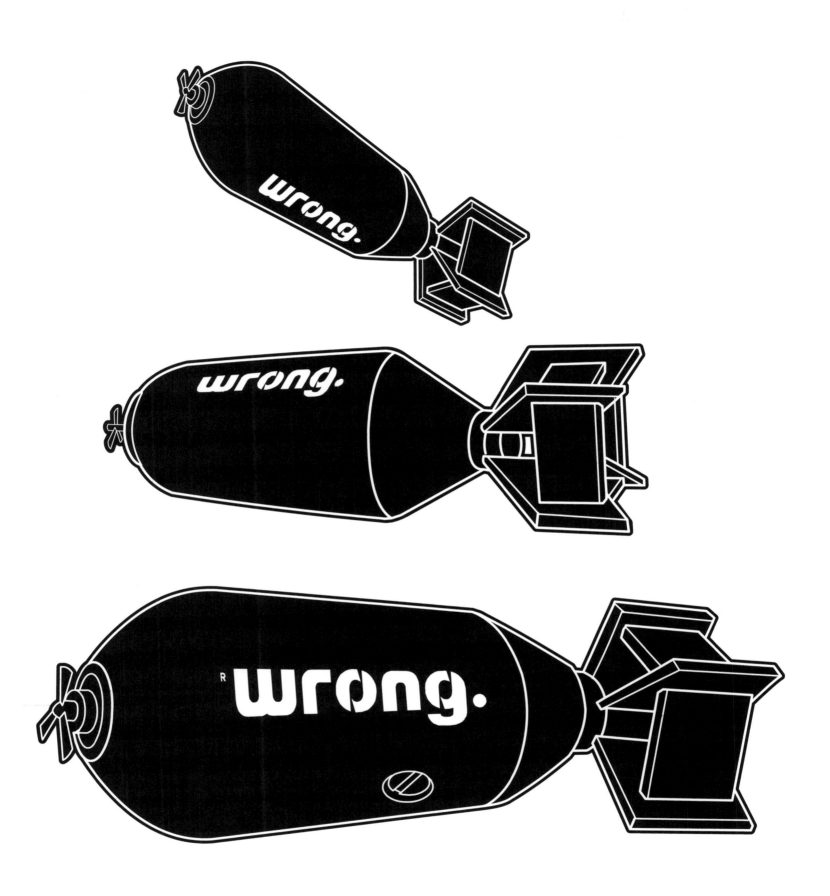

Artist: Zeb
Title: Wrong Bombs
Organization: Wake The World
Web Site: www.waketheworld.com
Country: United Kingdom

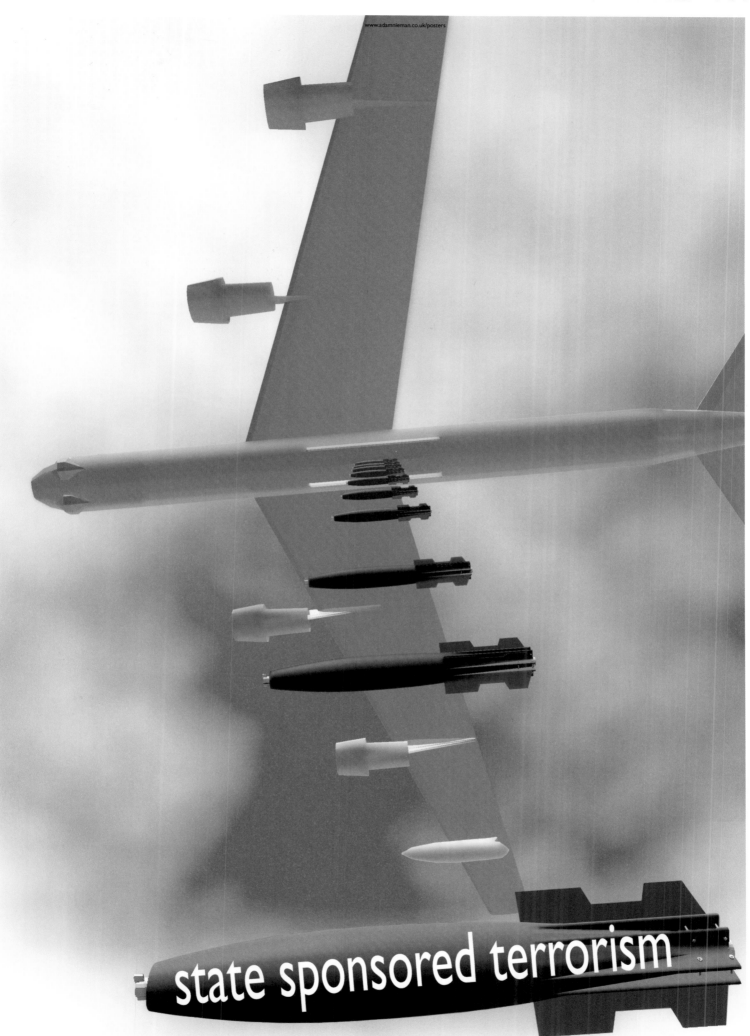

state sponsored terrorism

Artist: Adam Nieman
Title: B52-State Sponsored Terrorism
Web Site: www.adamnieman.co.uk/posters
Country: United Kingdom

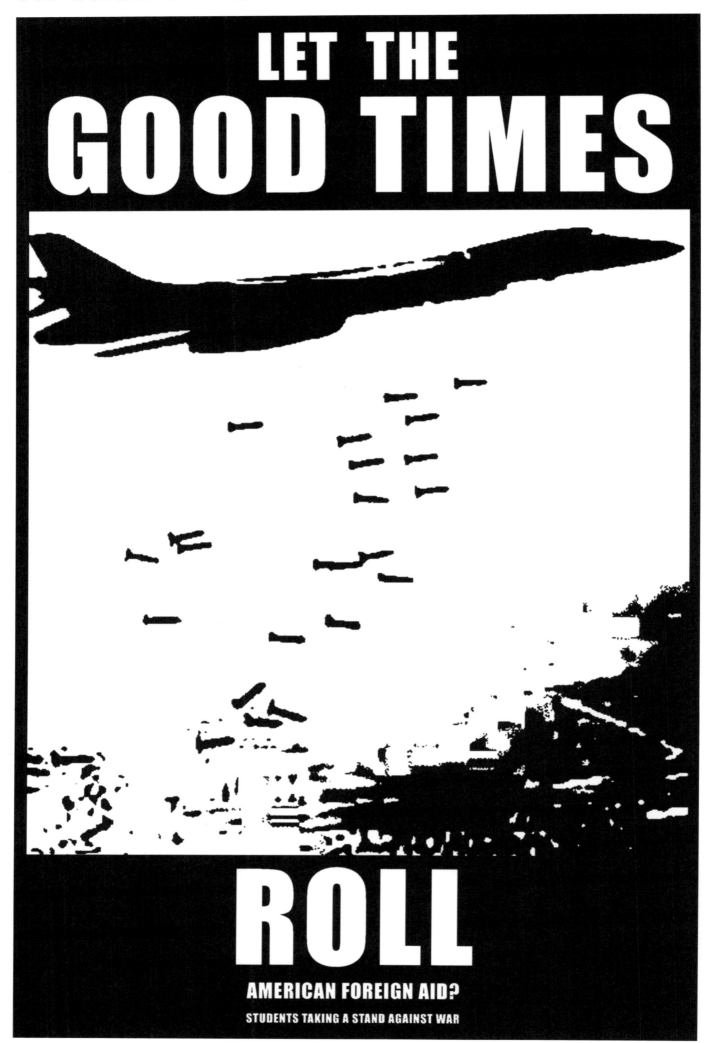

Artist: Matthew Marin
Title: Let the Good Times Roll
Organization: Villa Maria College of Buffalo, NY
Web Site: www.boredyouth.com
Country: United States of America

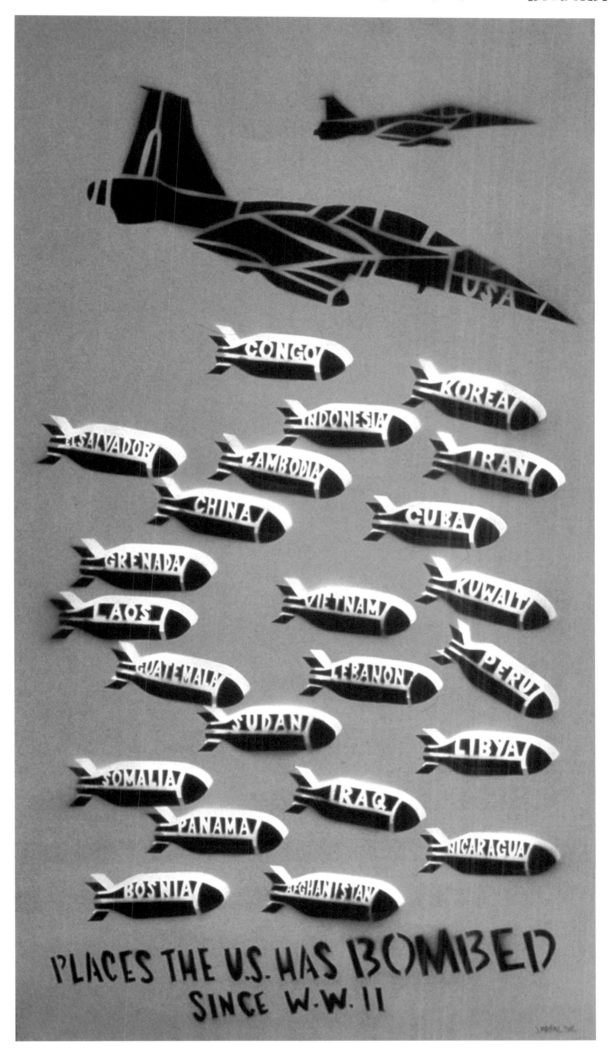

Artist: Josh MacPhee
Title: Places the U.S. has Bombed
Web Site: www.justseeds.org
Country: United States of America

STOP THE MADNESS
SAVE THE WORLD
LET YOUR VOICE BE HEARD AT WAKETHEWORLD.ORG

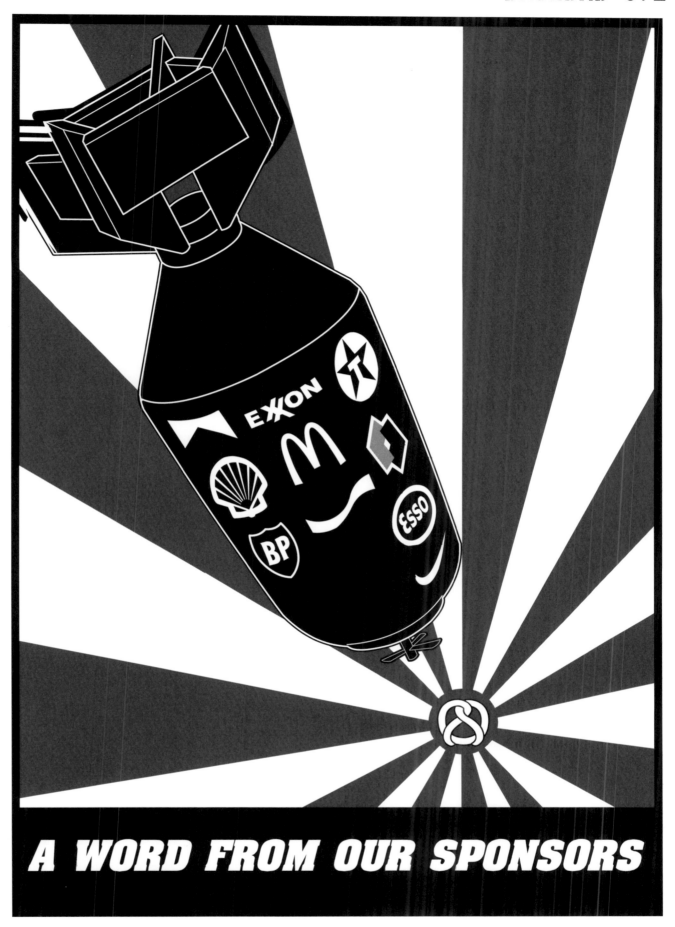

Artist: Zeb
Title: Sponsors
Organization: Wake The World
Web Site: www.waketheworld.com
Country: United Kingdom

Artist: Niels K
Title: NO WAR
Web Site: www.nielsk.dk
Country: Denmark

Artist: Juan Felipe Rubio
Title: Pretzels not bombs
Organization: Sicoactiva.net
Web Site: www.sicoactiva.net
Country: Columbia

BAD HABIT

Artist: Dylan
Title: Bad Habit
Organization: Wake The World
Web Site: www.waketheworld.com
Country: United Kingdom

Contra las ansias de guerrear...

Bombamizin
Calmante antibélico
28 Obuses Vía Rectal

¡Acaban con todo!

A. Hurtado

Artist: THINK AGAIN
Title: Bitter Pill
Web Site: www.protestgraphics.org
Country: United States of America

Artist: Andrés Hurtado
Title: BOMBAMIZIN
Web Site: http://homepage.mac.com/andreshurtado/
Country: Spain

Connect the pictures with the corresponding words

O O **Democracy**

O O **Justice**

O O **Liberation**

O O **Equality**

O O **Grace**

Artist: Samuli Viitasaari
Title: Connect...
Web Site: www.autographicdesign.com
Country: Finland

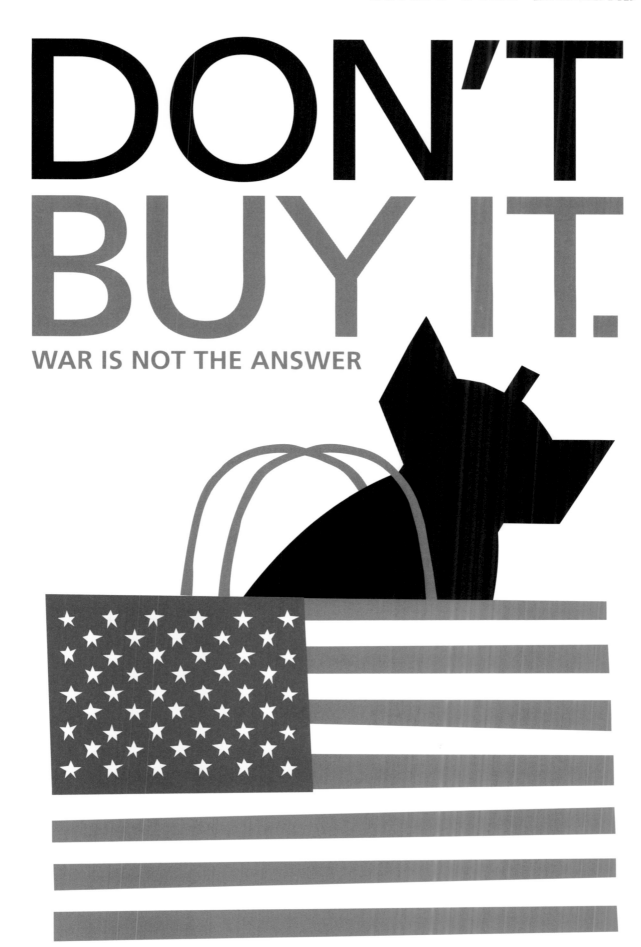

DON'T
BUY IT.
WAR IS NOT THE ANSWER

Download this poster for free at www.anotherposterforpeace.com DESIGN COURTESY OF ANOTHER POSTER FOR PEACE WITH APOLOGIES TO CRAIG FRAZIER

Artist: Kimberly Cross
Title: Don't Buy It
Organization: Another Poster for Peace
Web Site: www.anotherposterforpeace.com
Country: United States of America

Artist: Steven Lyons
Title: Stop Your Shopping, Bombs Are Dropping
Organization: Steven Lyons Studio
Web Site: www.stevenlyons.com
Country: United States of America

Military Budget - by Country[1]		Militärhaushalt nach Land[1]		Budget militaire – par pays[1]	
United States:	$ 379 billion (2003)[2]	USA:	379 Milliarden Dollar (2003)[2]	Etats-Unis:	$ 379 milliards (2003)[2]
United Kingdom:	$ 34.8 billion (2001)	Großbritannien:	34,8 Milliarden Dollar (2001)	Grande-Bretagne:	$ 34,8 milliards (2001)
Russia:	$ 29 billion (2000)	Russland :	29 Milliarden Dollar (2000)	Russie:	$ 29 milliards (2000)
France:	$ 27 billion (2000)	Frankreich:	27 Milliarden Dollar (2000)	France:	$ 27 milliards (2000)
Germany:	$ 23.1 billion (2001)	Deutschland:	23,1 Milliarden Dollar (2001)	Allemagne:	$ 23,1 milliards (2001)
Saudi Arabia:	$ 18.7 billion (2000)	Saudi-Arabien:	18,7 Milliarden Dollar (2000)	Arabie Saoudite:	$ 18,7 milliards (2000)
India:	$ 15.9 billion (2000)	Indien:	15,9 Milliarden Dollar (2000)	Inde:	$ 15,9 milliards (2000)
China:	$ 14.5 billion (2000)	China:	14,5 Milliarden Dollar (2000)	Chine:	$ 14,5 milliards (2000)
South Korea:	$ 12.8 billion (2000)	Südkorea:	12,8 Milliarden Dollar (2000)	Corée du Sud:	$ 12,8 milliards (2000)
Taiwan:	$ 12.8 billion (2000)	Taiwan:	12,8 Milliarden Dollar (2000)	Taiwan:	$ 12,8 milliards (2000)
Spain:	$ 8.4 billion (2002)	Spanien:	8,4 Milliarden Dollar (2002)	Espagne:	$ 8,4 milliards (2002)
Iran:	$ 7.5 billion (2000)	Iran:	7,5 Milliarden Dollar (2000)	Iran:	$ 7,5 milliards (2000)
Pakistan:	$ 3.3 billion (2000)	Pakistan:	3,3 Milliarden Dollar (2000)	Pakistan:	$ 3,3 milliards (2000)
Syria:	$ 1.8 billion (2000)	Syrien:	1,8 Milliarden Dollar (2000)	Syrie:	$ 1,8 milliards (2000)
Iraq:	$ 1.4 billion (1999)	Irak:	1,4 Milliarden Dollar (1999)	Irak:	$ 1,4 milliards (1999)
North Korea:	$ 1.3 billion (2000)	Nordkorea:	1,3 Milliarden Dollar (2000)	Corée du Nord:	$ 1,3 milliards (2000)
Yugoslavia:	$ 1.3 billion (2000)	Jugoslawien:	1,3 Milliarden Dollar (2000)	Yougoslavie:	$ 1,3 milliards (2000)
Libya:	$ 1.2 billion (2000)	Libyen:	1,2 Milliarden Dollar (2000)	Libye :	$ 1,2 milliards (2000)
Sudan:	$ 425 million (2000)	Sudan:	425 Millionen Dollar (2000)	Soudan:	$ 425 millions (2000)
Cuba:	$ 31 million (2000)	Kuba:	31 Millionen Dollar (2000)	Cuba:	$ 31 millions (2000)

Notes:
1. Council for a Livable World, "US Military Budget Tops Rest of World by Far", www.clw.org, http://64.177.207.201/pages/8_47.html , 25, November 2003.
2. ($48 billion, increase from Fiscal 2002 to 2003) / (Eine Erhöhung um 48 Milliarden Dollar vom Steuerjahr 2002 zu 2003) / ($ 48 milliards de plus entre l'année fiscale 2002 et 2003)

don't BUY their WAR

"The de facto role of the US armed forces
will be to keep the world safe for our economy
and open to our cultural assault. To those
ends, we will do a fair amount of killings."

Major Ralph Peters, US Military

Consumerism and war are intextricably linked.
Saturday 30th November is International Buy Nothing Day.

Find out more at: www.uhc-collective.org.uk

Artist: Jai Redman
Title: Don't Buy their War
Organization: UHC Collective
Web Site: www.uhc-collective.org.uk
Country: United Kingdom

Countries US has bombed since WWII[3]

China	(1945-1946)
Korea	(1950)
Indonesia	(1958)
Cuba	(1959-1961)
Guatemala	(1960/1967-1969)
Vietnam	(1962-1973)
Congo	(1964)
Peru	(1965)
Laos	(1965-1973)
Cambodia	(1969-1973)
El Salvador	(1980's)
Nicaragua	(1980's)
Grenada	(1983)
Lebanon	(1983-1984)
Libya	(1986)
Panama	(1989)
Iran	(1989)
Iraq	(1990-present)
Somalia	(1993)
Bosnia	(1994-1995)
Sudan	(1998)
Bulgaria/Macedonia	(1999)
Afghanistan	(1998/2001-present)

Länder, die die USA seit dem zweiten Weltkrieg bombardiert haben[3]

China	(1945-1946)
Korea	(1950)
Indonesien	(1958)
Kuba	(1959-1961)
Guatemala	(1960/1967-1969)
Vietnam	(1962-1973)
Kongo	(1964)
Peru	(1965)
Laos	(1965-1973)
Kambodscha	(1969-1973)
El Salvador	(1980er Jahre)
Nicaragua	(1980er Jahre)
Grenada	(1983)
Libanon	(1983-1984)
Libyen	(1986)
Panama	(1989)
Iran	(1989)
Irak	(1990-heute)
Somalia	(1993)
Bosnien	(1994-1995)
Sudan	(1998)
Bulgarien/Mazedonin	(1999)
Afghanistan	(1998/2001-heute)

Les pays que les USA ont bombardés depuis la Seconde Guerre Mondiale[3]

Chine	(1945-1946)
Corée	(1950)
Indonésie	(1958)
Cuba	(1959-1961)
Guatemala	(1960/1967-1969)
Vietnam	(1962-1973)
Congo	(1964)
Pérou	(1965)
Laos	(1965-1973)
Cambodge	(1969-1973)
El Salvador	(dans les années 80)
Nicaragua	(dans les années 80)
Grenade	(1983)
Liban	(1983-1984)
Libye	(1986)
Panama	(1989)
Iran	(1989)
Irak	(1990 à aujourd'hui)
Somalie	(1993)
Bosnie	(1994-1995)
Soudan	(1998)
Bulgarie/Macédoine	(1999)
Afghanistan	(1998/2001 à aujourd'hui)

Notes:
3. William Blum, Killing Hope: US Military and CIA Interventions
Since World War II (Monroe, Maine, Common Courage Press, 1995)

La météo pour demain

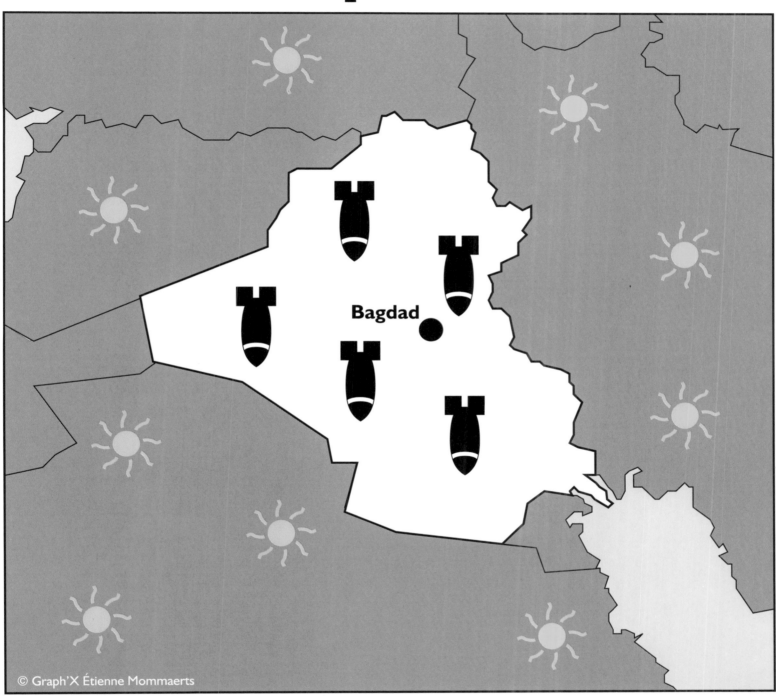

Bagdad

© Graph'X Étienne Mommaerts

Artist: Etienne Mommaerts
Title: La météo pour demain
Organization: Graph'X
Web Site: www.studiographx.net
Country: Belgium

Artist: Amanda Crichton
Title: Red Light Special
Organization: one more monkey
Web Site: www.onemoremonkey.com
Country: Australia

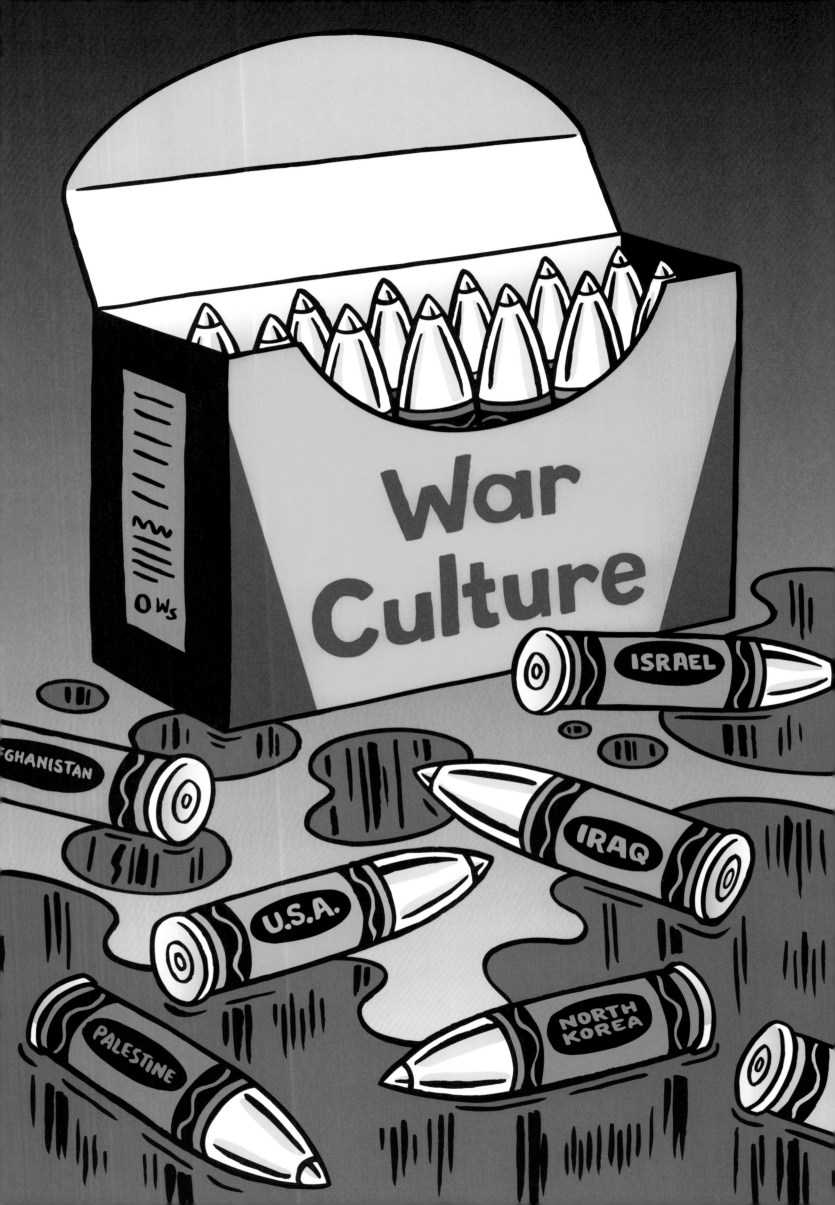

BLOCK BUSH'S WAR

SACK THE QUARTERBACK

Artist: John Carr
Title: Block Bush
Organization: 33 Graphic / Konscious.com
Web Site: www.33graphic.com, www.konscious.com
Country: United States of America

Artist: Ward Sutton
Title: War Culture
Web Site: www.suttonimpactstudio.com
Country: United States of America

PARODY & SATIRE

Parody and Satire

Politics and politicians have long been fodder for parody and satire and this conflict has certainly seen its fair share. The creativity of the witty slogans referenced everything from George W. Bush's lack of command over the English language (nucular?) to the reasons behind the war (How did our oil get under their sand?). Women could not resist the waiting breadth of possibilities attached to George W. Bush's name and created slogans such as "The Only Bush I Trust is My Own" referencing American slang for female pubic hair. Names aside, Bush and other politicians had long since created caricatures of themselves: Bush as the tough cowboy Texan and Blair as the "yes man." Artists responded with "Stop Mad Cowboy Disease", "Yee-ha is Not a Foreign Policy" and portrayed Blair as a hand puppet mouthing Bush's commands. Saddam Hussein and Osama Bin Laden were equally lauded, portrayed as accomplices, rather than enemies.

Many artists employed the format of movie posters, replacing Hollywood actors and actresses with politicians. A common reference was Stanley Kubrick's 1964 black comedy on cold war politics, Dr. Strangelove. The character Major T.J. Kong, who in the final scene rides a missile to Russia wearing a ten gallon cowboy hat, was supplanted with the image of George W. Bush. The film and the appropriated image alike take aim at the nuclear policy of world powers and the connections between war and the male sex drive. The use of movie posters and entertainment themes further parody the marketing of war to the public. They give voice to a rising frustration that many have with the corporate media's reporting techniques that often blur the lines between news and entertainment.

Artists recognized the importance of humor in overcoming the often singular views of the media. The US Government and media alike were quick to criticize those that didn't back the war. When the French withheld their support, self-proclaimed patriots renamed french fries (which actually hail from Belgium) "freedom fries" so as not to insult their sensitive palates. Artists parodied the unwitting alignment of patriotism and fast food in images such as "Murder King" and Chuck Sperry's "Machine Gun in the Clown's Hand." Other artists took aim at the US terror alert system and precautionary advice trumpeted nightly on network news. The ridiculous suggestion that Americans safeguard their homes with plastic and duck tape against chemical attacks is parodied in "Place Duct Tape Here" which suggests a better location for the tape (on George W. Bush's mouth).

The use of humor not only allows one to cope with the gravity of war but it allows one to remain optimistic and vigilant in the opposition of war. These posters are not meant to make light of the serious subject matter but merely expose its frivolity and absurdity, shining back a funhouse mirror that reflects its images often too clearly.

Parodie und Satire

Politik und Politiker geben schon seit langem eine Zielscheibe für Parodie und Satire ab, und auch in diesem Konflikt haben sie mit Sicherheit ihren Teil abbekommen. In ihrer Kreativität konnten die geistreichen Slogans alles mögliche als Ausgangspunkt nehmen, von George W. Bushs mangelhafter Beherrschung der englischen Sprache („nucular" statt „nuclear") bis hin zu den Gründen hinter dem Krieg („Wie ist denn bloß unser Öl unter deren Sand gekommen?"). Einige Künstlerinnen konnten der Versuchung nicht widerstehen, mit Bushs Namen zu spielen („bush" ist ein amerikanischer Slang-Ausdruck für die weibliche Schambehaarung) und dachten sich Slogans aus wie „The Only Bush I Trust is My Own" („Der einzige Bush, dem ich traue, ist mein eigener"). Von den Namen einmal ganz abgesehen, hatten Bush und andere Politiker sich schon längst selbst zu Karikaturen gemacht: Bush als harter texanischer Cowboy und Blair als Ja-Sager. Damit arbeiten Slogans wie „Stop Mad Cowboy Disease" („Stoppt den Cowboy-Wahnsinn", eine Anspielung auf „mad cow disease" = „Rinderwahnsinn"), „Yee-ha is Not a Foreign Policy" („Jippie ist keine Außenpolitik") und Bilder wie das von Blair als Marionette, die Bushs Befehle nachplappert. Auch Saddam Hussein und Osama bin Laden bekamen ihr Fett weg, indem sie als Komplizen, nicht als Feinde dargestellt wurden.

Viele Künstler wandelten Filmplakate ab, indem sie die Gesichter der Hollywood-Schauspieler und -Schauspielerinnen durch Politiker ersetzten. Ein häufig verwendetes Motiv war Stanley Kubricks 1964 entstandene schwarze Komödie Dr. Seltsam. Für die Filmfigur Major Kong, der in der Abschlussszene auf einer Bombe nach Russland reitet und einen riesigen Cowboyhut trägt, wurde ein Bild von George W. Bush eingesetzt. Der Film und das daraus verwendete Bild zielen auf die Atompolitik der Weltmächte und die Verbindungen zwischen Krieg und männlichem Geschlechtstrieb ab. Die Verwendung von Filmplakaten und Unterhaltungsthemen parodiert ebenfalls die Art und Weise, wie der Krieg der Öffentlichkeit verkauft wird. Hierin äußert sich die wachsende Frustration vieler über die Art der Berichterstattung durch die großen Medienunternehmen, bei der die Grenzen zwischen Information und Unterhaltung häufig verwischt werden.

Den Künstlern war die wichtige Rolle des Humors beim Kampf gegen die oft eingleisigen Ansichten der Medien bewusst. Die US-Regierung und ebenso die Medien waren schnell dabei, als es darum ging, die Gegner dieses Krieges zu kritisieren. Als die Franzosen ihre Unterstützung verweigerten, benannten selbst ernannte Patrioten die zwar als „French fries" bezeichneten, aber in Wirklichkeit aus Belgien stammenden Pommes Frites zu „freedom fries" („Freiheitsfritten") um, um ihre empfindsamen Gaumen nicht zu beleidigen. Diese unbeabsichtigte Verquickung von Patriotismus und Fast Food wurde in Bildern wie „Murder King" („Mörderkönig", statt „Burger King") und Chuck Sperrys „Machine Gun in the Clown's Hand" („Maschinengewehr in der Hand des Clowns") parodiert. Andere Künstler wandten sich dem Terrorwarnsystem und den Zivilschutzmaßnahmen zu, die allabendlich in den Nachrichtensendungen der großen Sendeanstalten verkündet wurden. Das lächerliche Ansinnen, die Bevölkerung solle ihre Häuser mit Plastik und Klebeband gegen Chemikalienangriffe schützen, nimmt „Place Duct Tape Here" („Klebeband hier anbringen") aufs Korn und schlägt sogleich einen besseren Platz für das Klebeband vor: Über George W. Bushs Mund.

Der Einsatz von Humor ist nicht nur ein Weg, mit dem Ernst des Krieges umzugehen, sondern macht es gleichzeitig möglich, in der Opposition gegen den Krieg optimistisch und wachsam zu bleiben. Diese Plakate sollen das ernste Thema nicht verharmlosen, sondern entlarven lediglich seine Frivolität und Absurdität, die wie in einem Zerrspiegel oft nur allzu deutlich zu erkennen sind.

Parodie et satire

La politique et les politiciens ont depuis longtemps été la cible de la parodie et de la satire. Cette guerre en a sans doute eu sa juste part. Les slogans fort créatifs et pleins d'esprit ont tout énuméré, de l'incapacité de George W. Bush à maîtriser la langue anglaise (nucular au lieu de « nuclear » pour nucléaire) aux raisons cachées derrière la guerre (Comment notre pétrole a-t-il pu arriver sous leur sable ?). Quelques artistes femmes n'ont pu résister aux jeux de mots avec le nom de George W. Bush et ont créé des slogans tels que « The Only Bush I Trust is My Own » (Le seul « bush » auquel je fasse confiance est le mien) se référant à l'argot américain qui désigne par « bush » les poils pubiens féminins. A côté des noms, Bush et d'autres politiciens avaient depuis longtemps généré leurs propres caricatures : Bush comme solide cow-boy texan et Blair en tant que « Monsieur Oui-Oui ». Certains artistes ont réagi par « Stop Mad Cowboy Disease » (Arrêtez la maladie du cowboy fou) ou bien « Yee-ha is Not a Foreign Policy » (Yee-ha – le cri des cow-boys à l'adresse des bœufs dans les plaines – n'est pas une politique étrangère) et ont fait le portrait de Blair en tant que marionnette débitant les ordres de Bush. Saddam Hussein et Osama Bin Laden en ont eu eux aussi pour leur grade, en étant considérés comme complices plutôt que comme des ennemis.

Beaucoup d'artistes employèrent le format des posters de films, remplaçant les acteurs et actrices de Hollywood par les politiciens. Le film de Stanley Kubrick de 1964, Dr. Strangelove, traitant la politique de la guerre froide dans une comédie noire a souvent servi de référence. Le protagoniste, Major T.J. Kong, qui, dans la dernière scène, monte à califourchon sur un missile dirigé vers la Russie en portant un chapeau de cow-boy particulièrement haut de forme, a été remplacé par George W. Bush. Le film ainsi que l'image réappropriée visent la politique nucléaire des pouvoirs mondiaux et les interconnexions entre la guerre et l'instinct sexuel masculin. L'utilisation de posters de films et de sujets de divertissement font par ailleurs la parodie de la commercialisation de la guerre. On y retrouve la frustration croissante du public face aux techniques de reportage des grandes entreprises médiatiques qui, bien souvent, effacent la ligne qui démarque l'information du divertissement.

Les artistes ont reconnu l'importance de l'humour pour dépasser les vues souvent monolithiques de ces grandes entreprises. Aussi bien celles-ci que le gouvernement lui-même ont été prompts à critiquer ceux qui ne soutenaient pas la guerre. Lorsque les Français ont refusé leur soutien, des patriotes autoproclamés ont rebaptisé les « French fries » (qui sont en réalité originaires de Belgique) « freedom fries » comme pour ne pas insulter leurs palais sensibles. Des artistes ont parodié l'amalgame involontaire de patriotisme et fast food dans des images telles que « Murder King » et « Machine Gun in the Clown's Hand » (Mitrailleuse dans une main de clown) de Chuck Sperry. D'autres artistes ont pris pour objectif le système d'alerte anti-terroriste des Etats-Unis qui diffusait des conseils de précaution tous les soirs au moment des infos télévisées. La suggestion ridicule que les Américains protègent leurs maisons par du plastique et du scotch contre les attaques chimiques est parodiée dans « Place Duct Tape Here » (Coller la bande adhésive ici) qui suggérait un meilleur emplacement pour le scotch (sur la bouche de George W. Bush).

L'utilisation de l'humour nous permet non seulement de supporter la gravité de la guerre mais également de rester optimistes et vigilants dans notre opposition à celle-ci. Ces posters ne minimisent le sérieux du sujet, mais en exposent plutôt sa frivolité et son absurdité, comme à travers un miroir de fête foraine qui renvoie des images souvent grossièrement déformées.

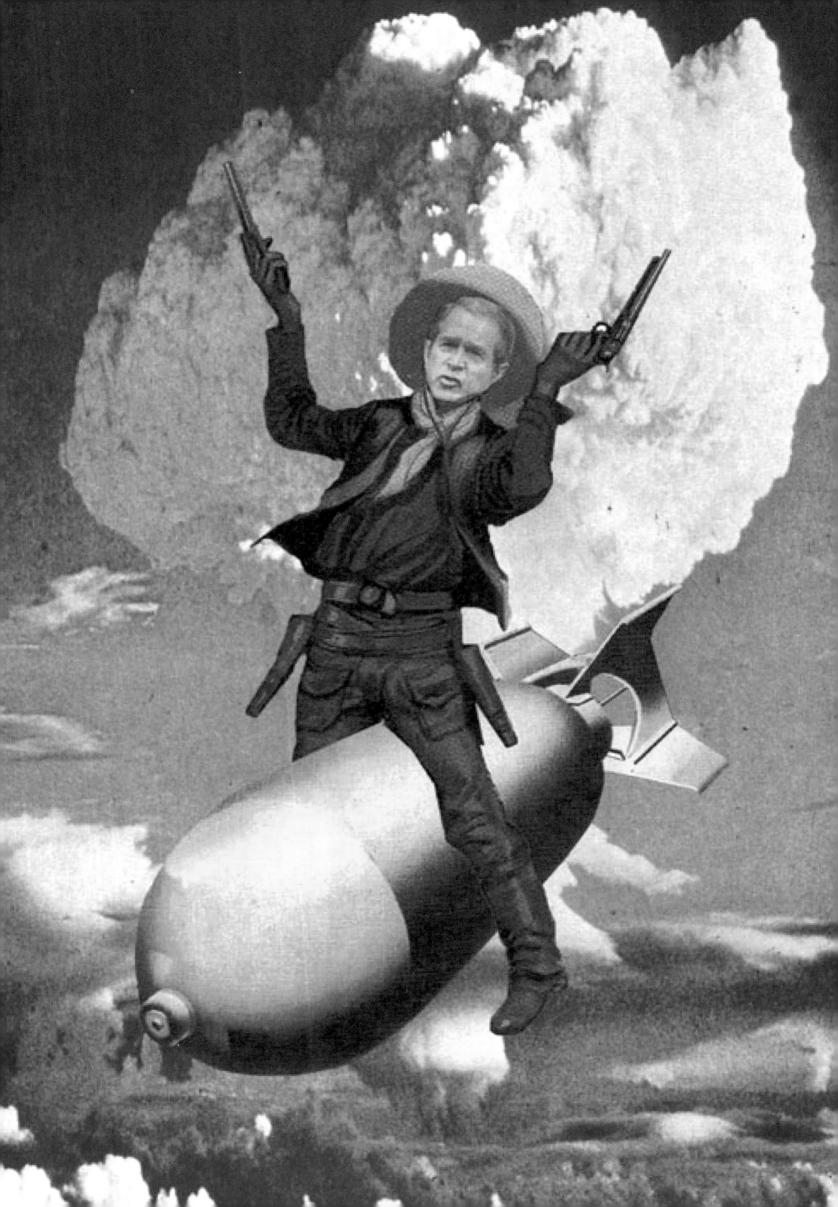

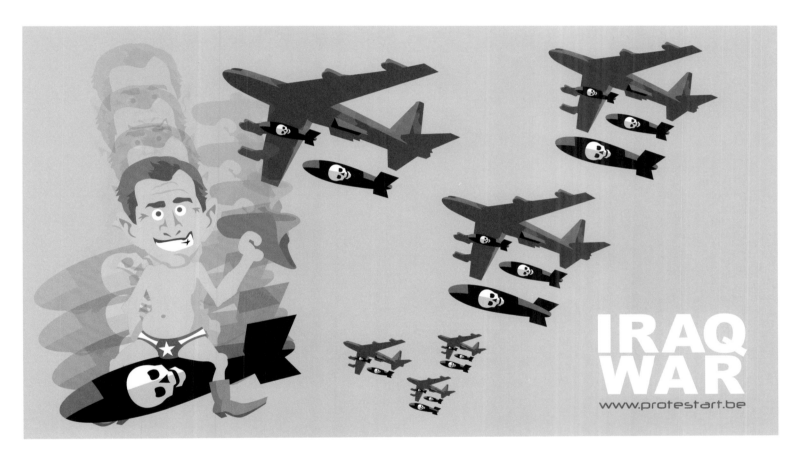

Artist: Repiso Christian
Title: Peace04
Organization: ProtestArt
Web Site: www.protestart.be
Country: Belgium

Artist: Jonathon Baker
Title: Don't Mess With Texas
Web Site: www.jonathonbaker.com
Country: United Kingdom

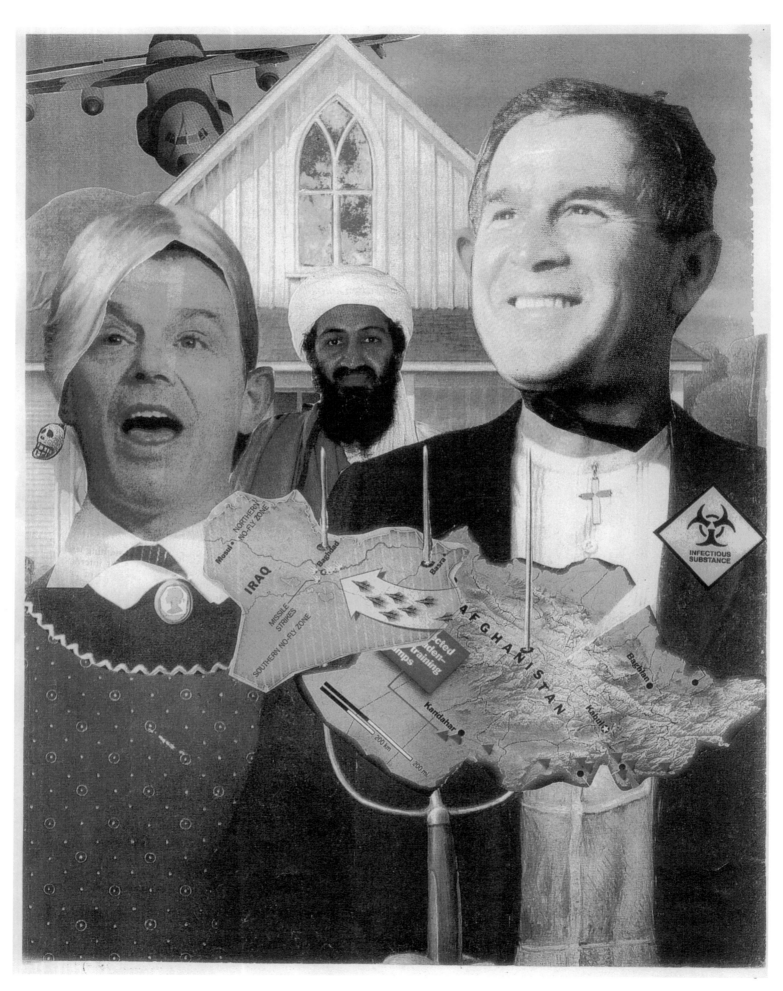

Artist: Michael Dickinson
Title: American Gothic 2
Organization: Carnival of Chaos
Web Site: http://carnival_of_chaos.tripod.com
Country: Turkey

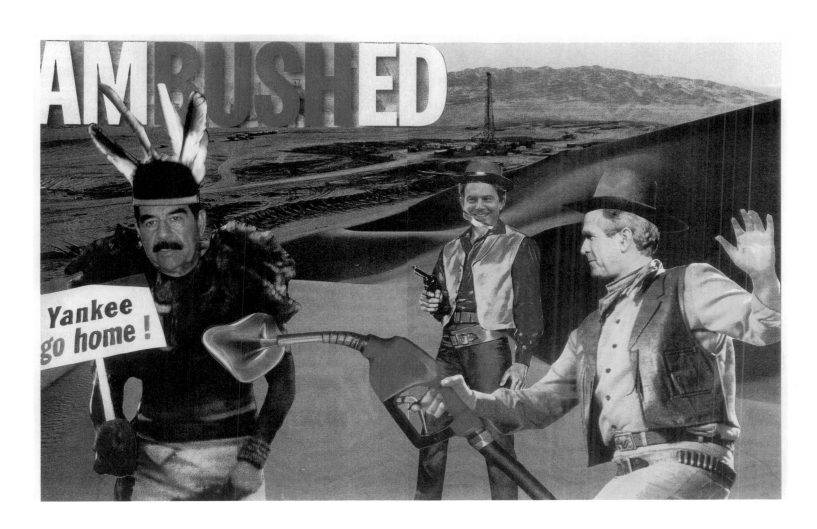

Artist: Michael Dickinson
Title: Ambushed/Bandits
Organization: Carnival of Chaos
Web Site: http://carnival_of_chaos.tripod.com
Country: Turkey

STOP

MAD
COWBOY
DISEASE

Artist: Bill Dawes
Title: Stop Mad Cowboy Disease
Organization: Dawesbiz.Net
Web Site: www.colorpro.com/wmdawes/about
Country: United States of America

"YEE-HA" IS NOT A FOREIGN POLICY.

NO WAR IN IRAQ

WWW.PROTESTPOSTERS.ORG

Artist: Karen Capraro
Title: Yee-ha is not a foreign policy
Organization: Underground Advertising
Web Site: www.undergroundAds.com
Country: United States of America

Artist: Louise Jarmilowicz
Title: What Face Do I Wear Today?
Web Site: www.jarmodesigns.com
Country: United States of America

SEND IN THE CLOWNS

Artist: Simon Stratford
Title: Send in the clowns
Organization: Seventyforty
Web Site: www.seventyforty.co.uk
Country: United Kingdom

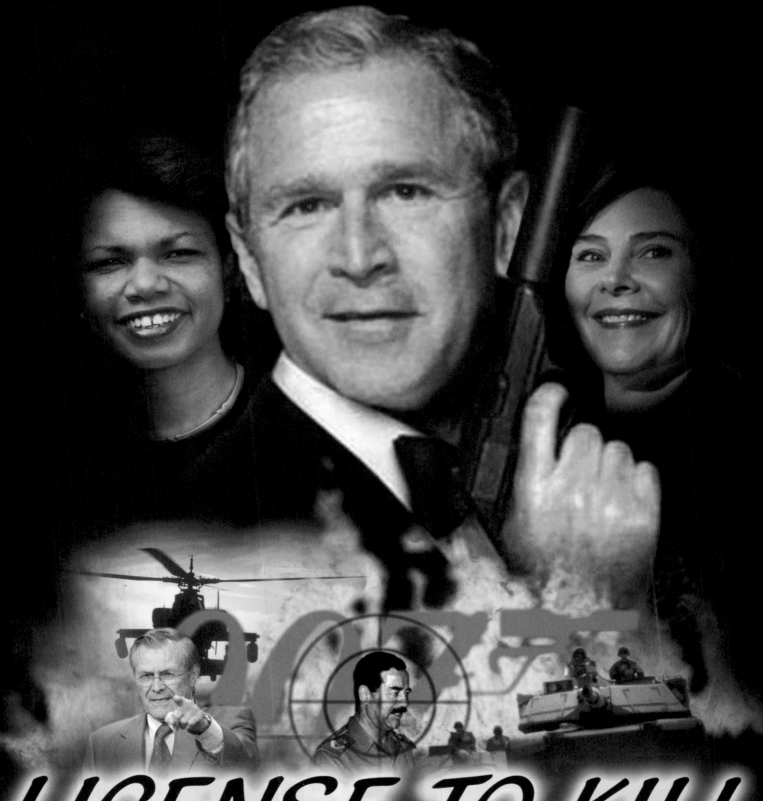

LICENSE TO KILL

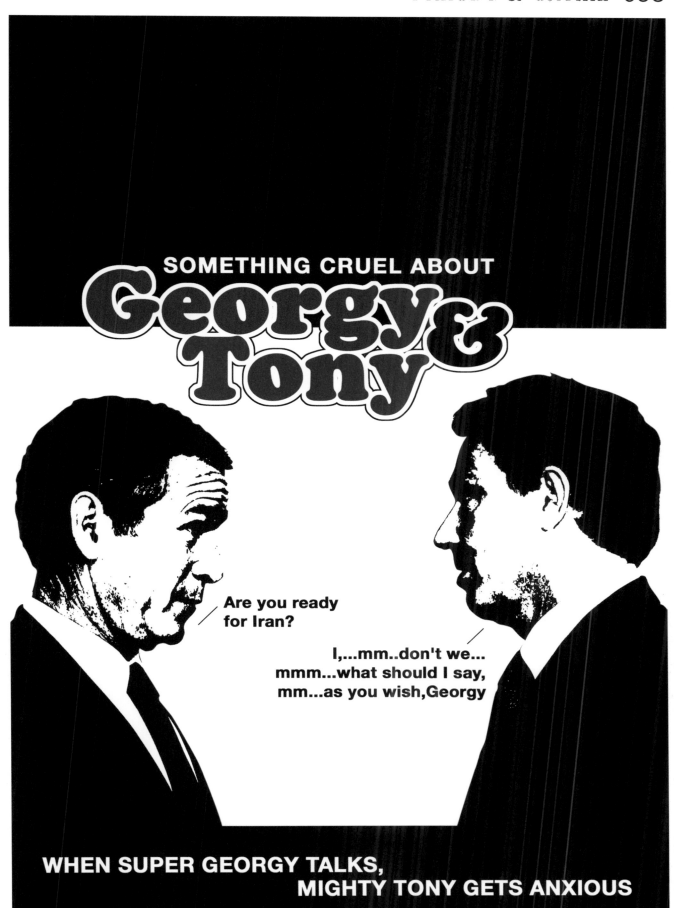

Artist: Adrianus Adityo Nugroho
Title: George & Tony
Organization: Sam Design
Web Site: www.sam-design.com
Country: Indonesia

Artist: Axel Feuerberg
Title: License To Kill
Web Site: www.nofurtherwar.de
Country: Germany

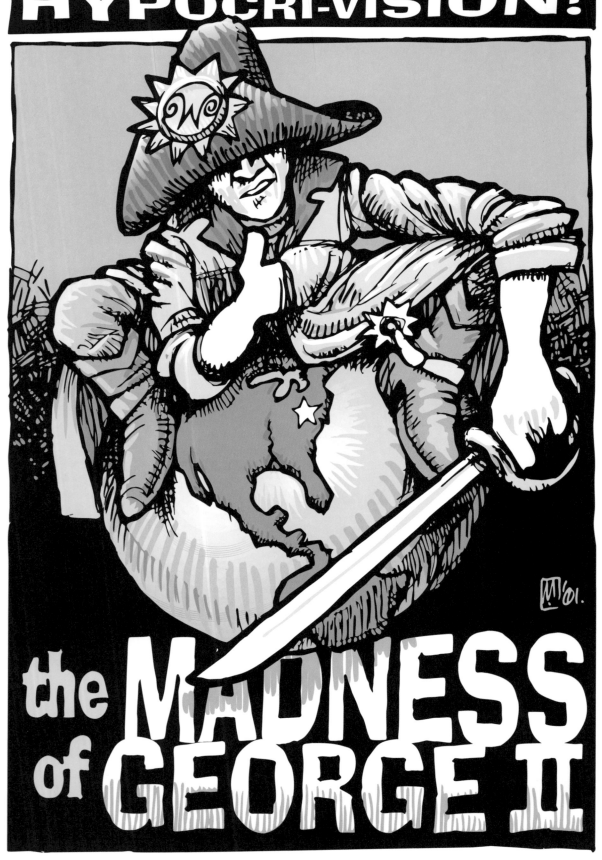

Artist: Mike Flugennock
Title: The Madness of George II
Organization: The "Progressive" Magazine
Web Site: www.sinkers.org/posters
Country: United States of America

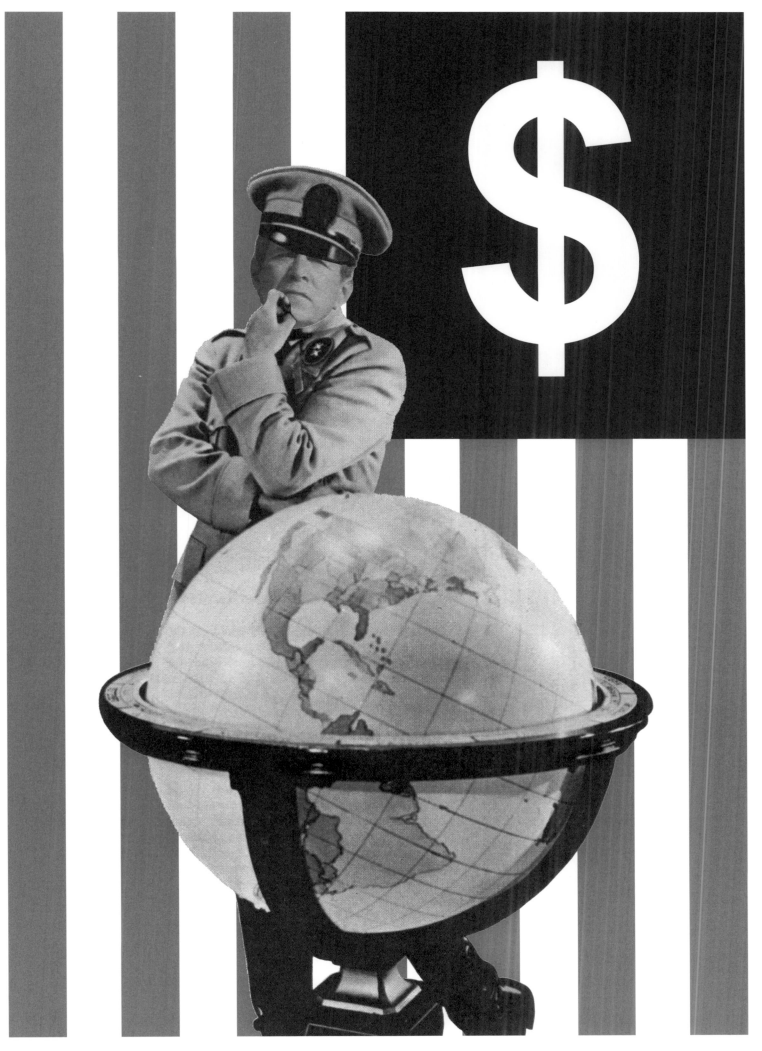

Artist: Jonathon Baker
Title: The Great Dictator
Web Site: www.jonathanbaker.com
Country: United Kingdom

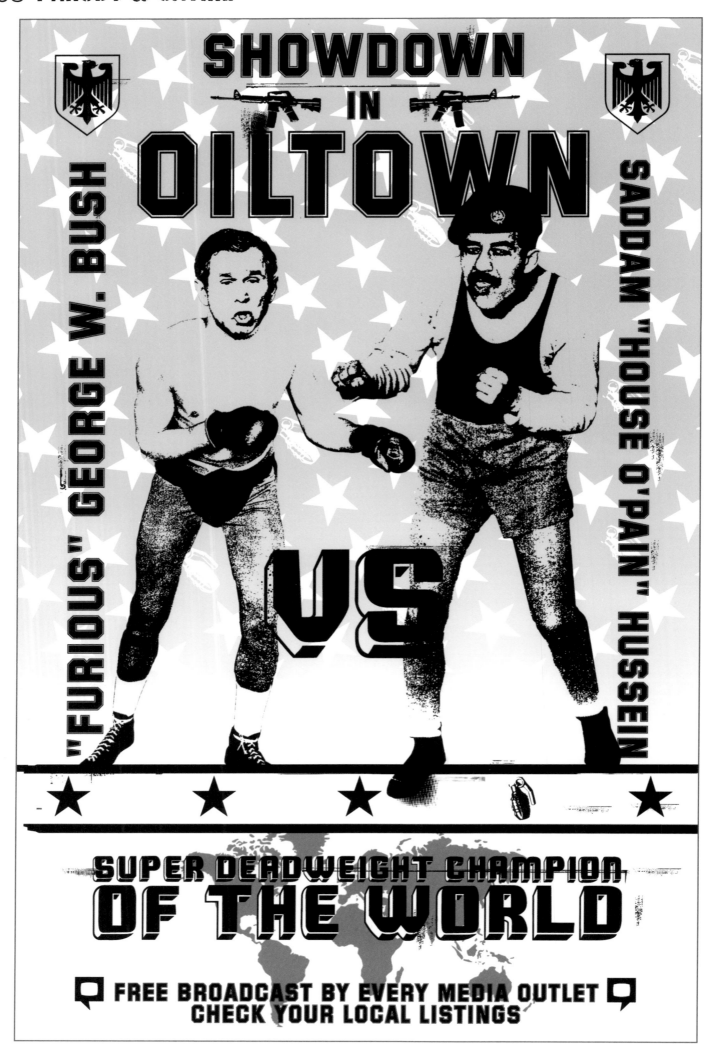

Artist: Dominic coKrishna Coballe
Title: Showdown in Oiltown or: How I Learned to Stop Worrying and Love the War
Organization: Subversive Associates
Web Site: www.fotoplus.org
Country: Canada

COMING SOON TO A STAGING AREA NEAR YOU

WAR
WITHOUT END

CHECK YOUR LOCAL PAPER FOR LISTINGS

NOW PLAYING AT THEATERS
ALL AROUND THE GLOBE
BE SURE TO GET IN LINE AND WAVE YOUR FLAG
BRING DEATH AND DESTRUCTION TO THOUSANDS THAT YOU WILL NEVER KNOW

FOR MORE INFORMATION CALL GEORGE WALKER BUSH 1 202 456 1414

Artist: Marc Lepson
Title: War Without End
Country: United States of America

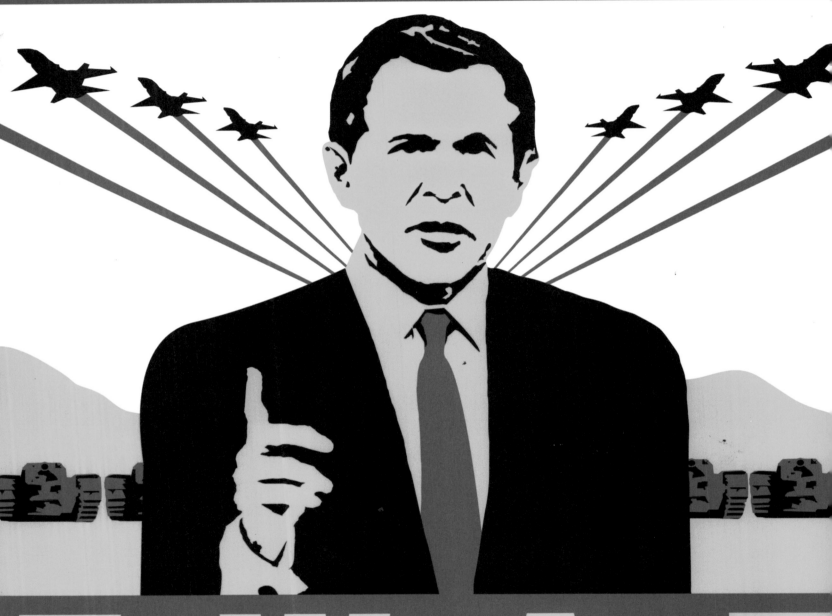

DON'T BE A FILTHY TERRORIST

SUPPORT

T.W.A.T

THE WAR AGAINST TERROR™

www.thesunmachine.net

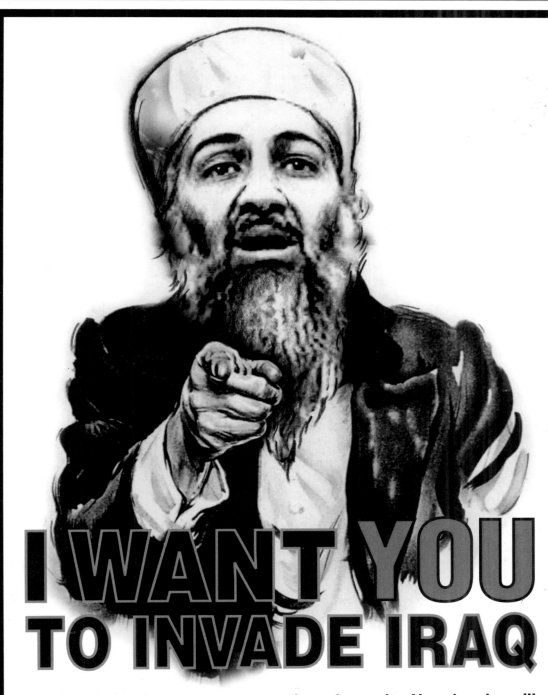

I WANT YOU
TO INVADE IRAQ

Go ahead. Send me a new generation of recruits. Your bombs will fuel their hatred of America and their desire for revenge. Americans won't be safe anywhere. Please, attack Iraq. Distract yourself from fighting Al Qaeda. Divide the international community. Go ahead. Destabilize the region. Maybe Pakistan will fall – we want its nuclear weapons. Give Saddam a reason to strike first. He might draw Israel into a fight. Perfect! So please – invade Iraq. Make my day.

TomPaine.common sense

Osama says: 'I Want You to Invade Iraq.'
TomPaine.com features reasons
why we shouldn't.

© 2002 The Florence Fund, PO Box 53303, Washington, DC 20009

Organization: TomPaine.com a project of the nonprofit Florence Fund
Title: I Want You
Web Site: www.TomPaine.com
Country: United States of America

Artist: Jamie Stanton
Title: TWAT
Organization: The Sun Machine
Web Site: www.thesunmachine.net
Country: Scotland

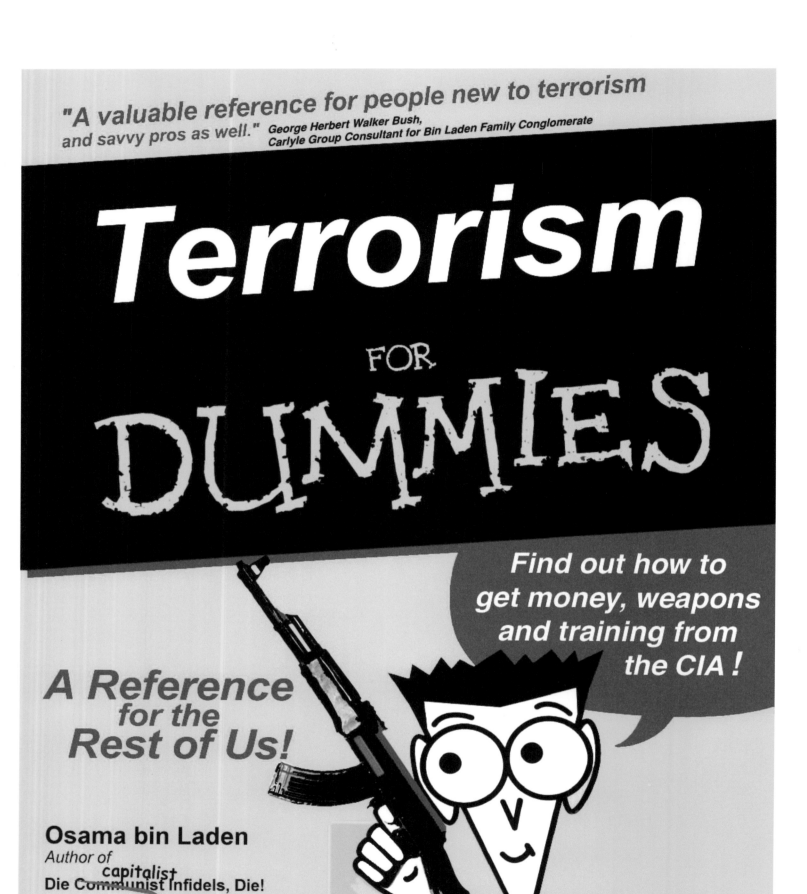

Artist: Jeff Grubler
Title: Terrorism for Dummies
Organization: The Ronald Reagan Home for the Criminally Insane
Web Site: www.insanereagan.com
Country: United States of America

Artist: Albert Cano
Title: Es un placer
Country: Spain

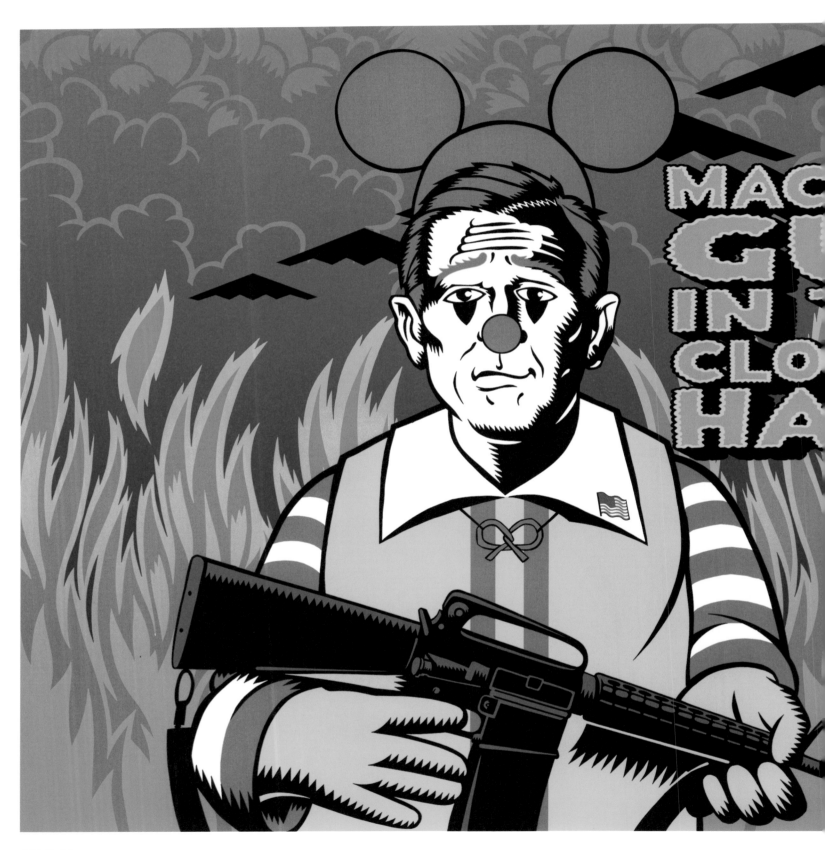

Artist: Chuck Sperry
Title: Machine Gun in the Clown's Hand
Organization: Firehouse Kustom Rockart Company
Web Site: www.firehouseposters.com
Country: United States of America

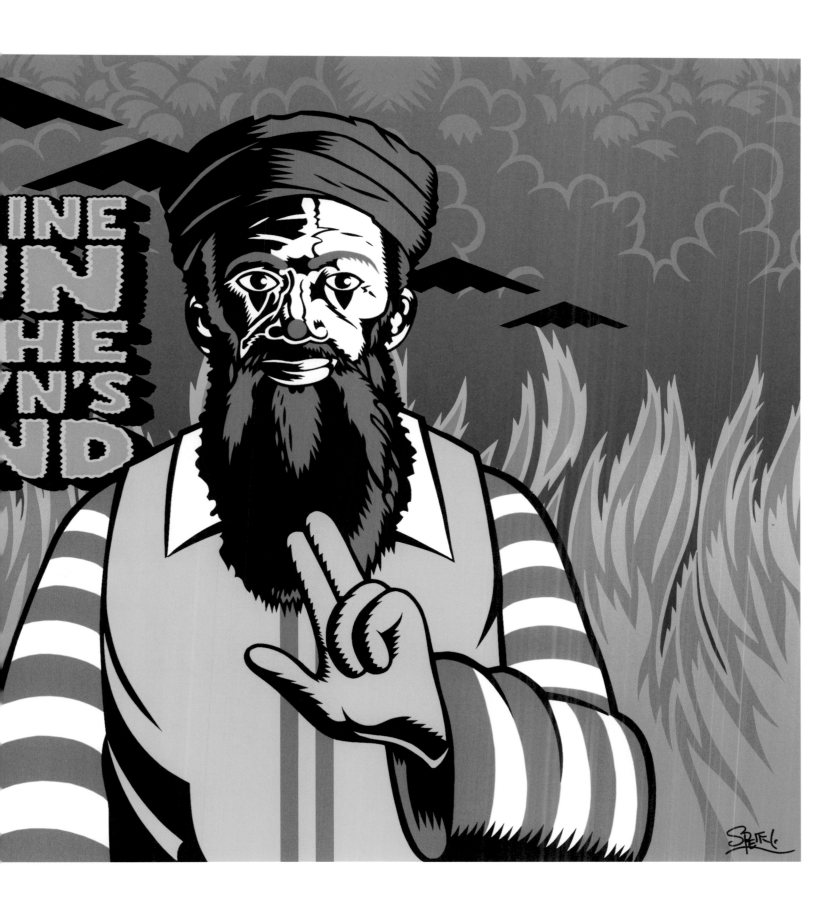

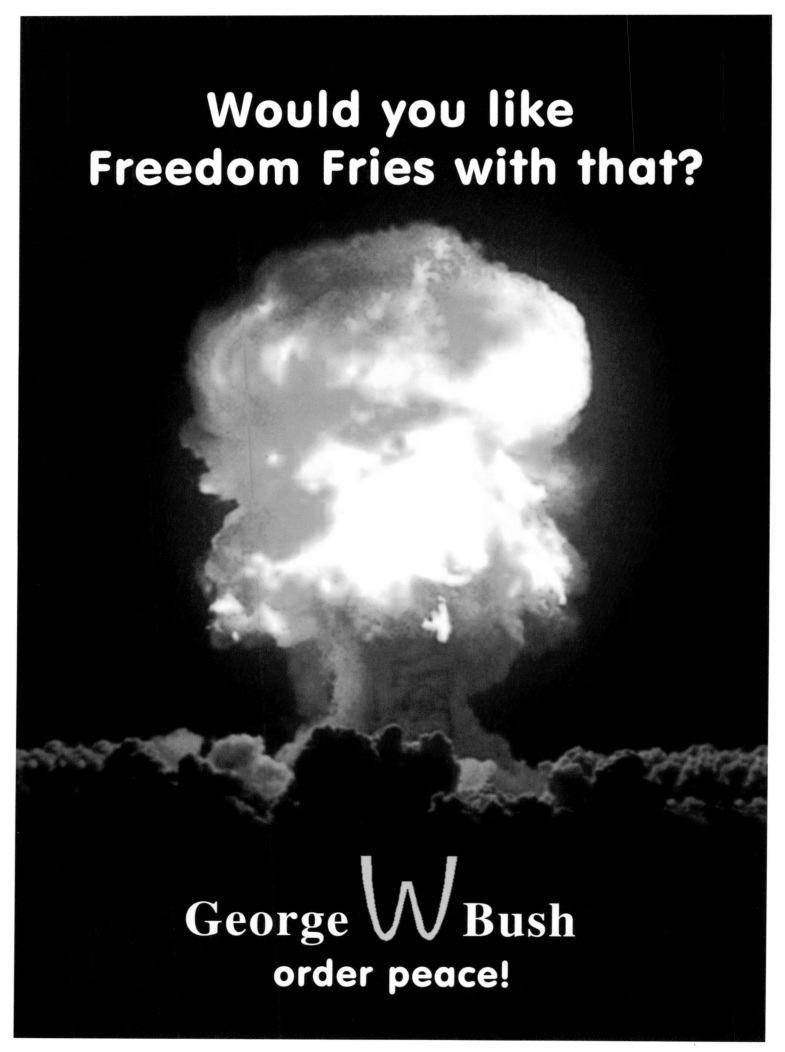

Artist: Deborah Michelle Clague
Title: Freedom Fries
Country: Canada

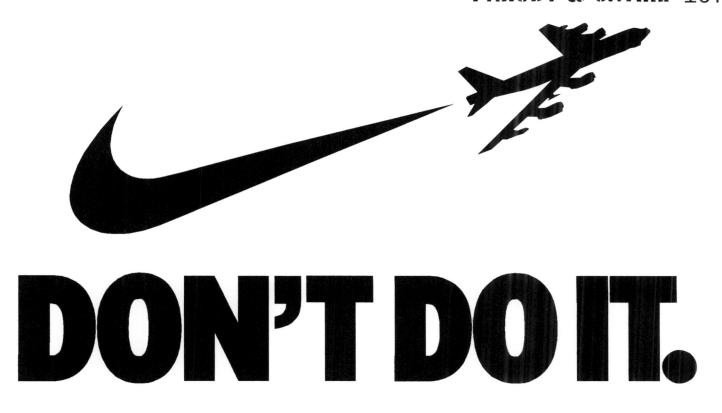

DON'T DO IT.

STOP THE WAR

Artist: Ignacio García and Juan Carlos Cammaert
Title: Don't do it
Web Site: www.cammaert.com
Country: Columbia/Spain

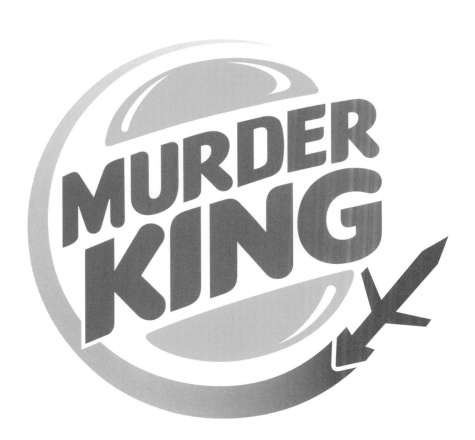

It just tastes bitter.

Artist: Stew Graham
Title: Murder King
Organization: Logoloco.net
Web Site: www.logoloco.net
Country: United Kingdom

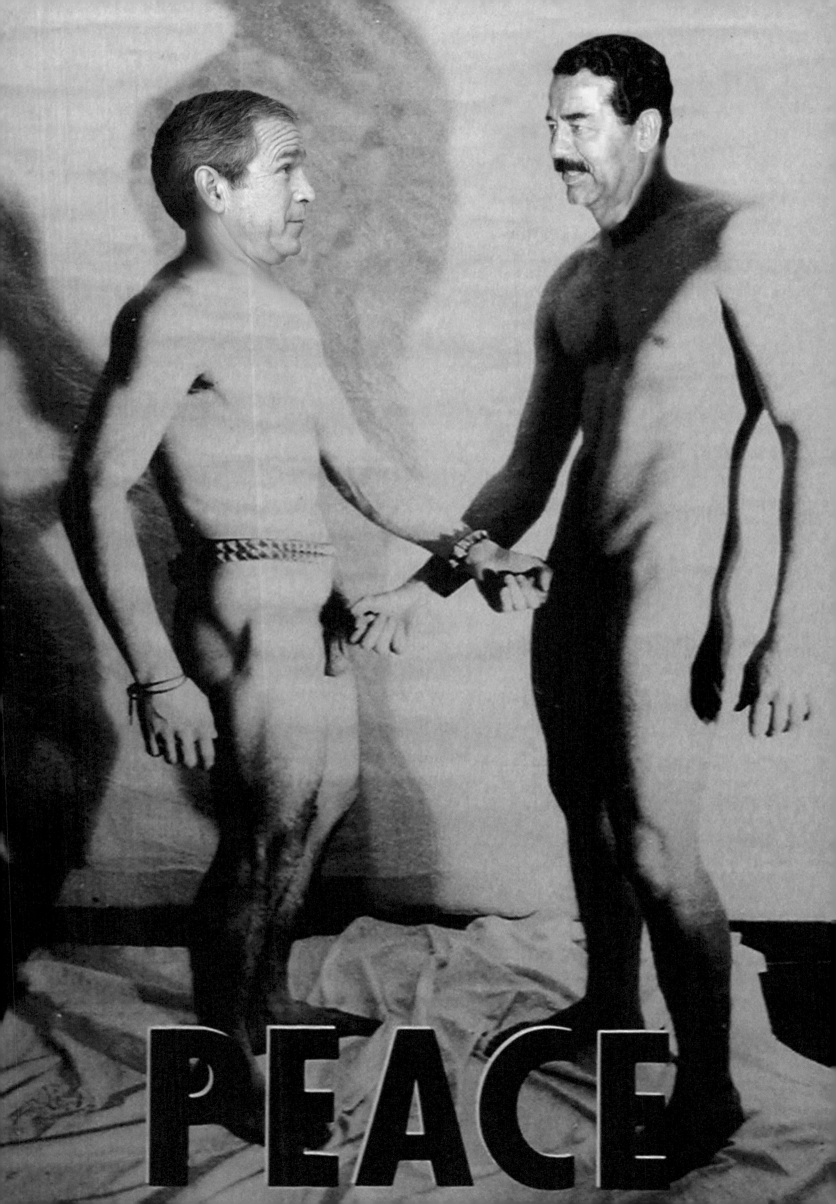

El orgullo masculino de George W.

Artist: Barbara Steinitz
Title: El orgullo masculino de George W.
Country: Germany

Artist: Axel Feuerberg
Title: Make Love Not War
Web Site: www.nofurtherwar.de
Country: Germany

Artist: Guillermo Rojo Llerena
Title: Invader
Country: Spain

Artist: Giovanni Ricchi
Title: RisIraq!
Web Site: www.minimalsonic.net
Country: Italy

Artist: Adam Faja
Title: Love You to Death
Organization: Miniature Gigantic
Web Site: www.miniaturegigantic.com
Country: United States of America

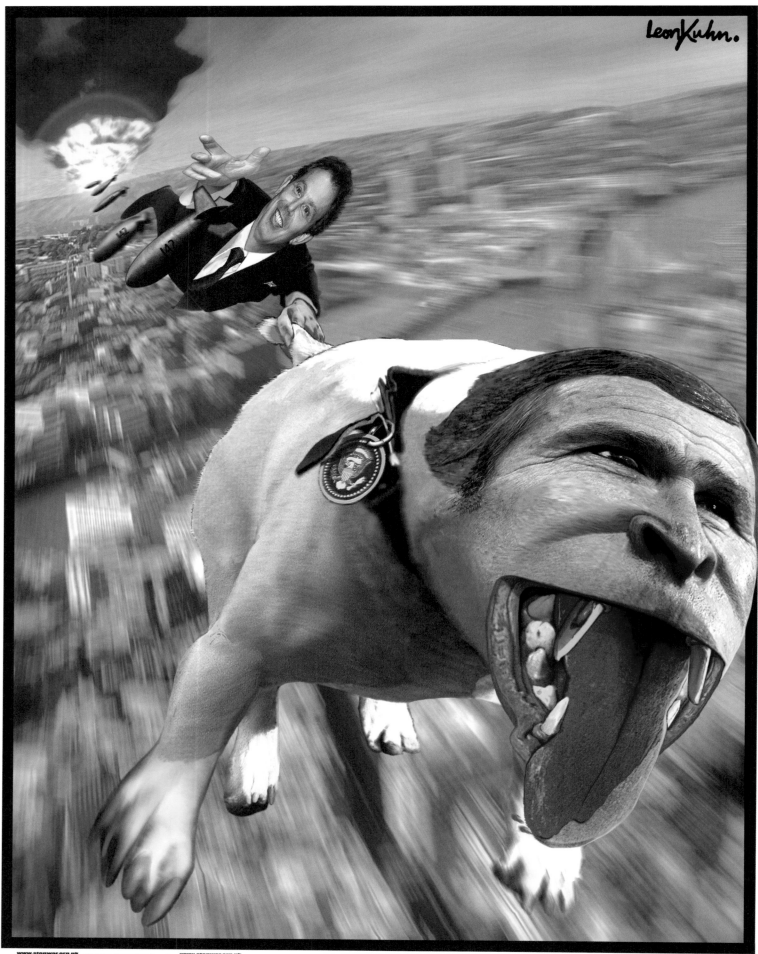

"MAD DOGS AND ENGLISHMEN..."

Artist: Leon Kuhn
Title: Mad Dogs and Englishmen . . .
Organization: The Stop the War Coalition
Web Site: www.stopwar.org.uk
Country: United Kingdom

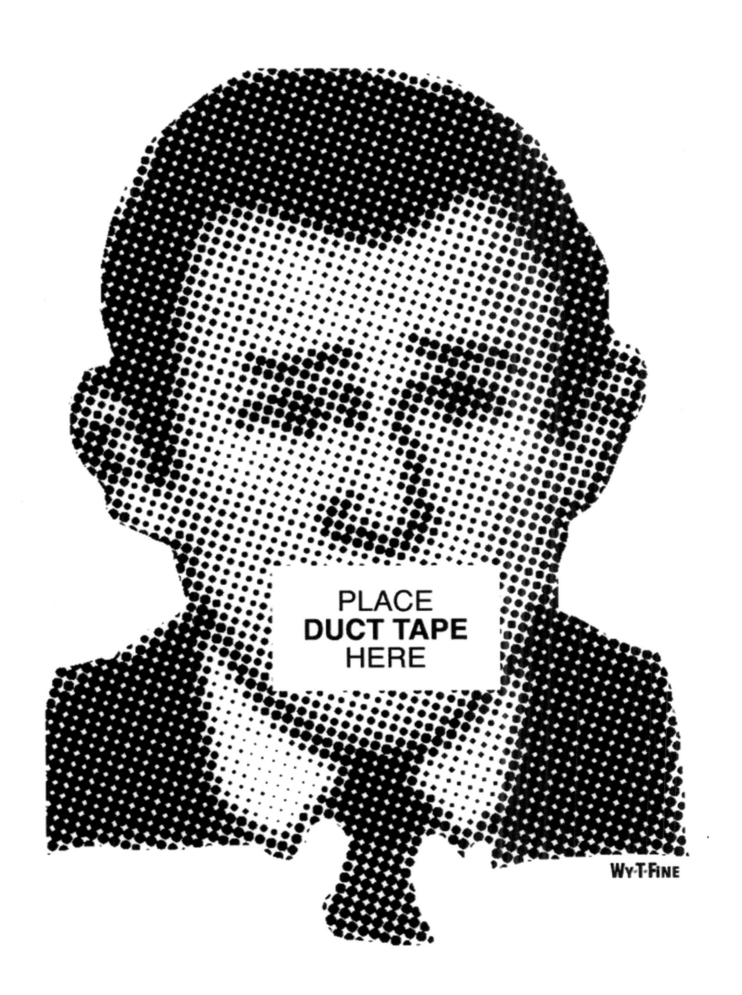

PLACE
DUCT TAPE
HERE

Wy·T·Fine

Artist: Peter Fine (Wy*T*Fine)
Title: Regime Change
Country: United States of America

EMPTY WARHEADS FOUND IN WASHINGTON

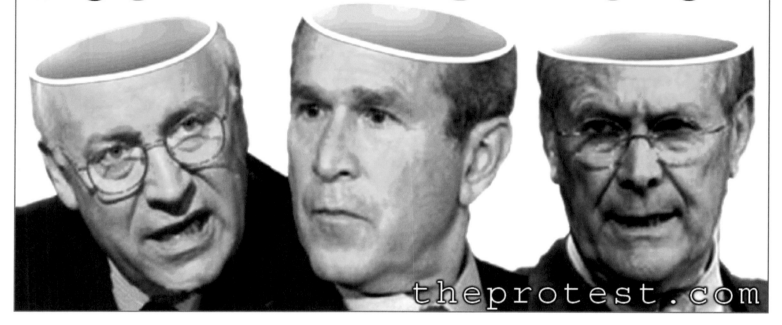

theprotest.com

Artist: John Leach
Title: Empty Warheads
Organization: TheProtest.com
Web Site: www.theprotest.com
Country: United Kingdom

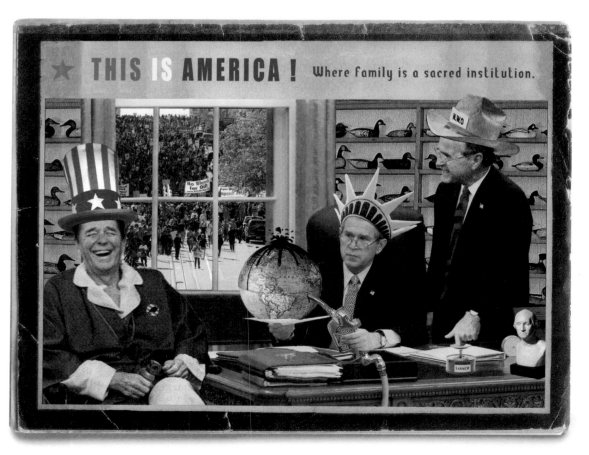

Artist: Amedeo De Palma
Title: THIS IS AMERICA!
Web Site: www.amedeodepalma.com
Country: Canada

FUCK SADDAM

"It is becoming increasingly clear that George Bush [Sr.], operating largely behind the scenes throughout the 1980's, initiated and supported much of the financing, intelligence, and military help that built Saddam's Iraq..."

TED KOPPEL, ABC NEWS "NIGHTLINE," JUNE 9, 1992

AND THE HORSE HE RODE IN ON

www.insanereagan.com

Artist: Jeff Grubler
Title: Fuck Saddam
Organization: The Ronald Reagan Home for the Criminally Insane
Web Site: www.insanereagan.com
Country: United States of America

CULTURA contra la guerra

Artist: Zeb
Title: Puppet Blair
Organization: Wake The World
Web Site: www.waketheworld.com
Country: United Kingdom

Artist: Rafael Arjona
Title: Pinta y Colorea
Web Site: www.webpersonal.net/ilustracion
Country: Spain

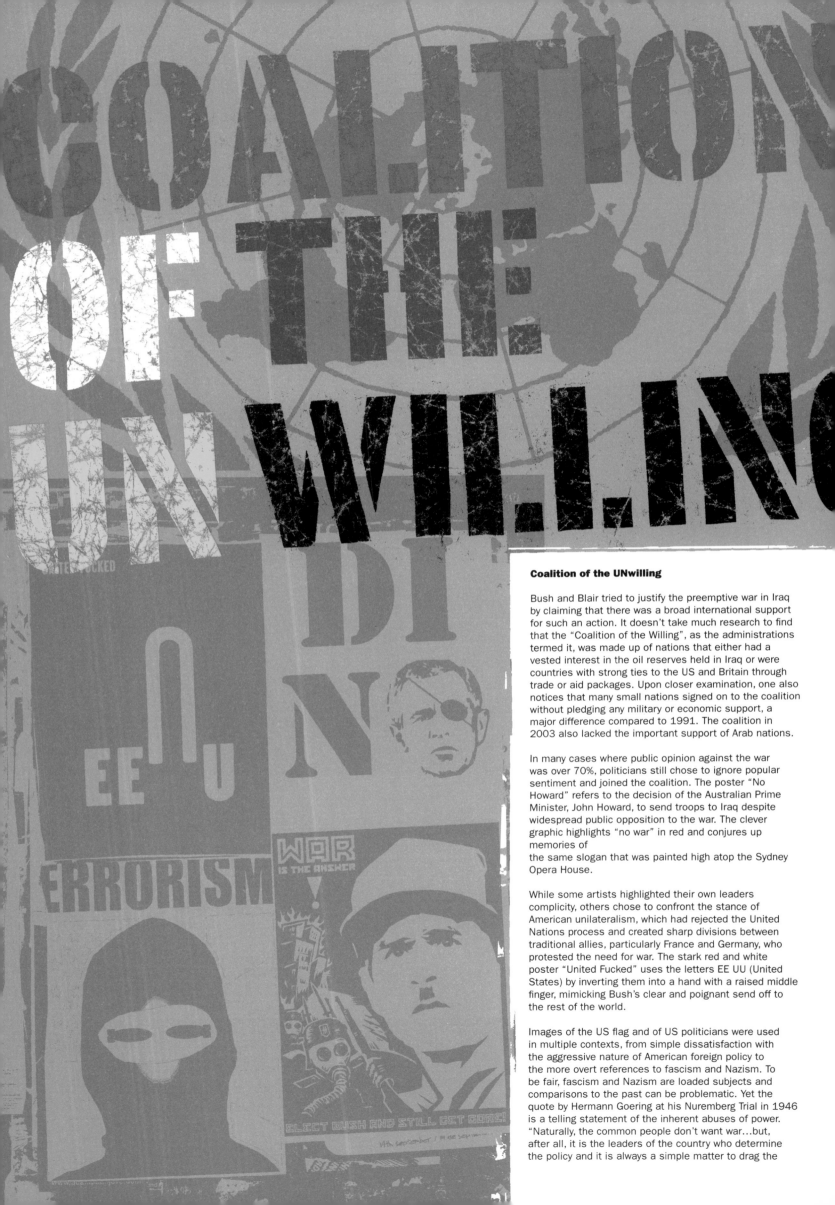

Coalition of the UNwilling

Bush and Blair tried to justify the preemptive war in Iraq by claiming that there was a broad international support for such an action. It doesn't take much research to find that the "Coalition of the Willing", as the administrations termed it, was made up of nations that either had a vested interest in the oil reserves held in Iraq or were countries with strong ties to the US and Britain through trade or aid packages. Upon closer examination, one also notices that many small nations signed on to the coalition without pledging any military or economic support, a major difference compared to 1991. The coalition in 2003 also lacked the important support of Arab nations.

In many cases where public opinion against the war was over 70%, politicians still chose to ignore popular sentiment and joined the coalition. The poster "No Howard" refers to the decision of the Australian Prime Minister, John Howard, to send troops to Iraq despite widespread public opposition to the war. The clever graphic highlights "no war" in red and conjures up memories of
the same slogan that was painted high atop the Sydney Opera House.

While some artists highlighted their own leaders complicity, others chose to confront the stance of American unilateralism, which had rejected the United Nations process and created sharp divisions between traditional allies, particularly France and Germany, who protested the need for war. The stark red and white poster "United Fucked" uses the letters EE UU (United States) by inverting them into a hand with a raised middle finger, mimicking Bush's clear and poignant send off to the rest of the world.

Images of the US flag and of US politicians were used in multiple contexts, from simple dissatisfaction with the aggressive nature of American foreign policy to the more overt references to fascism and Nazism. To be fair, fascism and Nazism are loaded subjects and comparisons to the past can be problematic. Yet the quote by Hermann Goering at his Nuremberg Trial in 1946 is a telling statement of the inherent abuses of power. "Naturally, the common people don't want war…but, after all, it is the leaders of the country who determine the policy and it is always a simple matter to drag the

people along, whether it is a democracy or a fascist dictatorship or a Parliament or a Communist dictatorship… Voice or no voice, the people can always be brought into the bidding of the leaders. That is easy. All you have to do is tell them they are being attacked, and denounce the peacemakers for lack of patriotism and exposing the country to danger. It works the same in any country".[1]

The fact that so many people referred to American politicians in the same breath as the Third Reich speaks of the global anti-American sentiment that has risen drastically since the bombing of Afghanistan in 2001. American citizens, often isolated and uninformed to global public opinion, would be shocked to learn just how low American prestige has fallen.

With the war in Afghanistan still ongoing in 2003, many people, even before the war in Iraq, saw what they believed to be a pattern emerging from the US: a war without end. Connections were drawn by artists between American colonial history and what many believed was the current advance of the American Empire. The work "Pax Americana" depicts a Native American headdress and an Arab headscarf with blood splattered between the two. This piece seeks to make an unbroken historical link of conquest from the time of America's founding as a sovereign nation.

The individual images in this chapter differ in style and content, but a common sentiment exists. They come from the Coalition of the Unwilling, citizens from around the world who chose peace over preemptive war and unilateralism. They disprove the notion of the "Coalition of the Willing" making it increasingly clear that the public views politicians as those who can be bought and sold, hired accomplices who are beholden to the political game in which they operate rather than their own constituents.

Koalition der UNwilligen

Bush und Blair versuchten den Präemptivkrieg im Irak mit der Behauptung zu rechtfertigen, dass eine solche Aktion breite internationale Unterstützung hätte. Man muss nicht sehr lange nachforschen, um festzustellen, dass die „Koalition der Willigen", wie sie von den Regierungen genannt wurde, aus Ländern bestand, die entweder ein eigenes Interesse an den Ölvorkommen im Irak hatten oder durch Handelsbeziehungen oder Entwicklungshilfen stark von den USA und Großbritannien abhängig waren. Bei näherer Betrachtung wird man außerdem feststellen, dass viele kleine Länder sich der „Koalition der Willigen" anschlossen, ohne militärische oder finanzielle Unterstützung zuzusagen – ein großer Unterschied zu 1991. Der Koalition von 2003 fehlte auch die wichtige Unterstützung der arabischen Länder.

In vielen Fällen, wo die öffentliche Meinung zu mehr als 70% gegen den Krieg war, entschlossen sich Politiker dennoch, die Meinung des Volkes zu ignorieren und sich der Koalition anzuschließen. Das Plakat „No Howard" („Nein zu Howard") richtet sich gegen die Entscheidung des australischen Premierministers John Howard, trotz der weit verbreiteten Opposition der Bevölkerung gegen den Krieg, Soldaten in den Irak zu schicken. Die geschickt gemachte Grafik betont „no war" („Nein zum Krieg") in Rot und erinnert damit an den gleich lautenden Slogan, der hoch oben an das Dach des berühmten Opernhauses von Sydney gepinselt worden war.

Einige Künstler wiesen auf die Mittäterschaft der Regierungschefs ihrer Länder hin, andere nahmen sich den amerikanischen Unilateralismus vor, der die Einbeziehung der Vereinten Nationen abgelehnt und für große Uneinigkeit mit traditionellen Verbündeten gesorgt hatte, insbesondere Frankreich und Deutschland, die beide den Krieg ablehnten. Das auffällige rot-weiße Motiv „United Fucked" („Gemeinsam sind wir am Arsch") verwendet die Buchstaben EE UU (die im spanischen Sprachgebrauch verwendete Abkürzung für die USA) und macht daraus eine Hand mit

erhobenem Mittelfinger als Symbol für Bushs klare und deutliche Absage an den Rest der Welt.

Bilder der amerikanischen Flagge und von amerikanischen Politikern wurden für viele verschiedene Aussagen verwendet, von einfacher Unzufriedenheit mit der aggressiven amerikanischen Außenpolitik bis hin zu deutlicheren Anspielungen auf Faschismus und Nationalsozialismus. In aller Fairness muss allerdings gesagt werden, dass Faschismus und Nationalsozialismus emotional besetzte Themen und Vergleiche mit der Vergangenheit problematisch sind. Dennoch ist Hermann Görings Aussage im Nürnberger Prozess von 1946 sehr aufschlussreich, was die der Macht innewohnenden Missbrauchsmöglichkeiten angeht: „Natürlich wollen die einfachen Leute keinen Krieg … aber schließlich sind es die Führer eines Landes, die die Politik bestimmen, und es ist immer einfach, die Menschen mitzuziehen, ob es sich nun um eine Demokratie, eine faschistische Diktatur, ein Parlament oder eine kommunistische Diktatur handelt … Stimme oder nicht, die Menschen können immer dazu gebracht werden, den Führern zu folgen. Das ist einfach. Dazu braucht man den Menschen nur zu erzählen, sie würden angegriffen, und die Pazifisten zu beschuldigen, dass es ihnen an Patriotismus mangele und sie das Land in Gefahr brächten. Das funktioniert in allen Ländern gleich."[1]

Dass so viele die amerikanischen Politiker auf eine Stufe mit denen des Dritten Reiches gestellt haben, zeugt von einem globalen antiamerikanischen Gefühl, das seit der Bombardierung von Afghanistan 2001 sehr viel stärker geworden ist. Amerikanische Bürger, die häufig von Informationen über die Ansichten im Rest der Welt abgeschnitten sind, wären entsetzt zu erfahren, wie sehr das Ansehen Amerikas gesunken ist.

Angesichts des auch 2003 noch andauernden Krieges in Afghanistan meinten viele Menschen auch vor dem Krieg im Irak ein von den USA ausgehendes Muster auszumachen: Krieg und kein Ende. Künstler zogen Verbindungen zwischen Amerikas Kolonialgeschichte und dem, nach der Meinung vieler, heutigen Vorrücken des amerikanischen Reiches. Das Motiv „Pax Americana" zeigt einen indianischen Federschmuck und ein arabisches Kopftuch, dazwischen Blutspritzer. Damit soll auf die Kontinuität einer Geschichte der Eroberungen verwiesen werden, beginnend mit der amerikanischen Unabhängigkeit.

Die einzelnen Bilder in diesem Kapitel unterscheiden sich in Stil und Inhalt, aber ihnen liegt eine gemeinsame Auffassung zugrunde. Ihre Urheber gehören der Koalition der Unwilligen an, sind Bürger aus aller Welt, die Frieden einem Präemptivkrieg und Unilateralismus vorziehen. Sie halten nichts von einer „Koalition der Willigen" und machen deutlich, dass die Öffentlichkeit Politiker als käuflich und verkäuflich betrachtet, als angeheuerte Komplizen, die dem politischen Spiel, das sie spielen, verpflichtet sind, anstatt ihren Wählern.

Coalition des opposants

Bush et Blair ont essayé de justifier la guerre préventive en Irak en avançant qu'il y avait un important soutien international pour une telle action. Cela ne requiert pas de longues recherches pour constater que la « Coalition of the Willing » (Coalition des volontaires), comme l'ont surnommée les administrations, était constituée de nations qui avaient des intérêts particuliers pour les réserves de pétrole de l'Irak ou bien étaient des pays ayant des liens forts avec les USA et la Grande Bretagne de par leur commerce ou des paquets d'aide économique. Après un examen plus approfondi, on remarque également que beaucoup de petits pays ont signé pour la coalition sans promettre de l'aide militaire ou du soutien économique – une différence majeure par rapport à 1991. Pour la coalition en 2003, il manquait également l'important soutien des nations arabes. Dans beaucoup de cas où l'opinion publique était

contre la guerre à plus de 70%, les politiques ont néanmoins choisi d'ignorer le sentiment populaire et ont rejoint la coalition. Le poster « No Howard » se réfère à la décision du Premier Ministre australien, John Howard, d'envoyer des soldats en Irak malgré une forte opposition publique à la guerre. Le graphique intelligent fait ressortir en rouge « no war » et évoque le même slogan qui avait été peint tout en haut de l'Opéra de Sydney.

Alors que certains artistes choisissaient de mettre en exergue la complicité de leurs propres leaders, d'autres ont choisi de traiter la position de l'unilatéralisme américain ayant rejeté le processus des Nations Unies et créé des divisions âpres entre les alliés traditionnels, en particulier la France et l'Allemagne qui ont refusé la guerre. Le poster cru rouge et blanc « United Fucked » (Enculés unis) se sert des lettres EE UU (utilisées en espagnol pour désigner les Etats-Unis) en les invertissant dans une main avec le doigt du milieu relevé et en mimant la façon claire et nette de Bush d'envoyer promener le reste du monde.

Des images du drapeau américain et des politiciens américains ont été utilisées dans de multiples contextes, du simple refus de la nature agressive de la politique étrangère américaine aux plus manifestes références au fascisme et au nazisme. Pour être juste, le fascisme et le nazisme représentent des sujets lourds chargés d'histoire et la comparaison avec ce passé peut se révéler problématique. Néanmoins, la déclaration de Hermann Goering lors de son procès à Nuremberg en 1946 est une déclaration révélatrice de l'abus de pouvoir inhérent. « Naturellement, le peuple ne veut pas de guerre… mais, après tout, ce sont les dirigeants du pays qui font la politique et il est facile d'entraîner les gens, que ce soit dans une démocratie, une dictature fasciste, un parlement ou une dictature communiste… Avec une voix ou sans voix, le peuple peut toujours être entraîné à suivre les volontés de ses dirigeants. C'est simple. Tout ce que vous avez à faire c'est de lui raconter qu'il va être attaqué puis de dénoncer les conciliateurs pour manque de patriotisme en disant qu'ils exposent leur pays au danger. Cela fonctionne de la même manière dans tous les pays »[1].

Le fait que tant de personnes aient amalgamé les politiciens américains au Troisième Reich révèle bien le sentiment global d'anti-américanisme qui a grandi considérablement depuis le bombardement de l'Afghanistan en 2001. Les citoyens américains souvent isolés et non informés de l'opinion publique mondiale seraient choqués de voir combien le prestige de l'Amérique a chuté.

La guerre en Afghanistan se poursuivant en 2003, beaucoup de personnes, même avant la guerre en Irak, assistaient à ce qu'elles considéraient comme un modèle venu des Etats-Unis : une guerre sans fin. Des liens ont été tracés par les artistes entre l'histoire coloniale américaine et ce que beaucoup considéraient comme l'avancée actuelle de l'Empire américain.
L'oeuvre « Pax Americana » dépeint la coiffe d'un natif américain et un foulard arabe avec du sang éclaboussé entre les deux. Cette pièce cherche à établir un lien historique ininterrompu de conquêtes depuis le moment où l'Amérique est devenue une nation souveraine.

Les différentes images de ce chapitre diffèrent en style et en contenu, mais un sentiment commun est néanmoins perceptible. Elles proviennent de la Coalition des Opposants, des citoyens du monde entier qui préfèrent la paix à la guerre préventive et à l'unilatéralisme. Elles prouvent la fausseté de la notion de la « Coalition des volontaires » en montrant de plus en plus clairement que le public considère les politiciens comme des personnes que l'on peut acheter et vendre, comme des complices embauchés, redevables au jeu politique et n'agissant plus dans l'intérêt de leurs électeurs.

Notes:
1. Gustave Gilbert, Nuremberg Diary (New York, Farrar, Straus & Co., 1947)

The Mad Hatter was the first to break the silence -
**"We must defy the U.N., to show the world
that the U.N. must not be defied".**

Illustration by John Tenniel

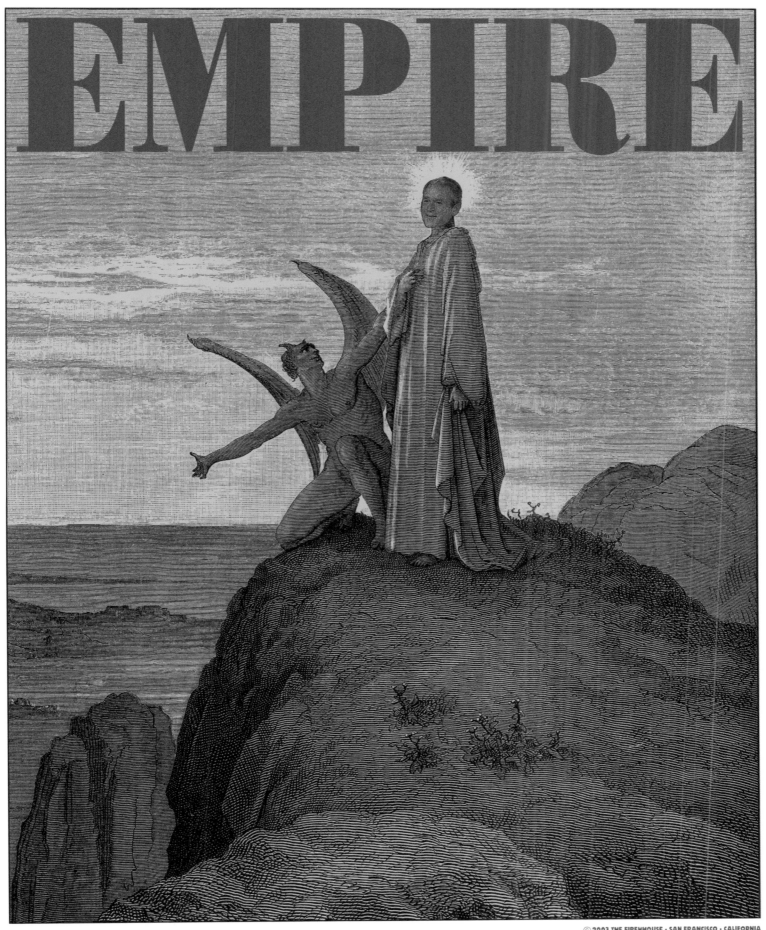

Artist: Chuck Sperry
Title: Empire
Organization: Firehouse Kustom Rockart Company
Web Site: www.firehouseposters.com
Country: United States of America

Artist: Corey Holms
Title: The Mad Hatter Speaks
Web Site: www.coreyholms.com
Country: United States of America

"**The leader of genius**

must have the ability

to make

different opponents

appear

as if they belonged to one category"

-Adolf Hitler

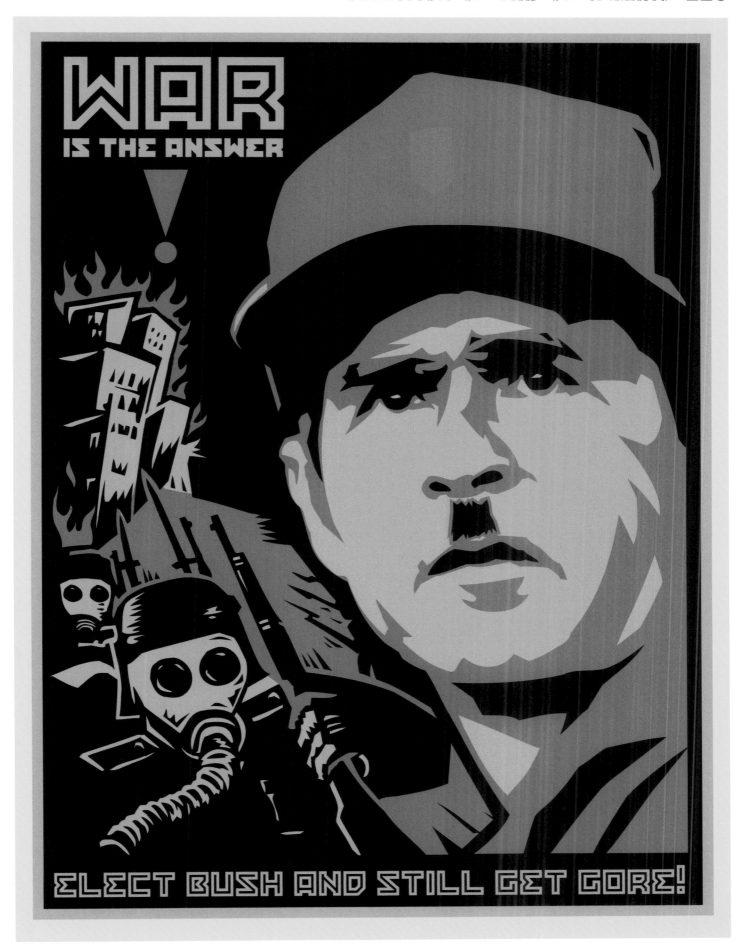

Artist: F. Shepard Fairey
Title: Stop Bush
Organization: OBEY GIANT ART, INC.
Web Site: www.obeygiant.com
Country: United States of America

Artist: Zohrab Gevorkian
Title: Misleading
Organization: Art Center College of Design
Country: United States of America

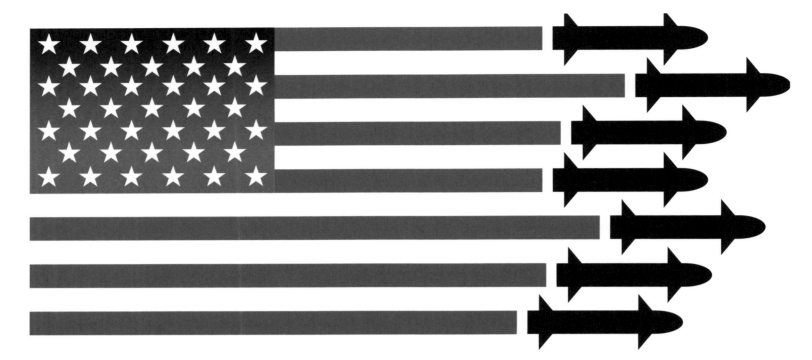

DEMOCRACY
THE FIGHT FOR FREE{OIL}DOM

Artist: Christopher May
Title: Defining Democracy circa 2003
Country: Canada

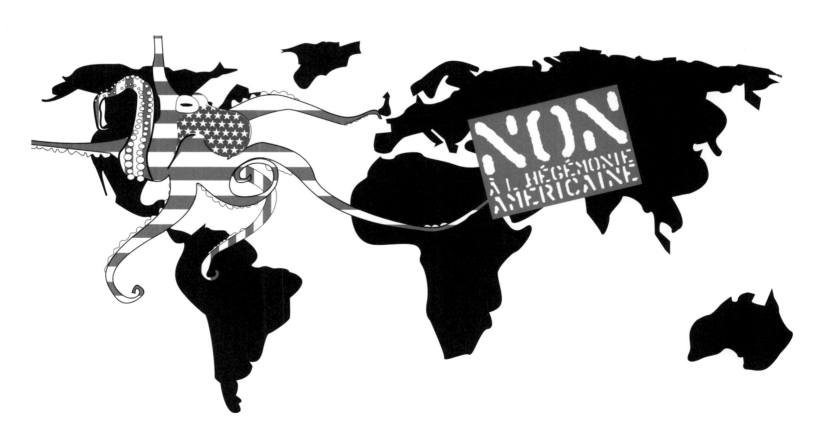

Artist: Sebastien Partika
Title: Non a L'Hegemonie Americaine
Organization: Kreatine
Web Site: www.kreatine.com
Country: France

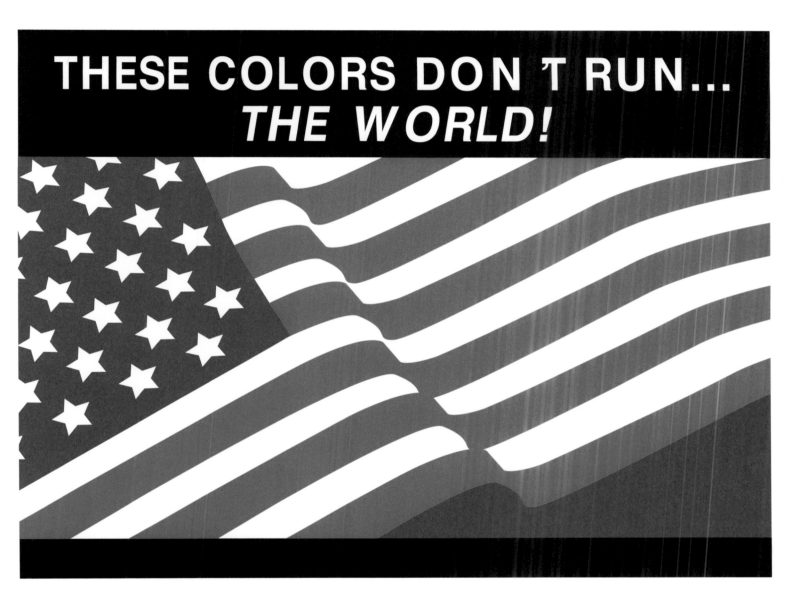

Artist: Design Action Collective
Text: Anonymous S.F. protester
Title: These Colors Don't Run The World
Organization: United for Peace
Web Site: www.designaction.org? / www.unitedforpeace.org
Country: United States of America

BUSH
CHENEY
RUMSFELD

AXIS
★ ★ ★ ★ OF ★ ★ ★ ★
LIES

WHO **DIES** FOR BUSH **LIES** ? whodies.com

Artist: The Committee to Help Unsell the War
Title: Axis of Lies
Organization: The Committee to Help Unsell the War
Web Site: www.whodies.com
Country: United States of America

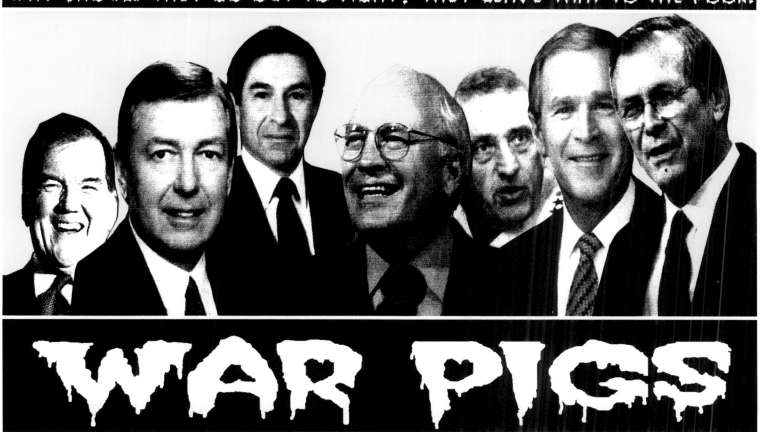

Artist: Brandon Bauer
Title: War Pigs
Country: United States of America

Artist: Anonymous
Title: US
Organization: San Francisco Print Collective
Country: United States of America

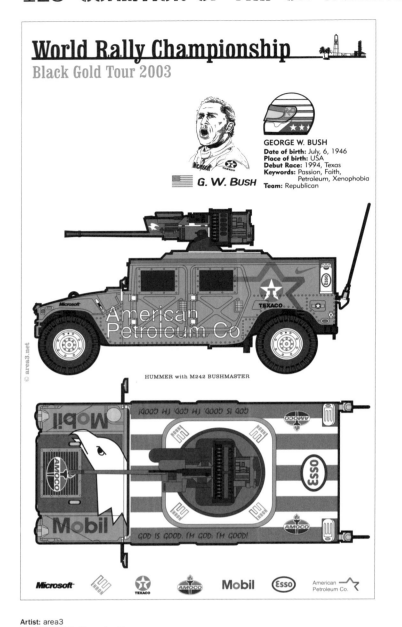

Artist: area3
Title: World Rally Championship
Organization: area3
Web Site: www.area3.net/barcelona
Country: Spain

According to the White House statement on March 20, 2003, more than 44 countries were publicly committed to the Coalition, including:[1]

2003 Coalition (Ground Forces)[2]
Afghanistan
Colombia
Estonia
Italy
Marshall Islands
Poland (200 troops)
Solomon Islands
Angola
Czech Republic
Ethiopia
Japan
Micronesia
Portugal
South Korea
Uzbekistan
Albania
Denmark
Georgia
Kuwait
Mongolia
Romania
Spain (1,300 troops)
Australia (2,000 troops)
Dominican Republic
Honduras
Latvia
Netherlands
Rwanda
Turkey
Azerbaijan
El Salvador
Hungary
Lithuania
Nicaragua
Singapore
Uganda
Bulgaria
Eritrea
Iceland
Macedonia
Philippines
Slovakia
United Kingdom (45,000 troops)
United States (255,000 troops)

1991 Coalition (Ground Forces)[3]
Afghanistan (300 troops)
Argentina (100 troops)
Australia
Bahrain (3,500 troops)
Bangladesh (6,000 troops)
Britain (35,000 troops)
Canada
Czechoslovakia (520 troops)
Denmark
Egypt (40,000 troops)
France (17,000 troops)
Germany
Greece
Hungary
Honduras (200 troops)
Italy
Kuwait (7,000 troops)
Morocco (1,700 troops)
Netherlands
Niger (500 troops)
Norway
Oman (2,500 troops)
Pakistan (10,000 troops)
Poland (210 troops)
Portugal
Qatar (4,000 troops)
Saudi Arabia
(95,000 troops)
Senegal (500 troops)
Spain
Syria (25,000 troops)
Turkey (10,000 troops)
United Arab Emirates (4,000 troops)
United States (540,000 troops)

Laut einer Aussage des Weißen Hauses vom 20. März 2003 gehörten mehr als 44 Länder offiziell der Koalition an, darunter folgende:[1]

2003: Koalition (Bodentruppen)[2]
Afghanistan
Kolumbien
Estland
Italien
Marshallinseln
Polen (200 Soldaten)
Salomonen
Angola
Tschechoslowakei
Äthiopien
Japan
Mikronesien
Portugal
Südkorea
Usbekistan
Albanien
Dänemark
Georgien
Kuwait
Mongolei
Rumänien
Spanien (1.300 Soldaten)
Australien (2.000 Soldaten)
Dominikanische Republik
Honduras
Lettland
Niederlande
Ruanda
Türkei
Aserbaidschan
El Salvador
Ungarn
Litauen
Nicaragua
Singapur
Uganda
Bulgarien
Eritrea
Island
Mazedonien
Philippinen
Slowakische Republik
Großbritannien (45.000 Soldaten)
Vereinigte Staaten von Amerika (255.000 Soldaten)

1991: Koalition (Bodentruppen)[3]
Afghanistan (300 Soldaten)
Argentinien (100 Soldaten)
Australien
Bahrain (3.500 Soldaten)
Bangladesch (6.000 Soldaten)
Großbritannien (35.000 Soldaten)
Kanada
Tschechische Republik (520 Soldaten)
Dänemark
Ägypten (40.000 Soldaten)
Frankreich (17.000 Soldaten)

THE AXIS OF EVIL!

DIE ACHSE DES BÖSEN!

YOU'RE EITHER WITH US OR AGAINST US

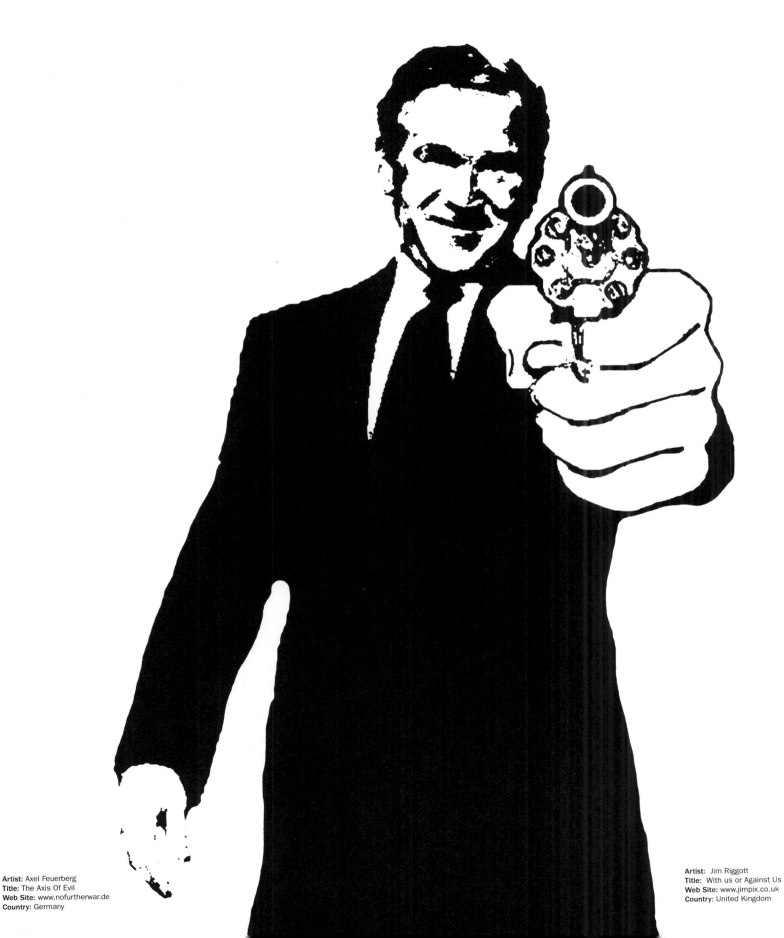

Artist: Axel Feuerberg
Title: The Axis Of Evil
Web Site: www.nofurtherwar.de
Country: Germany

Artist: Jim Riggott
Title: With us or Against Us
Web Site: www.jimpix.co.uk
Country: United Kingdom

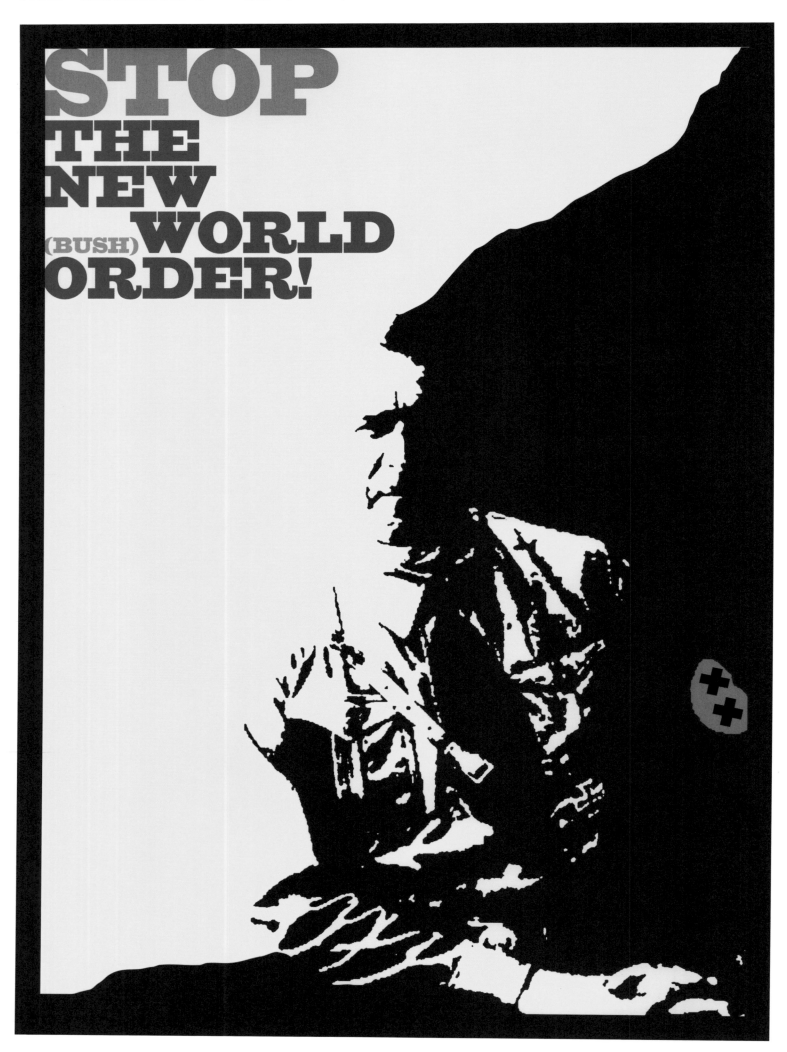

Artist: Albert Ruiz Villar
Title: Bush World Order
Web Site: www.albertruiz.net
Country: Spain

DUBYA LEADS US TO VICTORY

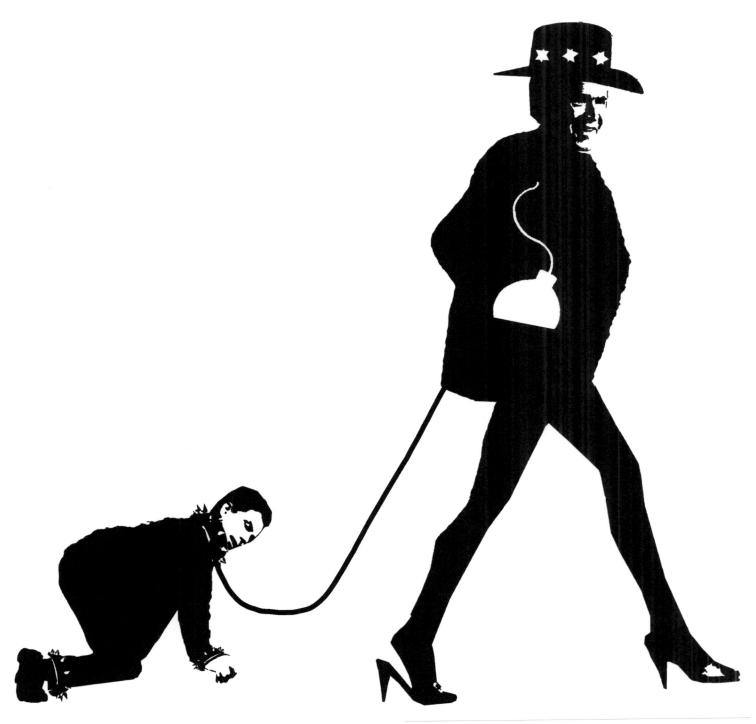

Artist: Simon Stratford
Title: Dubya leads us to victory
Organization: Seventyforty
Web Site: www.seventyforty.co.uk
Country: United Kingdom

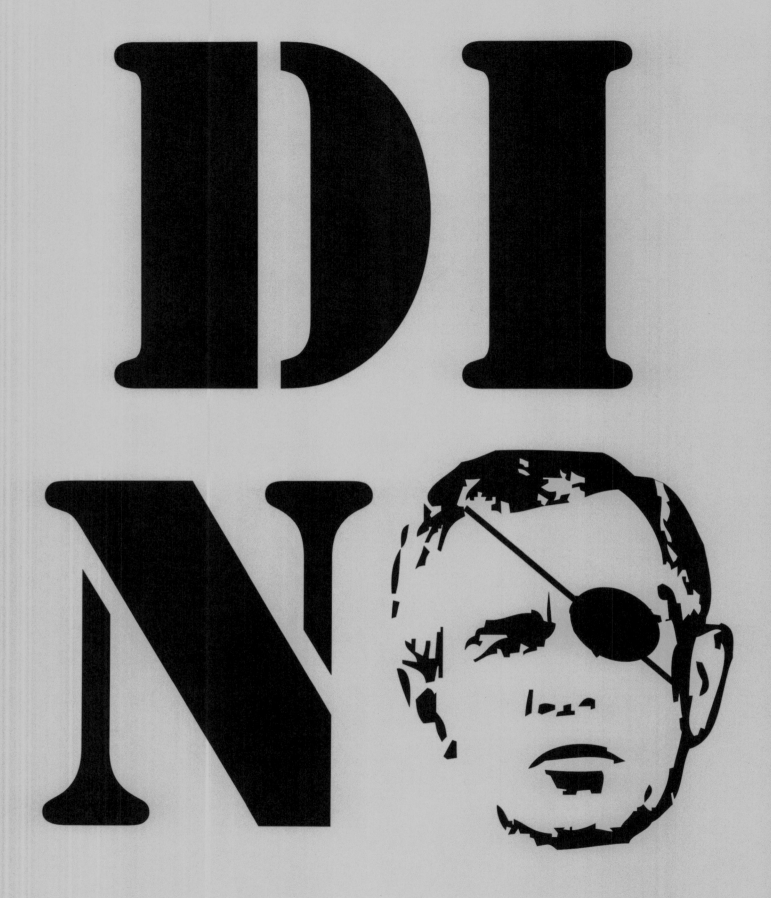

DINO

A LA PIRATERIA

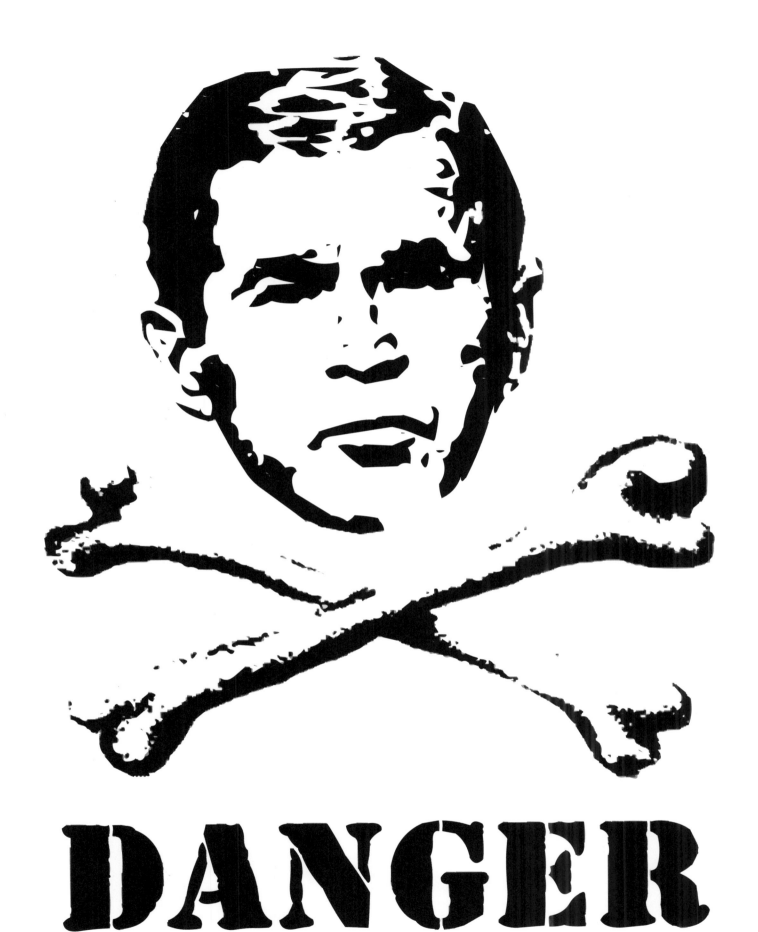

Artist: Jim
Title: Bush Danger
Organization: Wake The World
Web Site: www.waketheworld.com
Country: United Kingdom

Artist: Francisco Vargas Zepeda
Title: Piracy
Organization: El Toche, Afiches
Country: Mexico

UNITED FUCKED

EE∩U

UN MUNDO FELIZ / A HAPPY WORLD PRODUCTION

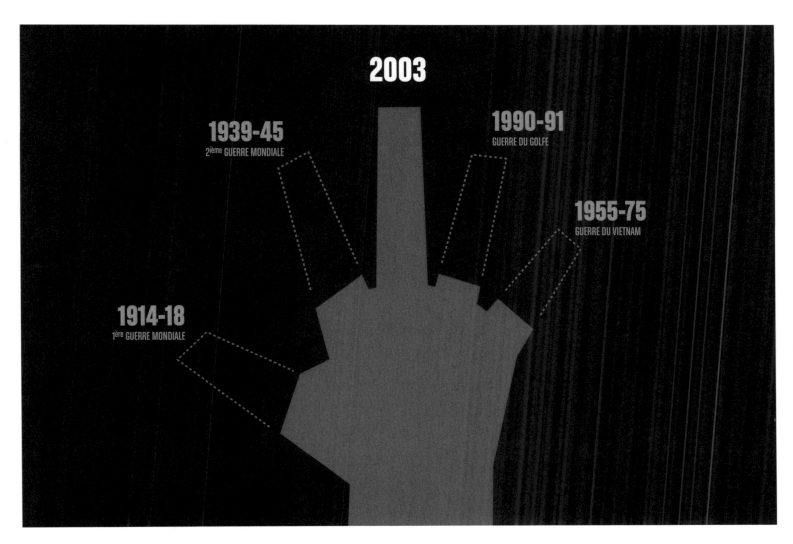

Artist: Stephane Legault, Creative Director: Daniel Fortin + George Fok,
Computer Graphics: André Renaud, Production Manager: Hélène Joanette
Title: Finger
Organization: EPOXY
Web Site: www.epoxy.com
Country: Canada

Artist: Sonia and Gabriel Freeman
Title: UNITED 1
Organization: Un mundo feliz / a happy world production
Web Site: www.unmundofeliz.org
Country: Spain

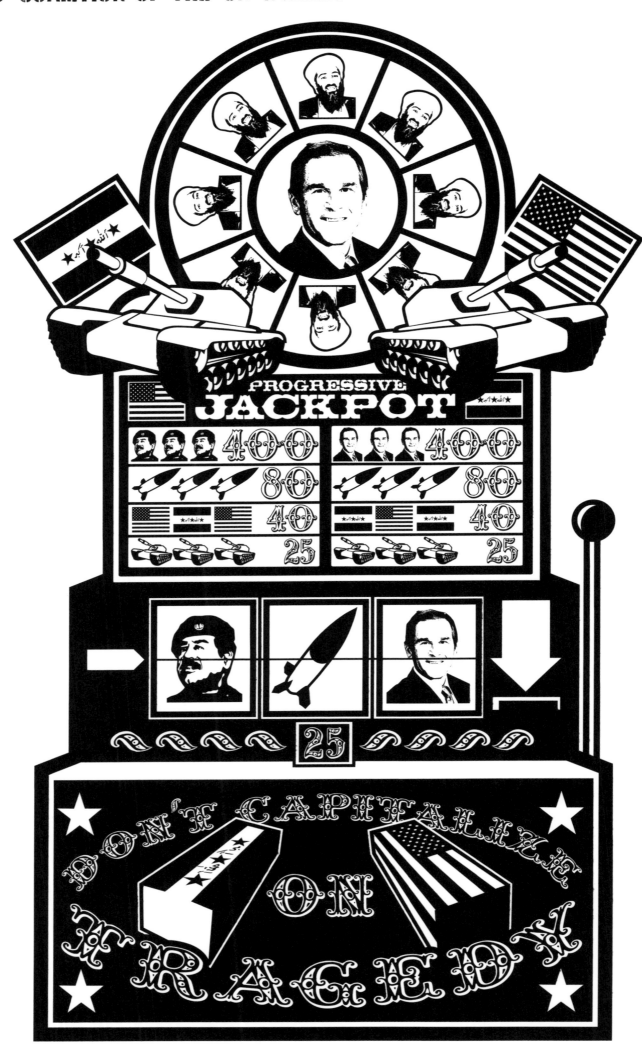

Artist: Darrin Isono
Title: Untitled
Organization: Art Center College of Design
Country: United States of America

U.S. WORLD TOUR

GREECE	1947
KOREA	1950-1953
CUBA	1961
DOMINICAN REPUBLIC	1963/ 1965
VIETNAM	1964-1972
CAMBODIA	1970-1975
IRAN	1979
EL SALVADOR, HONDURAS, NICARAGUA	1980'S
GRENADA	1983
PANAMA	1989
SAUDI ARABIA, IRAQ	1991
SOMALIA	1993
HAITI	1994
YUGOSLAVIA	1999
AFGANISTAN	2001-?

"AXIS OF EVIL" TOUR DATES... TBA

TERRORIZING THE GLOBE, ONE COUNTRY AT A TIME

"I watched them hang my brother. He was two years old. I could see I would die soon, and I thought it would be better to die running, so I ran."
--Chepe
(His brother was among hundreds killed in the 1981 El Mozote massacre in El Salvador. The U.S. funded and trained the Salvadoran army who tortured and executed thousands during the civil war.)

"The bullet hit my son's heart before it made any sound. It wasn't until after he crumpled to the ground that I heard the M16's supersonic bullet."
--Ali
(His son was murdered by an Israeli sniper in the Jenin refugee camp in Palestine. Israel is the second highest recipient of U.S. military aid in the world.)

"It looked like the helicopter was dropping rolls of paper with smoke coming out of them. When we heard the explosion, everything became dark. I tried to start running and my arm wouldn't move. I lost my children and grandchildren in the massacre."
--Margarita
(They were killed in Santo Domingo, Colombia, on December 13, 1998 by a United States-designed AN-M41 fragmentation bomb and fuse.)

Artist: Juan Compean, **Text:** Kari Lydersen
Title: U.S. World Tour
Organization: A Toda Madre Designs
Country: United States of America

OPSPORING VERZOCHT

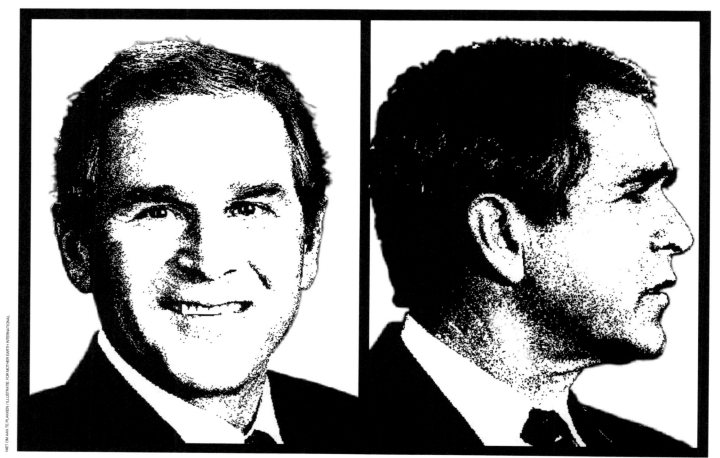

GEORGE W.BUSH

TERRORIST

WWW.INTERNATIONALESOCIALISTEN.ORG

Artist: Bart Griffioen
Bush-illustration used with permission by For Mother Earth International
Title: Opsporing Verzocht
Organization: Internationale Socialisten
Web Site: www.internationalesocialisten.org
Country: The Netherlands

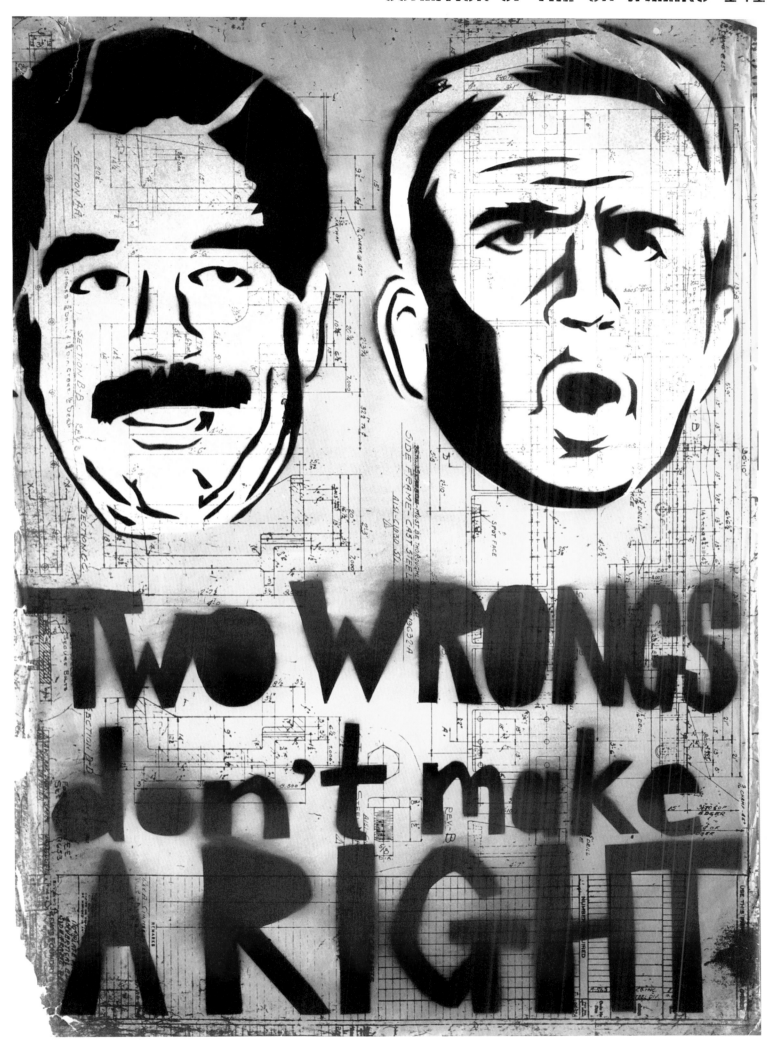

Artist: Eric Ruin
Title: Two Wrongs Don't Make a Right
Country: United States of America

COALITION OF THE UN WILLING

PAX
AMERICANA

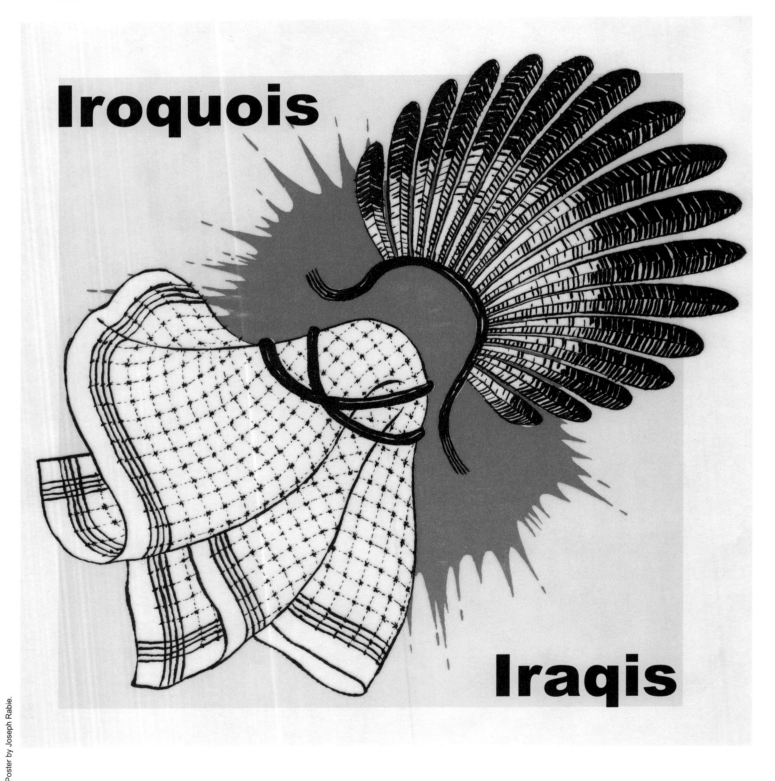

Iroquois

Iraqis

join the world wide online demo!
http://www.overmydeadbody.org

Artist: Joseph Rabie
Title: Pax Americana
Organization: The "Over My Dead Body" Project
Web Site: www.overmydeadbody.org
Country: France

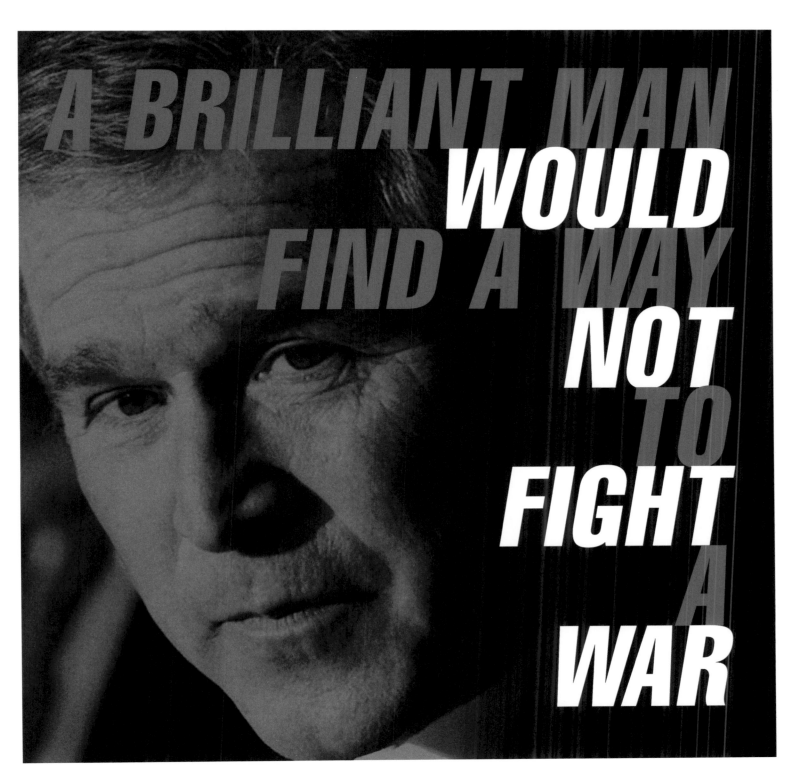

Artist: Yuto Peyan
Title: Brilliant
Country: United States of America

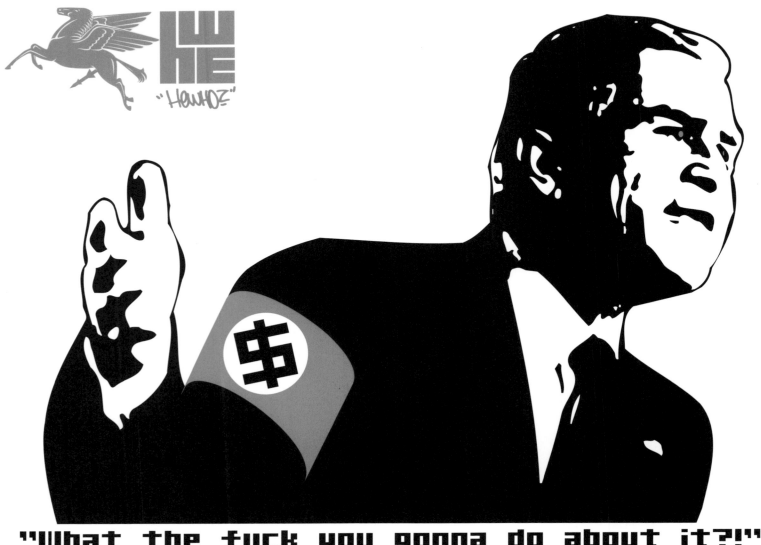

"What the fuck you gonna do about it?!"

Artist: Hugh A. Gran
Title: Corporate Fundamentalist
Organization: HeWho, Konscious
Web Site: www.hughgran.com, www.konscious.com
Country: United States of America

Artist: John Bartholomew
Title: No Howard
Organization: Graphic Innovation
Country: Australia

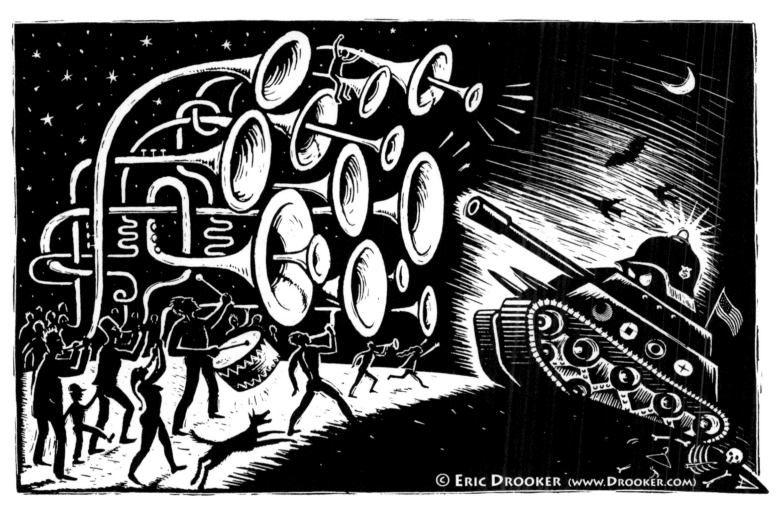

Artist: Eric Drooker
Title: People Vs. Military Industry
Web Site: www.drooker.com
Country: United States of America

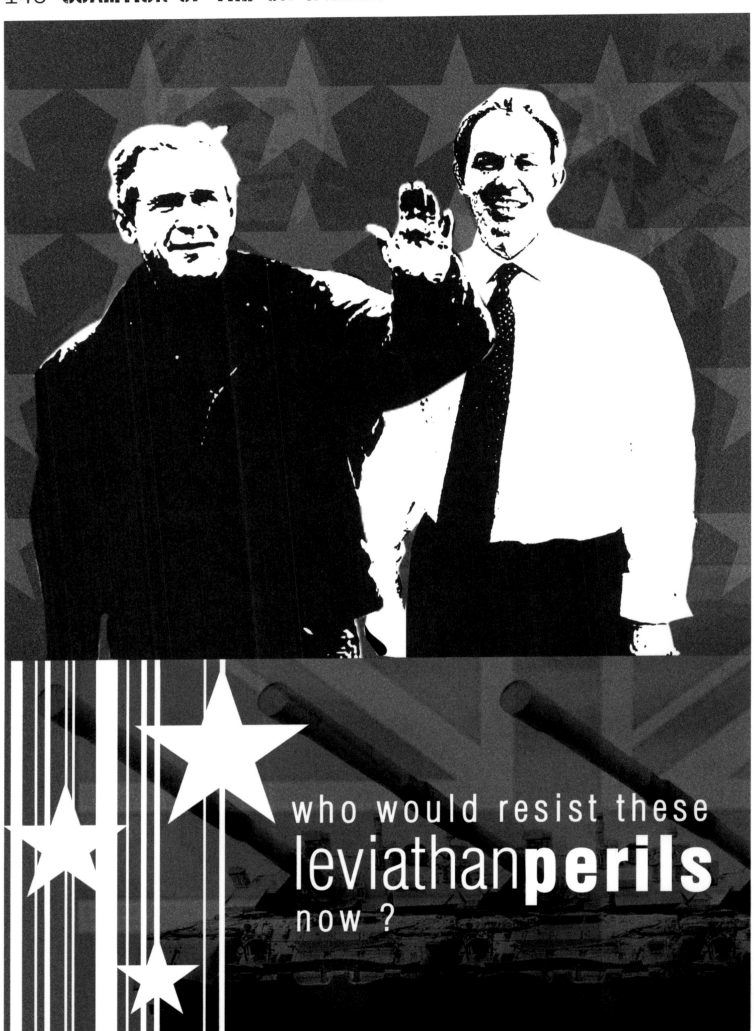

Artist: Adrianus Adityo Nugroho
Title: Leviathan Perils
Organization: Sam Design
Web Site: www.sam-design.com
Country: Indonesia

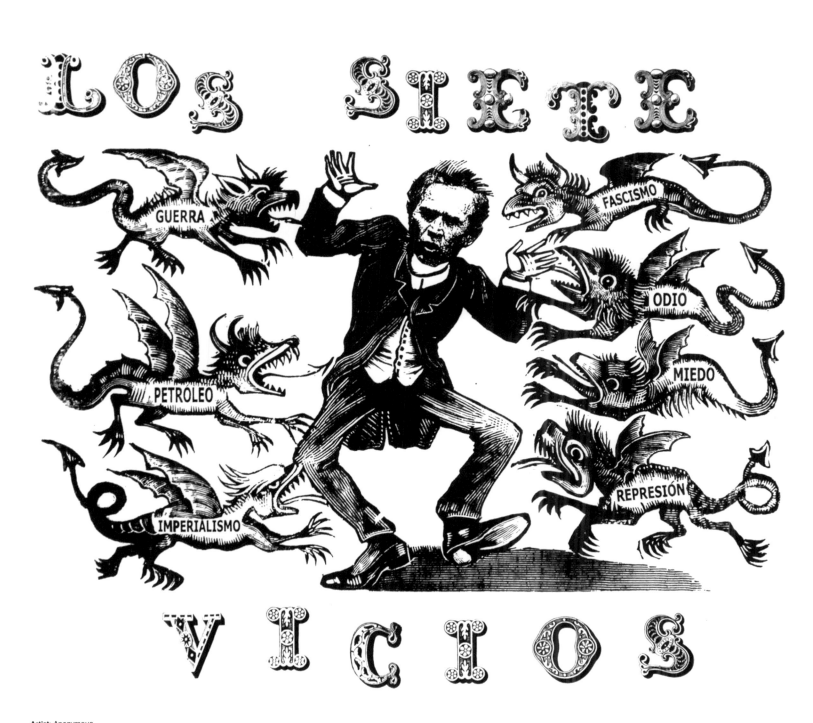

Artist: Anonymous
Title: Los Siete Vicios
Organization: San Francisco Print Collective
Country: United States of America

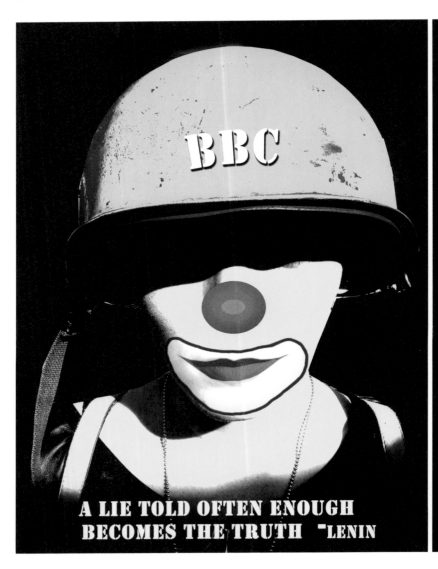

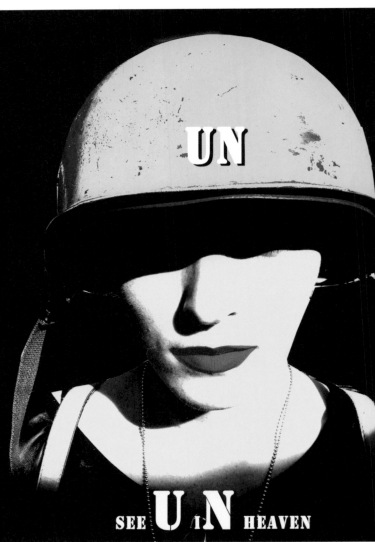

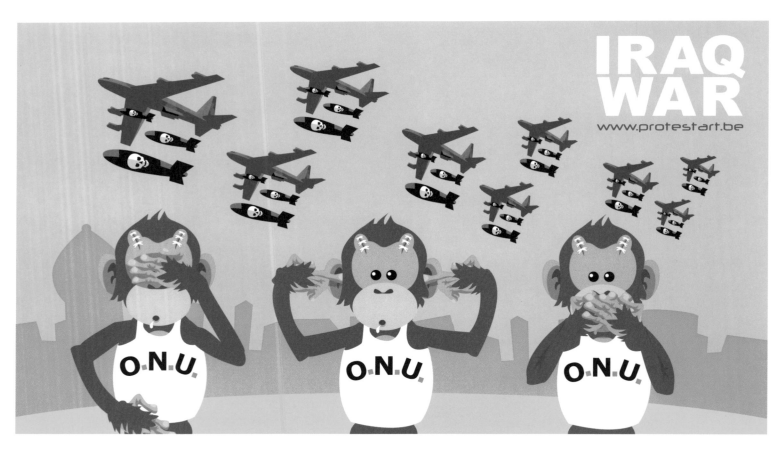

Artist: Repiso Christian
Title: Peace03
Organization: ProtestArt
Web Site: www.protestart.be
Country: Belgium

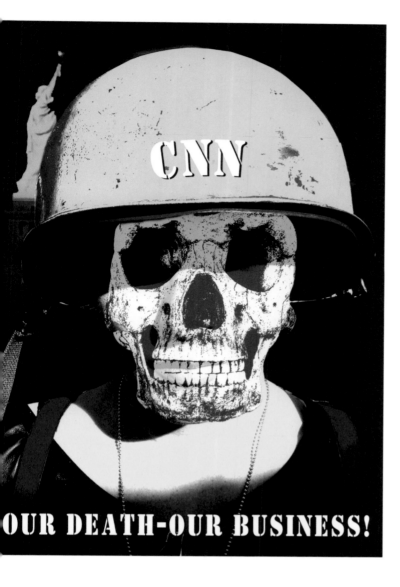

Artist: Thomas Dellacroix & Agnieszka Dellfina
Title: Tic-Tac-Toe
Organization: Dreamteam-Studio Utopia
Web Site: www.studio-utopia.net, www.picassomio.com
Countries: Sweden, United Kingdom, Poland, Spain, France

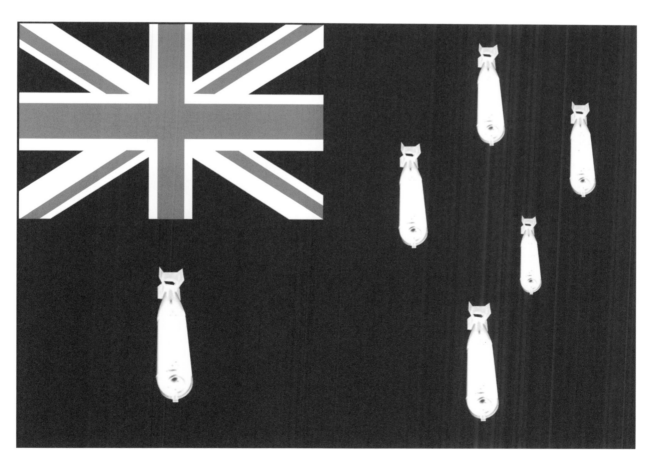

Artist: Sarah Tonin
Title: Australian bombs
Organization: Indymedia
Web Site: www.indymedia.org.au
Country: Australia

ERRORISM

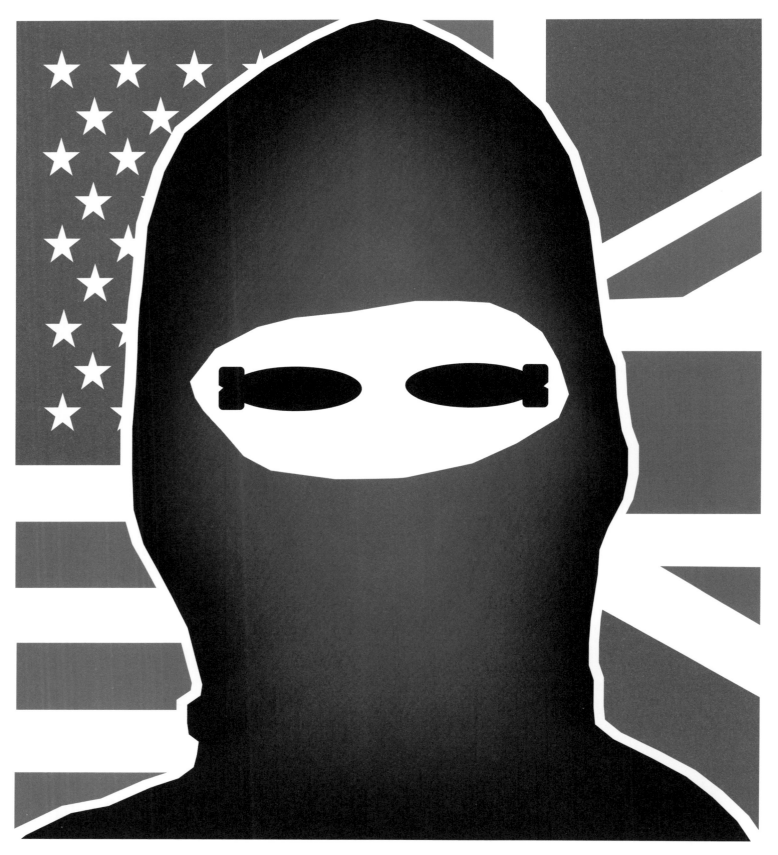

Artist: Ben Perry
Title: Errorism
Organization: Ben Perry
Web Site: www.benperry.co.uk
Country: United Kingdom

Artist: Flying Fortress
Title: Round 2
Organization: Flying Fortress
Web Site: www.flying-fortress.de
Country: Germany

COLLATERAL

DAMAGE

Greed Kills

www.waronpoverty.org

WE ARE NOT
THE ENEMY

GOODBYE
IRAI

NEJ TILL KRIG
MOT IRAK

INGET SVENSKT STÖD
TILL USA:S KRIG

KOALITIONEN FÖR FRED I MELLANÖSTERN
NÄTVERKET STOPPA USA:S KRIG

Collateral Damage

"Collateral damage" is the military term used to describe "unintended casualties of war", whether during the actual fighting or its aftermath. In modern warfare it is not unusual for larger numbers of casualties to be among citizens rather than combatants.[1] The impact of war can be felt for months, years and decades to follow. The catastrophic effects on a civilian population are far reaching, including long lasting health problems due to significant factors such as lack of institutional support, clean water, shortages of medicine and loss of electricity. Bullets made of depleted uranium further poison the environment leading to an escalation in cancer rates. Furthermore, the act of living through a war itself creates a generation plagued by post-traumatic stress syndrome and a variety of psychological conditions.[2] In declassified documents from the US Defense Agency referencing the 1991 Gulf War, it is clearly stated that a deliberate decision was made to target the civilian population by destroying Iraq's electricity-generating capacity along with water storage and treatment facilities.[3] After the pretext of victory was declared by the US, the war continued for the people of Iraq. The UN/US led economic sanctions prohibited thousands of items from being imported to Iraq, including chlorine for water treatment and specific medicines – deemed dual use chemicals. The 12 year long economic sanctions led to the death of 1.25 million Iraqis, half of which were children. When asked on May 12, 1996 during a "60 Minutes" television show by reporter Leslie Stahl, "Is the price worth it?", in reference to the United States governments support of the sanctions, Madeline Albright, then Secretary of State during the Clinton Administration responded, "Yes, I think the price is worth it".[4] The comment was universally condemned and further galvanized a growing movement of community groups from around the world to put pressure on leaders to end the sanctions.

Artists responded to the impact that war wreaks on a civilian population with their own slogans and images. A famous poster created during the Vietnam War by Lorraine Schneider read, "War is Not Healthy for Children and Other Living Things." The images of women and children found in these posters continue that line of thought, creating sympathy and a sense of commonality. One in particular, which features a woman from Afghanistan reads, "We are not the enemy." The simple statement speaks of a shared humanity with all people in the world, a way of breaking down the barriers of nation states, politics and preconceived notions based on stereotypes, and reminds us who the real victims are. As so poignantly stated by Arundhati Roy, "people rarely win wars, governments rarely lose them".[5]

Kollateralschäden

Der vom Militär verwendete Ausdruck „Kollateral-schäden" bezeichnet „die unbeabsichtigte Tötung von Menschen im Krieg", egal ob während der Kampfhandlungen oder danach. In modernen Kriegen gibt es nicht selten unter der Bevölkerung mehr Tote als bei den beteiligten Kämpfern.[1] Die Auswirkungen des Krieges sind noch nach Monaten, Jahren und sogar Jahrzehnten zu spüren. Die katastrophalen Auswirkungen auf die Zivilbevölkerung sind weit reichend und umfassen auch langfristige Gesundheitsprobleme durch so wichtige Faktoren wie mangelnde institutionelle

Unterstützung, Mangel an sauberem Wasser und Medikamenten sowie durch Stromausfälle. Geschosse aus abgereichertem Uran vergiften die Umwelt und sorgen für ein Ansteigen der Rate der Krebserkrankungen. Über all dies hinaus wächst durch das bloße Miterleben eines Krieges eine Generation heran, die unter posttraumatischem Stress-Syndrom und einer Vielzahl psychologischer Störungen leidet.[2] Freigegebenen Geheimdokumenten zum Golfkrieg von 1991 der US Defense Agency, einer Behörde des Verteidigungsministeriums, ist zu entnehmen, dass man bewusst die Entscheidung traf, die Elektrizitätserzeugung des Iraks zu zerstören ebenso wie Anlagen zur Speicherung und Aufbereitung von Wasser, um die Zivilbevölkerung zu treffen.[3] Der Krieg, der mit dem militärischen Sieg der USA scheinbar beendet wurde, ging für die Menschen im Irak weiter. Die von den UN/USA verhängten Wirtschaftssanktionen verboten die Einfuhr von vielen tausend Produkten in den Irak, darunter Chlor zur Wasseraufbereitung und bestimmte Medikamente – hielt man doch die Inhaltsstoffe dieser Chemikalien nicht nur für zivile, sondern auch für die militärische Nutzung geeignet. Die 12 Jahre andauernden Wirtschaftssanktionen kosteten 1,25 Millionen Irakern das Leben, die Hälfte davon waren Kinder. Als Madeline Albright, die damalige Außenministerin der USA in der Regierung Clinton, am 12. Mai 1996 in einer Fernsehsendung in Bezug auf die Unterstützung der Sanktionen durch die US-Regierung gefragt wurde, ob die Sanktionen angesichts dieser Fakten ihren hohen Preis wert seien, antwortete sie, „Ja, ich denke, sie sind ihren Preis wert"[4]. Dieser Kommentar wurde allgemein verurteilt und veranlasste eine wachsende Zahl von Bürgerinitiativen aus aller Welt, verstärkt Druck auf ihre Regierungen auszuüben, um ein Ende der Sanktionen zu erreichen.

Künstler antworteten mit eigenen Slogans und Bildern auf die Auswirkungen, die der Krieg bei der Zivilbevölkerung hinterließ. Auf einem berühmten, während des Vietnamkriegs von Lorraine Schneider gestalteten Plakat ist zu lesen: „War is Not Healthy for Children and Other Living Things" („Krieg ist ungesund für Kinder und andere Lebewesen"). Die Bilder der Frauen und Kinder auf diesen Plakaten setzen den Gedanken fort und erzeugen Mitgefühl und ein Gefühl der Gemeinsamkeit. Dies gilt insbesondere für ein Plakat, auf dem eine afghanische Frau zu sehen ist, das den Text trägt „We are not the enemy" („Wir sind nicht der Feind"). Diese einfache Aussage verweist auf das, was alle Völker dieser Erde teilen: sie gehören der Menschheit an. Aus dieser Perspektive werden die Grenzen, die durch Nationalstaaten, die Politik und auf Stereotypen basierenden Vorurteilen gezogen werden, nebensächlich und es wird deutlich, wer die wirklichen Opfer sind. Arundhati Roy hat dies sehr treffend auf den Punkt gebracht: „Menschen gewinnen selten Kriege, Regierungen verlieren sie selten."[5]

Dommages collatéraux

« Dommages collatéraux » est le terme militaire utilisé pour décrire les « morts de guerre sans intention de la donner », que ce soit pendant les combats ou tout de suite après. Dans les guerres modernes, il n'est pas inhabituel de voir plus de civils que de combattants tués[1]. L'impact de la guerre peut être ressenti pendant des mois, des années et même des dizaines d'années plus tard. Les effets catastrophiques sur les populations

civiles vont très loin, y compris les problèmes de santé à long terme dus à des facteurs significatifs tels le manque de support institutionnel, le manque d'eau propre, de médicaments et d'électricité. De plus, les balles fabriquées à base d'uranium appauvri empoisonnent l'environnement, ce qui a provoqué une augmentation des taux de cancer. Par ailleurs, le fait même de vivre une guerre engendre une génération frappée par le syndrome du stress post-traumatique de la guerre, souffrant de troubles psychologiques divers[2].

Dans des documents déclassés en provenance de l'Agence de Défense Américaine et ayant trait à la Guerre du Golfe de 1991, il est clairement dit que la décision de prendre comme cible la population civile en détruisant les centrales électriques de l'Irak en même temps que les installations de stockage et de traitement d'eau a été prise délibérément[3]. Après que les USA aient proclamé la victoire militaire, la guerre s'est donc poursuivie pour la population irakienne. Les Nations Unies et les USA ont imposé des sanctions économiques interdisant l'importation de milliers de produits en Irak, y compris le chlore pour traiter l'eau et des médicaments particuliers considérés comme produits chimiques à double emploi. Les sanctions économiques qui durèrent 12 ans ont conduit à la mort de 1,25 millions d'Irakiens, dont la moitié était des enfants. Le 12 mai 1996, lors de l'émission télévisée « 60 minutes » présentée par le reporter Leslie Stahl, Madeleine Albright, à l'époque Secrétaire d'Etat sous l'administration Clinton, se vit confrontée à la question « Le prix en vaut-il la peine ? » qui faisait référence au soutien du gouvernement des Etats-Unis en faveur des sanctions. Elle y répondit : « Oui, je pense que le prix en vaut la peine »[4]. Sa réponse a été condamnée mondialement. En réaction, un nombre croissant de groupes communautaires du monde entier ont augmenté leur pression sur les leaders afin de faire cesser les sanctions.

En raison de l'impact que la guerre a sur les populations civiles, les artistes répondent par leurs propres slogans et images. Un poster très connu créé durant la Guerre du Vietnam par Lorraine Schneider dit : « War is Not Healthy for Children and Other Living Things » (La guerre n'est pas saine pour les enfants et les autres choses vivantes). Les images de femmes et d'enfants trouvés sur ces posters suivent cette ligne de pensée en inspirant la sympathie et le sens du collectif. L'une d'elles, tout particulièrement, montre une femme d'Afghanistan et note : « Nous ne sommes pas les ennemis ». Cette simple déclaration exprime une humanité partagée avec tous les peuples du monde, une façon de casser les barrières des états-nation, des politiques et des idées préconçues basées sur des stéréotypes. Elle nous rappelle qui sont les vraies victimes. Arundhati Roy l'a dit de manière très poignante « Les peuples ne gagnent presque jamais la guerre, les gouvernements ne la perdent presque jamais »[5].

Notes:
1. British Medical Association, The Medical Profession and Human Rights: Handbook for a Changing Agenda (London, BMA/Zed Books, 2001)
2. Medact, "Collateral Damage: the Health and Environmental Costs of War on Iraq", www.medact.org, http://www.medact.org/tbx/pages/sub.cfm?id=556 , 25, November 2003
3. Thomas Nagy, "The Secret Sanctions: How the US intentionally destroyed Iraq's Water Supply," The Progressive; September 2001, 23.
4. Rahul Mahajan, "We Think the Price Is Worth It: Media Uncurious About Iraq's Policy's Effect – There or Here" www.fair.org, Extra, November/December, 2001, http://www.fair.org/extra/0111/iraq.html , 25, November, 2003
5. Arundhati Roy, "War is Peace" in The Power of Non-Violence: Writings by Advocates of Peace (Boston, Beacon Press, 2001)

GENOCIDE ≠ JUSTICE

WE ARE NOT THE ENEMY

INCITE! Women of Color Against Violence
www.incite-national.org
P.O. Box 6861 Minneapolis MN 55406

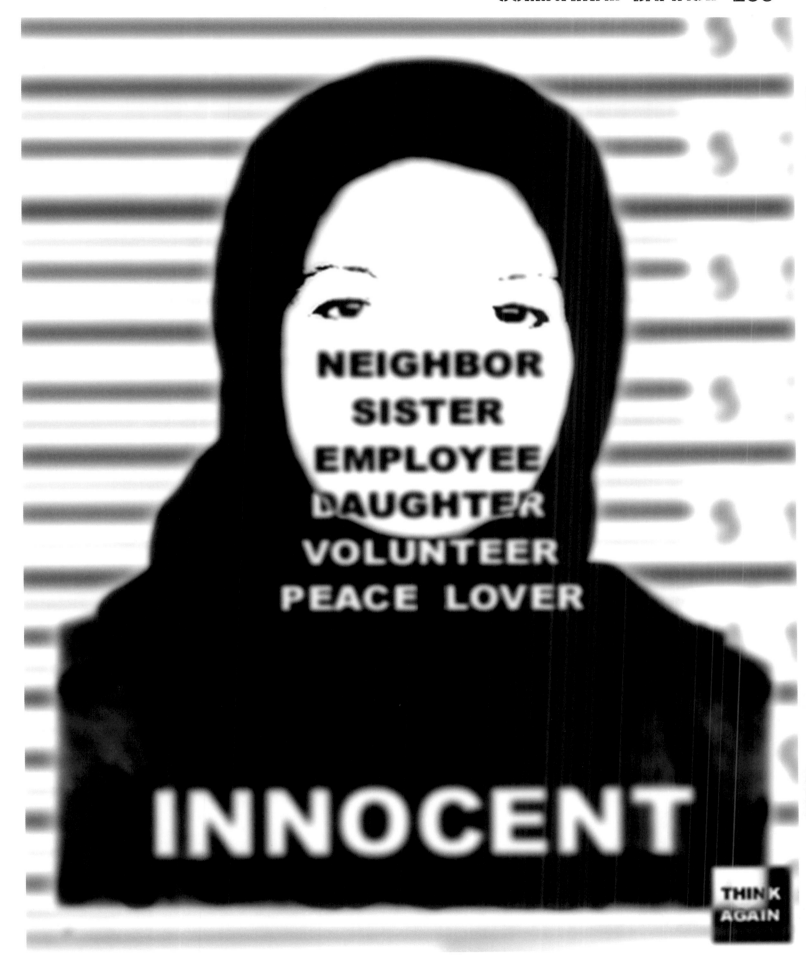

Artist: THINK AGAIN
Title: Sanctioned, Invaded, Occupied
Web Site: www.protestgraphics.org
Country: United States of America

Artist: Favianna Rodriguez
Title: We Are Not the Enemy
Organization: Ten13
Web Site: www.favianna.com
Country: United States of America

Artist: Leon Kuhn
Title: Free-Market Fundamentalism
Organization: Artists Against the War
Web Site: www.leonkuhn.org.uk
Country: United Kingdom

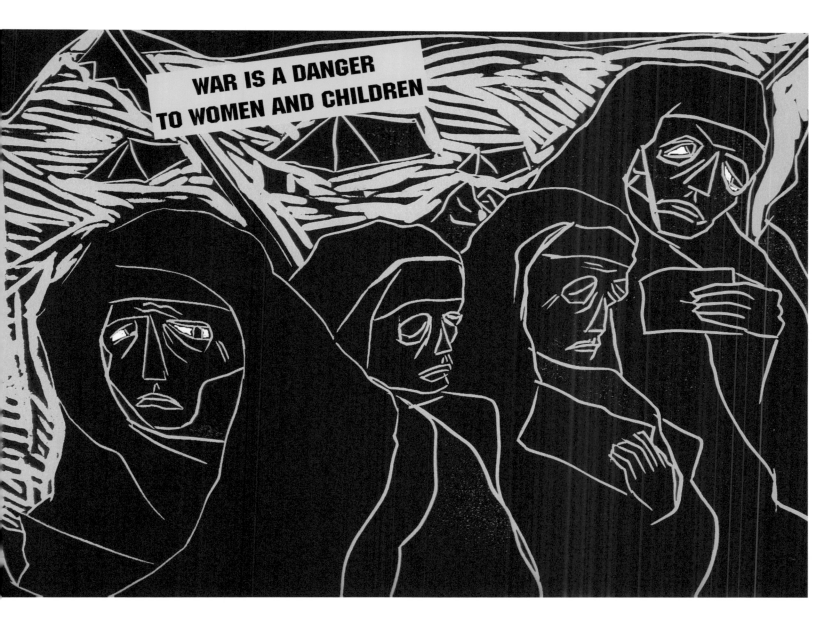

Artist: Lee Gough
Title: War is a Danger to Women and Children
Country: United States of America

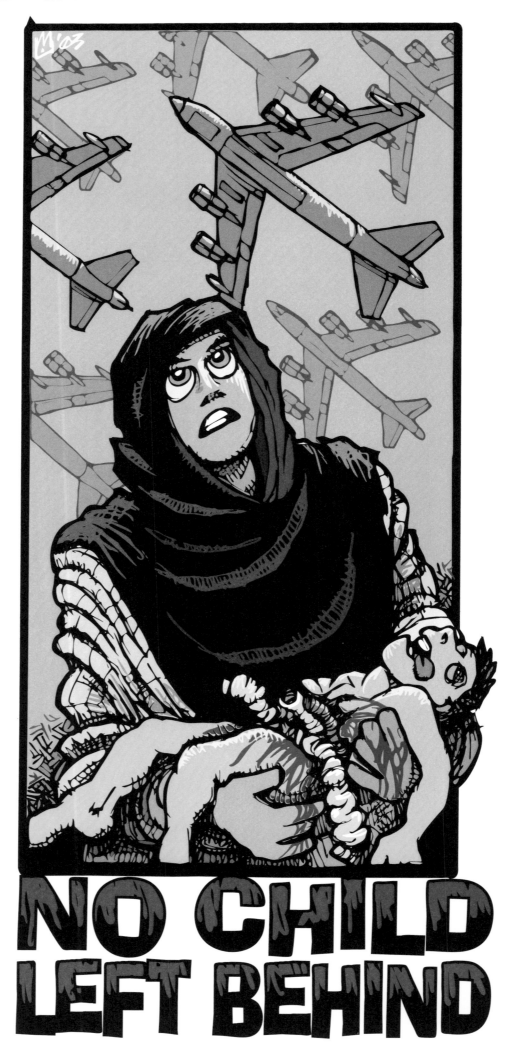

Artist: Mike Flugennock
Title: No Child Left Behind
Organization: DC Independent Media Center
Web Site: www.sinkers.org/posters
Country: United States of America

NOT OUR CHILDREN

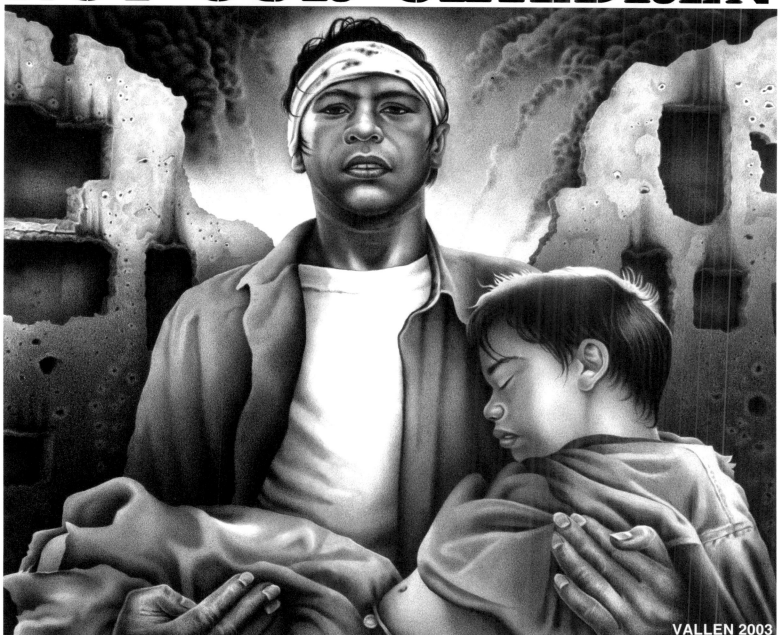

NOT THEIR CHILDREN

www.art-for-a-change.com

Artist: Mark Vallen
Title: Not our Children, Not their Children
Web Site: www.art-for-a-change.com
Country: United States of America

NOT IN OUR NAME!

WOMEN OF COLOR
AGAINST WAR

INCITE! Women of Color Against Violence
www.incite-national.org
P.O.Box 6861 Minneapolis, MN 55406

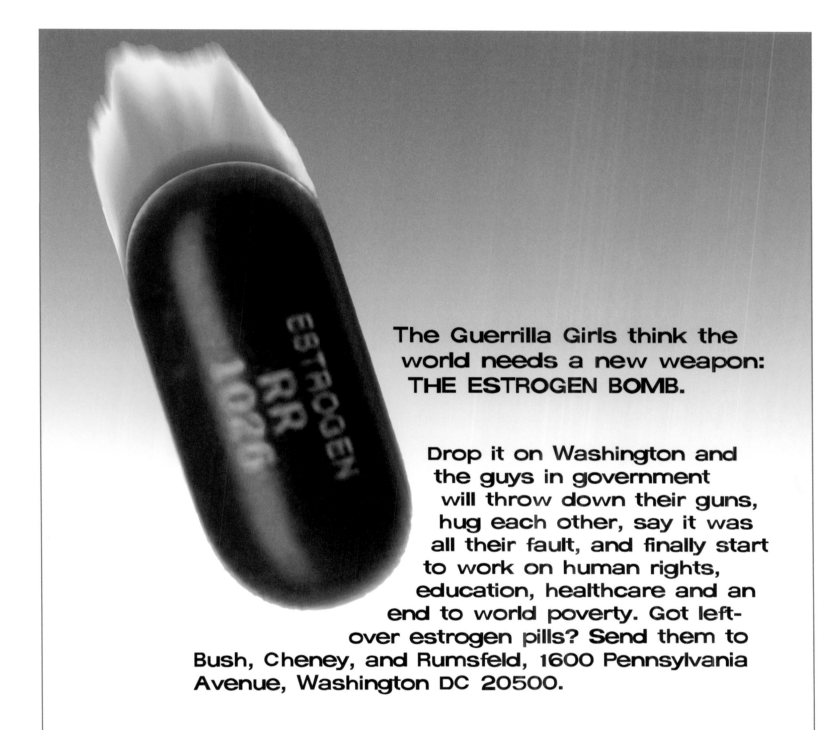

The Guerrilla Girls think the world needs a new weapon: THE ESTROGEN BOMB.

Drop it on Washington and the guys in government will throw down their guns, hug each other, say it was all their fault, and finally start to work on human rights, education, healthcare and an end to world poverty. Got left-over estrogen pills? Send them to Bush, Cheney, and Rumsfeld, 1600 Pennsylvania Avenue, Washington DC 20500.

www.guerrillagirls.com

Artist: Guerrilla Girls
Title: The Estrogen Bomb
Organization: Guerrilla Girls, Inc.
Web Site: www.guerrillagirls.com
Country: United States of America
Copyright ©2003 by Guerrilla Girls, Inc.

Artist: Favianna Rodriguez
Title: Women of Color Against the War
Organization: Ten12
Web Site: www.favianna.com
Country: United States of America

GOODBYE
IRAK

Artist: Sonia and Gabriel Freeman
Title: GOODBYE
Organization: Un mundo feliz/
a happy world production
Web Site: www.unmundofeliz.org
Country: Spain

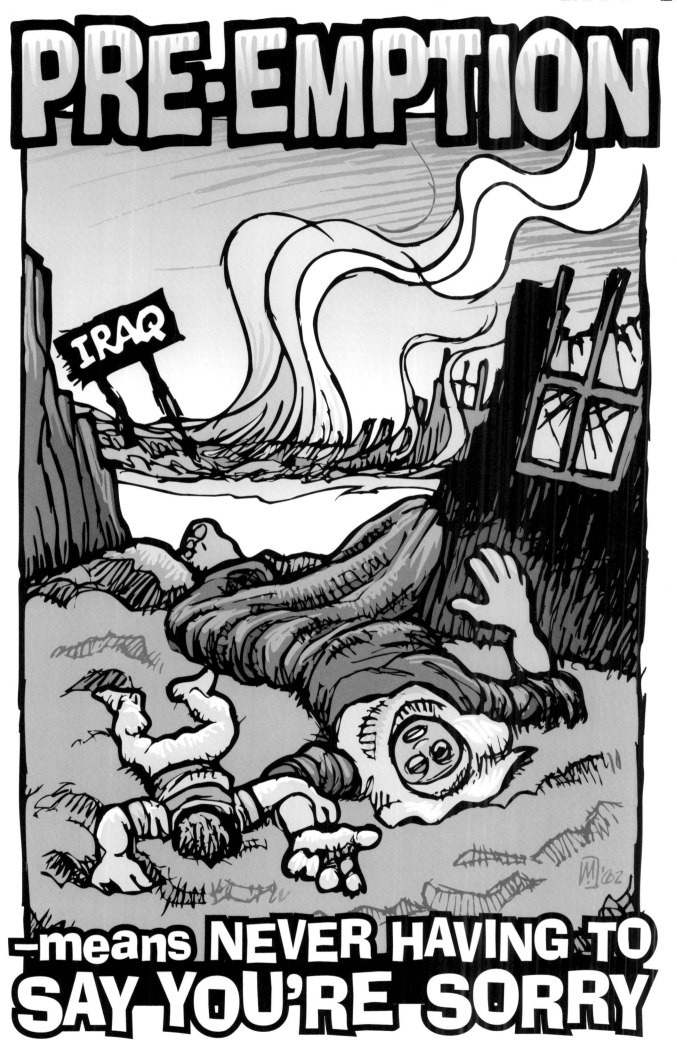

Artist: Mike Flugennock
Title: Pre-Emption Means Never Having To Say You're Sorry
Organization: DC Independent Media Center
Web Site: www.sinkers.org/posters
Country: United States of America

Artist: Philip Golabuk
Title: War is a weapon of mass destruction
Organization: the field center
Web Site: www.fieldcenter.com
Country: United States of America

Artist: Fiona Hamilton
Title: Dream
Web Site: www.fiona-hamilton.co.uk
Country: United Kingdom

2003: (2003 figures updated until November 25, 2003)
Iraqi civilians killed: Minimum:7918, Maximum: 9749 [1]
US soldiers killed: 434[2]
British Soldiers killed: 53 [3]
Italian soldiers killed: 17 [4]
Spanish soldiers killed: 3 [5]
Ukrainian soldiers killed: 3 [6]
Danish soldiers killed: 1 [7]
Polish soldiers killed: 1 [8]
Iraqi soldiers killed: 9,200, plus/minus 1,600 (17.5 percent) [9]

1991-2003: Iraqi civilian deaths due to sanctions: 1.25 million [10]

1991:
Iraqi civilians killed: 2,300 [11]
Coalition soldiers killed: 293 (US) 24 (UK) 2 (French) 39 (Allied Arab Casualties) [11]
Iraqi soldiers killed: 100,000 [12]
US Soldiers with Gulf War Syndrome: 5,000 [13]

1988: Civilian deaths due to the Iraqi Chemical Gas attack on Kurdish city of Halabja March 17, 1988: Estimates range from 5,000 immediate deaths to 12,000 people in the course of three days.[14]

2003: (Zahlen für 2003 vom 25. November 2003)
Getötete irakische Zivilisten: mindestens: 7.918, höchstens: 9.749[1]
Getötete US-Soldaten: 434[2]
Getötete britische Soldaten: 53[3]
Getötete italienische Soldaten: 17[4]
Getötete spanische Soldaten: 3[5]
Getötete ukrainische Soldaten: 3[6]
Getötete dänische Soldaten: 1[7]
Getötete polnische Soldaten: 1[8]
Getötete irakische Soldaten: 9.200, plus/minus 1.600 (17,5 Prozent)[9]

1991-2003: Aufgrund der Sanktionen gestorbene irakische Zivilisten: 1,25 Millionen[10]

1991:
Getötete irakische Zivilisten: 2.300[11]
Getötete Soldaten der Koalition: 293 (USA), 24 (Großbritannien), 2 (Frankreich), 39 (alliierte Araber)[11]
Getötete irakische Soldaten: 100.000[12]
US-Soldaten mit Golfkriegssyndrom: 5.000[13]

1988: Beim irakischen Giftgasangriff auf die kurdische Stadt Halabja am 17. März 1988 getötete Zivilisten: Die Schätzungen reichen von 5.000 unmittelbaren Opfern zu 12.000 Toten innerhalb von drei Tagen[14].

2003: (données de 2003 mises à jour jusqu'au 25 novembre 2003)
Civils irakiens tués : minimum :7 918, maximum : 9 749[1]
Soldats américains tués : 434[2]
Soldats anglais tués : 53[3]
Soldats italiens tués : 17[4]
Soldats espagnols tués : 3[5]
Soldats ukrainiens tués : 3[6]
Soldats danois tués : 1[7]
Soldats polonais tués : 1[8]
Soldats irakiens tués : 9 200, avec une marge d'erreur de 1 600 (17,5 pour cent)[9]

1991-2003 : mort de civils irakiens en raison de sanctions : 1,25 million[10]

1991:
Civils irakiens tués : 2 300[11]
Soldats de la coalition tués : 293 (USA), 24 (UK), 2 (France), 39 (victimes de l'Alliance Arabe)[11]
Soldats irakiens tués : 100 000[12]
Soldats américains touchés par le syndrome de la Guerre du Golfe : 5 000[13]

1988 : Mort de civils en raison de l'attaque au gaz chimique des Irakiens sur la ville kurde de Halabja, le 17 mars 1988 : les estimations vont de 5 000 morts immédiats à 12 000 morts en l'espace de trois jours.[14]

Notes
1. Hamit Dardagan, www.iraqbodycount.org, http://www.iraqbodycount.net/ , 25, November 2003
2. Pat Kneisler, Iraq Coalition Casualty Count, http://lunaville.org/warcasualties/Summary.aspx , 25, November 2003
3. ibid
4. ibid
5. ibid
6. ibid
7. ibid
8. ibid
9. Carl Conetta, The Wages of War: Iraqi Combatant and Noncombatant Fatalities in the 2003 Conflict, Project of Defense Alternatives, Research Monograph #8, October, 8, 2003, http://www.comw.org/pda/0310rm8.html , 25, November 2003
10. Farai Chideya, „Iraq and Ruin: A Country, and a U.S. Strategy, in Shambles", Seattle Post Intelligencer: Common Dreams News Center, February 22, 2001,http://www.commondreams.org/views01/0222-07.htm, Januarry 14, 2004
11. Frontline, "The Gulf War", PBS.org, 9, January 1996, http://www.pbs.org/wgbh/pages/frontline/gulf/.
12. CNN, "The Unfinished War: A Decade Since Desert Storm/Gulf War Facts", CNN Interactive: 25, November, 2003, http://www.cnn.com/SPECIALS/2001/gulf.war/facts/gulfwar/.
13. CNN, "Government study finds clue to Gulf War Syndrome", CNN Interactive: 21 January 1997, http://www.cnn.com/US/9701/21/gulf.war.illness/.
14. Joost R Hiltermann, "America Didn't Seem to Mind Poison Gas", Herald Tribune: The IHT Online : January 17, 2003, http://www.iht.com/articles/83625.html, 25, November, 2003

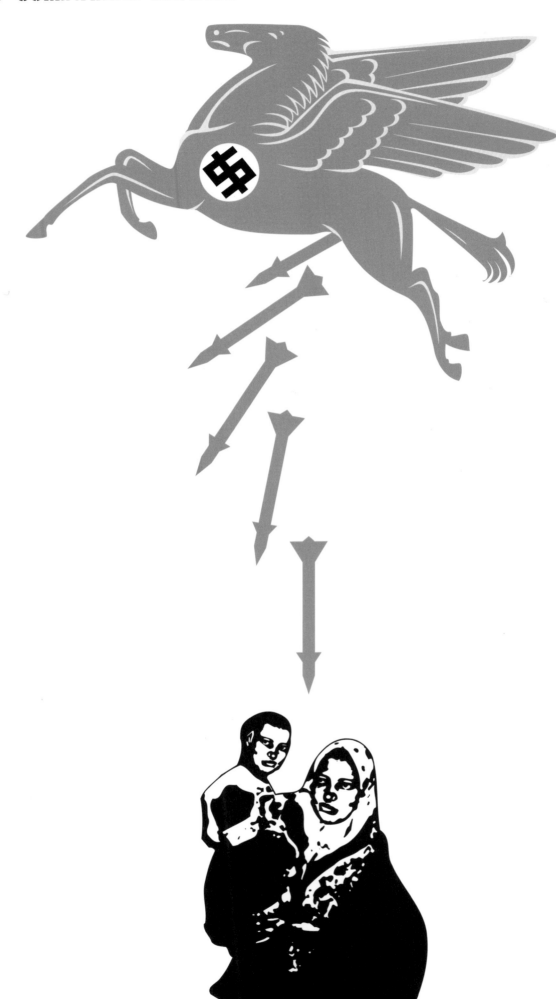

Artist: Hugh A. Gran
Title: Liberation From Above
Organization: HeWho, Konscious
Web Site: www.hughgran.com, www.konscious.com
Country: United States of America

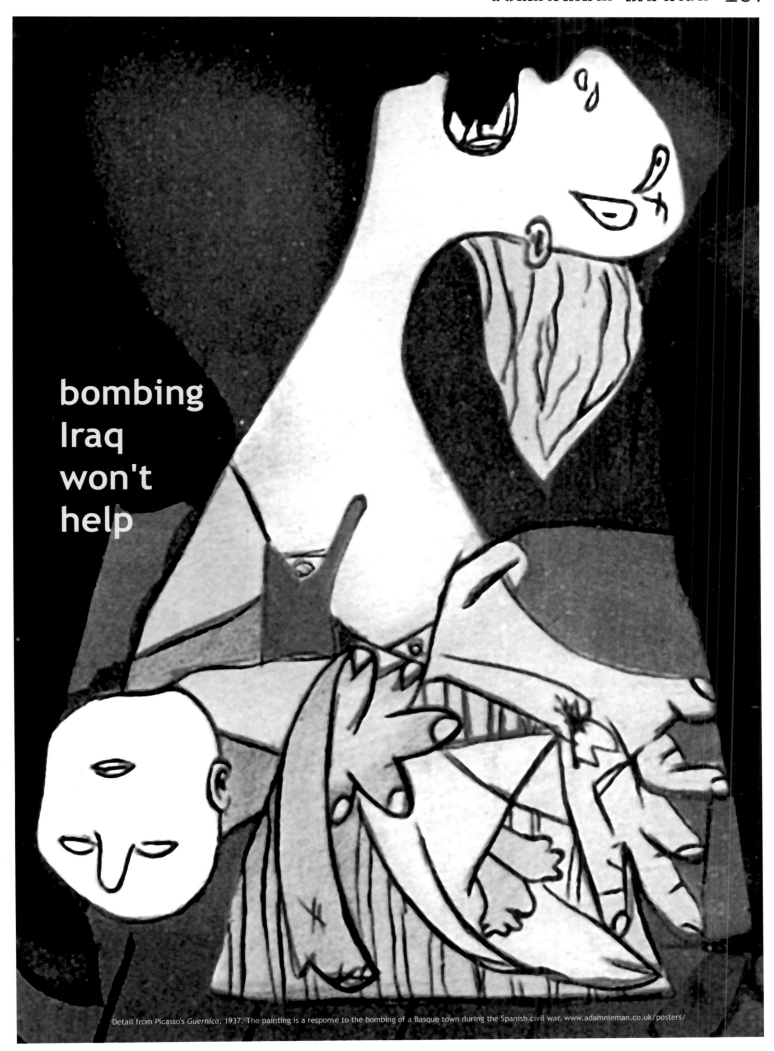

bombing
Iraq
won't
help

Detail from Picasso's *Guernica*, 1937. The painting is a response to the bombing of a Basque town during the Spanish civil war. www.adamnieman.co.uk/posters/

Artist: Pablo Picasso, Graphic design: Adam Nieman
Title: Guernica, bombing Won't Help
Web Site: www.adamnieman.co.uk/posters
Country: United Kingdom

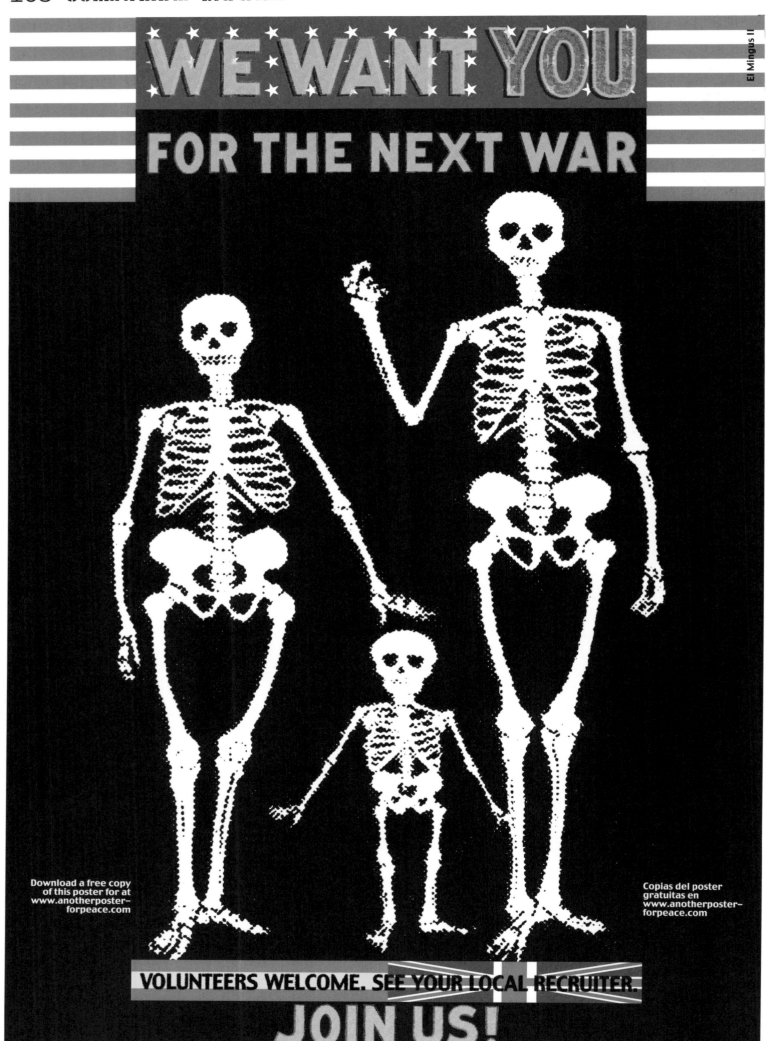

Artist: "El Mingus II" (J. S. Valverde)
Title: WE WANT YOU FOR THE NEXT WAR
Country: Spain

WHO DIES FOR BUSH LIES?

WHO DIES FOR BUSH LIES? whodies.com

Artist: The Committee to Help Unsell the War
Title: Who dies for Bush lies?
Organization: The Committee to Help Unsell the War
Web Site: www.whodies.com
Country: United States of America

NEJ TILL KRIG MOT IRAK

INGET SVENSKT STÖD TILL USA:S KRIG

KOALITIONEN FÖR FRED I MELLANÖSTERN
NÄTVERKET STOPPA USA:S KRIG

Stop the War Against Iraq

Act
Now to
Stop
War &
End
Racism

Int'l A.N.S.W.E.R.
415-821-6545

www.InternationalANSWER.org

Artist: Keith Pavlik, Migiwa Kanazawa, Bill Hackwell
Title: Iraqi Girl in Basra
Organization: International A.N.S.W.E.R. Coalition (Act Now to Stop War and End Racism)
Web Site: www.InternationalANSWER.org
Country: United States of America

Artist: Jonas Frankki
Title: Nej Till Krig Mot Irak (No war against Iraq)
Organization: Koalitionen för fred i Mellanöstern / Nätverket Stoppa USA's krig
Web Site: www.stoppakriget.tk
Country: Sweden

HURLTRUTH

over 100 billion dollars will be spent on the war in iraq.

three times what the federal government spends on K-12 education.

enough to provide health care for all uninsured children in the US, for 5 years

more than 4 times the total international affairs budget.

it's time to take care of our own

NOWAR

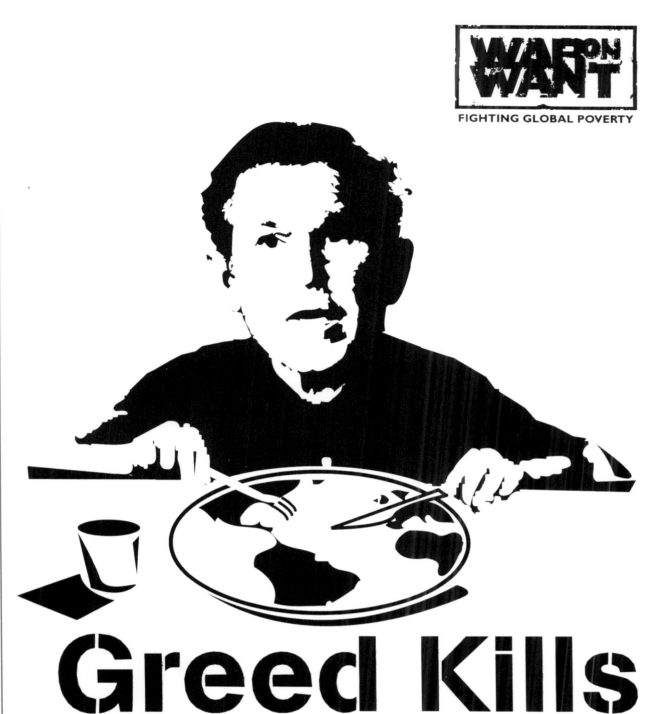

FIGHTING GLOBAL POVERTY

Greed Kills

www.waronpoverty.org

Registered Charity No. 208724

Organization: War on Want
Title: Greed Kills
Web Site: www.waronwant.org
Country: United Kingdom

Artist: A.Wayne Acree
Title: TRUTH
Web Site: www.awagraphix.com
Country: United States of America

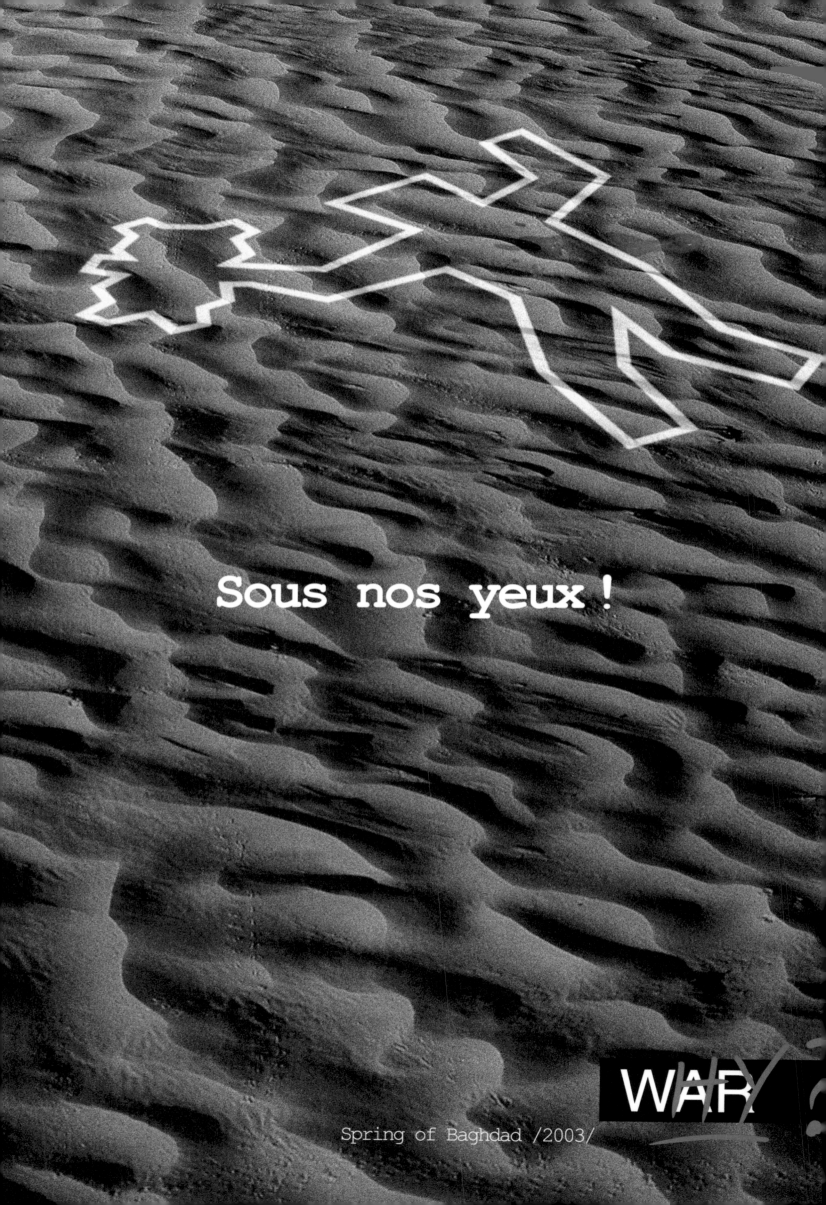

Sous nos yeux !

WAR

Spring of Baghdad /2003/

ESTO ES
DEMOCRA**CIA**!

OPOSICION

OTRO **MUNDO**
ES **POSIBLE**!

www.protestart.be

Artist: Repiso Christian
Title: Democracia 02
Organization: ProtestArt
Web Site: www.protestart.be
Pais: Belgium

Artist: Didier Gerardin
Title: SOUS NOS YEUX !
Country: France

PEACE SIGNS

Peace Signs

George W. Bush stated at the time of the air strikes in Afghanistan, "we're a peaceful nation," later to be echoed by Tony Blair's, "we're a peaceful people".[1] In a time when even the word "peace" is appropriated by those who wage war, its definition and imagery warrant a closer look.

Throughout this book you've seen a multitude of reactions to the war in Iraq from artists around the world. Whether using parody or a more serious tone, posters have addressed a broad spectrum of issues ranging from imperialism, corporate dominance and control of oil to the victims of war. The images in this chapter distill the peace movement in its simplest terms. They are not so much about the reasoning behind this specific conflict, but about the rejection of war itself.

In creating these posters many artists utilized familiar imagery from the peace movements of the past. The peace sign as we know it was designed by Gerald Holtom in 1958 as the logo for the Campaign for Nuclear Disarmament (CND) in England and was placed on flags and signs during the Aldermaston march that took place during that year. It has since become the most recognized international symbol of peace. In the poster "American Peace," the familiar symbol is retooled for contemporary times by overlaying a bomber to expose the contradictions of war and the duplicitous language of politicians. Similar to the reworked images of the CND peace sign, artists chose to reinterpret Picasso's peace dove. Posters such as Anthony Garner's "American Eagle" depicts a dove being killed by an American eagle while images such as Winston Smith's "Kill it!" and Repiso Christian's "Peace 01" speak of a violent disregard for peaceful alternatives to war.

By using imagery from previous movements, these posters remind us that peace movements

do not begin or end with any given war. As the US Government steadily moves towards a state of permanent warfare, we must realize that mere anti-war movements will not be enough; instead, a permanent peace movement is needed. The economic and social inequalities that exist within a society, between nation states, and between modern nation states and their indigenous communities that enable the conditions for war necessitate a broader and continual critique. As the American indigenous activist, Winona LaDuke points out, 72% of wars are fought between nation states and indigenous peoples – often in an attempt to annex their territories to extract resources. The over consumption by industrialized nations, the degradation of the environment, and the worldwide intolerance to different religious and cultural beliefs needs to be collectively addressed. If not, it is inevitable that war will be a permanent plight that cripples humanity.

As is evident by the global outcry against the war in Iraq, people from around the world have soundly rejected the path to armed conflict. The artwork in Peace Signs is part of this dialogue. War was not prevented in 2003, but what is not known is how close it came to being prevented. Politicians rarely reveal their breaking point when public pressure grows to a mass movement. Could of a few more days of vigilant protests, a few more million people in the streets have stopped the push to war? These are important questions to consider. Likewise, now that the war is "over," will public attention drift away from the current situation in Iraq? Will Iraq be left a war torn country similar to Afghanistan? – a place that no longer draws the news headlines or sympathy. As artists, activist and citizens of the world, we need to use our talents, be they visual or otherwise to work together to make sure that this does not happen in Iraq or anyplace else on earth. Community-based movements become global movements and in the process a more just and peaceful world becomes within our reach.

Friedenszeichen

George W. Bush erklärte zum Zeitpunkt der Luftangriffe in Afghanistan: „Wir sind eine friedliche Nation", eine Aussage, die später von Tony Blair als „Wir sind ein friedliches Volk" wiederholt wurde.[1] Zu einer Zeit, in der selbst das Wort „Frieden" von denjenigen in Besitz genommen wird, die Krieg führen, lohnt es sich, seine Definition und Darstellung im Bild etwas genauer unter die Lupe zu nehmen.

In diesem Buch haben Sie bisher vielfältige Reaktionen von Künstlern aus aller Welt auf den Krieg im Irak gesehen. Ob parodistisch oder ernsthaft, beschäftigten sich die Plakate mit einem breiten Themenspektrum, mit Imperialismus, der Macht der Großunternehmen und der Kontrolle über das Öl bis hin zu den Opfern des Krieges. Die Bilder in diesem Kapitel machen das Wesen der Friedensbewegung auf einfache Weise deutlich. Es geht dabei weniger um die Argumentation in Bezug auf diesen speziellen Konflikt, sondern vielmehr um die Ablehnung des Krieges an sich.

Für diese Plakate haben viele Künstler bekannte Bilder aus der Vergangenheit der Friedensbewegung verwendet. Das uns allen bekannte Friedenszeichen wurde 1958 von Gerald Holtom als Logo für die englische Campaign for Nuclear Disarmament (CND, Kampagne für nukleare Entwaffnung) entworfen und war im gleichen Jahr bei der Demonstration in Aldermaston, dem Produktionsort britischer Atomwaffen, auf Fahnen und Schildern zu sehen. Seitdem ist es zum bekanntesten internationalen Symbol für den Frieden geworden. Auf dem Plakat „American Peace" („Amerikanischer Frieden") wurde das vertraute Symbol für die heutige Zeit umgearbeitet, indem das Bild eines Bombers darüber gelegt wurde, was die Widersprüchlichkeit des Krieges und die Doppelzüngigkeit der Politiker verdeutlicht. Ähnlich wie das abgeänderte Friedenszeichen der

CND erfuhr auch Picassos Friedenstaube eine Neuinterpretation. So zeigt zum Beispiel Anthony Garners „American Eagle" („Amerikanischer Adler") eine Taube, die vom amerikanischen Wappenadler getötet wird, und auch Bilder wie „Kill it!" („Töte!") von Winston Smith und „Peace 01" („Frieden 01") von Christian Repiso illustrieren die völlige Missachtung von friedlichen Alternativen zum Krieg.

Die Verwendung von Motiven aus der Vergangenheit der Friedensbewegung erinnert uns daran, dass diese nicht mit einem bestimmten Krieg beginnt oder aufhört. Während sich die US-Regierung stetig in die Richtung eines Zustands permanenter Kriegführung bewegt, muss uns bewusst werden, dass punktuelle Anti-Kriegsbewegungen nicht mehr ausreichen werden: was wir brauchen, ist eine dauerhafte Friedensbewegung. Das wirtschaftliche und soziale Ungleichgewicht, das innerhalb einer Gesellschaft, zwischen Staaten sowie zwischen modernen Nationalstaaten und ihrer Ursprungsbevölkerung, die Voraussetzungen für kriegerische Auseinandersetzungen schafft, muss breit angelegte und fortdauernde Kritik erfahren. Winona LaDuke, Aktivistin der amerikanischen Ureinwohner, weist darauf hin, dass 72 % aller Kriege zwischen Nationalstaaten und Eingeborenenvölkern geführt werden – häufig ausgehend von der Intention, das Territorium der Ureinwohner unter Kontrolle zu bringen, um die Ressourcen auszubeuten. Probleme wie der übermäßige Konsum der Industrienationen, der Raubbau an der Umwelt und die in aller Welt anzutreffende Intoleranz gegenüber anderen Religionen und Kulturen müssen als Gesamtheit behandelt werden. Geschieht dies nicht, wird Krieg unvermeidlich zu einer permanenten Plage werden, die die Menschheit verkrüppelt.

Wie beim weltweiten Protest gegen den Krieg im Irak deutlich geworden ist, lehnten Menschen in aller Welt lautstark den Weg bewaffneter Konfliktlösungen ab. Die Bilder in Peace Signs sind Teil dieses Dialogs. Der Krieg wurde 2003 nicht verhindert, aber wir wissen nicht, wie nahe wir einer solchen Verhinderung vielleicht gekommen sind. Politiker lassen selten durchblicken, wo ihre Grenzen liegen, wenn der öffentliche Druck sich zu einer Massenbewegung auswächst. Hätten einige weitere Tage wachsamer Proteste, ein paar Millionen Menschen mehr auf den Straßen die Kriegstreiberei stoppen können? Dies sind wichtige Fragen. Und wird sich jetzt, da der Krieg „vorüber" ist, die öffentliche Aufmerksamkeit von der aktuellen Situation im Irak abwenden? Bleibt der Irak ein vom Krieg gezeichnetes Land, ähnlich wie Afghanistan? Dieses Land macht keine Schlagzeilen mehr und ruft kein Mitgefühl mehr hervor. Als Künstler, Aktivisten und Bürger der Welt müssen wir unsere Talente, gestalterische wie auch andere, zur Zusammenarbeit nutzen und so dafür sorgen, dass dies weder im Irak noch an einem anderen Ort der Erde passiert. Aus Bewegungen, die an der Basis entstehen, können weltweite Bewegungen werden, und in diesem Prozess nähern wir uns einer gerechteren und friedlicheren Welt.

Signes de paix

Au moment des attaques aériennes en Afghanistan, George W. Bush a déclaré « Nous sommes une nation de paix », affirmation reprise plus tard par Tony Blair qui annonçait « Nous sommes un peuple de paix »[1]. A une époque où même le mot « paix » est réapproprié par ceux qui mènent des guerres, sa définition et son symbolisme justifient un examen plus approfondi.

Tout au long de ce livre, vous avez pu voir une multitude de réactions face à la guerre en Irak en provenance d'artistes du monde entier. Qu'ils utilisent la parodie ou un ton plus sérieux, les posters ont traité un large éventail de sujets allant de l'impérialisme en passant par la domination institutionnelle et le contrôle total du pétrole jusqu'aux victimes de la guerre. Les images de ce chapitre distillent le mouvement de paix dans

ses termes les plus simples. Elles ne traitent pas tellement du raisonnement derrière ce conflit spécifique, mais du rejet de la guerre en elle-même.

En créant ces posters, de nombreux artistes se servent d'images familières issues des mouvements de paix du passé. Le signe de la paix comme nous le connaissons a été dessiné par Gerald Holtom en 1958 en tant que logo pour la Campaign for Nuclear Disarmament (CND) en Grande-Bretagne et a été placé sur des drapeaux et des pancartes au cours de la marche de Aldermaston qui a eu lieu cette année-là. Depuis ce jour, ce symbole est devenu le symbole de paix le plus reconnu au niveau universel. Sur le poster « American Peace », le symbole familier a été retravaillé pour les besoins des temps présents en lui superposant un bombardier pour montrer les contradictions de la guerre et le langage à double face des politiciens. De manière similaire aux images du signe de paix CND retravaillé, des artistes ont choisi de réinterpréter la colombe de la paix de Picasso. Des posters tels celui de Anthony Garner intitulé « American Eagle » montrent le dessin d'une colombe tuée par un aigle américain, alors que des images telles que « Kill it! » (Tue-le) de Winston Smith et « Peace 01 » de Repiso Christian montrent un mépris cruel des alternatives pacifiques à la guerre.

En utilisant les symboles des mouvements précédents, ces posters nous rappellent que les mouvements de paix ne commencent ni ne se terminent avec un conflit. Comme le gouvernement américain avance inexorablement en direction d'un état de guerre permanent, nous devons réaliser que de simples mouvements antiguerre ne seront pas suffisants. Par contre, un perpétuel mouvement de paix est nécessaire. Les inégalités économiques et sociales au sein des sociétés, entre diverses nations, entre des états modernes et leurs populations indigènes réunissent les conditions de base propices aux guerres. Une critique plus large et permanente est nécessaire. Comme le montre l'activiste indigène américaine, Winona LaDuke, 72% des guerres sont menées entre des états-nation et leurs populations autochtones souvent dans une tentative d'annexer le territoire de ces dernières afin d'en exploiter les ressources. La surconsommation des pays industrialisés, la dégradation de l'environnement et l'intolérance mondiale face à des religions et des croyances culturelles différentes doivent être traitées collectivement. Sinon les guerres deviendront inévitablement une plaie permanente qui invalidera l'humanité.

Ainsi qu'il ressort clairement du tollé général contre la guerre en Irak, les peuples du monde entier ont sainement rejeté la voie du conflit armé. Le travail artistique de Peace Signs fait partie de ce dialogue. La guerre n'a pas pu être enrayée en 2003, mais ce qui n'est pas connu, c'est combien nous étions proches de pouvoir l'empêcher. Les politiciens révèlent rarement leur point de rupture lorsque la pression publique se transforme en mouvement de masse. Quelques jours de plus de protestations vigilantes, quelques millions de plus de gens dans les rues auraient-ils pu arrêter l'avancée vers la guerre ? Ce sont des questions importantes à poser. De même, maintenant que la guerre est « terminée », l'attention du public se détournera-t-elle de la situation actuelle en Irak ? L'Irak restera-t-il un pays miné par la guerre tout comme l'Afghanistan, un lieu qui n'intéresse plus les gros titres et n'attire plus les sympathies ? En tant qu'artistes, activistes et citoyens du monde, nous nous devons d'utiliser nos talents, visuels ou autres, pour travailler ensemble afin que cela n'arrive pas en Irak, ni nulle part ailleurs dans le monde. Les mouvements communautaires deviennent des mouvements globaux, et dans ce processus, un monde plus juste et plus pacifique est à notre portée.

Notes: 1. "Bush's Remarks on US Military Strikes in Afghanistan", New York Times, 8 October, 2001, B6

Artist: Jai Redman
Title: Skate Poster
Organization: UHC Collective
Web Site: www.uhc-collective.org.uk
Country: United Kingdom

Artist: Stephen Sampson (POD)
Title: War Monkey
Web Site: www.podboards.com
Country: United Kingdom

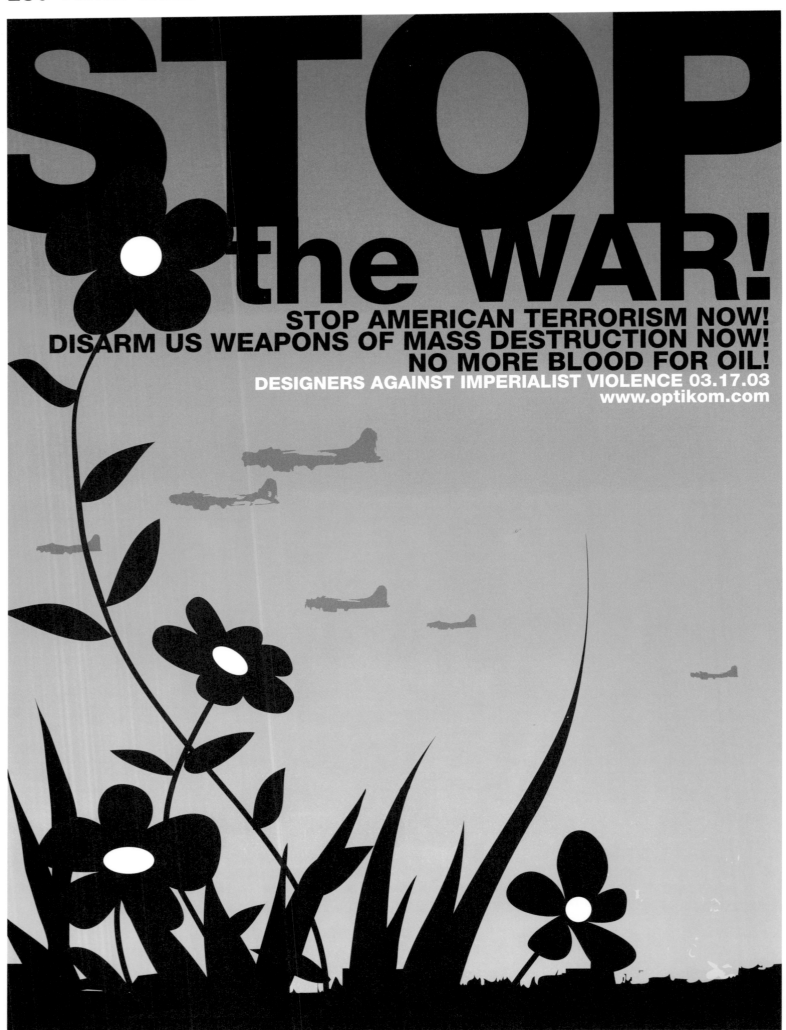

STOP
the WAR!
STOP AMERICAN TERRORISM NOW!
DISARM US WEAPONS OF MASS DESTRUCTION NOW!
NO MORE BLOOD FOR OIL!
DESIGNERS AGAINST IMPERIALIST VIOLENCE 03.17.03
www.optikom.com

Artist: Zhao
Title: STOP SIGN
Organization: optikom
Web Site: www.optikom.com
Country: United States of America

claude.schaub@lowe.ch

IHR KRIEGT IHN,
IHR KRIEGT IHN NICHT,
KRIEGT IHN,
KRIEGT NICHT!

EINE AKTION GEGEN DEN KRIEG IM NAHEN OSTEN.

Artist: Claude Schaub
Title: BlumenKrieg
Country: Switzerland

Artist: Design Action Collective
Title: Not in Our Name Globe Poster
Organization: Not In Our Name Project
Web Site: www.designaction.org? / www.notinourname.net
Country: United States of America

Artista: Chuck Sperry
Title: Not in our name
Organization: Firehouse Kustom Rockart Company
Web Site: www.firehouseposters.com
Country: United States of America

THINK SPRING

Artist: Jim Lasser
Title: Think Spring
Organization: Planet Propaganda
Web site: www.planetpropaganda.com
Country: United States of America

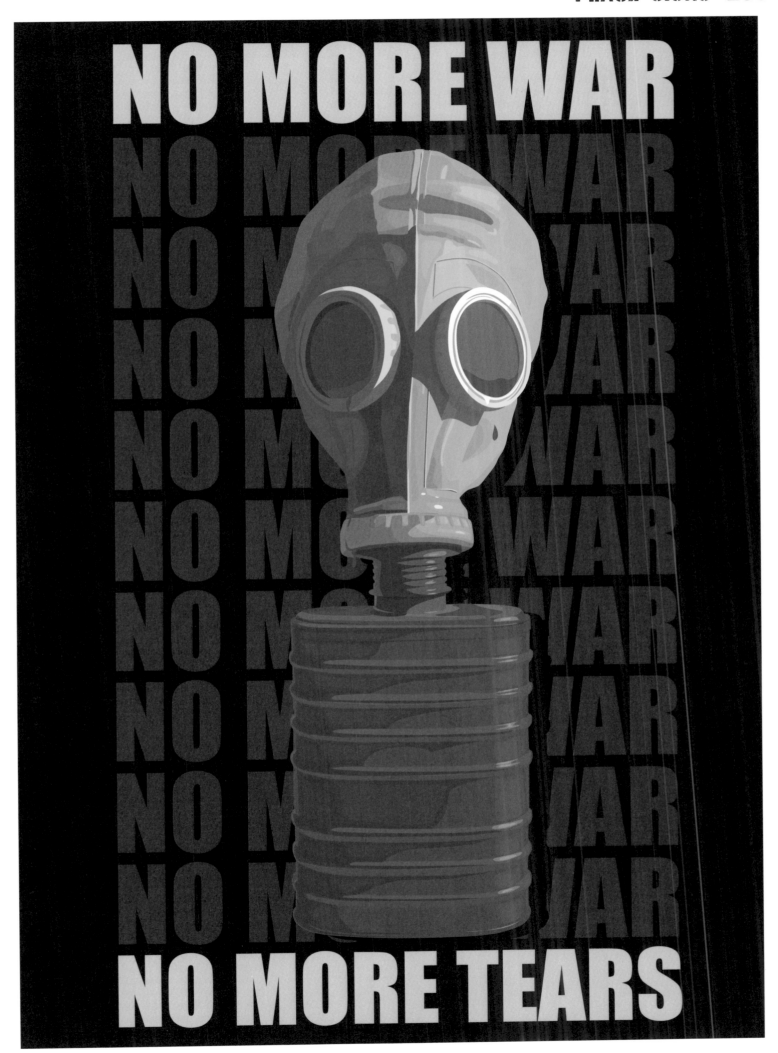

Artist: Adam Jedrzejewski
Title: NO MORE TEARS
Web Site: http://republika.pl/borned
Country: Poland

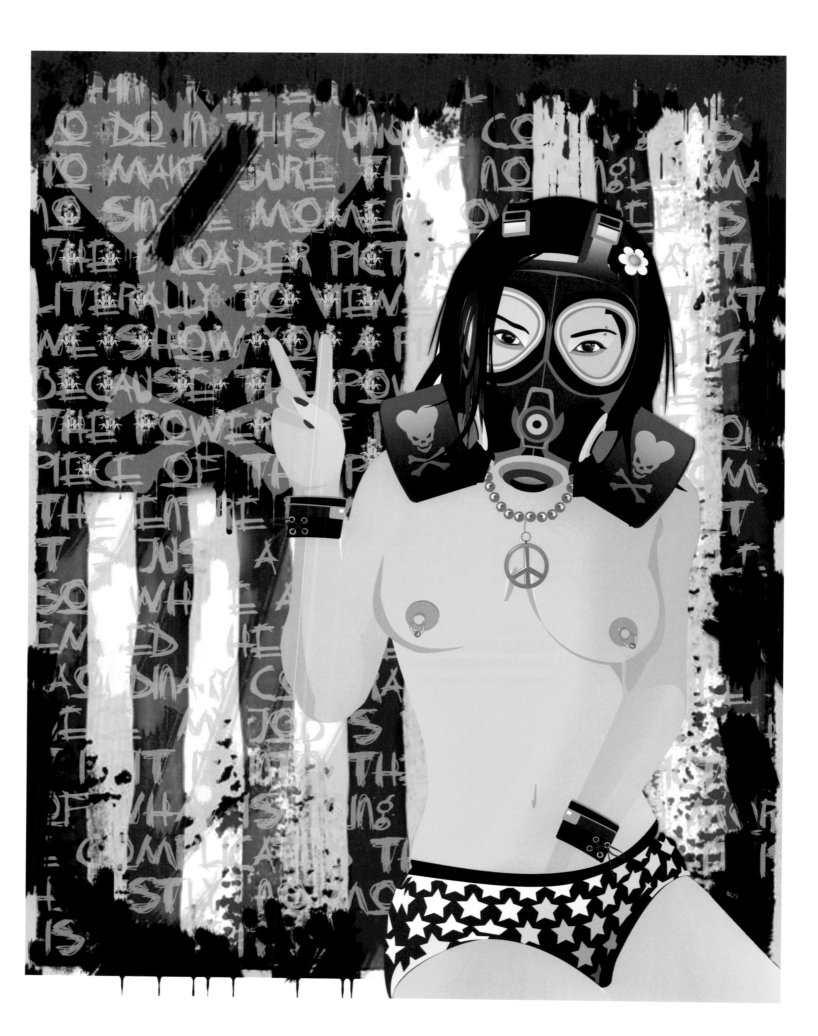

Artist: Patrick Boyer
Title: Masturbate 4 Peace
Organization: Patrick Boyer Illustrations, UrbanCowboy
Web Site: www.urbancowboy.net
Country: Canada

design: www.toko.nu (formerly known as 21")

Make love
not war...

Artist: Toko
Title: Make Love
Web Site: www.toko.nu
Country: The Netherlands

make

not war

Artist: Michael Redding
Title: Make 69 Not War
Organization: Divinepixels
Web Site: www.divinepixels.com
Country: United States of America

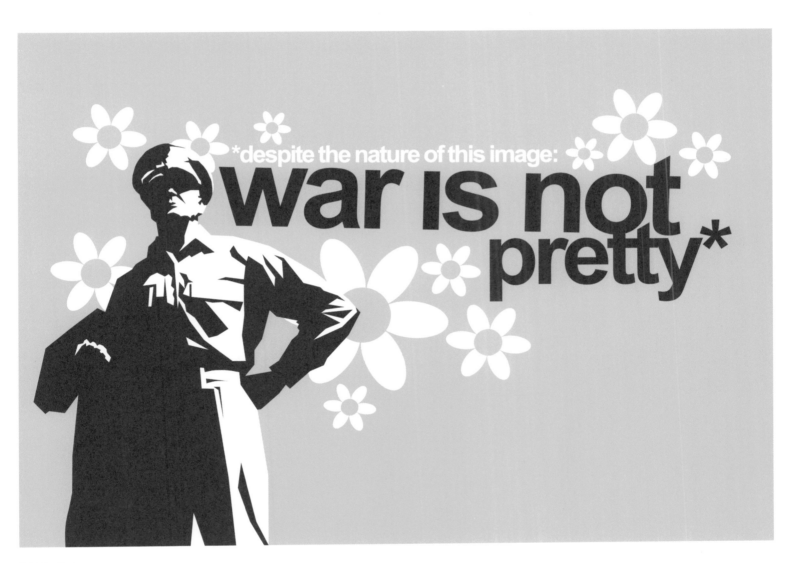

Artist: Tom Borgas
Title: War is not pretty
Organization: dep[art]ure
Country: Australia

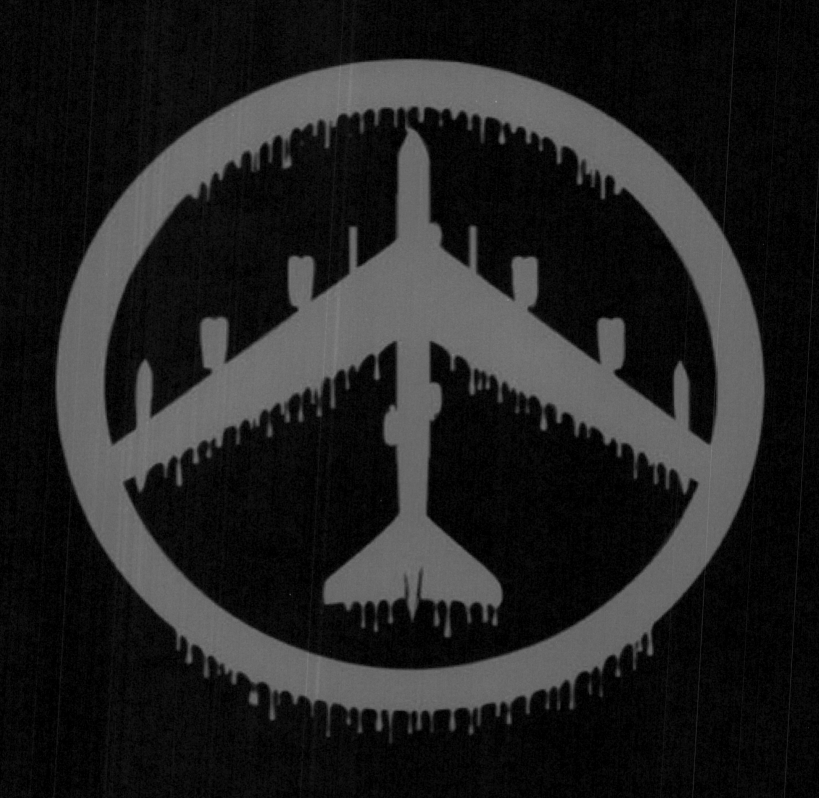

AMERICAN PEACE

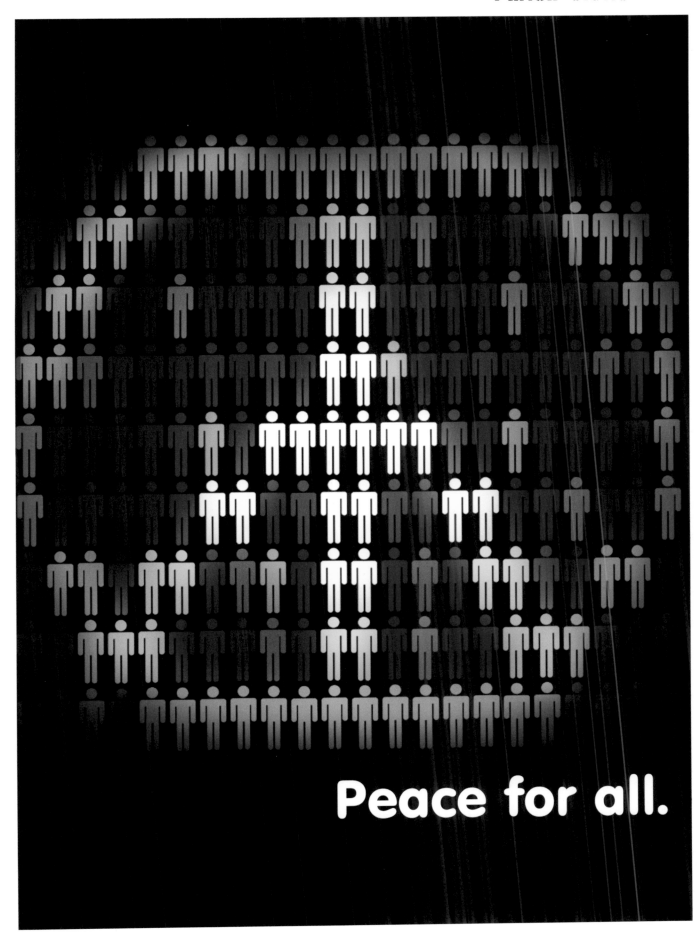

Peace for all.

Artist: Deborah Michelle Clague
Title: Peace For All
Country: Canada

PEACE
BEGINS WITH

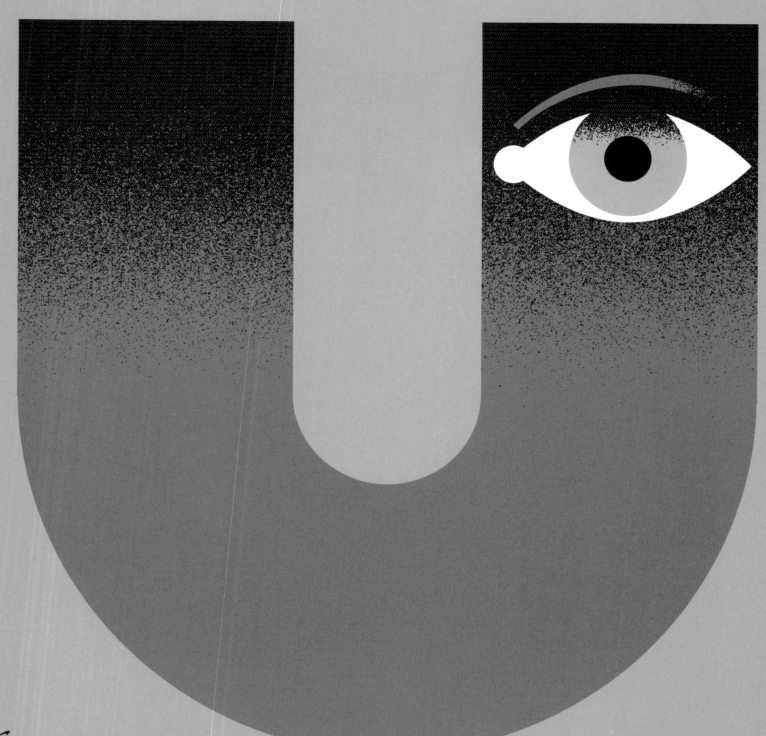

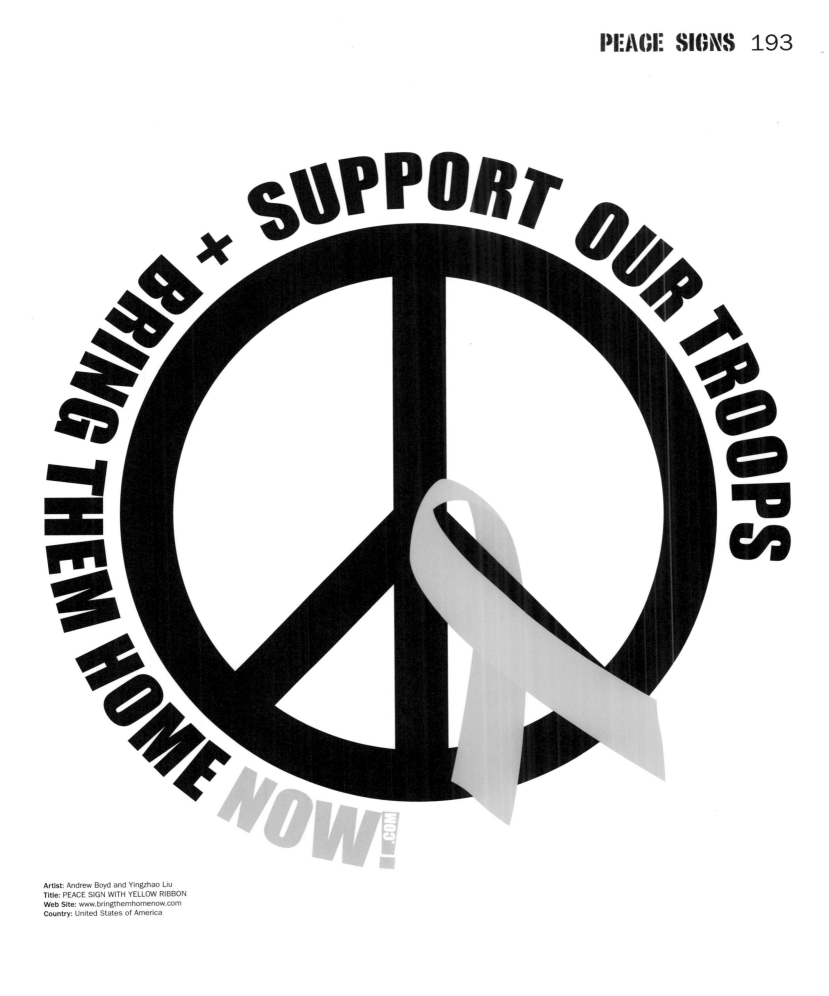

Artist: Andrew Boyd and Yingzhao Liu
Title: PEACE SIGN WITH YELLOW RIBBON
Web Site: www.bringthemhomenow.com
Country: United States of America

Artist: Glenn Sakamoto
Title: Peace Begins with U
Organization: Glenn Sakamoto Design
Web Site: www.glennsakamoto.com
Country: United States of America

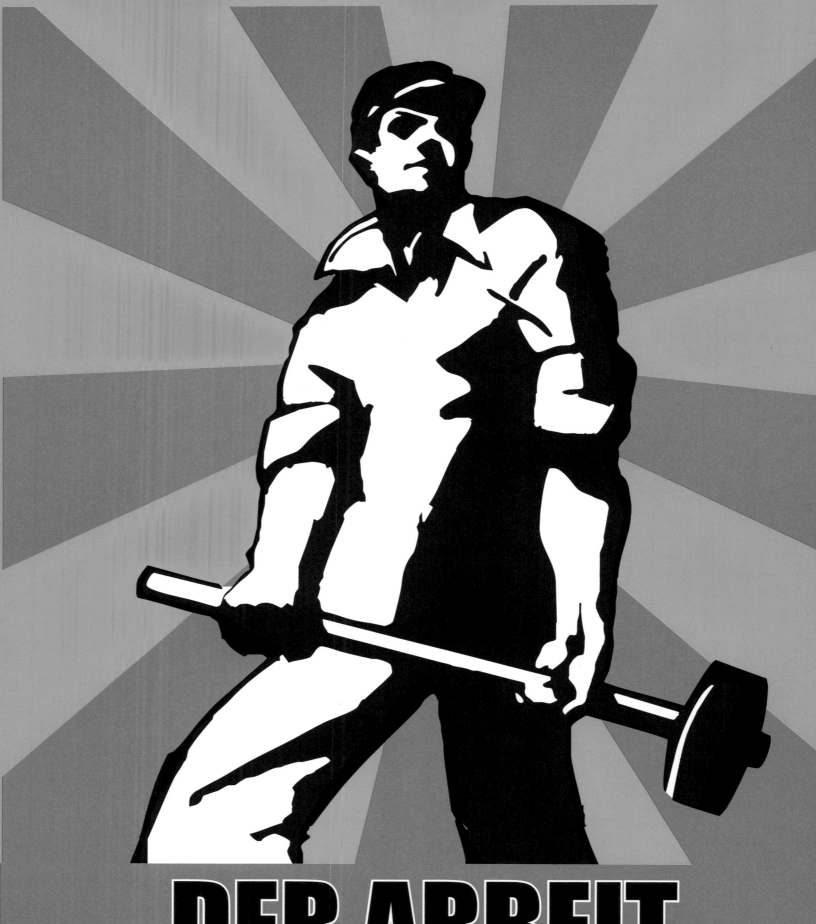

DER ARBEIT
GEGEN KRIEG!

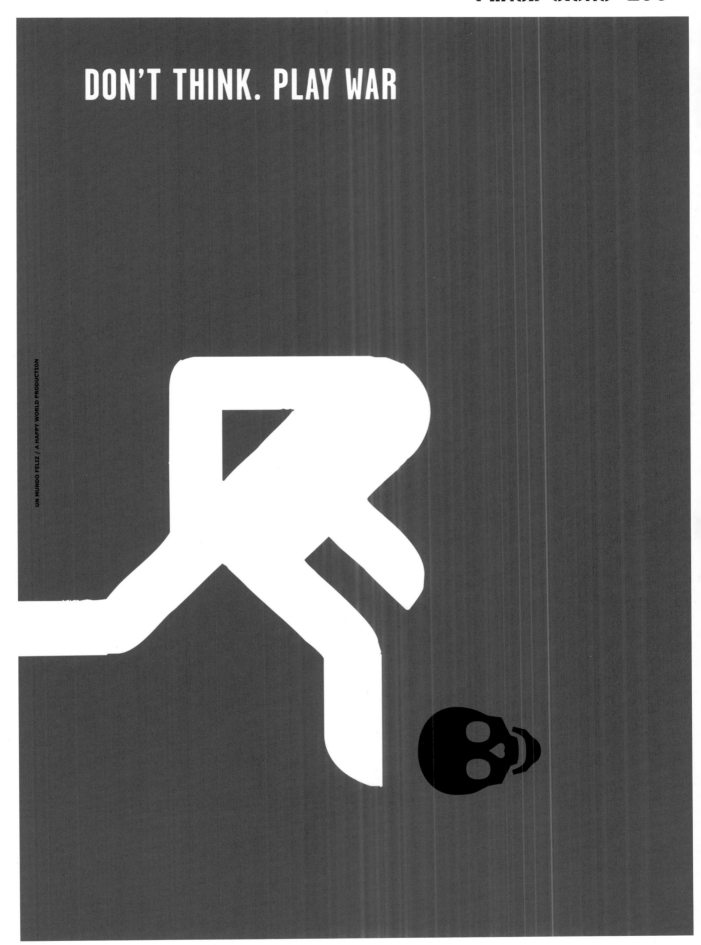

DON'T THINK. PLAY WAR

UN MUNDO FELIZ / A HAPPY WORLD PRODUCTION

Artist: Sonia and Gabriel Freeman
Title: PLAY WAR
Organization: Un mundo feliz / a happy world production
Web Site: www.unmundofeliz.org
Country: Spain

Artist: Andreas Kräftner (der arbeit)
Title: Der arbeit gegen krieg
Organization: designliga / GMAM
Web Site: www.designliga.de
Country: Germany

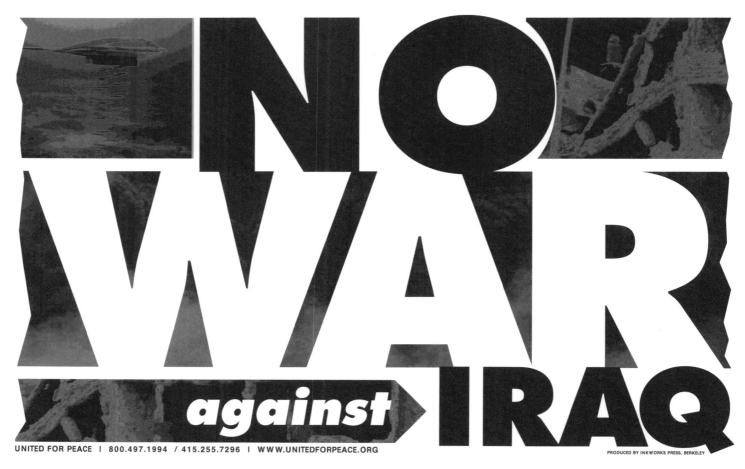

UNITED FOR PEACE | 800.497.1994 / 415.255.7296 | WWW.UNITEDFORPEACE.ORG

PRODUCED BY INKWORKS PRESS, BERKELEY

Artist: Design Action Collective
Title: No War Windowsigns
Organization: Inkworks Press
Web Site: www.designaction.org / http://inkworks.igc.org/
Country: United States of America

COEXISTENCE

Artist: Piotr Mlodozeniec
Title: Coexistence
Organization: zafryki
Web Site: www.zafryki.art.pl
Country: Poland

TM © Copyright Show Peace, Inc., 2001 ShowPeace.org

Think Peace

Artist: John D. Kirkpatrick
Title: "Think Peace" Dove Icon
Organization: Show Peace
Web Site: www.showpeace.org
Pais: United States of America

Artist: Daniel Koethe
Title: Made in USA
Organization: DKKD
Country: Germany

Artist: Anthony Garner
Title: American Eagle
Organization: Ant Art
Web Site: www.atomweb.net/ant.html
Country: Spain

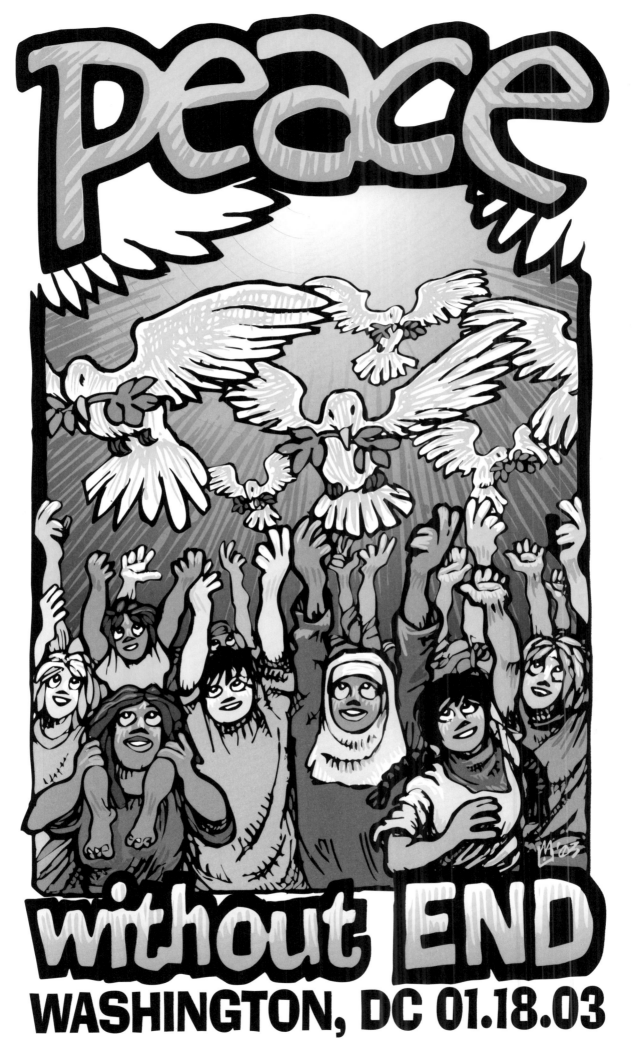

Artist: Mike Flugennock
Title: Peace Without End
Organization: DC Independent Media Center
Web Site: www.sinkers.org/posters
Country: United States of America

we don't want war!

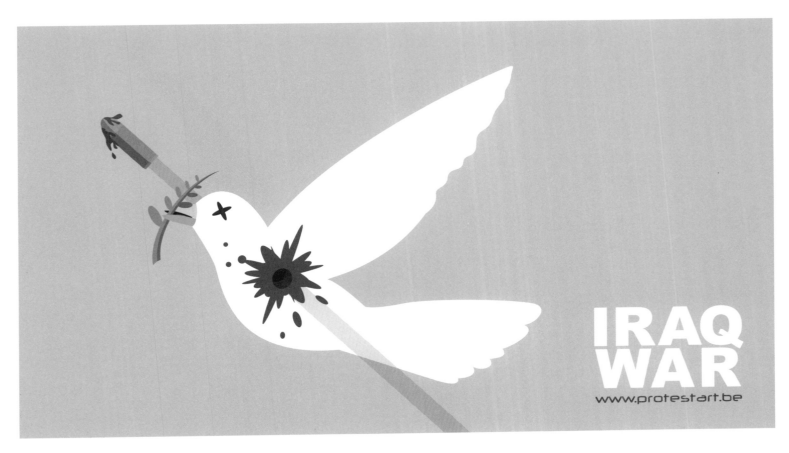

Artist: Repiso Christian
Title: Peace01
Organization: ProtestArt
Web Site: www.protestart.be
Pais: Belgium

Artist: Philip Stanton
Title: We don't want war
Organization: Stanton Studios S.L.
Web Site: www.stantonstudio.com
Country: Spain

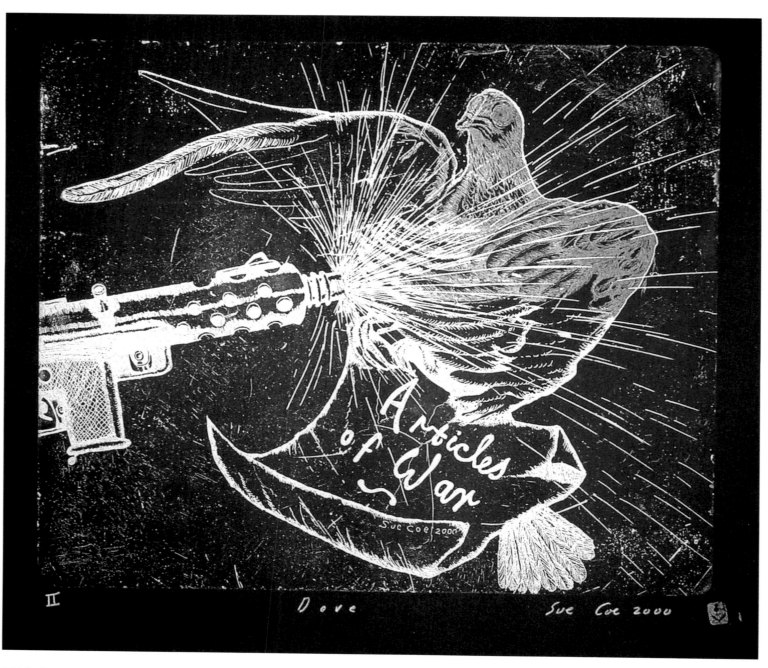

Artist: Sue Coe
Title: Articles of War
Country: United States of America

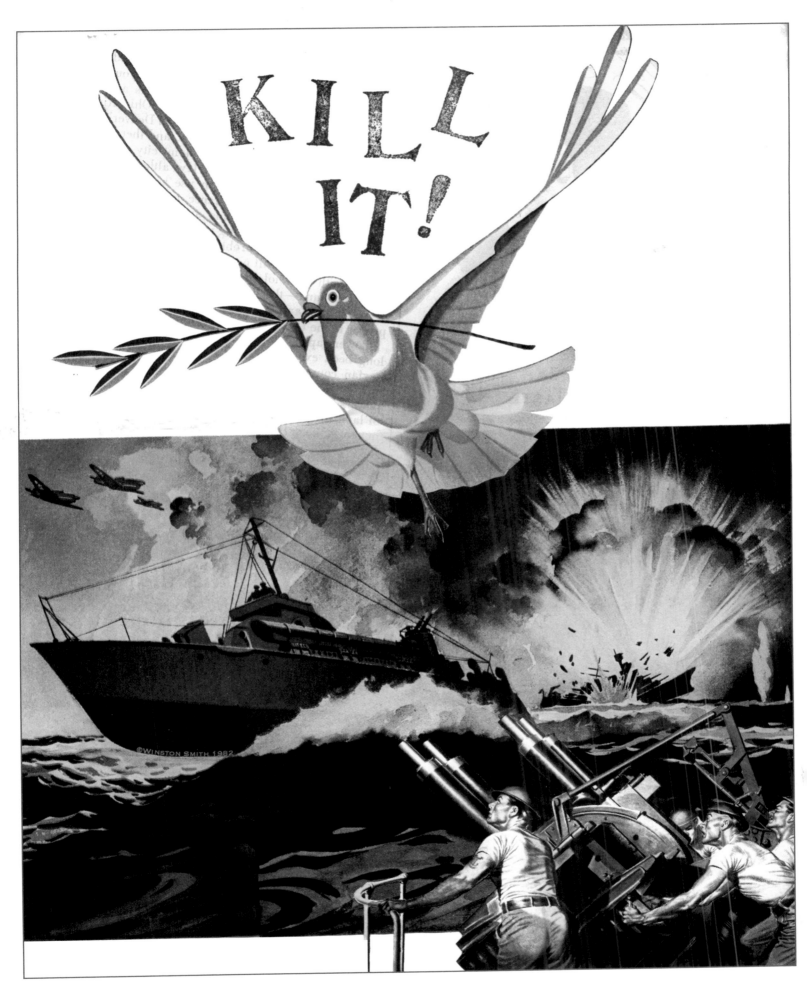

Artist: Winston Smith
Title: Kill it!
Web Site: www.winstonsmith.com
Country: United States of America

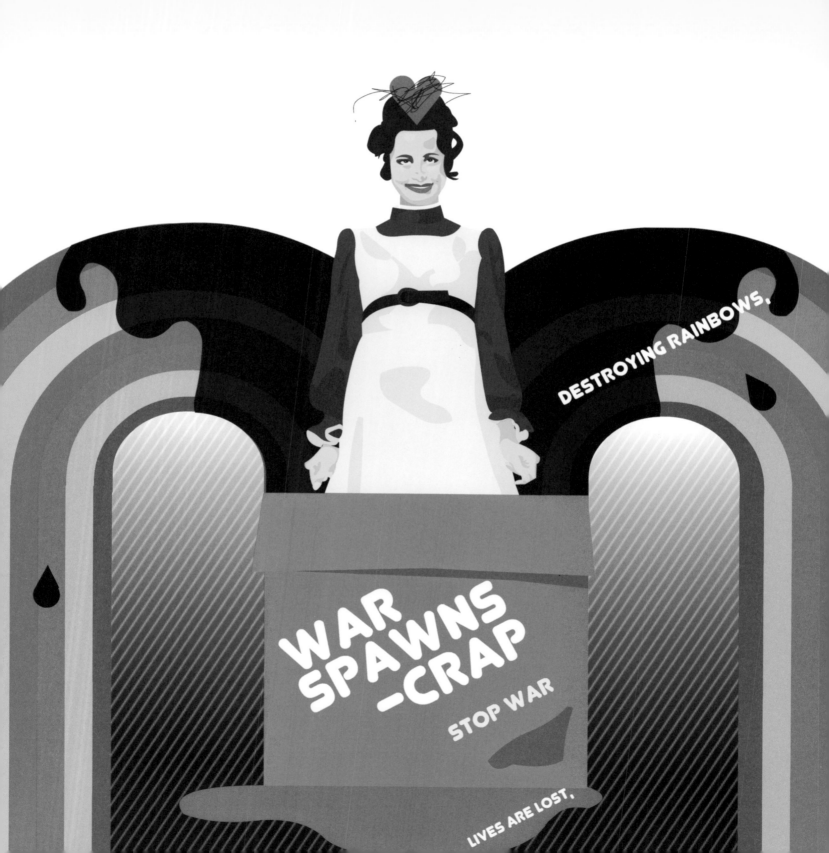

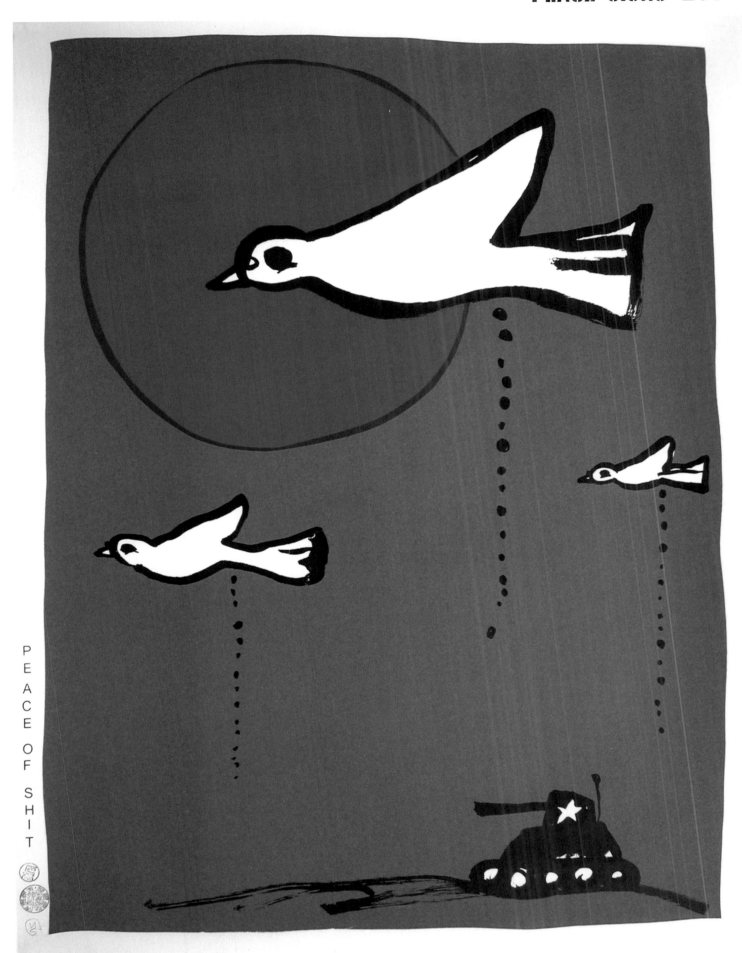

PEACE OF SHIT

Artist: Yuri Shimojo
Title: Peace of Shit
Organization: Cross World Connections
Web Site: www.yurishimojo.com
Country: Japan / United States of America

Artist: Jose Ezekiel Aquino
Title: War Spawns Crap
Web Site: www.SaturateDesaturate.com
Country: Philippines

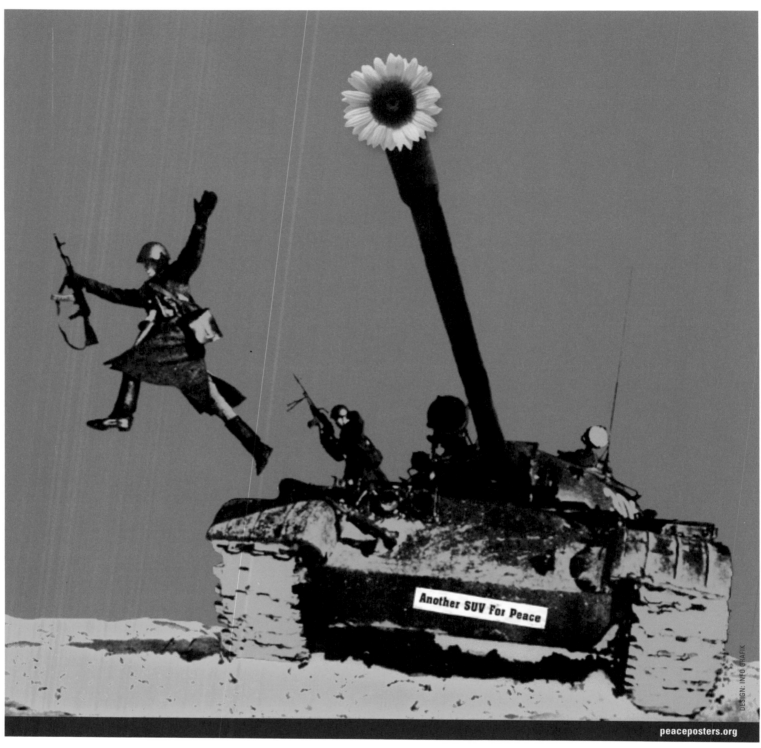

Another SUV For Peace

peaceposters.org

DESIGN: INFO GRAFIK

Artist: Oren Schlieman
Title: SUVs for Peace
Organization: Info Grafik Inc.
Web Site: www.peaceposters.org
Country: United States of America

Artist: Thomas Dellacroix & Agnieszka Dellfina
Title: Give Peace a Chance (Dad una oportunidad a la paz)
Organization: Dreamteam-Studio Utopia
Web Site: www.studioutopia.net, www.picassomio.com
Countries: Sweden, United Kingdom, Poland, Spain, France

Acknowledgments

I would like to thank the hundreds of artists and activists who sent artwork for consideration for the book, it was a hard selection process and I wish I could include everything. The thousands of people who sent me kind words of support and encouragement and kept me from looking for a full-time job because I wanted to answer all their emails every day. Without them, this book would never have become reality. Nadxieli Mannello for editing the final text for the book, putting up with my disorganization and pulling me out of the quagmire. Nicolas Lampert for writing the introduction and for being so supportive from our first contact. Brandon Bauer for helping with the research and writing for many of the chapters. For the collaborative effort between Nadxieli, Nicolas and Brandon that made the text in this book what it is, much more than I could have hoped for. A big thanks goes to Carol Wells of the Center For The Study of Political Graphics whose support and help on this project was incredible. Jon Emerson for helping me procure the "I want out" image for the introduction. Special thanks goes to Jon Carr who curated the "Yo! What Happened to Peace?" exhibit, produced by Cross World Communications/CWC-i (New York) and was responsible for helping me get artwork from Seth Tobocman, Winston Smith, Shepard Fairey, Hugh Gran, Chuck Sperry, and Yuri Shimojo. Thanks to Peter Kuper for spreading the word about the project and all the many others who did the same, especially those who posted the call for entries or a link to my website on theirs. John Couture for advice with the chapter writing. Michael Schumaker for programming my website which allowed me to spread the word about the project and provided a platform for artists to submit their artwork. Delphine Doidy for photographing many of the posters. The publisher, Manfred Olms, who believed in the project and made this book see the light of day. Amnesty International for supporting the project and for helping people caught in the tragedy of war. My family and friends who told me to put my money where my mouth is and although may differ in political opinion, always believed in me and my project and offered advice and encouragement. This book serves as an example that anyone can make a difference if they feel strongly enough about something, you can always make a change but it starts with you. Lastly I would like to thank my mother for teaching me at a very young age that war is not a game and that peace and love is always a better solution. My father for never letting me believe in politicians and for his advice and encouragement. **Jim Mann**

Danksagungen

Mein Dank geht an die vielen hundert Künstler und Aktivisten, die mir ihre Arbeiten für dieses Buch zugeschickt haben. Das Auswahlverfahren war sehr schwierig und ich wünschte, ich hätte alle Bilder aufnehmen können. Mein Dank geht auch an die vielen tausend Menschen, die mir so freundlich zur Unterstützung und Ermutigung geschrieben haben und die mich davon abgehalten haben, mir eine Vollzeitstelle zu suchen, weil ich jeden Tag all ihre E-Mails beantworten wollte. Ohne sie wäre dieses Buch niemals Wirklichkeit geworden. Ich danke Nadxieli Mannello für das Lektorieren der endgültigen Textfassung des Buches, sie hat mein Organisationschaos ertragen und mich aus dem Durcheinander gerettet. Dank geht auch an Nicolas Lampert für das Verfassen der Einleitung und seine große Unterstützung seit unserem ersten Kontakt. An Brandon Bauer für seine Hilfe bei der Recherche und dem Schreiben vieler Kapitel. Ich danke für die Zusammenarbeit von Nadxieli, Nicolas und Brandon, durch die der Text in diesem Buch zu dem geworden ist, was er ist, weit mehr, als ich zu hoffen gewagt hätte. Ein riesengroßes Dankeschön geht an Carol Wells vom Center For The Study of Political Graphics, deren Unterstützung und Hilfe bei diesem Projekt unglaublich waren. An Jon Emerson für seine Hilfe bei der Beschaffung des Bilds „I want out" für die Einleitung. Besonderer Dank gebührt Jon Carr, Verwalter der Ausstellung „Yo! What Happened to Peace?" („Hey! Was ist mit dem Frieden passiert?"), die von Cross World Communications/CWC-i (New York) produziert wurde und mir eine große Hilfe beim Beschaffen der Grafiken von Seth Tobocman, Winston Smith, Shepard Fairey, Hugh Gran, Chuck Sperry und Yuri Shimojo war. Danke an Peter Kuper, der das Projekt bekannt gemacht hat, und an die vielen anderen, die dies ebenfalls getan haben, insbesondere diejenigen, die den Aufruf für Zusendungen oder einen Link zu meiner Website auf ihrer Website veröffentlicht haben. Danke an John Couture für seine Hilfe beim Schreiben der Kapitel. An Michael Schuhmacher für die Programmierung meiner Website, die mir ermöglichte, Informationen über mein Projekt zu veröffentlichen, und Künstlern eine Anlaufstelle für das Einreichen ihrer Arbeiten bot. An Delphine Doidy für das Fotografieren vieler Plakate. An den Verleger Manfred Olms, der an das Projekt glaubte und dafür sorgte, dass dieses Buch tatsächlich entstand. An Amnesty International für die Unterstützung des Projekts und ihre Hilfe zugunsten derjenigen, die unter der Tragödie des Krieges leiden. An meine Familie und meine Freunde, die mir rieten, mit Taten für meine Worte einzustehen, und trotz möglicherweise unterschiedlicher politischer Ansichten immer an mich und mein Projekt geglaubt haben und mir mit Rat und Ermunterung zur Seite gestanden haben. Dieses Buch ist ein Beispiel dafür, dass jeder Mensch einen Unterschied machen kann, wenn ihm etwas wichtig genug ist. Jeder kann Veränderungen bewirken, muss aber bei sich selbst anfangen. Und zum Schluss danke ich meiner Mutter dafür, dass sie mir schon sehr früh beigebracht hat, dass Krieg kein Spiel ist und dass Frieden und Liebe immer die bessere Lösung sind. Ich danke auch meinem Vater dafür, dass er mich nie an Politiker hat glauben lassen, und für seine Ratschläge und Unterstützung. **Jim Mann**

Remerciements

J'aimerais remercier les centaines d'artistes et d'activistes qui nous ont envoyé leurs travaux artistiques pour être publiés dans ce livre. Le processus de sélection a été difficile, et j'aurais aimé pouvoir les inclure tous. Merci aux milliers de personnes qui m'ont fait parvenir des mots gentils de soutien et d'encouragement, de sorte que je me suis abstenu de rechercher un travail à plein temps car je voulais répondre chaque jour à tous leurs courriels. Sans eux, ce livre ne serait jamais devenu une réalité. Nadxieli Mannello pour l'édition du texte final du livre, s'arrangeant avec mon chaos et me tirant du bourbier. Nicolas Lampert pour avoir écrit l'introduction et pour m'avoir tant soutenu depuis notre premier contact. Brandon Bauer pour m'avoir aidé lors des recherches et de l'écriture de beaucoup de chapitres. Pour les bons efforts de collaboration entre Nadxieli, Nicolas et Brandon qui ont fait des textes de ce livre ce qu'ils sont, bien plus que ce que j'avais pu espérer. Un grand merci va à Carol Wells du Center For The Study of Political Graphics (Centre d'étude des graphiques politiques) dont le soutien et l'aide pour ce projet ont été fabuleux. Jon Emerson pour m'avoir aidé à me procurer le poster « I want out » (« Libérez-moi ») pour l'introduction. Des remerciements particuliers vont à Jon Carr qui était responsable de l'exposition « Yo! What Happened to Peace? » (« Hé ! Qu'est-ce qui est arrivé à la paix ? ») produite par Cross World Communications/CWC-i (New York) et qui était chargé de m'aider à réunir les travaux artistiques de Seth Tobocman, Winston Smith, Shepard Fairey, Hugh Gran, Chuck Sperry et Yuri Shimojo. Merci à Peter Kuper pour avoir fait connaître le projet autour de lui et à tous les nombreux autres qui ont fait de même, en particulier à ceux qui ont publié l'appel d'envois de dessins ou ont mis un lien vers mon site web sur le leur. John Couture pour ses conseils sur l'élaboration des chapitres. Michael Schumaker pour programmer ma page web, ce qui m'a permis de diffuser le projet et de fournir une plate-forme pour des artistes qui souhaitaient nous soumettre leur travail. Delphine Doidy pour avoir photographié la plupart des posters. L'éditeur, Manfred Olms, qui a fait confiance au projet et qui a fait que ce livre voie le jour. Amnesty International pour son soutien au projet et pour son aide apportée aux personnes prisonnières dans la tragédie de la guerre. Ma famille et mes amis qui m'ont dit de ne pas seulement parler, mais d'agir et, bien que parfois d'une autre opinion politique, ont toujours cru en moi et en mon projet et m'ont offert conseil et encouragement. Ce livre doit attester que l'on peut tous faire la différence si on se sent suffisamment fort sur un sujet. On peut toujours changer quelque chose, mais ce changement commence avec soi-même. Finalement, j'aimerais remercier ma mère pour m'avoir enseigné à un très jeune âge que la guerre n'est pas un jeu et que la paix et l'amour sont toujours une meilleure solution. Mon père pour ne m'avoir jamais laisser croire ce que racontent les politiciens, pour ses conseils et ses encouragements. **Jim Mann**

Further Reading / Weitere Literatur / Bibliographie

Aulich, James, Sylvestrova, Marta; *Political Posters in Central Europe Eastern Europe 1945–1995*; Manchester and New York; Manchester University Press; 1999

Becker, Carol, *The Subversive Imagination: Artists, Society, and Social Responsibility*, New York: Routledge, 1994

Bruckner,D.J.R; Chwast,Seymour; Heller, Steven; *Art Against War: 400 Years of Protest in Art*, New York; Abbeville Press; 1984

Center for the Study of Political Graphics;Track 16 Gallery; *Decade of Protest: Political Posters from the United States, Vietnam, Cuba 1965–1975*; Santa Monica; Smart Art Press; 1996

Clark, Toby; *Art and Propaganda in the 20th Century: The Political Image in the Age of Mass Culture*; New York; Harry N. Abrams; 1997

Gregory, G.H; *Posters of World War II*; New York; Gramercy Books; 1993

Honnef, Klaus; Pachnicke, Peter; *John Heartfield*; New York; Harry N. Abrams; 1992

Landsberger, Stefan; *Chinese Propaganda Posters: From Revolution to Modernization*; Amsterdam and Singapore; Pepin Press BV; 1995

Lippard, Lucy R. ; *A Different War: Vietnam in Art*; Seattle; The Real Comet Press; 1990

McQuiston, Liz; *Graphic Agitation: Social and Political Graphics Since the Sixties*; London; Phaidon; 1995

Rauls, Walton; *Wake Up America!: World War I and the American Poster*; New York; Abbeville Press; 1988

Schiller, Herbert I.; *Culture Inc.: The Corporate Takeover of Public Expression*; Oxford; Oxford University Press; 1989

Willet, John; *Heartfield Versus Hitler*; Paris; Pocket Archive; 1997

Zurier, Rebecca; *Art for the Masses: A Radical Magazine and Its Graphics, 1911–1917*; Philadelphia; Temple University Press; 1988